CALIFORNIA
EXPOSURES

Selected books by

RICHARD WHITE

THE REPUBLIC FOR WHICH IT STANDS
The United States during the Gilded Age and Reconstruction

RAILROADED
The Transcontinentals and the Making of Modern America

REMEMBERING AHANAGRAN
Storytelling in a Family's Past

THE ORGANIC MACHINE
The Remaking of the Columbia River

THE MIDDLE GROUND
Indians, Empires, and Republics in the Great Lakes Region, 1650–1815

"IT'S YOUR MISFORTUNE AND NONE OF MY OWN"
A New History of the American West

THE ROOTS OF DEPENDENCY
*Subsistence, Environment, and Social Change among
the Choctaws, Pawnees, and Navajos*

LAND USE, ENVIRONMENT, AND SOCIAL CHANGE
The Shaping of Island County, Washington, 1790–1940

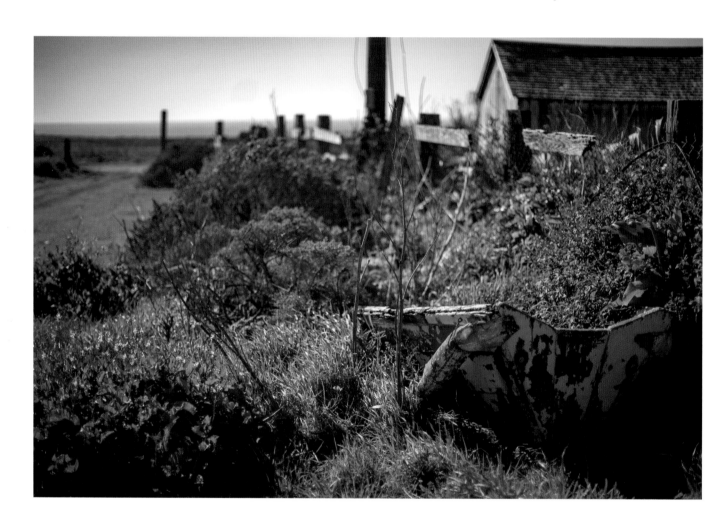

CALIFORNIA EXPOSURES

ENVISIONING MYTH AND HISTORY

RICHARD WHITE

Photographs by
JESSE AMBLE WHITE

Cartography by
ERIK STEINER

W. W. NORTON & COMPANY
Independent Publishers Since 1923

For information about permission to reproduce selections from this book,
write to Permissions, W. W. Norton & Company, Inc.,
500 Fifth Avenue, New York, NY 10110

For information about special discounts for bulk purchases, please contact
W. W. Norton Special Sales at specialsales@wwnorton.com or 800-233-4830

Manufacturing by Versa Press
Book design by Chin-Yee Lai
Production manager: Julia Druskin

Library of Congress Cataloging-in-Publication Data

Names: White, Richard, 1947– author. | White, Jesse Amble, photographer |
 Steiner, Erik B, cartographer.
Title: California exposures : envisioning myth and history / Richard White ;
 photographs by Jesse Amble White ; cartography by Erik Steiner.
Description: First edition. | New York : W. W. Norton & Company, 2020. |
 Includes bibliographical references and index.
Identifiers: LCCN 2019032319 | ISBN 9780393243062 (hardcover) |
 ISBN 9780393243079 (epub)
Subjects: LCSH: California—History. | California—History—Social aspects.
Classification: LCC F861 .W63 2020 | DDC 979.4—dc23
LC record available at https://lccn.loc.gov/2019032319

W. W. Norton & Company, Inc., 500 Fifth Avenue, New York, N.Y. 10110
www.wwnorton.com

W. W. Norton & Company Ltd., 15 Carlisle Street, London W1D 3BS

1 2 3 4 5 6 7 8 9 0

To Sofia,

who reminds her grandfather to look to the future.
And to the memory of Floyd O'Neil, a man of the West and a
scholar of the West. We will not see his like again.

CONTENTS

MAPS

PREFACE

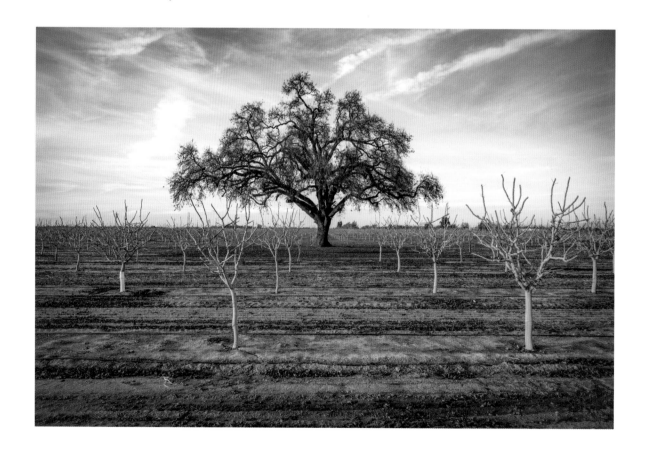

An old oak in a new orchard, Kings County

This book is a collaboration between a historian and a photographer who happen to be father and son. Relations between the present and past are fraught, but so too are relations between fathers and sons. We do not necessarily agree on the work a photograph can do. Jesse White has no illusions that his photographs are simple slices of reality. He selects, he frames, he alters, and he reacts. He regards a photograph as an artifact of a moment, a captured slice of time that was different before the now often metaphorical shutter clicked and will change again the second after it clicked.

I do not deny that this is true, but I also think, as I will explain, that every photograph reveals a history because every element in the frame existed before the photograph—often long before the photograph. Starting from a photograph, I can tell a story of a place by attaching the elements of the photograph—trees, buildings, land, animals, roads, levees, and more—to documents in archives, books, other photographs, maps, and memories. Our work focuses on three places, with remnants of a fourth. In moving back and forth from place to place, I use the photographs to tell stories. When I stitch the stories together, the result is a montage that is also a history—a peculiar and very partial history—of California.

D Ranch on Point Reyes, the Tulare Lake Basin, and the lands of the cojoined San Gabriel and San Fernando missions are not the usual vantage points for writing a history of California. None of them, except perhaps the missions, are iconic; but all of them are revealing. As I deciphered the photographs, I began to realize that they are like tree rings in that big events and trends have left traces on them.

It is easiest to define the book by what it is not. It is not a photography book, although the photographs are at its center and without them there would be no book. It is not an art history book, which would focus more narrowly on the photographs themselves and on the photographer. Nor is it a conventional history, for in no histories that I know does the narration proceed from the photographs. Usually, photographs illustrate the historical text. They are decorative.

The book can be read as a collage, but I intend the collage to function like the frames of a graphic novel whose illustrations are an intrinsic part of the narrative. I would like to claim R. Crumb's *Short History of America* as an inspiration, but I cannot since I looked at it carefully only when this book was nearly complete, though I claim it as an analogy.

I put photographs at the center because I am pursuing a particular way of looking and seeing. I want to see the past in the present. I do not mean in museums, although Jesse took some of the photographs in museums. I do not mean at historical sites or in archives, although Jesse has photographed historical sites, and I have spent considerable time in archives. I mean seeing the past in plain sight, in the quotidian places where we live, work, and travel. People cannot recognize the importance of the past, and of history, if they cannot even see it and recognize how pervasive it is.

If this sounds like proselytizing, then so be it. I have spent my adult life teaching and writing about history in ways that now often seem quixotic. History has become less and less important in the schools and in public discourse and public policy. It seems irrelevant to daily life even as I cannot imagine daily life without it. We ignore at

our peril the dead who walk among us, jostle us, constrain us, and enable us.

Traces of the dead surround us. The dead have made things, broken things, planted things, and killed things. The sum total of their actions and thoughts, along with what we have added and what nature has provided, constitutes our world. Our societies, economies, politics, and cultures are composed mostly of what the dead have done. We, like our world, are their progeny. Subtract the works of the dead, and the world would be diminished and unrecognizable. This is why history matters. Without history, we are strangers in a strange land, never understanding what we are seeing and unable to grasp how it came to be there.

In everyday life, the past remains visible. It not only can be photographed, but virtually every photograph of our contemporary world is a historical photograph.

Why? The photographer's arrangement of the elements of the past, as Jesse insists, might be of the moment and vanish the instant it is captured, but the elements themselves endure for varying amounts of time. These elements are fragments of once-more-complete pasts. They lead away from their present configuration and into the past, into earlier and different configurations.

But if the past is everywhere in our lives, why not just look around? Why do we need photographs? We need them because photographs allow us to concentrate. They corral our attention away from the flux of vision that is always rushing us on to the next scene. This book is an extended exercise in expanding a lived experience and recovering context.[1]

The lived experience, more unconventionally, includes my own. This is not the first time I have encountered many of the places in this book. History is just one way that humans approach the past; memory is another. The personal does not belong in all histories, but I think it belongs in this one.

I have several techniques, not wholly compatible, for using photographs. Some are more elliptical than others. I excavate, I dismember, and I associate. What I do with the photograph determines how a chapter unfolds. When I excavate, I usually concentrate on digging down into a particular place. In others I follow the references I find in the image; I can move far from the site of a given photograph. Just as Jesse sometimes employed a drone to take a photograph, sometimes my views can hover above the photograph's subject as I seek a panoramic view. The result is that the chapters, like the photographs, are not all of a kind. The asymmetry arises from the technique.

The premise of my excavation is that a modern photograph represents the temporal top layer of a sedimentary construction that extends below it. I am engaging in a kind of historical archaeology without the shovels. Going through the sediments yields a history. The logic is spatial, and the goal is to recover what was on the site of the photograph at various times in the past. For this I often use old maps as well as old photographs and contemporary descriptions.

No sedimentary layer is pure. All around us are erratics, as geologists call deposited materials transported by glaciers from somewhere else. Space—the site captured in the photograph—always reflects time. When viewers concentrate on a particular space, they inevitably move backward in time.

My second technique, dismemberment, approaches a photograph the way a coroner approaches a corpse. Dismembering a photo-

graph isolates and explores a single element or group of elements. Coroners use parts of the body or alien objects present in the body to construct a larger story, a history of what turned a body into a corpse. The disease, the bullet, the split cranium all point to things beyond the body itself. Similarly, isolating and following the elements in a photograph can carry me to other places and to people connected to but separate from the places I am describing. I find these elements compelling because no matter how wispy they might seem, the photograph led me to them.

Dismembering thus leads to the third technique: association. Association often connects me to previous attempts to understand and shape California's past. I have found that I am hardly the first person to think that he can see the past. Americans have not only told stories about California almost as soon as they arrived, but they have preserved the past, re-created the past, memorialized the past, pictured the past, and reenacted the past. All of these activities claim a visualized past in order to shape a future. The mythic stories of California are like the fogs at Point Reyes where this book begins. They can seem to obscure the actual landscape until you realize they are parts of the landscape.

ORGANIZATION

Taken together, the chapters proceed roughly chronologically as most histories do; but within chapters, time bounces around. Each chapter begins in the present (or rather the near past)—the moment the metaphorical shutter clicked—before darting off into various sectors of the past. The guides to the narrative's path are the brief introductions of each part.

I fully recognize that in harnessing photographs to history I need to hold the reins tightly. These powerful images would just as readily pull the narrative along as myth, by which I mean timeless stories that differ from history.

My first section is an examination of myths, and I do not use *myth* pejoratively. Myths are not so much falsehoods as explanations. Myths, as Richard Slotkin has written, are representations that collapse into a single emblematic story the assumptions and values of a culture.[2] History and myth both aspire to tell why things and people are the way they are. But where historical stories tend to be particular, contingent, and relatively open-ended—anything can happen—myths seek universal meanings and claim to explain why things have to be how they are.

The very framing, and thus meaning, of landscape photographs is mythic: wide open spaces, men to match the mountains, home sweet home. Once a myth makes a photograph its host, the line between myth (an explanation) and reality (what it explains) nearly vanishes.

While writing this book, I began to recognize that the three mythic stories about the origins of California that appear in the book's photographs—Sir Francis Drake and discovery, the mission myth, and the gold rush myth—are all just variants of a larger Anglo-Saxon myth of California that is remarkably hard to shake. It is the myth of the preordained white man, the idea that California always awaited the white men who would give the state its proper form. Another set of myths belongs to Native California. They revolve around the character known as Coyote. My goal in examining these myths is not to debunk them but to historicize them, treating them as consequences rather than causes.

The first three parts of this book examine myths and then yield to parts focusing on property and capital. Their chapters usually concern the simultaneous process of dividing and allocating land and the new connections that the movement of people and capital forge between what has been severed.

The last parts seek to reunite the myths and the culture they inform with the economic and social realities of modern California. Here the span between the taking of the photographs and the pasts they reveal are foreshortened.

This book began as a wager between Jesse and myself. I bet I could turn his photographs into a history of California. I have lost the bet—what follows is too partial to be a complete history. The book is more a proof of concept than the complete history of California I envisioned. The time and topics that the book covers are critical, but they are not complete. I touch on the state's deep racial divisions, but Watts, for instance, lies outside the frame. I spend time on technological innovation, but Silicon Valley, where I teach, lurks only around the edges. The rise and rapid decline of the state's educational system and Proposition 13, which precipitated the decline, receive only glancing mention in the book. The state's frequently peculiar politics sometimes enters the story, but more often does not.

The photographs led me to pursue five themes. The first is the mythic structure of California—the California Dream—that California politicians still refer to. The second is environmental transformation, for better or worse, which accelerated rapidly with American conquest and whose consequences pose immense challenges today. The third is California's self-image as a land of individualists and its reality as a creature of the state—both the state and federal governments. The fourth is the hybrid nature of the place, not only in its environment but in its population. That today California is a majority-minority state with no single racial or ethnic group forming a majority was not inevitable, but it was foreshadowed in the nineteenth and early twentieth centuries. California's American history began in 1848 when the United States annexed Mexican territory, and more than any other part of the United States, California has grasped the Pacific and Central and South America as essential to its identity and future. It is no wonder that Asian and Latino immigrants and their descendants form such a large proportion of the state. The fifth theme is the dynamism of the California economy, which began less with the gold rush than the agricultural developments of the nineteenth and early twentieth centuries. Economic promise and individual opportunity have been hallmarks of the California Dream since the gold rush, but large periods of the state's history have been marked by dangerous levels of economic inequality.

I may have lost the wager with Jesse, but few bets have proved more profitable to me. I am astonished at what a photograph can reveal. I do not have to pretend that it reveals everything. In California, as elsewhere, history will never displace myth and memory. Its goal is not to eliminate them but to encompass them.

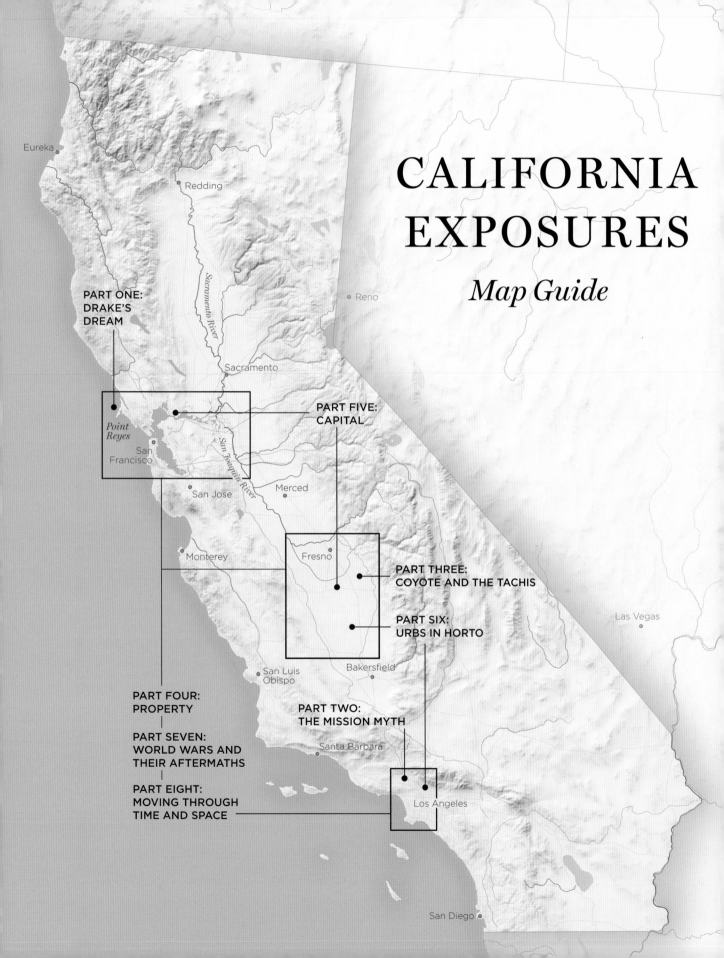

CALIFORNIA EXPOSURES

Map Guide

Eureka

Redding

Sacramento River

Reno

PART ONE:
DRAKE'S
DREAM

Sacramento

PART FIVE:
CAPITAL

Point Reyes

San Francisco

San Joaquin River

San Jose

Merced

Monterey

Fresno

PART THREE:
COYOTE AND THE TACHIS

PART SIX:
URBS IN HORTO

Las Vegas

San Luis Obispo

Bakersfield

PART FOUR:
PROPERTY

PART TWO:
THE MISSION MYTH

PART SEVEN:
WORLD WARS AND
THEIR AFTERMATHS

Santa Barbara

PART EIGHT:
MOVING THROUGH
TIME AND SPACE

Los Angeles

San Diego

PART ONE

DRAKE'S DREAM

There is an old dory at Point Reyes National Seashore, lost among the weeds of D Ranch and decayed nearly to the vanishing point. I had passed it many times, but I did not really think about it until Jesse photographed it.

It took a while, but the photograph reoriented me. It emphasizes the dory's slow decay, but Jesse framed the picture so that the boat points to the strip of sea between the land and sky in the background. The D Ranch sits on the edge of the continent. The boat decays; the sea endures.

D Ranch had been a working ranch when its residents last used this boat. They took it to the sea and hauled it back to the ranch regularly until, one day, they no longer did so. The photograph made me wonder why they went to the sea and why they stopped. Photographs lead the viewer to wonder and ask questions about the spaces within the frame of the photograph. Those spaces have names; those spaces have often been mapped.

Many of the spaces where the sea abutted D Ranch had been named for Sir Francis Drake. I had no idea what strange stories these names contained. I initially was interested in where the dory was launched into the sea. By the time Jesse and I walked across D Ranch to Drakes Estero (Spanish for *estuary*), I was in search of Drake. Drake had landed on North America before Roanoke, before Jamestown, before Plymouth. In the nineteenth and twentieth centuries, people attached great significance to his being the first Anglo-Saxon. To look for Drake was to encounter the Anglo-Saxons as the founders of California.

Decaying boat, D Ranch, Point Reyes

Chapter 1

IS SEEING BELIEVING?

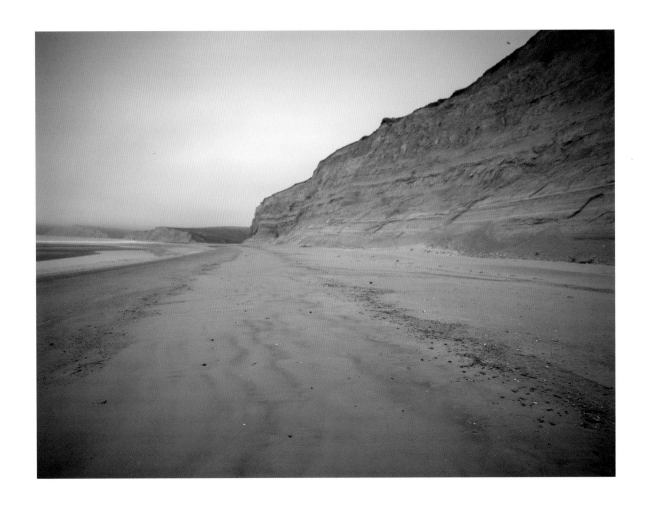

Beach along "white" cliffs, Drakes Bay, Point Reyes

This photograph is the most convincing visual connection between Sir Francis Drake and D Ranch. It is not much of a connection, nor did Jesse intend it to be. It is a sandy cliff along Drakes Bay. Jesse took it, I think, because the lines the water etched on the beach parallel those on the cliff, which disappears into the fog as it recedes into the background. Only later did I realize that these were presumably the cliffs Drake's crew said reminded them of the white cliffs of Dover.[1]

Connections to Sir Francis Drake come easily when you are walking along a beach on Drakes Bay. To get to D Ranch, Jesse and I had driven down Sir Francis Drake Boulevard. We were walking to Drakes Estero—which, supposedly, contains Drakes Cove. If history had billboards at Point Reyes, they would all advertise Sir Francis Drake. But the advertising campaign is relatively recent.

The names connecting Drake to Point Reyes officially appeared only in the late nineteenth century with the U.S. Coast Survey. In the seventeenth and eighteenth centuries, Drake's name was sporadically attached to the modern Drakes Bay but was also applied to other sites. For a time in the nineteenth century, Drakes Bay was known as Jacks Bay, a name still attached to an inlet at its head.

Nobody is looking for Jack, but Jesse and I were walking the beach below the cliffs because I had become the latest in a long line of people looking for Drake. One morning at the end of May 2014, the two of us left the old buildings at D Ranch to walk to Drakes Estero. The names had awakened questions about a ship that Drake had supposedly careened—that is, "heaved down" to expose its hull for repairs—near the site of the old hunting cabin at D Ranch. We were walking only a few miles, but we hoped to travel back roughly four centuries. We thought that if we could see what Drake had seen in June and July 1579, we could find him and his ship, the *Golden Hind*. We would, at least figura-

tively, see his ship as clearly as I saw the rowboat on D Ranch.

Thinking about the dory and the things salvaged from shipwrecks had led me to the archives to find out how people got from D Ranch to Drakes Bay and to Drakes Estero. In 1997 the National Park Service mapped D Ranch both as it was then and as it had been in the recent past. The dory had made its way to Drakes Estero on the back of a truck that the Horicks, the last family to reside here, had driven along an old ranch road to the hunting lodge on the estuary. Neither the lodge nor an earlier nearby dock remained when the map was drawn. The map records the tail end of a watery past that began in the nineteenth century when ranchers sent their butter to San Francisco by ship. The hunting lodge was gone by 1973; the dock, well before that. As we found out, by 2014 only traces of the road remained.[2]

Jesse and I were stragglers in the search for Drake. Since the late nineteenth century historians and archaeologists, but mostly enthusiasts, have sought the spot where Drake careened his ship before continuing his journey around the world. I was a conflicted searcher. I really didn't care much about either Drake or the exact spot. I was more interested in *why* people had persisted in looking for him for so long, how they had searched for him, and the places they had gone. Convinced that beginnings are the most important thing about a story, I thought I could

learn something about California and its history if I could understand why Californians had once started the story of the state with the arrival of Sir Francis Drake. Because the National Park Service has rather equivocally decided that he landed at Drakes Bay, and the Drake Navigators Guild has proclaimed that this decision verified their claim that the exact spot was Drakes Cove on D Ranch, I started there.[3]

Virtually everybody known to have searched for Drake has found him, but they have all found him in different places. The oldest accounts mention his landing at both 38 and 34 degrees of latitude, creating a competition between California and Oregon. Many of the Californians in search of Drake claimed that the anchorage where the "Generall" had spent a month repairing the *Golden Hind* was in San Francisco Bay or Bodega Bay, but other claimants marked spots farther north and south. Even when they found him in Drakes Bay, they put the anchorage at different locations. Since everyone could not be right, they have quarreled bitterly, angrily, and sometimes hilariously. They have filled books, archival collections, and personal letters with their disputes.[4]

I think they are a little nutty; I also think that I have become one of them. Like them, I believe that we can see into the past. It is not gone. It is right in front of us; we can even capture it in photographs, which is why Jesse is along. He takes photographs. I know nothing about taking photographs. I specialize. I look. I am looking for something both more obvious and more elusive than Sir Francis Drake. I am looking for the origin of California, the imagined moment when nineteenth-century Americans believed California began and the state's destiny spun out like a road before it. Drake was, they thought, the source from which

all else followed. The boat in the weeds set us off on a long walk into the past.

PORTUS NOVAE ALBIONIS

Before Drakes Bay became Drakes Bay, Spanish explorers had given it various names, most notably the *Bahia de San Francisco*. The Miwok called it *tamál-húye*. Drakes Bay and Drakes Estero have elbowed their way onto modern maps by claiming to be *Portus Novae Albionis*, using the name Drake gave to the place he landed. Drakes Bay and Drakes Estero are today easy to find, but Drakes Cove demands some looking. It is not a cove; it has no water. It exists only in the past, if it even existed there.[5]

Drake was a painter as well as a privateer and a pirate, but none of his journals, logs, or paintings of the voyage have survived. Nor do any of his maps remain, although it is credibly claimed that one of the insets—the one on the upper left-hand corner of the 1595 Jodocus Hondius Map of the World—is a sketch by Drake or a member of his crew showing the harbor, *Portus Novae Albionis*, where the Englishman put in on the Pacific Coast to repair his ship.

Generations of searchers for Drake have amply demonstrated that it does not require a great deal of imagination to find the seal-headed harbor of the Hondius Inset in many places along the coast. George Davidson, the first American hot on the trail of Drake, acknowledged the flaws of the Hondius Inset. It had "neither geographical position scale, meridian or soundings. It is destitute of any explanatory note. . . . From its shape and the scale of the ship and surrounding, one is

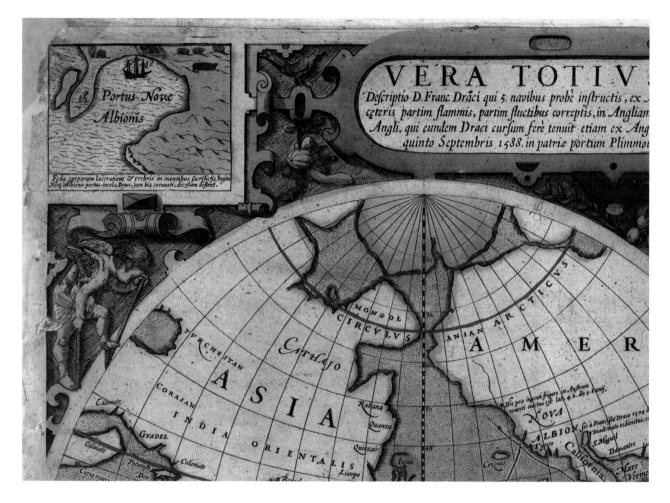

Portus Novae Albionis (*Hondius Inset*), *in Jodocus Hondius*, Vera totius expeditionis nauticæ: descriptio D. Franc. Draci

led to suppose that it is a small anchorage. As such there is no harbor like it on the coast."[6]

And then he found that harbor. George Davidson had started mapping the California coast for the U.S. Coastal Survey in the early 1850s, and by the 1880s he was writing the fourth edition of the *United States Coast Pilot*. Davidson looked like the sea captain that he was, and no sea captain knew the coast better than he did. As he became fascinated with Drake and sailed the *R.* *H. Fauntleroy*, a U.S. Coast Survey brig, "over the very track Drake had pursued," his skepticism over the Hondius Inset diminished. In the 1850s he thought Drake had entered San Francisco Bay, but thirty years later he knew better. He concluded that Drake anchored in Drakes Bay just south of Drakes Beach, below the entrance to the estuary.[7]

How did he know? He saw it. He looked into the past. He saw *Portus Novae Albionis*. He "could almost point out the spot where he careened his

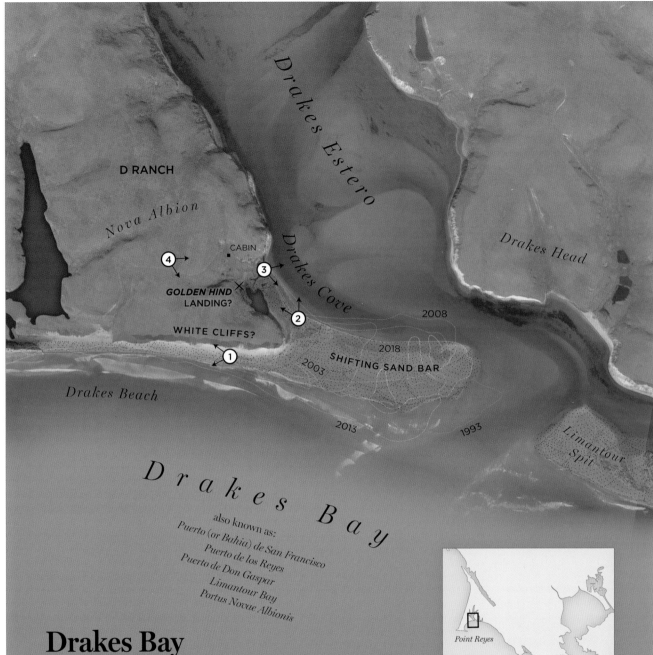

D RANCH

Nova Albion

CABIN

Drakes Estero

Drakes Cove

4 ↗→↘

3

GOLDEN HIND LANDING? ✕

2

WHITE CLIFFS?

1

Drakes Head

2008

2018

SHIFTING SAND BAR

2003

2013

1993

Drakes Beach

Limantour Spit

$$D \; r \; a \; k \; e \; s \qquad B \; a \; y$$

also known as:

Puerto (or Bahía) de San Francisco
Puerto de los Reyes
Puerto de Don Gaspar
Limantour Bay
Portus Novae Albionis

Drakes Bay *and* Point Reyes

0.25 MILES

PHOTOGRAPH SITES

1 Beach along "white" cliffs, p. 2
2 Drakes Cove, looking up Drakes Estero toward the bluff, p. 11
3 Bluff above juncture of Drakes Bay and Drakes Estero, p. 20
4 Panorama of Drakes Bay, p.24

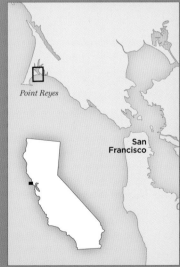

Point Reyes

San Francisco

ship." Having sailed where he thought Drake sailed, he saw what Drake saw. He had not "the shadow of a doubt . . . as to the exact locality."[8]

Some things did not change over centuries. The accounts of Drake's voyage mentioned the white cliffs, which reminded the Englishmen of Dover and gave the harbor the name of New England (*Portus Novae Albionis*). Whether the cliffs look white or not depends on the light and perspective. In Jesse's photograph they do not look white. On a sunny day from the distance, they are at least whitish cliffs, and Davidson saw those cliffs with his own eyes.[9]

Accounts of Drake's progress along the coast are sketchy and vague. By contrast, Davidson's description of the Englishman's route was full and detailed, because he was not really describing Drake's voyage in the sixteenth century but rather his own in the nineteenth. Davidson wrote as if he were standing beside Drake. "He was steering to the southeastward. . . . He could already see the wooded sides of Tamalpais . . . he would also note the low, small, black rock."[10] Davidson was a skilled sailor and Drake was a skilled sailor, so Drake must have done what Davidson would have done. Centuries vanished. The vague narrative gave way to the certainty of common experience.[11] The place where nineteenth-century ships sought shelter from the strong summer winds must have been where Drake sought shelter.[12] By calculating the place with the greatest shelter—"under the northern shore of the promontory, and farther than five-eighths of a mile from the eastern point"—Davidson had the place where Drake "hove down his vessel."[13]

Portus Novae Albionis was a geographical Rorschach test.[14] Davidson browbeat his evidence, dismissing information that did not fit. When the old maps made in the wake of Drake failed to show any safe anchorage on the coast, it was, he concluded, because the mapmakers had missed the anchorage. It had been, he remarked, hard to discern until James Lawson's 1852–53 U.S. Coast Survey made the "characteristics of this harbor of refuge fully known."[15]

By the 1940s Davidson's site had become the landing of Consolidated Fisheries and a Coast Guard rescue station; Aubrey Neasham, a National Park Service archaeologist, took up Davidson's determination to shoehorn the site into the available evidence. Neasham suggested that a stone floor, which he had excavated, was not just the site of a nineteenth-century quarry but the stone floor of Drake's Fort; he dated an iron spike to Elizabethan times; he mentioned various artifacts—an anchor inscribed with the name "Golden Hind," a "16th century gun butt," and a "16th century English coin," as further signs of Drake's presence. All of these had disappeared. Neasham's credulity and liberality of interpretation alarmed and embarrassed Robert Heizer, a Berkeley anthropologist also fascinated with Drake.[16]

THE DRAKE NAVIGATORS GUILD

Drake's landing place kept moving during the twentieth century. By the 1950s the Drake Navigators Guild led the search. Raymond Aker was its leading light. Like Davidson, and like me, Aker thought we could see into the past.

In 1970 Aker compiled a massive research report, which he updated in 1976. He gave it the suitably academic title *Report of Findings*

Relating to Identification of Sir Francis Drake's Encampment at Point Reyes National Seashore. His work is quite impressive. Aker was a brilliant and determined researcher who reprinted or cited much of what is known about Drake's California voyage. I envy his perseverance and talents.[17]

For nearly a century academics and enthusiasts had combed archives in Europe, North America, and Central America for mentions of Drake's voyage. Drake straddled the always thin line between pirates, who robbed and plundered on their own account, and privateers, who robbed and plundered under a license from an empire or state; neither group left many records. Drake had pillaged and murdered his way up and down the Pacific coast of Spanish America from present-day Chile to Mexico, and the Spanish understandably wanted to catch the man and execute him. The Spanish did not treat those crew members who fell into their hands kindly. Torture does not produce reliable information. Given all this, what researchers found was astonishing, even if relatively little of it came directly from the hands of those who made the voyage.[18]

The two most important sources overlap in time—Richard Hakluyt's "Famous Voyage," published in 1589, and *The World Encompassed*, published by Drake's nephew and namesake in 1628. These works contained many similar passages because they were largely derived from a single, now lost, source written by Francis Fletcher, chaplain on the *Golden Hind*.[19]

A different source, the *Anonymous Narrative* or "A discourse of Sir Francis Drakes' iorney and explloytes after he had past ye Stratytes of Megellan . . . ," alone seems to come directly from a participant in the expedition. That account survives in the British Museum. There are also some memoranda: the testimony of Spaniards captured by Drake and later interrogated by Spanish authorities, as well as the testimony of John Drake, a cousin and crew member who was captured by the Spanish while he was on a later buccaneering voyage and was then persuaded to talk.[20]

There were records of Spaniards who went in search of Drake, but they found neither him nor any trace of his presence. Sebastian Rodriguez Cermeño wrecked his galleon on Limantour Spit within sight of Drakes Cove in 1595, but he found no sign of Drake, his fort, or the plate he left behind to record his presence. Nor did Sebastián Vizcaíno, who entered Drakes Bay eight years later, find any sign of Drake.[21]

Cermeño fixed what is now Drakes Bay at 38° in 1595, but he called it *Puerto* (or *Bahia*) *de San Francisco*; eight years later Vizcaíno imposed new names to the bays around 38°. Drakes Bay is either his *Puerto de los Reyes* or *Puerto de Don Gaspar*.[22] After Vizcaino, there is no record of Europeans entering the bay until 1793. Vizcaíno's charts vanished into the Spanish Archives, to be resurrected around the turn of the nineteenth century and reproduced on the "*Carta plana de los reconocimientos hechos por el Capitan Sebastián Vizcaíno*."[23] Cermeño and Vizcaíno had entered Drakes Bay when the signs of Drake's visit would have been most visible; they came into contact with Miwoks who should have remembered him. Neither explorer found evidence that Drake had ever been there.[24]

The argument made by Drake Navigators Guild for Drakes Cove was not the first one, but it was the most detailed and most visual. In 1888 Kate Field, writing in *Picturesque California*, a

volume edited by John Muir, located the landing at Limantour Bay (Drakes Estero), but she had to imagine the harbor. Aker and the guild photographed it. They surveyed the landscape in search of a place Drake could have safely careened a ship. This brought them to the estuary. They took photographs, comparing them to the engraving on the borders of the Hondius Insert of 1595.[25]

Aker, acting as a forensic sketch artist, rendered visible what was invisible on the modern landscape. Drakes Estero lacked three elements of the Hondius engraving: an inlet shaped like a seal's head, an offshore island, and a long peninsula. "Drakes Cove" was only an expanse of sand with "long established vegetation." But a photograph taken on November 24, 1952, from a bluff on the west side of the estuary gave them a "break." It revealed a resemblance between the inset and a small cove that formed when a sand spit emerged to create "the seal-head shape of the cove." The sand spit was transitory and no water covered the "cove," but Aker reasoned that as fleeting as the spit and a sandbar offshore were, they were evidence of Hondius's peninsula and island. Other guild members remained skeptical. They dug to find traces of Drake's fort but found nothing.[26]

In 1952, the same year the guild took its photograph, the U.S. Department of Agriculture conducted an aerial survey of the Point Reyes peninsula. The guild did not obtain the survey's picture of the cove until 1956. It fortuitously "chanced to capture the entrance to Drakes Estero when its configuration was analogous to the inset view." A generous amount of latitude must be allowed to see in the sandbars of the 1952 photograph the equivalent of the Hondius sketch. But there is a sandbar adjacent to the point at the entrance and another one offshore. The Hondius Inset, the guild decided, was not a sketch but "but a fairly accurate map projection." It had morphed from a crude decorative drawing without scale or cardinal directions into a map that "must be strictly interpreted as a faithful view of his landing place as it appeared in 1579." Aker attributed those parts of the site that did not conform to the inset to the "artistic liberty" of the mapmaker.[27]

A LONG WALK

To get to the place where the Drake Navigators Guild located Drakes Cove, Jesse and I should have followed the National Park Service map. Instead we cut across coastal scrub and rangeland. The land is not the same as it was in the sixteenth century. Coastal scrub seems remarkably resistant to disturbance, but even it has been reshaped over the centuries. Americans suppressed Miwok fires, and Mexicans and Americans heavily grazed the land. Some patches were farmed.[28]

We had not gone far when I nearly stepped on a coyote. It was dead. Coyote was the central character in Miwok stories. Olema, the name of a small village at Point Reyes, is Miwok for *coyote*. Coyote was a trickster who could be tricked, and in some stories he dies—although never permanently. That day Olema looked up at me with a death grin. He looked permanently dead to me.[29]

Coyote prefigured Drake. In the early twentieth century Maria Copas Frias, a Marin Miwok, told Drake's story to the anthropologist Isabel Kelly, except with Coyote as Drake. "Coyote came

from the West, where the sun sets. The old people think the dead go to the West, because Coyote went back there." In Frias's story transmutations and transformations followed.[30]

After our encounter with Coyote, we followed elk trails. The elk were not supposed to be on D Ranch. It is pastoral land; the elk were supposed to be in the wilderness section of the park on the other side of the estuary. Elk ignore signage, and they can swim. Like coyote, elk were ubiquitous in Miwok stories. The elk called coyote "grandfather."[31]

In May of 2014 California was in the third year of drought. Late rains had produced patches of tall grass, wildflowers, and thistle among the scrub. The cattle had not yet been turned onto the ranch. We could see the elk in the distance. We had to circumvent a small two-forked and unnamed estuary, once blocked by a dam and weir, that cuts the ranch. We crossed a brackish lagoon; an old tire stood upright within it. The mud was mixed with tar. When we reached the beach along the bay, it looked like a scene from a battle that Dungeness crabs had lost. Dismembered crabs were everywhere.

Following the beach, we eventually arrived at the mouth of Drakes Estero, turned into it as Drake supposedly did, and looked for the cove—Drakes Cove. We walked into a picture/map Raymond Aker had drawn that encapsulated his version of Drakes landing. The guild had kept taking and collecting photos that revealed a changing and ephemeral landscape. Sandbars emerged and disappeared; the ocean cut tidal sloughs, which were blocked only to reemerge. What they saw in this estuarial kaleidoscope was the landscape seen by Drake and his crew.

Reading Aker's account is disorienting, with surmise built upon surmise and surmise morphing into fact. It is like watching plastic surgery: the landscape changes shape so it will conform to the Hondius Inset. The reader becomes confused, but the writer never does. All those vectors, adjustments of scale, and correlations are possible because nothing is fixed or found on the actual landscape, which contains no cove, no fort, no remnant of Drake's actual presence.

The landscape ultimately assumed the desired form in Aker's "Conjectural Appearance of the Drakes Cove in the summer of 1579." He imposed the fort, the ship, the peninsula, and the spit onto a photograph of the cove taken in February 1955.

As a strict interpretation of the Hondius map, the "Conjectural Appearance" does not pass muster. The fort in the inset does not match the fort

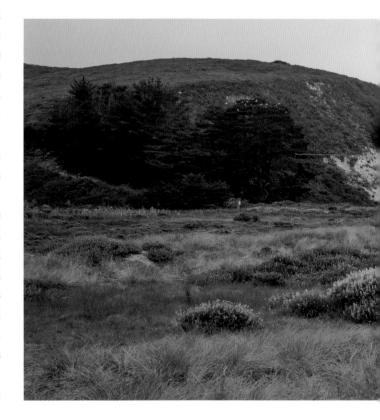

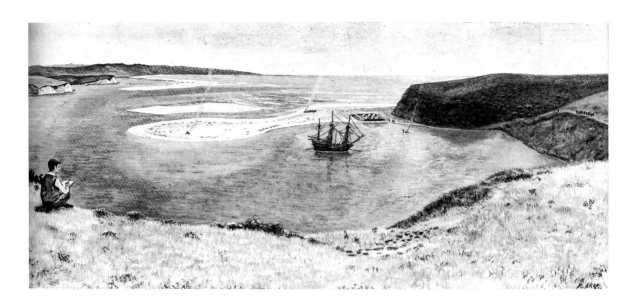

Conjectural appearance of Drakes Cove (two figures in the original)

Drakes Cove, Point Reyes, looking up Drakes Estero toward the bluff

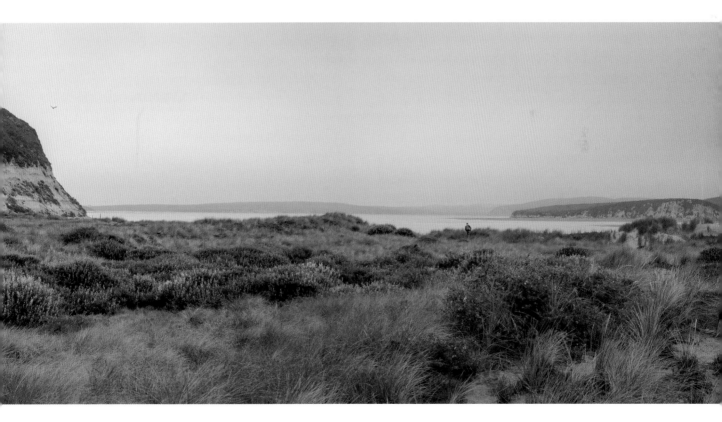

in the conjectural reconstruction. It has been moved from the cove proper to the peninsula or sand spit. It sat beneath the bluff. Building a fort on a sand spit beneath an overhanging bluff might seem an odd choice, although the guild explains it with more vectors showing lines of fire, but it removed the necessity for the guild to locate the fort or any remains of Drake's presence. All of it had washed away.

Raymond Aker had spent years trying to find a place where everything he knew about Drake cohered, where he could look out and see *Portus Novae Albionis*. He imposed his gaze on an Elizabethan in his painting.[32] Jesse and I stood in what Aker believed to be the cove. We were, in effect, the ship staring back at Drake's men on the bluff. Jesse took a photograph. Reconciling that photograph with Drake is not easy.

Standing in Aker's picture, I could see no trace of the Generall; and neither for many years could the National Park Service or the California State Historical Resources Commission. The Drake Navigators Guild tried to get those groups to see; the guild staked its faith in the power of anniversaries. Americans might not be enthusiastic about history, but they love anniversaries. The year 1979 marked the 399th anniversary of the landing of Sir Francis Drake somewhere on the Pacific Coast, which meant that it was a launching pad for those seeking to commemorate the 400th anniversary of Drake's landing. The trick was celebrating at the right spot. The guild wanted a State Historical Resources Commission plaque at Drakes Cove in Drakes Estero for the anniversary. Robert H. Power, the leading advocate for a rival site at San Quentin, regarded the guild as a "historical cult," and he demanded that the plaque be placed in San Francisco Bay. The guild members referred to Power, founder of the Nut Tree restaurant (a landmark on the highway from San Francisco to Sacramento), as "the Chief Nut from the Tree" and a purveyor of "idiotic nonsense."[33]

To buttress the case for Drake's having landed in Drakes Estero rather than other sites promoted by other enthusiasts, the guild had by the late 1970s enlisted retired Admiral Chester Nimitz, the victor at the Battle of the Coral Sea. Admiral Nimitz had access to U.S. Navy vessels, and he agreed to take part in a short voyage on USS *Tulare* arranged by the Drake Navigators Guild. The plan was to sail to three of the disputed sites. Even on a naval ship far too large to navigate any of the anchorages where Drake had supposedly landed, the guild thought that seeing would lead to believing. It would convince any skeptics, and the California State Historical Resources Commission, that the true landing place was in Drakes Estero.[34] Obtain the right vantage point, look with seaman's eyes, and the centuries would burn off like the fog to reveal Drake's true site. The point of the cruise up the coast was "to see the land as Drake would have seen it."[35]

At the time, Vivian Horick ran D Ranch, and since Drakes Cove lay just below the Horick hunting lodge, the guild invited the Horicks on the voyage. It was a nice touch—having the present inhabitants of the ranch view the land as Drake supposedly saw it. It was worthy of Clio, the Greek muse of history, and Vivian Horick responded in a perfect hand on a "Cleo" note card, with roses on the cover. This was a nice pun—Cleo and Clio—but I doubt the Horicks intended it or anyone else recognized it. The Horicks eventually had to decline. They hoped, however, to join the guild

at Drakes Beach or at the hearings that followed the voyage.[36]

Drake had not much liked the "stinkin fogges" of the coast, and nearly four hundred years later, the fog again blanketed the area. The guild's voyage to see what Drake had seen was "frustrated by thick fog" that prevented anybody from seeing much of anything. The State Historical Resources Commission refused to take a position on the landing site.[37] It was all very disappointing.

WHAT DRAKE MEANT

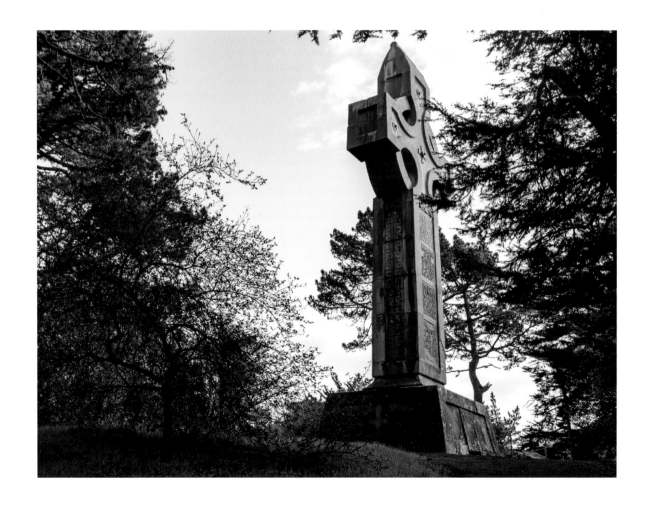

Drakes Cross, Golden Gate Park, San Francisco

Jesse's photographs at D Ranch ultimately led me to San Francisco and the monument to Sir Francis Drake in Golden Gate Park. Intended to be visible for miles, the monument is hard to find. Monuments to Drake proliferated in the late nineteenth and early twentieth century, but what once seemed obvious and important became obscure in a way captured by the photograph of the Celtic cross in San Francisco. Jesse framed the photograph from the hillside, looking upward. The photograph centers on the cross, as if the photographer has stumbled on an old gravestone in the woods. It is fitting that this monument is nearly invisible. In theory, monuments make history visible, notifying a visitor that here something happened, but such markers often don't record history; they record controversies. They are attempts in metal and stone to end an argument. They remain even after the argument has been lost.

Episcopalians placed the monument in what was then the state's largest city, and they wanted it to be visible from ships entering the Golden Gate. It was the Episcopalians' third attempt at commemorating Drake. The first came at Davidson's site near Chimney Rock on Point Reyes, where in 1892 Episcopal Bishop Nichols planted a modest wooden cross. The next year Episcopalians erected a far more elaborate Celtic cross there, with funds donated by George W. Childs, editor of the *Philadelphia Ledger*. It commemorated, the *Sausalito News* declared, "our own Plymouth Rock," but few people went there.[1]

Even those who were willing to concede Chimney Rock as the literal place of Drake's landing recognized that San Francisco was a better figurative site of his arrival. In 1894 the Episcopalians erected a cross in Golden Gate Park that dwarfed the wooden one at Point Reyes. It was made of blue sandstone, and newspaper accounts claimed, "several of the stones in it are larger than the largest stone of the pyramid of Cheops." It was designed as "a sermon in stone," but it became a tourist site celebrating an Anglican pirate and the founding of California.[2]

The cross added a necessary Protestant element to Drake's landing, but this claim of Protestant triumphalism was not without problems. The monument was a figurative sermon to honor an actual sermon given by Francis Fletcher, the chaplain on the *Golden Hind*, considered by Drake the "falsest knave that liveth," but what Fletcher preached was not known. That Drake was a pirate made the celebration of his religious faith incongruous, but the Episcopalians angrily denied this part of the story. When Hiram Johnson, the governor of California, innocently and absentmindedly asserted it at a later commemoration ceremony near Point Reyes, the rector of St. Paul's Episcopal Church intervened to proclaim Drake the "priceless possession of all English people." Johnson's response was the early twentieth-century equivalent of "whatever." The point of the cross was less about the sermon than the association of Drake and the English with piety rather than piracy. Drake was religious. He was a praying, psalm-singing pirate who hoped the Indians would, somehow, become Anglicans. By stressing *English* sermon, the Episcopalians escaped the objection that there must have been Spanish sermons in the 1542–43 expedition of Juan Rodríguez Cabrillo up the California coast.[3]

Today millions of motorists on Park Presidio Drive, part of the major route across the western part of San Francisco, pass within less than a hundred yards of the cross. Few ever see it. Few visit it.

Planting trees around the cross was not a good idea, nor was constructing it of sandstone. The engravings are fading; some are gone. Those that remain are more than a century old, but their text sounds even more ancient. They celebrate Drake as first—the first Protestant, the first Englishman, the first missionary—on "our" coast, in "our" country, on "our" continent.

The monument carries us back into a putatively Anglo-Saxon America of the late nineteenth century. At a time of heavy immigration and deep worries about the racial identity of the state and the country, Drake shouldered the Anglo-Saxon burden. The beginning of California was white, Anglo-Saxon, Protestant, and peaceful. Indians bestowed their country on Englishmen and, eventually, just disappeared. The story persisted even as immigration transformed the country in the late nineteenth and early twentieth centuries. In the *Los Angeles Times* in 1930, George Wycherley Kirkman echoed the cross's claims, celebrating Drake as "the first Anglo-Saxon" to see California, the first English speaker, and the first booster who wanted to plant an English colony in the future state.[4]

Anglo-Saxonism had a gravity so strong that it sought to pull the actual Drake and the *Golden Hind* out of Drakes Bay and into San Francisco Bay. A subset of Drake enthusiasts insisted that he, not the Spanish, had "discovered" San Francisco Bay. Their arguments were clearer on what was at stake than on the supporting evidence. Destiny was preparing for an Anglo-Saxon America, they argued, and it would not have sent Drake into one of the region's worst anchorages when perhaps the best harbor in the world was a few miles away. As Robert Power, a former head of the California Historical Society and one of the leading advocates for San Francisco Bay as Drake's real landing place, wrote as late as the 1970s, "San Francisco Bay would have provided the English Nation with a magnificent introduction to North America, warranting the poet Parmenius's words, 'Take up the standards, don't delay, and use your swift sails to go as fast as the winds allow.'" Point Reyes, on the contrary, would have "given the English Nation a bleak introduction, and would hardly have caused men to risk 'life or death' to come back to North America, again quoting Parmenius to 'Exercise . . . authority in a worthy manner.'" In other words, Point Reyes was hardly worth a trip to California, but San Francisco was a destination to remember even if Power had to quote a forgotten Hungarian poet to prove it. The very fact that Anglo-Saxons did come back a few centuries later meant Drake must have landed in San Francisco.[5]

The photograph of the existing cross speaks to an earlier photograph: the cross is constant, but most everything around it has changed. The buggies are gone; the trees have grown, and the cross that was meant to be visible from the Golden Gate and the Pacific has vanished behind the foliage. In its obscurity, the cross commemorating the founding of Anglo-Saxon California became a symbol of Anglo-Saxonism's decline.

The crosses should have been a cautionary tale. They were not. In 1979, on the 400th anniversary of Drake's arrival and a year after the ill-fated voyage of the Drake Navigators Guild with Admiral Nimitz, the Sir Francis Drake Quadricentennial Committee placed a plaque above Drakes Beach. The beach runs northeast to southwest underneath the white sandstone cliffs of Drakes Bay, from just below the estuary down toward Chimney Rock and Drakes Head. Beyond is the Pacific Ocean.[6]

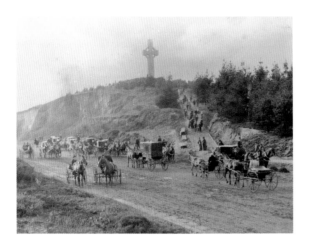

Drakes Cross, 1894, Golden Gate Park, San Francisco

England, which led to the American Revolution, which eventually produced American expansion that came full circle to California. So, in the nineteenth century, the forty-niners were not invaders; they were just coming home. Drake had gone from being an Anglican and thus near Episcopalian to being at least an honorary American. All this was pretty bold talk and a heavy burden to put on a pirate who spent a month on a beach supervising a crew patching a ship.

The guild had asked both the Drake Committee established by the state and the National Park Service to name Drakes Cove a historical landmark with an appropriate plaque, but the state committee deadlocked and did not choose between the contested sites within Drakes Bay. Instead, it situated the plaque between them. Drake, the plaque proclaimed, had sailed into "Drake's Bay on June 17, 1579, and sailed out on July 25. He saw the white cliffs and named the place Nova Albion." He had "claimed the region for Queen Elizabeth I," and was the first English commander "to circumnavigate the earth."[7] The plaque equivocated about the site but not about Drake's significance. "Drake's exploits and claim encouraged England to colonize Roanoke in 1585, and Jamestown in 1607. Captain John Smith, in 1616, named the east coast New England, a reflection of Drake's Nova Albion."

Somewhere near this patch of California beach between Chimney Rock and Drakes Estero, or so the claim went, the United States began. Drake inspired Sir Walter Raleigh to found Roanoke, which led to Jamestown and then New

HERE COME THE ANGLO-SAXONS

The critical date on any monument is not the date of the event or person it commemorates but its construction date, which tells you why it is significant and to whom. This is true of Confederate monuments put up in the Jim Crow era, and it is true of Drake. Enthusiasm for Sir Francis Drake was a phenomenon of the late nineteenth and twentieth centuries. It is deeply entwined with Anglo-Saxonism, but Drake enthusiasts have always sought to tie the monuments to actual sixteenth-century events.

Drake has remained a frustrating man to pin down. He had landed somewhere along the Pacific Coast, most likely within a day's sail of the Farallon Islands just offshore from the Golden Gate, but the details of his stay on the coast are confusing, contradictory, and often unlikely. Drake saw snow: snow just north of San Francisco Bay in June. Granted, this was the Little Ice Age, and extreme weather with a prolonged drought took place during those years; but still, snow in June? He claimed there were signs of gold and silver

everywhere. He described animals no one can conclusively identify. Whole volumes have been devoted to deciphering a few pages' worth of dubious information.[8]

But then, Drake may not have claimed these things at all, since the accounts of his voyage are from other hands. The Queen confiscated the log and the illustrated journal and suppressed both of them. Drake pictured as well as recorded what he saw, but the pictures and writings are lost.[9]

In California Drake encountered people whom he did not understand: he could not translate their language, and he almost certainly failed to comprehend their actions. These difficulties were the commonplace events of exploration. But whenever the accounts should have been uncertain, they were certain. And most of the time, they were probably wrong.

Drake and his men thought the Indians in that area regarded them as gods and could not be persuaded to the contrary. The Indians were understandably confused about who, or what, Drake and his crew were; but since Coyote arrived from the western sea and the dead departed over the western sea, they may have believed that Drake and his men were the returning dead. In the 1940s Robert Heizer, a leading California anthropologist who may have been the most sensible academic to get sucked into the Drake controversy, presented a good case for why the Indians were Coast Miwoks, with perhaps some Pomos among them, and why they thought the English were either ghosts or the walking dead.[10]

Parts of the accounts collected from the Indians fit some of what we know about later Miwok culture. The stories give a recognizable description of Miwok houses: "digged round about with earth" with "clifts of wood set upon them, join-

ing close together at the top like a spire steeple." They describe the women as wearing garments made from "bulrushes" and cloaks of deerskin. Accounts of Indian baskets include the distinctive decorations typical of later Miwok and Pomo baskets. They record words, some of them unidentifiable, but others that might correspond to Miwok words collected hundreds of years later in the area around San Francisco Bay. And the lengthiest account, *The World Encompassed*, describes extraordinary behavior that corresponds to later Miwok mourning behavior.[11]

"They acted," as the chronicler puts it, "as men rauished [ravished] in their mindes." When they left the English camp, they began to lament, "extending their voices, in a most miserable and doleful manner of shrieking." When they returned two days later, the men gave gifts and the women "cried and shrieked piteously, tore their cheeks with their fingernails until the blood flowed," tore off the cloaks they wore and "holding their hands high, cast themselves on the ground with great violence, regardless of consequences." They watched the English psalm singing with great interest, recognizing it as a ritual even if they did not know the ritual's purpose. When the Indians left the English "fort," they gave back all the gifts the English had presented to them.[12]

The Indians' behavior mirrored that of later Miwok: They both mourned the dead and feared their ghosts. When the English departed, the Indians burned a "sacrifice" of shell beads and feathers. The burning of beads to honor the dead was a practice of both later Miwok and Pomo. The moaning, cutting, and sacrifices all indicate that the Indians thought the English were returning spirits of the dead. Except for a ceremony with the young Englishmen, they avoided

touching the English, believing that physical contact with the dead would bring misfortune. One phrase the English heard and remembered—apparently because they heard it so often—was *nocharo mu*, meaning "touch me not," or in later Miwok, *notcáto mu* ("keep away"). The phrase may very well have been a response to the insistent lust of English sailors. Miwok women had no desire to lie with the dead.[13]

Amid all this strangeness and misunderstanding, simple, human moments also took place. The Miwoks greatly enjoyed hearing the English sing. They would gather and ask these psalm-singing pirate/privateers to perform for them.[14]

Drake's final piece of confusion led to the creation of the first European historical marker in the present United States, one that eventually eclipsed the crosses, great and small. A leading man among the Miwoks came with a large retinue, and the English thought him a king. The "king," in turn, recognized Drake as the leader, the "Hioh" of the English. He showered Drake with gifts, and he placed a feathered crown on Drake's head and shell bead necklaces around his neck. The English interpreted this as the Indians acknowledging Drake as their king and sovereign, and, following the analogy to the end, imagined the Indian king bestowing his country upon Drake.[15]

Drake commemorated the imagined cession by setting up a monument.

Before we went from thence, our Generall caused to be set up a monument of our being there, as also of her maiesties and successors right and title to that kingdome; namely, a plate of brasse, fast nailed to a great and firme post, whereon is engraven her graces name, and the day and year of our arrival there, and the free giving up of the province and kingdome, both by the king and people, into her maiesties hands: together with her highnesse picture and armes, in a piece of sixpence currant English monie, shewing itself by a hole made of purpose through the plate; underneath was likewise engraven the name of our Generall, etc.[16]

The Anonymous Narrative described the plate as lead with a less elaborate inscription. "At this place Drake set up a greate post and nailed theron a vi^d [a vi^d being 6 denarii, the standard abbreviation of pence] w^ch [which] the countrey people worshipped as if it had bin God; also he nailed upon this post a plate of lead, and scratched therein the Queenes name."[17]

And then Drake, his crew—or at least most of them—and three slaves they had captured from the Spanish boarded the *Golden Hind*, abandoning a smaller ship that his cousin testified Drake had seized from the Spanish off the coast of Nicaragua. They supposedly sailed out of the estuary, into what would be Drakes Bay, and away.[18]

DRAKE'S PLATE:
FINDING DRAKE

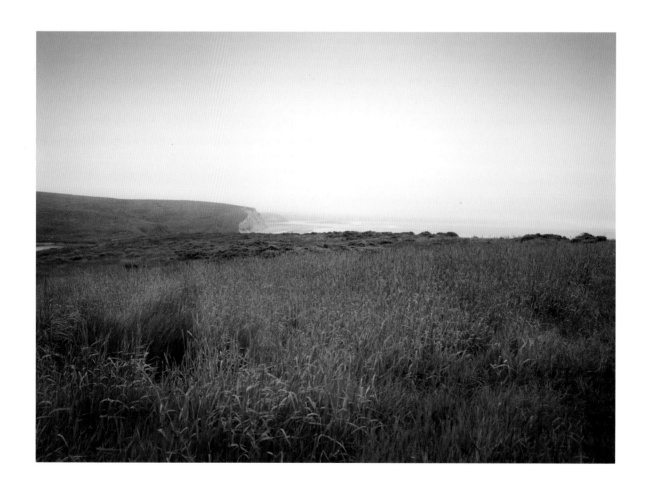

Bluff above juncture of Drakes Bay and Drakes Estero, Point Reyes

The headlands are above Drakes Estero. We walked here on the way back from the cove to see the estuary from above. The photograph records what we saw: grass, scrub, sea, sky, and fog. The sea and the sky often seem to merge at Point Reyes. The photograph seems timeless. On any day across many centuries, the place would look like this. But it also records an absence. Drake left a plate nailed to a post above wherever it was that he landed. Although the Drake Navigators Guild erected its own post at the cove, there was never a sign of the original plate or post. A generation of Drake enthusiasts elaborately explained why.

The story of the 1936 discovery of the plate—five by eight inches in size and made of brass—begins like a fairy tale. "A young clerk in a store in Oakland, while picnicking in Marin County about six months ago, found an old blackened piece of metal, which seemed to him curious. . . ." He originally intended to use it to patch the frame of his car. The clerk was not alone. He was with a girl—apparently "a chance pick-up acquaintance of the day," whom he refused to identify. He seemed "a little ashamed of that part of the affair." This meant that his was the only account of the discovery. A friend advised him to take the metal plate to a famous historian, or at least as famous as historians get to be—Dr. Herbert Bolton at Berkeley, who was the leading scholar of Spanish America. "Dr. Bolton immediately recognized it as the plaque which Drake set upon a post as shown in his accounts of the voyage." Bolton and Allen Chickering, then head of the California Historical Society, set about raising money to buy the plate.[1]

The fairy tale soon morphed into a detective story. Trying to sniff out fraud, Bolton and Chickering "minutely" questioned Beryle W. Shinn—the young clerk who worked at Kahn's Department Store—about finding the plate at Point Tiburon. Shinn, whom Chickering thought "a simple young man" with little education, panicked, thinking the Catholic Church, which owned the land where he found the plate, might try to repossess it. The two

men reassured him, and he agreed to sell the plate for $3,500—a sizable sum in Depression-era California. Shinn seems to have paid off some debts, "scattered the rest around," become impressed with his own importance, and asked Kahn's for a better position. Instead, the store let him go. Chickering got him another job.[2]

For years Bolton had supposedly been telling his students to be on the watch for the plate, which he expected to turn up near Drakes Bay. Once the discovery was triumphantly announced, William Caldeira came forward. He claimed that he had thrown the plate from a moving car at Point Tiburon. Caldeira, a chauffeur, had taken his employer, Mr. Leon Bocqueraz, hunting on Point Reyes near

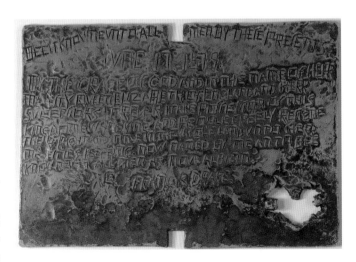

The Plate of Brass

what was then a ranch and is now a wilderness area. Bocqueraz was the "warm personal friend" of Allen Chickering. Caldeira drove a big Lincoln touring car to the Marin Country Club near Point Reyes Station, where Bocqueraz liked to ride a horse out to hunt. Caldeira would meet him at an appointed place where the keeper took the horse and then Caldeira drove Bocqueraz home. Until Bocqueraz appeared, Caldeira killed time by shooting jays and hawks. In 1934 he had found the plate near Laguna Ranch (at Point Reyes), picked it up, placed it in the car, and then forgot about it. When he later rediscovered it in the side pocket of the car, he had thrown it out between San Quentin and San Alselmo, where Shinn found it.[3] Allen Chickering accepted this story.[4]

The California Historical Society rushed to print *Drake's Plate of Brass: Evidence of His Visit to California in 1579*. Bolton's first sentence set the tone: "One of the world's long-lost historical treasures apparently has been found!" Others, including R. Flowers, assistant curator of the Department of Manuscripts at the British Museum in London, and Reginald B. Haselden, a specialist in Elizabethan literature and curator of manuscripts at the Henry E. Huntington Library and Art Gallery, suspected a con. The lettering did not look Elizabethan, and some of the spelling was odd.[5] The doubts alarmed Robert Sproul, president of the University of California, whose school would permanently house the plate in the Bancroft Library. To settle the question, the California Historical Society turned to science. They would use chemical analysis to date the brass.[6]

Science, in the person of Colin G. Fink of Columbia University, along with a consulting engineer, E. P. Polushkin, performed a "large number of tests." They proclaimed the plate authentic. The patina on the surface had "formed during a long period of time." Microscopic and chemical tests confirmed the metal was old and typical of Elizabethan manufacture. It contained levels of magnesium supposedly not found in modern brass; and it had definitely not been rolled, as was done for modern brass. Those who thought otherwise retreated into a sullen silence. There was a rage for replicas. The Episcopalians, of course, wanted one for Grace Cathedral in San Francisco; the Palace of Fine Arts exhibited the plate during the Golden Gate International Exposition of 1939. With the plate accepted as genuine, the battle to attach it to a specific place raged with new intensity.[7]

By the 1950s the Drake Navigators Guild had incorporated the "plate of brasse" into its argument for Drakes Cove. Guild members thought it would have been astonishing if the plate had survived in situ. Certainly, the Indians would have removed it. The movement of the plate was easier to explain after all than the failure of Sebastian Rodriguez Cermeño and Sebastián Vizcaíno to find any sign of it, or Drake's visit, or his fort.[8]

That the plate had appeared near San Quentin in San Francisco Bay—another contender for Drake's landing—was embarrassing to the guild, but Raymond Aker employed the same techniques as he had on the Hondius Inset. He accepted Heizer's and Chickering's conclusion that the plate had ended up at San Quentin only because the original finder had discovered it at Point Reyes, thought it worthless, and tossed it from his car. This put the plate closer to Drakes Cove. Aker reasoned that Drake had originally put the plate upon the headland at the entrance to the estuary facing Drakes Bay. He then undertook the kind of detailed detective work that he had brought to the Hondius Inset.

He concentrated on the physical marks on the plate itself and the two layers of corrosion that coated it, particularly the outer black layer. He said the plate had no marks from prying or vandalism from European tools, but there were scratches and indentations that he attributed to the stone tools. He did not think the Indians removed the plate immediately. They just banged on it, leaving it long enough to acquire the first, underlying layer of corrosion. Neither the soil at Laguna Ranch, where the plate was supposedly first found, nor at its ultimate resting site had sufficient carbon to create the outer layer. The guild agreed with Dr. Aubrey Neasham, the archaeologist who worked for the National Park Service, that the outer layer came from being buried in an Indian midden, which would contain the required carbon. Aker reasoned that the Indians, presumably before Cermeño showed up, removed the plate and eventually stored it. Then as the plate darkened and lost its luster, their interest in it faded, and they discarded it at the Laguna Ranch site. Aker suspected the original village site had been near Drakes Bay because one element of the coating—boron—was, he said, found only at Drakes Bay. He had his story of the plate and its movement based on chemical analysis, archaeology, and a conjectural history that matched the known facts about the plate. He relied heavily on Neasham, a man of many theories. Robert Heizer was afraid that Neasham would plant some of those theories among the guild, and he did.[9]

Aker's analysis of the plate was as impressive, imaginative, and full of esoteric details as his analysis of the Hondius Inset. No matter where the guild looked, everything led back to Drakes Cove. All this unfolded on a landscape seemingly so plastic that it could contain all the ever-shifting versions of Drake the centuries placed upon it. Where Jesse and I stood could have been the supposed original site of the post and plate. Across the estuary, on what was then Laguna Ranch, was where Caldeira said he had found the plate.

Chapter 4

DRAKE STORIES

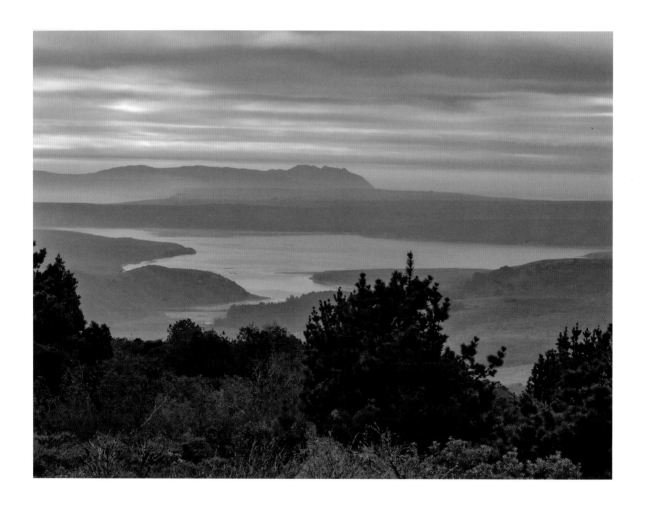

Panorama of Drakes Bay

Jesse takes a photograph, and we see different things. He creates a vista, a particular moment among the bishop pines on Inverness Ridge. Drakes Estero is beneath us; Drakes Bay is beyond, and in the upper right-hand corner somewhere beneath the fog is the Pacific. I see the stage on which the Drake story unfolds.

As we drove up the ridge, vultures picking at road kill rose awkwardly. But the photograph is tranquil, a fitting stage for the stories of Hakluyt's "Famous Voyage" and the account of Drake's nephew, "The World Encompassed," where California achieves a near virgin birth. Drake had planted a seed—although given the long lapse between Drake and the emergence of Protestant California, Drake would eventually seem more a sperm donor than a father. The children of the encounter that mixed Christianity and Indian land would be twinned: both California and the United States.

Drake was no innocent. His circumnavigation had been full of lies, mutiny, executions, and assorted disasters as well as the usual murder, rape, and plunder.

The "Anonymous Narrative," which did not surface until the nineteenth century, was hard on Drake. It portrayed a contentious relationship between Drake and the preacher of the first Protestant sermon commemorated by Drakes Cross, Francis Fletcher. Both men were religious, but they often disagreed on God's purposes and His opinions of Drake. Fletcher thought the various misfortunes that befell the expedition were God's punishments for deeds of Sir Francis Drake and his crew. His preaching and prayers dwelled on Drake's faults, offered Fletcher's apologies to God for Drake's misdeeds, and requested that God show Drake and his men mercy. The two men not surprisingly developed a deep and mutual antipathy. For Fletcher, being confined to a small ship where Drake was the "Generall" and Fletcher only the chaplain did not work out well. On the way home, Fletcher offered yet another sermon after the *Golden Hind* ran onto a reef in the Celebes. Whatever he said offended Drake. When, miraculously, the *Golden Hind* broke free, Drake "sitting cross-legged on a chest with a paire of pantofles [either slippers or high-heeled, cork-soled indoor shoes] in his hand," excommunicated Fletcher. He ordered the chaplain to be chained to the forecastle with a "posy" bound around his arm. It said "Francis Fletcher, ye falsest knave that liveth." Drake told Fletcher that if he removed the posy, he would be hanged.[1]

TELLING STORIES

Two parallel streams of stories carried Sir Francis Drake and the *Golden Hind* forward into twentieth-century California. Both streams deposited artifacts as they flowed on.

The first stream arose in California and flowed from the Sir Francis Drake Association of George Davidson and Zelia Nuttall, the California Historical Society, and finally the Drake Navigators Guild, which saw itself as the child of Allen Chickering, the "Drake Dean of the California Historical Society." Without Chickering's "adroit handling of the "Plate of Brass," the guild "would not have been born." The guild was not a child Chickering wished to acknowledge. He turned down its

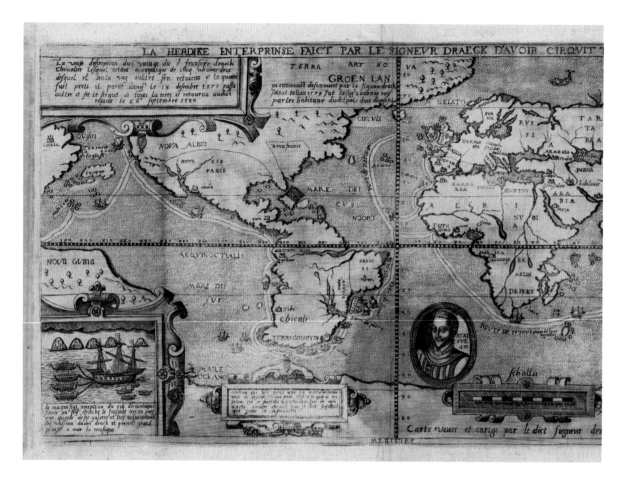

Herdike map

presidency. All these organizations depended on archival research by both trained scholars and enthusiasts. They sought to reinscribe Drake on the California landscape and implant in popular memory the idea that California began with Drake.[2]

The kinds of men and women you might expect to be attracted to a pirate fed the stories of the second stream, which was more interested in potential American claims on Britain than Drake's claim to California. As con artists, they were quite comfortable with theft and deception, and they preyed on American victims longer, if less bloodily, than Drake had preyed on the Spanish. They thrived on American credulity.

The first stream stressed what Drake had already bestowed on the United States. Mrs. Zelia Nuttall suggested in her *New Light on Drake* (London, 1914) that the explorer had dreamed of an Anglo-Saxon North America, which the United States brought to fruition. She claimed that a commemorative world map, titled in part *La Herdike Enterprise . . . Draeck* (1587, Antwerp), which contained two lines drawn through North

America, was in fact a record of Drake's claims. "One [line] extends from the Gulf of California to the Mississippi river across the continent . . . the other encloses 'New France.' . . . These obviously indicate an intuition to map out a 'New England' embracing the entire North American continent north and west of the limits assigned to New Spain and New France. . . . It thus appears as though the present occupation of the North American continent by the Anglo-Saxon race, is after all, but a realization of what may be called Drake's dream."[3]

Californians founded a Sir Francis Drake Association in 1913, but only in 1922 did William Ford Nichols get around to explaining why. His metaphors of "blood" and "white light" were as illuminating as his explicit claims. Nichols stressed that Drake revealed "a real blood relationship between a Sir Francis Drake Association and an English-speaking Union." But "in the white light of our California history," Drake's importance was not "confined to its bearing upon this forecasting of the English speech here. It was prophetic of an English-speaking civilization here." Drake may have been "premature," but in "intent and in formal act, Drake, as we say, put his nation on the California map."[4]

This became the position taken by the California Historical Society in the 1930s and the Drake Navigators Guild in the 1950s. Drake was first. He had beat Raleigh by eight years and Jamestown by twenty-eight years. California "was called New England (*Nova Albion*) some forty-one years before the pilgrims landed on the Atlantic seaboard." To go looking for Drake today involves finding the physical monuments—the plaques, crosses, and markers—Drake's enthusiasts erected to make their claims manifest.[5]

The second stream of stories stressed what Americans, as Drake's actual descendants, could inherit from his supposed estate. The detritus left by the second stream is harder to find, but it once flowed just as strongly. Drake spawned a "lost estate swindle" that originated in the Midwest, but spread to the West Coast.[6] Americans were not just figuratively but literally the heirs of Drake; he had left American heirs an unimaginable fortune. In the 1890s as George Davidson worked to establish Drake's landing spot, Robert Todd Lincoln, the American minister to Great Britain, warned Americans against being conned by people claiming to represent the Sir Francis Drake estate.[7]

Newspapers that denounced the schemes as swindles in one issue would sometimes report the inheritance as fact in another.[8] The *San Francisco Chronicle* published a story as early as 1913 warning against a search for a mythical fortune. An American contending that he was a Drake heir was then in London. He was not the first. A few years previously, 146 Americans had applied as heirs of Drake. But the story did not deny that there was a Drake fortune, only that most stories were "purely imaginary" or the work of swindlers.[9] At one point the American embassy in London was so overwhelmed by inquiries and requests that it had to resort to printed forms to reply. The Sir Francis Drake estate swindle would occasionally go dormant, only to blossom again like spring flowers.[10] Through the 1920s Californians traveled to England to claim their fortune in cash, jewels, and castles, even when they were a little hazy on the location of the castles.[11]

In 1915 the Associated Press published a story on Mrs. Sudie Whittaker, who developed the clas-

sic version of the scam. She was arrested in Des Moines, Iowa, after obtaining nearly $5,000 from local businessmen. Sudie Whittaker was collecting funds to pay for the expenses necessary to settle the estate of Sir Francis Drake, which would make her and the contributors fabulously wealthy.[12]

The Drake confidence artists created their own material trail. They manufactured wills, genealogies, and official letters. Where Davidson and Drake enthusiasts looked for Drake within the California landscape, the confidence men and women sought to connect Americans to Drake's England. They would inherit Drake's estates, his treasure, his jewels, and more. Drake had carried American treasure home, and now Americans would harvest its fruits. A *Los Angeles Times* article in 1927 reported that the California representatives of the Drake Estate said the heirs would receive Drake Castle (Buckland Abbey) with 8,000 acres of land, British shipyards, docks, and "other rich holdings in the British isles," 1,000 acres in Virginia, and "land around Drakes Bay, Cal."[13]

Richard Rayner tracked the Whittaker/Oscar Hartzell version of the scam, which ran for more than three decades. Sudie Whittaker, a widow, was operating in the Midwest as early as 1900. She came equipped with genealogical reports— all forged—that showed the rightful heir had migrated to America and that the present heir was George Drake of Rocheport, Missouri—who, as fate would have it, was her cousin. George had given her power of attorney, and to raise the funds necessary to pursue the case in British courts, Sudie was selling "sub-contracts." Since the value of the estate was now supposed to be $10 billion,

she promised to repay the money invested at 500 to 1,000 to one. After being indicted for fraud, she and her lawyer fled to England.[14]

Oscar Hartzell accompanied them. He was an unlikely accomplice, since Whittaker had swindled his mother, but he seems initially to have believed in the scheme. The accounts differ, and it is always hard distinguish the truth when all the principals were liars and thieves. At some point Hartzell realized that he was party to a fraud, but he did not go home. He displaced Whittaker and her lawyer and took over the con in the early 1920s. He gave it a new twist. He claimed he had unmasked the swindle, but in doing so he had discovered that the estate was real and that a Colonel Drexel Drake was the rightful heir. The British Crown Commission had ruled the will legitimate. Drexel Drake signed the estate over to Hartzell because his niece, Lady Curzon, had fallen in love with Hartzell and they were to be married. There was neither a British Crown Commission nor a Drexel Drake, let alone a Lady Curzon and a will.[15] All were products of Hartzell's fertile imagination.

It was now Hartzell who needed the money to straighten out the details of the inheritance. He recruited subagents who sold shares that paid 6 percent plus a large discretionary bonus when the estate was settled. The agents sold shares in the Midwest. They sent the money to Hartzell, who returned to London and lived large. In 1933 the British deported him, and federal agents arrested him on his arrival in the United States. Convicted of mail fraud and his appeals denied, he was imprisoned at Leavenworth in 1935.[16]

Until the 1970s almost everyone assumed that the two streams—the one of Anglo-Saxon origins

and the other of fraud—flowed separately. Some scholars had been suspicious of Drake's Plate, but science had validated it; one of California's most prominent historians had authenticated it, and the leading state historical organization had provided for its preservation in Bancroft Library at the University of California at Berkeley. It seemed a world away from the artifacts manufactured by felons. But Hartzell's attorney had cynically and strategically asserted that there was no distinguishing between Hartzell's fraud and Drake's history. "All history," he said, "is inaccurate."[17]

In 1950 a California historical organization, *E Clampus Vitus*, had added to the collection of Drake memorials by erecting a plaque commemorating Drake's landing at the Davidson site. *E Clampus Vitus* is sometimes described as a historians' drinking society, sometimes as a drinkers' historical society. Its motto is *Credo quia absurdum*: "I believe it because it is absurd." Members of *E Clampus Vitus* were, most likely, the manufacturers of the Drake's Plate that Bolton had embraced. It was a joke some members played on other members. It got out of hand.[18]

The plaque, in fact, was an old piece of metal that had been banged up with a ball-peen hammer and had a hole cut in it to contain the coin mentioned in *The World Encompassed*. The forgers made up the inscription, leaving clues to alert the skeptical that it was a fraud. They had spray-painted the letters *ECV*—for *E Clampus Vitus*—in phosphorescent paint on the back. Under an infrared light, the initials would appear. The forgers went further when the plate was discovered. In 1937 they published *Ye Preposterous Booke of Brasse, which includes . . . a fulle & compleate historie of Ye Plate of Brasse set upon our fair shores by Ye Antient Buccaneer Franke Drake*. The book not so subtly pointed out everything wrong with the plate, from its lack of patina and weathering to its hammer marks. It suggested using infrared fluorescent light to reveal the initials ECV. Rarely have hoaxers tried so hard to reveal their hoax.[19]

The will to believe was too strong. The likely initiator of the hoax, George Barron, the curator of the De Young Museum in San Francisco, supposedly hated Bolton and intended the joke to embarrass him. But Barron had not meant it to go so far as to dupe other members of the California Historical Society, such as Allen Chickering. When scientists pronounced the plate genuine, the hoaxers gave up. They let it stand as the most famous artifact in California. It remained on display at the Bancroft Library.

Only with the 400th anniversary of Drake's voyage would new questions about the plate arise, prompting new tests. Robert Power stood by the Plate of Brass and saw it as the founding of the British Empire, which foreshadowed an American empire "built on free association with mutual benefits without the use of might."[20] This was, he said, "the concept of manifest destiny." But that same year Samuel Eliot Morison, a prominent Harvard historian, published *The European Discovery of America: The Southern Voyages*. In the book, he pronounced the plate a fraud. Tests at Oxford and the Lawrence Laboratory at Berkeley resulted in a report dated July 1977 that revealed the brass to be of modern manufacture and the plate a fake. There were traces of phosphorescent paint on the back. Berkeley decided to keep the plaque on display, with "a two-page account of the scholarly detective work 'which shows how history can be investigated.'"[21] Everything asso-

ciated with Sir Francis Drake seemed an exercise in American credulity. Everyone who touched Drake seemed capable of fooling not only others but themselves.[22]

DRAKE KEEPS GOING ALONG

By the twenty-first century, Sir Francis Drake's landing on the Pacific Coast had left only a collection of fragments. With the plate gone, the best that advocates of Drakes Cove could do was point to porcelain recovered from the middens of Miwok villages. Cermeño's wrecked ship, which had come from the Philippines in search of Drake in 1595, was full of Chinese porcelain, and archaeologists had found it in Indian middens for years. The argument that made the porcelain evidence for Drake was vintage Navigators Guild. Drake did not have porcelain when he returned to England; therefore, he must have given them away, and they were among those at Point Reyes. That he simply might never have had porcelain was not seriously discussed. And since there were two different styles of porcelain in the middens, one must have belonged to Drake. Why Cermeño could not have had two types of porcelain on board, one older than the other, was not explained. The need to place Drake on the landscape would not die. A few pieces of porcelain were enough to accomplish what the plate of brass had been unable to do. In 2012 the National Park Service gave equivocal approval to Drakes Cove as the landing site. It still did not place a marker there.[23]

Drake may have landed at Drakes Cove, but the evidence still could convince only a true believer, and it was hard to recruit true believers. By 2012 the need for a birthplace of an Anglo-Saxon California had run out of steam. The search for Drake had never really been about history; it was about myth. The Drake story was meant to encapsulate the ideological meaning of the United States and California's foundational status. It explained how the United States came to be not just white but Anglo-Saxon; how the land was not taken but given.[24] But in the twenty-first century the state had become majority minority, and most people really did not care if the first European in the present-day United States—the presumed founding father of the state—was or was not an Anglo-Saxon Protestant.

Older stories, rarely mentioned earlier, now seemed more pertinent, and they described a more malign Anglo-Saxon paternity. The *Anonymous Narrative* is the only account that contains the story of Maria, who was the sole woman aboard the *Golden Hind*. On April 4, 1579, more than two months before he came ashore to repair the *Golden Hind*, Drake took a ship of Don Francisco de Zarate off the coast of Guatemala and removed an African woman—a "negro wench called Maria, which was afterward gotten with child between the captaine and his men pirates."[25] Drake also carried away two black men, slaves on trial for burning the town of Aguatulca in New Spain. By capturing them, Drake certainly saved their lives—at least for the moment. They were with Drake if he sailed into Drakes Bay; they were with him when he sailed out. The *Anonymous Narrative* said Drake eventually put the two men and the pregnant Maria ashore with some provisions on an apparently uninhabited island in the Molucca Sea on the other side of the Pacific. Here was Anglo-Saxon paternity, but

in the form of rape, abandonment, and probably murder.[26]

Drake had complained of the "stinkin fogges" of the coast. The fogs, at least, remain. There is something eerie and beautiful about D Ranch in the fog. Like the stories about Drake, it rises faint and ghostly in the distance. More than four hundred years after the English arrived and departed, it appears the Miwoks were right. In the sixteenth century Drake was not yet a ghost, but he and his men were on their way to becoming ghosts. Like Coyote, the Trickster, they are out there still.

Doorway, San Fernando Mission: Los Angeles

THE MISSION MYTH

This photograph of the interior of San Fernando Mission is also a photograph of the mission myth. Founded in 1797 during the last great wave of building, San Fernando is now part of Los Angeles. Since the early twentieth century, tourist guidebooks have claimed that at the missions, the pull of the past can be so strong that sandaled padres seem about to appear through a distant door. A photograph of reconstructed San Fernando, with the right combination of sunlight and shadow, makes that seem possible.

The missions remain alive, seemingly unchanged even as the world has changed around them. Their spirit continues to pervade California and inspire at least some visitors. But these reconstructed missions do not really celebrate the Spanish, and they certainly do not celebrate the Mexicans. As for Indians, they are present, but sometimes barely so. The modern missions struggle with their presentation of Indians and their relation to the Franciscans who founded the missions. Such interpretations are evolving, but mostly the modern missions still celebrate the Americans who have preserved them.

WALLS AND PALMS

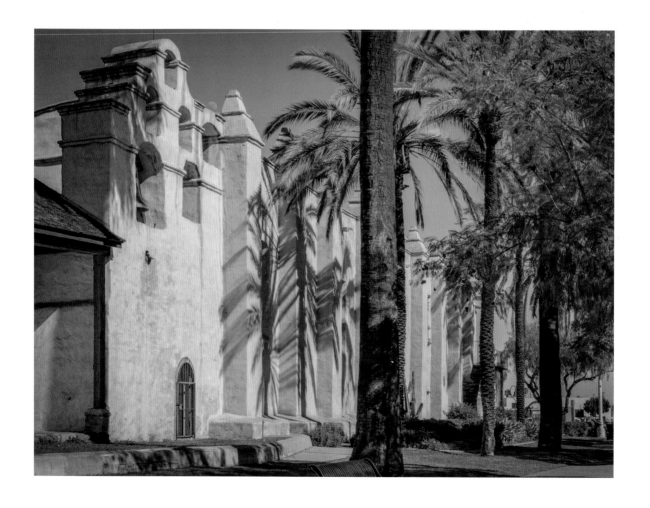

Modern San Gabriel Mission, San Gabriel, California

In the photograph of the southern façade of Mission San Gabriel Archangel, a row of date palms parallels the wall's buttresses. They provide the verticals that define the picture. The sidewalk, the undulating swaths of lawn, and a busy street in the distance add horizontal lines that draw the viewer in. The photograph elongates the mission, making it look as if it extends off beyond the last buttress. Any expansiveness the mission lacks in space, it achieves in time.

The building, which sustained damage in the earthquake of 1812, is not the original mission church. In 1775 Franciscans abandoned a site farther south along the Rio Hondo River, then the main channel of the San Gabriel River, at Whittier Narrows. They began construction of the present church in 1794, finishing it in 1806. It has undergone some modification and restoration, but it has remained among the most durable of mission structures because unlike most missions built of adobe, it was built partially of stone.[1]

The buttresses—the geometrical pillars along the side of the church capped by *almenas* shaped like small, stacked pyramids—made the church distinctive. The design followed the so-called Fortress style then common in Mexico. But Father Antonio Cruzado, who oversaw construction, copied the *almenas* from the cathedral at Córdoba, his birthplace in Spain. That cathedral had once been a mosque, and San Gabriel has a Moorish and Muslim air.[2]

The palms are more than decorative; they point the missions toward a California future as well as a past. Sometime after 1901 C. C. Pierce, a prominent Los Angeles photographer, shot the mission with a line of young California fan palms in front of it. They replaced the California pepper trees that had bordered the south-facing wall of the church for much of the late nineteenth century. Like the streetcar tracks, the palms signaled the birth of a modern "semitropical" Los Angeles, a beloved idea of the city's boosters. So common has the combination of palms and missions become, it is virtually impossible to compose a modern photograph of San Gabriel that is not an echo of earlier photographs.

When Carleton Watkins photographed San Gabriel Mission in 1877, no mission myth existed, nor were there palm trees along the wall. The pepper trees—the first Los Angeles street tree—along the dirt road formed the photograph's foreground. In front of the mission stood a man, probably non-Indian given his dress, and three women—most likely Indian—holding a baby.[3]

Palms had not yet achieved pride of place. Sometime before 1881 Watkins took a mammoth plate photograph of the old date palm at San Gabriel, but it was just a large exotic tree planted for the fronds used on Palm Sunday. It did not yet stand for either the missions or California.

CHARLES LUMMIS CREATES THE MISSION MYTH

The mission myth and the palm plantings had their origins in Charles Lummis's visit to the "picturesque old Mission at San Gabriel" on February 1, 1885. Lummis had recently recovered from malaria, but his trip was less about health than experience, pleasure, and knowledge. He wanted to know his country intimately. So he walked. Near the end of his "tramp" across the continent,

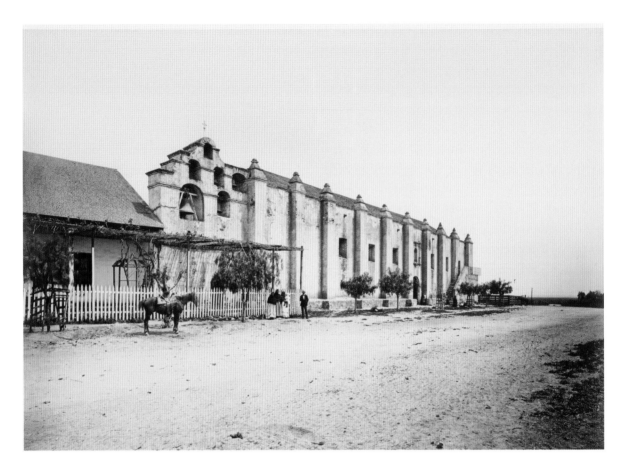

Carleton Watkins, San Gabriel Mission, 1877

he paused at San Gabriel.[4] Under an oak at the old mission, Lummis met Harrison Gray Otis, the publisher of the *Los Angeles Times*, although that meeting is not mentioned in the book he wrote about his journey. Like Lummis, and an increasing number of other Angelenos, Otis was a midwesterner who had arrived in Los Angeles only a few years earlier. He had struggled to find his footing after the Civil War. The collapse of the first real estate boom in Los Angeles would make Otis increasingly reactionary by the late 1880s, and he came to believe that the city's success depended on the open shop and the defeat of unions. Boosterism, real estate speculations, and a bitter hostility to organized labor pretty much defined him after that.[5]

Otis had already hired Lummis as the newspaper's city editor. The two men shared a picnic under the mission oak and then hiked ten miles to the city, arriving at midnight. Having regained his health, Lummis spent the next two years destroying it. He smoked, drank, worked, and fornicated himself into a paralytic stroke. He was not yet thirty.[6]

Unlike Otis, Lummis was not a reactionary. What united the two men, even after Lum-

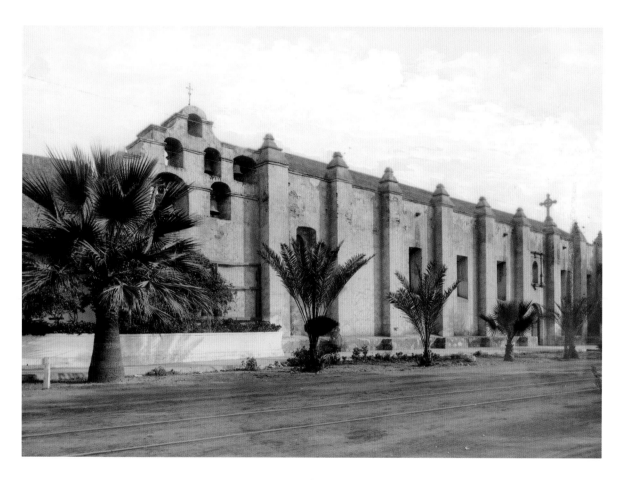

C. C. Pierce, San Gabriel Mission, c. 1900

mis left the *Times*, was real estate. Sometimes speculation in land seemed like the only glue holding Los Angeles together. After his stroke, Lummis retreated to New Mexico to recuperate. He returned to Southern California even more entranced with a Spanish past that had captivated him during his first trip through the Southwest. In 1895 he became editor of the magazine *Out West/The Land of Sunshine* and the founder of the Landmarks Club, both of which proved central to the mission myth. Little else changed. He drank, he smoked, he worked too long and too hard, he philandered, and each of his wives divorced him.[7]

On the way to making himself a human ruin, Lummis fell in love with ruins. This was not hard. Helen Hunt Jackson had already attached romance to old adobe. She had published her *Ramona: A Story* in 1884 and described a "picturesque life, with more of sentiment and gayety in it, more also that was truly dramatic, more romance, than will ever be seen again on those sunny shores." The setting was the *Rancho Moreno* in modern Riverside County, and the memory of Spanish California would endure "so long as there is left standing one such house as the Senora Moreno's."[8]

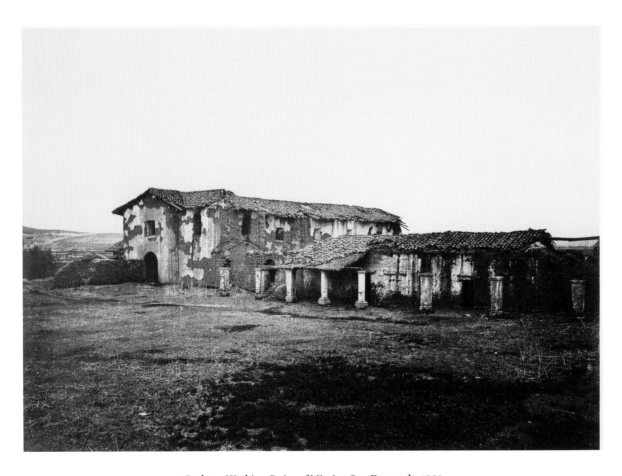

Carleton Watkins, Ruins of Mission San Fernando, 1880

RESURRECTING SAN FERNANDO

The old adobe that most entranced Lummis was San Fernando Rey de España, the mission ruins Watkins had captured in an 1880 photograph.[9]

Jesse did not know about Lummis and ruins when he began photographing San Fernando. He was more interested in how the oldest parts of Los Angeles blend into quotidian street scenes. In 2016 when he stood on San Fernando Boulevard, he wanted to picture the mission as part of everyday Los Angeles. He photographed an exceptional old building on an unexceptional Los Angeles street. Los Angeles is so rife with Spanish Revival architecture that the *convento* could hide in plain sight. Mexican fan palms rose among telephone poles and distant high-voltage lines.

Jesse did not know about Watkins, either, when he took the first mission photographs, but he could not escape him. Watkins had also photographed the *convento* with the ruins in the background as part of an everyday scene. The *convento* had seen service as a ranch house for the last Mexican governor of California, Pio Pico, a station for the Butterfield stage, and headquarters for the Porter Land and Water Company. Priests had

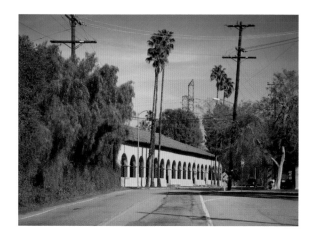

San Fernando Mission, San Fernando, California

Carleton Watkins, San Fernando Mission, c. 1882

abandoned the church in 1874, moving many of its furnishings into a room in the *convento*, where they conducted Mass.[10]

At the centennial celebration of San Fernando's founding on September 9, 1897, Lummis and Harrison Gray Otis sat under the portico of the *convento* with Bishop George Thomas Montgomery of the Los Angeles–Monterrey Diocese. They chatted and ate lunch; meals under the portico seem to have become a tradition in the ensuing years.[11]

As Lummis romanticized the mission ruins, he worked to reanimate them not only with holy Franciscans but also with Indians. In 1896, the year before Lummis celebrated the centennial of San Fernando, *The Land of Sunshine* published an article about the death of the oldest surviving mission Indian—a man named Gabriel, whose life had supposedly encompassed the entire history of the missions and their abandonment. Gabriel had originally lived at Mission San Carlos, which Junípero Serra, the Franciscan founder of the California missions, first established at Monterey but later moved to Carmel. Gabriel lived his last years in Salinas. He had died in 1890 at "a reputed age of 151 years." The author, Edith Wagner, had not met Gabriel. But she did not have to, since Gabriel was less a person than the encapsulation of the mission myth, which—like the Drake myth—began with the gifting of California by its original inhabitants. Gabriel had been the "oldest Californian," and he was, of course, a chief, the last survivor "of a now extinct tribe of Tulare Indians." He was also supposedly the first Indian baptized by Junípero Serra in the Monterey region.[12]

Gabriel played a holy Tonto to the sainted Serra. He cried when he told later priests of his baptism. Gabriel remembered his conversion and his loyalty to Serra, whom he had supposedly accompanied to found other missions. Kind priests and grateful Indians lived together at the core of the myth of the missions.[13]

The mission myth made Spanish rule an idyll, blamed the decline of the missions—and with them, Indians—on Mexico's decision to secularize them and redistribute their lands. Lummis attached their preservation and restoration to the Americans. This was part of his message, and it was also one that Helen Hunt Jackson—in part—

AN ILLUSTRATED MONTHLY DESCRIPTIVE OF
SOUTHERN CALIFORNIA.

Los Angeles. SEPTEMBER, 1894 Price, Ten Cents.

Cover, The Land of Sunshine *(September 1894)*

drove home in her novel *Ramona*, which quickly embraced the mission myth.[14]

The mission myth would have been little more than nostalgia, a story of paradise lost, if it had not made Protestant Americans the unlikely successors of the Franciscans. Lummis anchored his California story in eighteenth-century Spain. He did so to give California a meaning beyond moneymaking, but without rejecting either moneymaking or Anglo-Saxonism. The mission myth allowed the Franciscans to be superior to Anglo-Saxons as well as prefigure them.

Lummis made the Spanish the first pioneers and the first "civilizers" in every sense in advance of the English. I suspect that Juan del Rio, who wrote and illustrated largely for *The Land of Sunshine*, was a pseudonym for Lummis. Writing as Del Rio, Lummis took on a Spanish persona to publish on topics that interested Lummis. Del Rio even wrote about Lummis. When "Juan del Rio" wrote of San Fernando, he emphasized that the Franciscans were "remarkable pioneers" who were "not only missionaries and martyrs, but businessmen of an astonishing capacity." They turned the missions

into a church, a school, and "a genuine industrial beehive" that anticipated Anglo-Saxon California.[15]

The mission myth was so successful that the Native Sons and Native Daughters, groups founded to celebrate American pioneers, gave their parlors, or chapters, Spanish names and supported the effort to preserve the missions. Modern Americans became the true successors of Spanish padres.[16]

The myth's purpose was less about a past reality than a future one. It arose from a modern mixture of commerce, culture, and regional rivalry—in this case between Northern and Southern California. Most Southern California boosters were crass, seeking only more tourism and increased growth from a romantic branding of Southern California. The Los Angeles Chamber of Commerce funded *The Land of Sunshine* and sent out free copies to boost Southern California. In celebrating the missions, the magazine sold real estate, but Lummis sold something far grander: a vision of California that turned Spanish California into a template for a progressive American future.[17]

American succession turned the mission story into an account of paradise regained. The mission myth became at once nostalgic and progressive. It salvaged a Spanish/Indian past for American use, but it left Indians behind. It maintained a disdain for Spanish-speaking Mexicans and made California white.

Chapter 6

THE VIRGIN AND THE GABRIELEÑOS

Painting of the Annunciation of the Virgin Mary, San Gabriel Mission

Charles Lummis designed the mission myth to appeal to Protestants, but to the extent that the missions remained functioning churches, they radiated a bedrock Catholicism. In this photograph that Jesse took at the San Gabriel Mission, the pillars enclose a frame that holds a much-faded image of the Annunciation of the Virgin Mary. The Virgin is off center, partially obscured by vegetation, with the rough cloth hanging above her the focus. Its texture and color resonate with the pillars. The Virgin provides a splash of pink to echo the pink of the roses.

Because I went to Catholic schools (and Jesse didn't), I initially assumed the Virgin was the center of the composition. I misread the photograph aesthetically, but my focus on the Virgin was historically fruitful. The stones embedded in the church wall once joined it to the bell tower that collapsed in an earthquake on the feast day of the Annunciation of the Virgin Mary in 1812. Quite logically, the priests placed a picture of the Annunciation there.[1]

Since the Annunciation turned out to form a perfect symbolic fit with the ruins, I thought I knew what was behind the cloth: a statue of the Archangel Gabriel, who had revealed the news of the Annunciation to Mary. In my Catholic memories, statues were shrouded each year during Holy Week. I asked Jesse if he took the photograph during Holy Week. Jesse, who has no Catholic memories, asked what that was, and I told him the week before Easter Sunday. But that was not when he took the photograph.

A few days after New Year's in 2018, Jesse and I went to San Gabriel together for the first time. The cloth was still there, but it had been partially torn by the wind. The covering had nothing to do with Catholic ritual; the cloth concealed a window and kept birds from getting into the church. But the symbolism of the Virgin on that wall remained clear. In placing the picture of the Annunciation between the destroyed pillars, the priests had asserted eternal hope in the face of temporal destruction.[2]

The Catholicism of the missions is fundamental, but it is also complicated. At San Gabriel, Mary turned out to be both ubiquitous and liminal; she asserted the triumph of Christianity but also created a bridge between Christianity and older Gabrieleño beliefs.[3] Mary is fixed—always *Mater Dei*, the mother of God—but she is also malleable. She appears in the Annunciation and the Assumption. She can be Our Lady of Guadalupe, *Maria Regina Caeli* (Mary, Queen of Heaven), or Our Lady of Sorrows. She is the threshold between humanity and divinity, and this liminality allowed the Gabrieleños to associate her with Chukit, a virgin whom they believed had been impregnated by lightning and given birth to a god. The Gabrieleños to be baptized were Tongvas, and female Tongva shamans controlled fertility and rain. According to Spanish, but not Tongva stories, women brought offerings of seeds and food to a painting of the Virgin.[4]

The day Jesse and I came to see the cloth between pillars, two Indian women were sitting on a bench in the mission garden. In passing, I heard a bit of their conversation. There had been a question about a child. "He just flunked Indian 101," one of the women replied. They laughed. The women were waiting for Julia Bogany, a Gabrieleño/Tongva elder, who was using a walker to lead a tour. She had stopped her group at the pillars with the picture of the Annunciation. I did not overhear what she was saying, and stepped

aside to let her and the group pass. She looked at me and said, "Don't I know you?" I looked at her. She was striking, with the kind of amused eyes unusual among tour guides. I gave my name and said, "Yes." We had met before. "I thought so," she said, and moved on.

Later, when we crossed paths again, I asked her if she regularly led tours. No, she said, this was for a special group. Later, I recognized the odd serendipity of the photograph, my looking for representations of the Virgin, and meeting a Tongva elder returning to a place where her female ancestors may have brought offerings to the Virgin.

LA DOLOROSA

From the beginning, Father Junípero Serra thought that the Virgin stood guard over the church. Our Lady of Sorrows was the founding image of San Gabriel. A painting titled *La Dolorosa* sits to the left of the altar at the mission. It is small—conspicuous only by its place of honor. When the Spanish arrived in 1771, on the Feast of the Birth of Mary, they said that the Gabrieleños gathered, armed and angry, to oppose them; but when the Indians saw the painting of Our Lady of Sorrows, they put down their arms.[5]

This incident did not end resistance. In 1785 the Indians again took up arms under Nicolás José, a Tongva who had been baptized and served as an *alcalde* (mayor), and whose first two wives and son had died at the mission. He resented the Spanish for their suppression of the mourning ceremonies meant to honor his relatives and reconcile their survivors. His ability to balance his Catholic and native beliefs fractured, and he allied with an unbaptized shaman, a Tongva woman named Toypurina who claimed to know spells to kill or disable the soldiers. She complained that the Spanish and baptized Tongvas from outside San Gabriel were living on her village's lands and threatening the villagers' livelihoods.[6]

Such complaints were both irrefutable and open to debate. Franciscans denied, and would long continue to deny, Toypurina's contention that they took the Indians' lands. Franciscans were forbidden to own land either individually or in common. Although the neophytes, as the Spanish called baptized Indians, no longer controlled their use, they still owned the lands of those *rancherias* (Indian villages) now attached to the missions. Within the Spanish legal system, the Franciscans acted only as guardians of converted Indians. The property of the mission still belonged to the Indian community as a whole.[7]

The plot was betrayed to the Spanish, who imprisoned the ringleaders, whipped them, and exiled Nicolás José to San Diego. They sent Toypurina into "perpetual exile" so "she would not have hope to reunite with her relatives, nor cause new disturbances with her influence, power and tricks." While still a prisoner, she was baptized. She married a soldier, and had four children.[8]

In a sense the suppression of the revolt was another victory of the Virgin, but the triumph contained other meanings. When she was baptized, Toypurina acquired a new name: Maria Regina, derived from *Maria Regina Caeli* (Mary Queen of Heaven). The name might not have meant anything to her at all; but read one way, the name acknowledged Toypurina's defeat by naming her after her conqueror. Read another way, she presented herself as Maria the Queen—not a name that signaled the holder had been humbled.[9]

La Dolorosa, San Gabriel Mission

The Franciscans hung *La Dolorosa* in the sanctuary, where it remained until a schizophrenic antiquarian stole it in the 1970s. The police recovered it and returned it along with a hoard of other pilfered items in 1991. The theft was not unusual. Artifacts have regularly vanished from missions.[10]

Charles Lummis recognized the potency of the Virgin. He used her to promote the missions as an alternative both to the Anglo-Saxon California of Sir Francis Drake and to a cruder version of Anglo-Saxonism inspired by the gold rush days of forty-nine. She was as powerful in opposition to them as she had been to the Gabrieleños.[11]

GOLD RUSH NARRATIVE

The gold rush was, as a character in *Ramona* put it, Americans "running up and down everywhere seeking money, like dogs with their noses to the ground." It was male, rough, and disorderly, but the Society of California Pioneers, established in 1850, made participation in it heroic. By opening membership to all non-Indian males who had arrived in the state before 1850 and their male descendants, the society made the gold rush a mark of the true Californian. The society included some prominent Californios—Mexican citizens who became American citizens following conquest—but the bulk of its members were Americans. The Native Sons of California expanded this version

of California generationally while narrowing it racially; the Native Sons was open to any white man born in California.[12]

The gold rush narrative did not wear well. As early as 1873, *The San Francisco Newsletter and California Advertiser* dismissed the Society of Pioneers as a "harmless set of Old Fogies" whose overblown Admission Day orations boasted of "mock heroic achievements." Others were harsher. In 1890 the Pioneers became the target rather than the deliverers of Admission Day sermons. Speakers denounced the Pioneers as men who, unlike the Pilgrims, came "not for conscience, but for coin." They banded together like thieves to protect their spoils. Lacking the refining influence of women, "their great faults were love of money, ungodliness, and gambling." The Society of California Pioneers and the Native Sons fought to make the forty-niners into stalwarts of free labor and exemplars of self-discipline and independence, but it was a hard case to make for men who in many cases had abandoned their families.[13]

When he declared the gold rush merely "an apprenticeship of human stupidity" and wrote that the dream of the forty-niners was "to get rich and get out," Lummis was hardly an outlier in scorning the gold rush story. What made him different from other skeptics was that he offered an alternative.[14]

The mission myth created an ideological balance within California. Drake's landing and the gold rush focused on northern California, and for much of the nineteenth century California meant San Francisco. In the twentieth century, California would mean Southern California, Lummis's Mediterranean "Land of Sunshine." Although the archetypal missions of the myth were in Southern California, the missions extended from San Diego north into Sonoma County. They allowed for a wider story as well as a more extensive tourism. By 1907, with the installation of a statue of Father Serra in Golden Gate Park and another in Statuary Hall at the U.S. Capitol, northern California's acquiescence in the mission myth was complete.[15]

Lummis turned the dissolution of the missions into a new American beginning. An American civilization superior to that of the East was arising in Southern California, and the missions, the symbol of California's possibilities, predicted and validated American achievement. The willingness of Southern Californians to contribute to the "purely artistic and intellectual purpose" of saving the San Fernando mission signaled, according to the Landmark Club, California's rise and superiority to the East. The money "could not be raised in any of the great cities of the East so surely as it can be and will be in this new and more cultured community."[16]

Lummis argued that "Spanish California of 'before the gringo' was perhaps as near Utopia as the race is ever likely to get." Catholics welcomed Lummis's celebration of the missions as an antidote to the "black legend" that emphasized Spanish cruelty and persecution of the Indians. They created a white legend as unnuanced as the account it opposed. Father Eugene Sugranes, a Catholic historian, gave a typical version in 1922: "With noblest motives impelling them, the men who bore the Cross to and planted it in California, carried Christianity and civilization to a then wild region infested by barbarous beings." Despite his friendliness with Bishop Montgomery, the head of the Los Angeles Diocese, Charles Lummis was not a Catholic. He intended his story for an Anglo-American Protestant audience.[17]

Along with San Juan Capistrano, San Fernando epitomized Lummis's attraction to the mission and the foundations of the mission myth. In December 1896 *The Land of Sunshine* had published an article entitled "A Splendid Ruin," written by "Juan del Rio." In del Rio's telling, everything about San Fernando was perfect because virtually everything about the missions was perfect. The "extraordinary beauty" of the site of the mission was to be expected because the "Franciscan missionaries never blundered either practically or artistically in the selection of sites." San Fernando was "among the largest and finest" of the missions; it was "unusually wealthy" because of its expert administration.[18]

Like all the missions, it was a commonwealth between walls, a little world in itself set down amid a savage universe, a citadel of civilization within whose adobe ramparts religion and learning and human mercy could make head against barbarism. It was a wonderful picture of the patriarchal and the hierarchical life in one—this missionary frontier outpost which for its place and time was a splendid metropolis.[19]

Lummis lost control over the fate of the physical missions, but his myth triumphed. He wanted to stabilize the ruins, but not reconstruct them as

Room in the convento, *San Fernando Mission*

others did. "Let their noble, broken walls testify to the spirit that built them. . . . We will not put back a single block of stone more than is necessary to arrest destruction, and we will let no work of our hands deface the work of their builders nor belie the spirit that wrought them."[20] As ruins, the missions reminded Americans of a Spanish *past* that, as one guidebook put it, formed "an idyllic epoch, a time of missions, and siestas and languorous existence in a land of golden plenty." The missions had served their purpose; they were past, but they testified to the possibilities of an equally idyllic *future* California. Americans appropriated the past, rendering it both exotic and accessible. As a tourist destination for modern Americans, the missions provided both a refuge from a hectic present and an inspiration for an American future.[21]

Frank McGroarty, another employee of Harrison Gray Otis, translated the myth into *The Mission Play*, which debuted in 1912. Although both Catholic scholars and Lummis had objections to the play, it became a popular success performed annually in San Gabriel into the 1920s. When the play began to lose money, the Los Angeles Chamber of Commerce and wealthy Angelenos stepped in to rescue it, creating a nonprofit corporation to keep it going. They failed. The play died in the 1930s, but intermittent attempts to revive it continued. In altered form, there was even a revival in 2013.[22]

Only the kindness of old friends preserved Lummis in his sick and impoverished final years, but San Fernando grew young, and the ruins gradually vanished. So carefully are the rooms and gardens arranged at the reconstructed buildings of Mission San Fernando that pointing a camera at them seems like taking a photograph of a photograph. With their contents already curated, the rooms in the *convento*—where the priests lived, received visitors, and housed guests—appear to confess everything. They pretend that the past is present. What need is there to deconstruct photographs to retrieve a history when the rooms claim to freeze and preserve moments captured from the past? But this is not the past. The restorers rearranged things. They moved fountains, created interiors different from the originals. Lummis never intended such elaborate restorations. He wanted haunted ruins, not restored missions. But the re-creations are still his bastard children.

San Fernando's curators struggle against the gravitational pull of the mission myth that makes Indians satellites of the Franciscans. The curators want to offer a re-creation that is an Indian as well as Franciscan world. Even though Indians are not immediately visible in these rooms, they are there. During the alterations and repairs of the 1920s, workers stripped away paint and old plaster. When they uncovered traces of the original decorations, which revealed the missions to be a blaze of color, they found the work of Indians. In the 1930s artists working for the Index of American Design, part of the Works Progress Administration, made reproductions of the wall paintings and decorations. In between earthquakes the art historian Norman Neuerburg repainted many of the original murals, trying to return *convento* rooms to their appearance in the early nineteenth century.[23]

Much of the mission complex rose again, and then in 1971 the Sylmar earthquake destroyed the church, and workers battered down the remains of its massive adobe walls. The current church follows the original design, but it is a modern concrete building. Although heavily damaged,

Doorway, San Fernando Mission

the *convento* survived the quake, and restoration resumed until the 1994 Northridge earthquake undid much of this work. Undiscouraged, the diocese gave the building a seismic retrofit, and Neuerburg restored the restorations.[24]

Restoration was a grander, and cruder, version of what the photograph of San Gabriel captures: the Virgin triumphant in the ruins.

Chapter 7

HUERTAS

Exhibit in mayordomo's *house, San Fernando Mission*

In Jesse's photograph of the exhibit in the *mayordomo*'s house at the San Fernando Mission, the dark bars and the silver lock dominate the foreground. On the rear wall, the vertical of the cross parallels the bars. Only gradually does the furniture come into focus, and, last of all, the female mannequin.

The *mayordomo*, who is not present in the photograph, oversaw the economic production of the mission, particularly the *estancias*—detached farms and ranches attached to the mission and the *huerta*, which provided the corn in the exhibit. *Huertas* were irrigated orchards and vegetable beds enclosed by adobe walls next to the main mission buildings. *Huertas* were not gardens. Gardens were for contemplation and relaxation; in the *huertas*, people worked.[1]

Jesse's photographs of the mission tend to be street or interior views. Tightly framed, they direct the eye to certain objects while others are diffuse. His cameras can do easily what nineteenth-century cameras could not do at all, but nineteenth-century photographers could stand where Jesse could not. They could position themselves in the remains of the *huertas*.

Charles Lummis photographed the *huerta* at San Fernando long after it had been abandoned, but when its palms and some of its old orchard trees remained. Virtually anyone with a camera took similar photographs. The palms appeared in the same 1896 issue of *The Land of Sunshine* that contained the article by "Juan del Rio," a.k.a. Charles Lummis, on San Fernando. Del Rio wrote of the "noble old olive orchard," which after a century was still vigorous, and the "superb palms" that grew and thrived among the ruins.[2]

Much rarer are photographs that showed the *huertas* while they still retained some of their original vigor. These photos often view the mission through the *huerta*.[3]

The fruits of the missions were not only Christian converts—neophytes—but also fruits. Missions contained fruit trees, vegetable gardens, and grain fields; they had herds of cattle and flocks of sheep tended by Indian *vaqueros* and shepherds. In 1819 San Fernando alone had 21,745 head of livestock. San Gabriel was even larger: 100 Indian vaqueros worked at the mission and its *estancias*. At San Fernando, they produced more than 7,200 bushels of grain each year, as well as corn, peas, lentils, and garbanzos.[4]

Livestock and grain, more than the love of Christ, explained why the first Indians came to the missions, even though they could, if left alone, feed themselves. The Indians around San Fernando already farmed, herded cattle, and served as muleteers for Californios before the mission was established. Spanish settlers depended on the labor of unconverted Indians. As a contemporary observed, "If it were not for the gentiles there would be neither pueblo nor rancho."[5]

Yet the *rancherias*—independent native villages—gradually dwindled, disappearing over large sections of Southern California, because Indian subsistence systems could not stand against livestock. As the herds spread outward, particularly in drought years, they took their toll on the food sources of those still living in *rancherias*. Among the goals of the 1785 revolt at San Gabriel Mission was to kill the sheep that ravaged native foods.[6]

The missions were like pumps that sucked in displaced Indians and depopulated the surrounding country in wider and wider circles year by year. By 1814 the Indians at San Fernando spoke four native languages: Gabrieleño/Tongva,

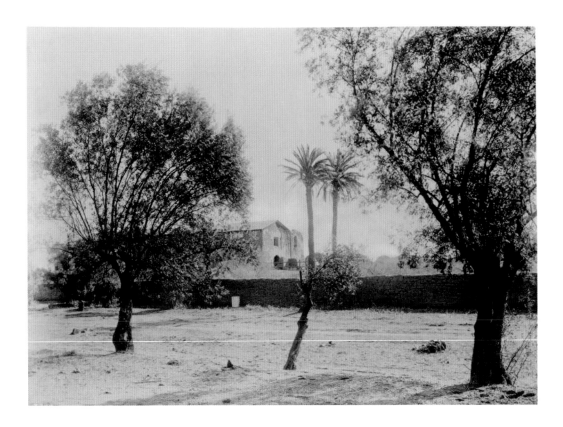

Remains of old olive orchard, San Fernando, c. 1890

Tataviam, Ventureño Chumash, and Serrano, as villages in the San Fernando Valley, Antelope Valley, Ventura County, and the coastal canyons emptied. Converts came even from Catalina, the large island off the coast.[7]

The expanding herds indirectly killed Indians by forcing them into the missions, where diseases, initially more endemic than epidemic, ran rampant among the concentrated populations. Chief among them was syphilis, and to a lesser extent gonorrhea, both introduced by the Spanish. Infant mortality rates fluctuated between 35 percent and 40 percent, and those babies that survived fared little better. In the first decades of the nineteenth century, there were two deaths for every birth

at San Gabriel. Children were often born with venereal disease, and three out of every four died before reaching age three. Of those who survived, most were dead before reaching twenty-five. San Fernando was one of the healthier missions. Only about 40 percent of its children died before age two, but even at San Fernando another 40 percent of those who survived their first birthday were dead before turning five. Each year 10 to 20 percent of adults died, and childbearing women made up a disproportionate percentage of that total. The first serious epidemics, initially measles, took place between 1800 and 1810.[8]

When the missionaries arrived in 1769, approximately 60,000 Indians lived along the

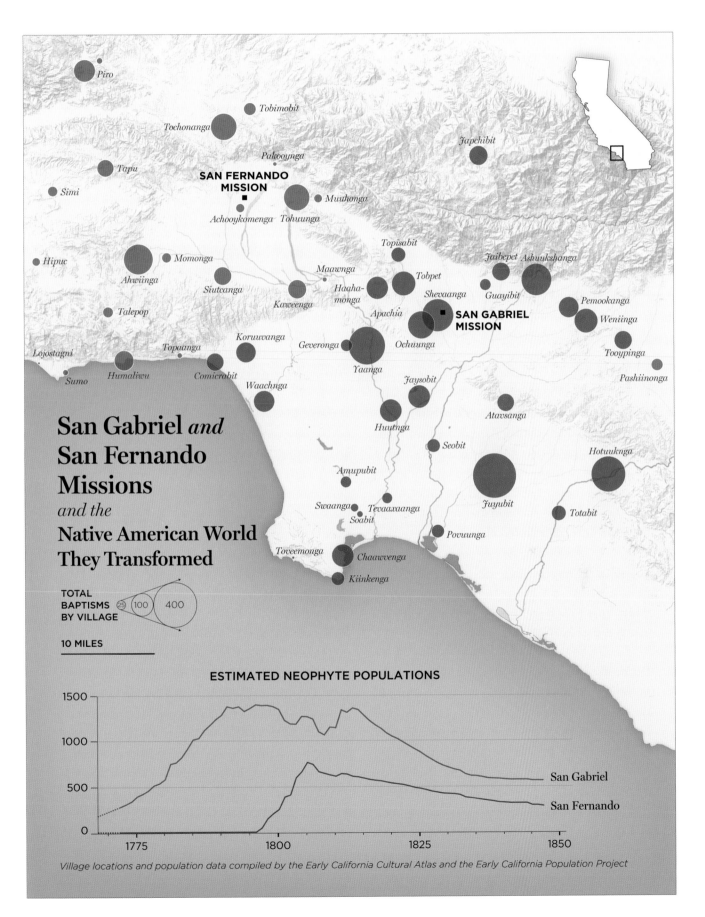

Piro
Tobimobit
Tochonanga
Pakooynga
Japchibit
Tapu
SAN FERNANDO MISSION
Simi
Achooykomenga Tohuunga
Muuhonga
Topisabit
Hipuc
Momonga
Jaibepet Ashuukshanga
Ahwiinga
Maawnga
Tobpet
Shevaanga Guayibit
Siutcanga
Haaha-monga
Pemookanga
Talepop
Kaweenga
Apachia
SAN GABRIEL MISSION
Weniinga
Koruuvanga
Geveronga
Ochuunga
Lojostagni
Topaanga
Tooypinga
Sumo
Humaliwu
Comicrabit
Yaanga
Pashiinonga
Waachnga
Jaysobit
Atavsanga
Huutnga
Hotuuknga
Seobit

San Gabriel *and*
San Fernando
Missions
and the
Native American World
They Transformed

Amupubit
Juyubit
Totabit
Swaanga
Tevaaxaanga
Soabit
Povuunga
Toveemonga
Chaawvenga
Kiinkenga

TOTAL
BAPTISMS
BY VILLAGE 25 100 400

10 MILES

ESTIMATED NEOPHYTE POPULATIONS

1500

1000

San Gabriel

500

San Fernando

0

1775 1800 1825 1850

Village locations and population data compiled by the Early California Cultural Atlas and the Early California Population Project

coast between San Diego and San Francisco, and the whole state had a population of 310,000. When the mission era ended in the 1830s, the population of Native California had declined by half. The greatest losses came where the missionaries were most active.[9]

The mission Indians who survived reached partial accommodations with the Franciscans. Native leaders became *alcaldes*, the leading Indian officials in the missions; old subsistence practices continued alongside new; traditional religious beliefs became grafted onto Christianity; old trading relationships incorporated new goods. Frictions between different native groups persisted, but the relentless demographic decline also led to merging of groups within the missions, and the emergence of a stronger Christian identity among Indians born and raised in them.[10] The constant piling of new groups on top of existing inhabitants partially explains the contradictory accounts of Indian devotion to Christianity, flight, and the ubiquitous coercion and repression. The missions were complicated places.[11]

THE UNTIMELY END OF FATHER ANDRÉS QUINTANA

Dig deep enough into the elements of Jesse's photograph of a room—the corn, the mannequin of the woman, the wooden doll, the cross, and the bars—and you see the complicated convergence of food, sex, and violence in the missions. The priests took for granted that they could and should regulate the sexuality of Indians, just as they should control the distribution of food. Indian women took for granted that the first Spanish soldiers

who helped establish the missions were violent men who could rape them. Children conceived through rape were supposedly sometimes aborted or strangled at birth. The Spanish made sex toxic.[12]

In 1813 missionaries at Santa Clara, east of the Santa Cruz Mountains, listed fornication and abortion, along with theft and dancing, as the chief vices of the Indians. At San Gabriel, and apparently elsewhere, the priests began to equate any miscarriage or the death of an infant with abortion and infanticide, and they punished the mothers accordingly.[13]

A combination of prudery and sexual violence typified the missions. Beginning in the 1820s, Eulalia Pérez de Guillén Mariné was *llavera*, or the keeper of the keys, at San Gabriel. She did many of the tasks that usually belonged to male *mayordomos* at the missions. She distributed food and clothing, and she received the keys from the *alcalde* after he locked the single men into their quarters—the *jayunte*—every night. She also held the keys to the *monjerío* where the single women were confined for the night. The two groups were not allowed to mingle.[14]

When in the later nineteenth century the American historian Hubert Bancroft sent people out to gather material for his popular histories, stories of food, sex, and violence clustered around the *huertas*.[15] Thomas Savage interviewed José María Amador, a Californio born in 1781 at Watsonville. Amador led him to "the Indian Lorenzo Asisara," who had been a singer at Mission Santa Cruz and whose father had been one of the early neophytes at the mission, coming from the Asar *rancheria* on the Jarro Coast above Santa Cruz.[16]

In Asisara's stories, some of which his father had told him, there were kind priests and cruel priests. Two of the most fully rendered charac-

ters in his stories were two missionaries at Santa Cruz, Father Andrés Quintana and Father Ramón Olbes. Quintana was unusual in that he served at a single mission and was exceptionally cruel. All missionaries had Indians flogged—some barely, some excessively—but even among the excessive, Quintana was unusual. He performed floggings himself and used a special whip with metal points inserted to tear the flesh more quickly and fully.

Quintana administered such a flogging to "a man who was working inside the plaza of the mission by the name of Donato."[17] After the whipping of Donato, some neophytes decided to kill Quintana, who had been sick and had gone to Monterey for treatment. The wife of Julian, another Indian who, like Asisara's father, was a gardener, suggested the plan. She told Julian, who was "always sick," that he should summon Quintana to administer last rites, and that on the priest's return through the orchard the conspirators would waylay and kill him.[18]

Asisara's account of the conspiracy is macabre, horrible, and hilarious, eerily mimicking and reversing the Gospel story in which Peter denies Christ three times. The murderers summoned Quintana to give last rites to Julian, who, when the priest left, rose from the purported deathbed to follow him surreptitiously. The murderers, however, lost their nerve, and the priest had to be summoned again. At the second visit Julian came to believe that he truly was dying because Quintana had put "weeds" in the holy oils to poison him. When after the second visit the conspirators again failed to waylay the priest, Julian's exasperated wife told them if they failed a third time, she would inform on them and not return home. On the third visit an equally exasperated Quintana told Julian's wife that her husband was now ready to live or die; he said, "Do not call me anymore."[19]

The murderers finally accosted the priest on his third visit, telling him that he would die because of the metal whip. He responded that he intended it only for bad people. "Well," they said, "you are in the hands of bad people. Be thinking of God." They suffocated him and squeezed one of his testicles off, saying, without explanation, that they did "so [in order that] there would be no evidence that he had been beaten." They took Quintana to his room and put what they presumed to be a corpse to bed—but he was not dead. Checking after midnight, they found him breathing and thought he would regain consciousness. They squeezed off his other testicle and killed him. Despite the missing testicles, the Spanish concluded the priest had died in his sleep. They recorded the date of Quintana's death as October 12, 1812, and for several years thought he had died naturally.[20]

The details of the murder and its eventual discovery capture the everyday life of the missions. A gardener dying suddenly in the prime of life did not surprise the priest. Floggings did not surprise Indians, although such treatment provoked anger and resentment. To refuse to labor, run away, engage in sex outside of marriage, miscarry, or anger the priest was to encounter the whip and stocks. Only "excessive" and "cruel" whippings got much notice.[21] Quintana died because he used a wire-pointed whip and punished people "as if we were animals."[22]

Many of the "bad people" Father Quintana flogged had engaged in sex outside of marriage, and when Quintana died, the Indians celebrated his death with sex. Both the *monjerío*, where they locked the unmarried women, and the *jayunte*, where they locked unmarried men, were opened and the "youth of both sexes got together and had their entertainment."[23]

Food ultimately revealed the murder. The murderers had stolen gold and silver from the mission after they killed Quintana. A *mayordomo*, such as the one at San Fernando whose reconstructed house we see in the first photograph in this chapter, was the godfather of one of the murderers and understood native languages. He heard two women talking. One said she was secretly eating *panocha*, or brown sugar. The other asked, "How is it that you have so much money?" The woman replied, "You also have [it] because your husband killed the priest."[24]

The death of Quintana did not change the administration of Santa Cruz. An investigation by the colonial governor declared that Quintana was excessive not in his punishment but in his love of the Indians. His whippings, the governor declared, were no worse than those given to children of six: only fifteen stripes.[25]

Father Olbes, who arrived at Santa Cruz in 1818 to replace Quintana, had connections to San Gabriel, where he had conducted baptisms in the spring and summer of 1813. He was "a very suspicious man and very mean." He ordered eight-year-old children to receive twenty-five lashes on either the buttocks or belly. Father Olbes was a violent man, but he also recognized that the declining material conditions at the mission had to be addressed. He was, Asisara said, "cruel in his punishment yet, on the other hand, he took care to keep his people well clothed and fed."[26]

When Olbes distributed food on the Feast of La Purísima (December 8), he noticed two women with scratched faces. He interrogated both of them but concentrated on one who did not have children. The interrogation took place in the rooms of a building like the *convento*.[27]

Probably suspecting abortion or some form of birth control, he demanded to know why the childless woman had not given birth. He then summoned her husband and examined him through an interpreter, to ascertain whether he slept with his wife. He said yes. "Then the Father put them in a room in order to 'level' them out, in other words, to have them perform coitus in his presence." The husband refused, but "he was forced to show his member [penis] in order to make certain that it was functioning properly. Then, the priest took the woman and put her in a room. The husband was sent to the guards in a pair of shackles."[28]

Father Olbes continued to interrogate the man's wife, who admitted that her husband had scratched her in a fight over another woman. The priest demanded to know whether her husband slept with her and she answered yes. When he asked, "Why can't you give birth?" she answered, "I do not know."[29]

He ordered her to another room "in order to check her private parts. She resisted and grabbed the father's cord. She tried to sink her teeth into his arm but only managed to bite his habit." When Father Olbes yelled out, the interpreter and *alcalde* came to his aid. He ordered the woman taken outside and given fifty lashes. He then had her shackled and locked in the nunnery. "After this was done, Father Olbes ordered that a wooden doll be made in the shape of a newly born baby and took it to the flogged woman and ordered her to treat the doll as her child and carry it for nine days in the presence of the people. He forced her to present herself at the door of the Church with the doll as if it were her son until she completed the nine days." At San Gabriel, this was the punishment of women suspected of inducing miscarriages. It was inflicted on any woman who had a stillborn child. Olbes

had the woman's husband shackled and cow horns attached to his head. He brought him to Mass adorned with the horns every day, where the other Indians mocked him.[30]

Olbes, too, soon faced resistance. When he attempted to flog a man who was late returning to the *jayunte*, he provoked a confrontation. The man had been playing cards and then stopped by the house of relatives for food and gathered firewood for them in return for the meal. He insisted he had done nothing wrong and refused to be whipped. The men in the dormitory ignored the priest's orders to seize him; instead, they drove off Olbes and the corporal of the guard.[31] By 1820, sick and it seems tired of the ongoing crisis at the missions, Olbes asked to be relieved of his duties. He went back to Mexico and asked permission to return to Spain.[32]

Peace came to Santa Cruz in 1820 with the priest's successor, Father Luís Gil y Taboada, who had served earlier at San Gabriel.[33] Most priests knew that *huertas* could be places for assignations and moments of stolen sex. It was their revulsion at Indian sexual freedom that led them to confine single men and single women in separate locked buildings every evening. Spaniards, to be sure, were fanatical in protecting the chastity of their daughters, but they did not lock up their sons. According to Indian accounts, Father Gil y Taboada was less interested in suppressing sex among unmarried Indians than participating in it. He gambled and slept with Indian women. He caught syphilis, and the sores prevented him from standing to say Mass. The Indians considered him "a very foolish, very happy person, who would go and enjoy himself with the Indians." He also taught them to read and ordered that they be taught in their own language.[34]

There is another set of stories. In 1826 Gil y Taboada, who may very well have had reason to know, accused all the women of Branciforte, the *villa* that became the town of Santa Cruz, of being guilty of "immoral conduct." He singled out Clementina Montero, who was considered Spanish—a *gente de razon*—by virtue of her Spanish father; but her mother, by then deceased, was Toypurina, the Tongva shaman who had led the revolt at San Gabriel in 1785. Her uncle was the *tomyaar* or headman of Japchivit, who was probably the man baptized as Tiburcio at Mission San Fernando in 1805. These mission worlds intertwined.[35]

The murder of Quintana, the disciplinary voyeurism and cruelty of Olbes, and the libertinism of Father Gil y Taboada were not necessarily replicated at San Fernando, but they represented the possibilities of the mission. All the missions shared the material constraints that came with the decline of imperial funding. Most Catholic clergy had a fanatical concern with Indian sexual practices, and their determination to halt polyandry and to enforce chastity led them to flog Indians for what they considered illicit sex. This, presumably, was as resented at San Fernando and San Gabriel as at Santa Cruz. All of these missions had *huertas*, where Indians worked, produced food, and retreated to make love.[36]

Which brings me back to Jesse's photograph of the reconstructed room at San Fernando: the bars that confine, the cross, and the female mannequin in the corner. She is preparing food. In the shadows at the picture to the woman's left lies a doll in a cradle. The references to forcible restraint, Indian women, and stillborn babies are probably not intentional. They may be more accurate than the designers imagined. They gesture toward stories Lummis never wanted to tell.

PART THREE

COYOTE AND THE TACHIS

Jesse photographed these two billboards on the Santa Rosa *rancheria* in Kings County in 2015. Both signs were recent. One advertised a Tachi casino. The other warned, "No Trespassing." Both featured a stylized image of a coyote, a central figure in the origin stories of California Indians.

Tachi signified nothing to me when Jesse took this photograph. I was barely aware of the Tulare Basin, where the Tachis lived. I knew that Anglo-Saxons careened into this country in the nineteenth century, but I didn't know that Coyote and Sir Francis Drake, who connected at D Ranch on Point Reyes, connected here too. When Admiral Nimitz sailed into Drakes Bay with the Drake Navigators Guild looking for Sir Francis Drake and the beginning of Anglo-Saxon California, he sailed on the USS *Tulare*.

Viewed in tandem, the signs tell the viewer that the Tachis, one of the many groups who make up the Yokut Indians, are here, and that, if the viewers are not Tachis, they are ambivalent about the viewers' presence. Visitors are welcome, but not here. Go over there—to the casino. Ambivalence always implies a history. The history suggests that the "No Trespassing" sign might be a couple of centuries too late.

Billboards, Santa Rosa rancheria, Kings County, California

WILD HORSES AND
NEW WORLDS

Playground south of Hanford, California

At first I saw only cheerful horses on a playground carousel at a shuttered elementary school south of Hanford. It was the winter of 2013, and the horses were frozen in a cartoon gallop before the bare valley oaks in the background. History can steal a photograph and alter its meaning, moving it beyond the photographer's intention. The horses, quite unwittingly, gestured toward terrible things that happened near here. But I didn't know that then. The photograph led me there. I followed the horses.

When John J. Audubon passed through Tachi country in November 1849, the same year that John Marshall discovered gold at Sutter's Mill, the western part of the Tulare basin in the San Joaquin Valley was bursting with horses. The year before, in the Treaty of Guadalupe Hidalgo, which ended the U.S.–Mexican War, Mexico had ceded California to the United States.

Looking northeast from the trail that became known as *El Camino Viejo à Los Angeles* "the old road to Los Angeles," Audubon described his view of the Tulare Basin as "quite grand," with the valley stretching out before him and the Sierra Nevada range rising in the east. The valley floor was too wet and boggy for his party's mules, so they skirted it. Wild horses, elk, antelope, and wolves abounded. Geese and sandhill cranes swarmed the sky. Salmon had run up the San Joaquin, and in such a wet year probably passed into the basin. Audubon thought the Yokuts had been pleased "to see Americans coming into the country." He had a traveler's ignorance, not knowing that American trappers and horse thieves had been in the country for years. He did not know that malaria had already ravaged the Central Valley, cutting the population in half, but it appears to have burned out at the Kings River on the basin's northern edge.[1]

Audubon believed in progress. He could not imagine more Americans as anything but a good thing. He believed that the Indians' "condition will be greatly ameliorated by the change from savage to half-civilized life." Improvement was, for him and most of his contemporaries, inevitable. He reported that an unnamed American party had settled in the valley, but he saw no sign of Californios or Americans from the Kings River to nearly Stockton.[2]

The American conquest of California represented yet another claim by strangers over a region that they did not really control, and there was no reason to think this claim more significant than prior ones. The Russians had made such claims farther up the coast; the Spanish had made them, and so had the Mexicans. Each had settled a strip of territory, more or less extensive and not always secure. For decades the Americans had asserted a similar right to vast reaches of the trans-Missouri West with little change on the ground. There was initially no reason to expect that their annexation of California would be any different.

The discovery of gold did not necessarily signal lasting change. Mineral rushes usually prove transient. The world might rush in, but only to pause briefly on its way to the exit.[3] A modern tour of gold- or silver-rush country usually features ghost towns and abandoned mines. The Argonauts, as the forty-niners styled themselves, ransacked the state for gold; but most of them never intended to stay, nor did they. But they ushered in important changes. Miners were like a tsunami: their passage rearranged the world.

THOMAS JEFFERSON MAYFIELD

When the backwash of the gold rush reached the Tulare Basin in the 1850s, Thomas Jefferson Mayfield was among the latecomers. Only a child when he arrived, he would spend ten years, from 1852 to 1862, living among the Yokuts. Mayfield repressed his story for six decades. When he finally told it, it became only an odd and largely ignored addendum to the valley's narrative of civilization. The story resembles a photograph. It can stand alone; but like a photograph, the story can be deconstructed, its details traced back in time.

In 1928 Thomas Jefferson Mayfield, then in his eighties, gave an account of his life to Frank Latta. He died upon finishing it, as if he had finally fulfilled some long overdue obligation, freeing him to depart. He mostly told of his youth among the Yokuts. "I never talked about my life with the Indians," he said, "because I had very little to tell that the white people liked to hear." Mayfield told a story out of time. He had been born into the gold rush narrative and the Anglo-Saxon myth and tried to step out of it. It turned out that he could not escape.

Mayfield's father, whom Mayfield always referred to as "My Daddy," had brought his family into the Kings River country from Texas in 1850. They entered the San Joaquin Valley when the wildflowers were in bloom, and at the end of a long life, Mayfield still had never seen anything to equal that scene. He thought the Yokuts "the finest people that I have ever met." A story that begins in perfection can only be a tragedy.[4]

The Mayfields settled where Sycamore Creek joined the Kings River. It was a place with "many fine oak trees." One tree sufficed to build their cabin, and another immense oak shaded it. The Mayfields could run stock in the valley in the winter and let them range the foothills and mountains in the summer. The Choynimni Yokuts, who lived in two *rancherias* nearby, supplied the family with meat and acorn bread. Mayfield's mother died soon after their arrival, and because his father and brothers were gone for long periods tending stock, eight-year-old Thomas Jefferson Mayfield lived with the Yokuts for the next ten years. During two stretches of three years each, Mayfield said he saw "none of my people."[5]

Much of Mayfield's account was idyllic. Before the whites occupied the basin, food was plentiful, and the Indians were in every way more cordial, friendly, and pleasant than those who replaced them. He detailed games and the rhythms of daily life, and the kindness the Yokuts showed him.[6] Among the Indians he knew well were the Tachis, whose headman was the ex-neophyte Gregorio—or "Ghee-gorio" as Mayfield recalled it. Some years the people on the *rancheria* where Mayfield stayed made a trip on large rafts made from the abundant tule reeds that lined the waterways down the Kings River to the Tachis on Tulare Lake. They timed the voyage to catch the high water from the snowmelt in the mountains, and they hunted and fished as they traveled.[7]

Mayfield's daddy, like other whites, had taken to capturing and breaking wild horses. Sometime after 1858, when Mayfield still lived with the Yokuts, his father and a partner bought hogs in San Luis Obispo to fatten on the foods Indians used: acorns, tule roots, and mussels. They planned to sell the hogs in the mines. On the way back to the Tulare basin from San Luis Obispo, they bought some mustangs. They periodically

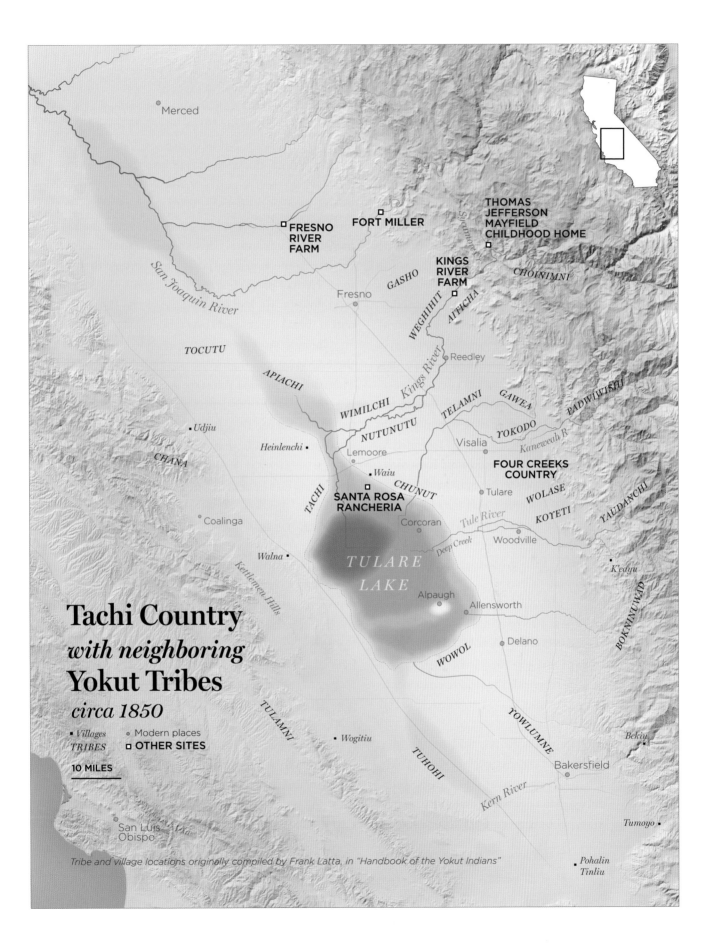

Merced

FRESNO RIVER FARM

FORT MILLER

THOMAS JEFFERSON MAYFIELD CHILDHOOD HOME

GASHO

KINGS RIVER FARM

CHOINIMNI

Fresno

WEGHIHIT

AITICHA

TOCUTU

APIACHI

Kings River

Reedley

Udjiu

WIMILCHI

TELAMNI

GAWEA

PADWIWISHI

NUTUNUTU

YOKODO

Heinlenchi

Lemoore

Visalia

Kaweah R.

CHANA

Waiu

FOUR CREEKS COUNTRY

YAUDANCHI

TACHI

CHUNUT

SANTA ROSA RANCHERIA

Tulare

WOLASE

Corcoran

Tule River

KOYETI

Coalinga

Woodville

Deep Creek

BOKNINUWAD

Walna

TULARE LAKE

K'eayu

Alpaugh

Allensworth

Tachi Country
with neighboring Yokut Tribes
circa 1850

Delano

WOWOL

■ *Villages* ● Modern places
TRIBES ☐ **OTHER SITES**

10 MILES

TULAMNI

YOWLUMNE

Bekiu

Wogitiu

TUHOHI

Bakersfield

San Luis Obispo

Kern River

Tumoyo

San Joaquin River

Kettleman Hills

Tribe and village locations originally compiled by Frank Latta, in "Handbook of the Yokut Indians"

Pohalin Tinliu

shot the horses, one by one, and cut them open, letting the hogs eat them down to the bare bones. The business proved "quite profitable."[8]

When he was eighteen Mayfield returned to live with his daddy, and horses triggered a confrontation between them. Thomas spoke Yokut better than English and took considerable abuse from white boys because of it. There was, he thought, "some sort of stigma attached to my life with the Indians." Few Yokut skills carried into white society, but their abilities with horses did. When Mayfield's daddy organized a local company to fight the Indians in Owens Valley, Thomas helped break horses for them to ride. Once, a group of "Visalia idlers and bums" sat on a fence rail ridiculing him as he broke a horse. When he got the horse to stop bucking, he quickly dismounted. His father took this as a sign of fear, and told him to get back on the horse or he would whip him. Mayfield refused—the only time, he said, that he defied his daddy. He told his father that the elder Mayfield knew he could ride the horse, but he would not put on a show "for a lot of bums like those." His father relented; he turned his anger on the bums and drove them off.[9]

Mayfield's daddy died on that expedition into the Owens Valley. The retreating soldiers abandoned his body. When they returned, "they found that the Indians and the coyotes had left only a few of My Daddy's bones." Mayfield tried to locate his daddy's final resting place but failed. "I found a few brass buttons, but that was all."[10]

His troubles with whites, and his daddy's death at the hands of Indians, explained Mayfield's resolution "to never speak of my life with the Indians." He did occasionally break that vow, though. In 1893 he stopped to visit a friend, Joe Medley, who had married a Yokut woman. She had carried Mayfield across the San Joaquin when he was a child, and she knew his father. Mayfield intended to stay only briefly, but he remained for a week. Each morning, the woman told him that he was not leaving that day, and each day he stayed. They talked about bygone days: "With tears streaming down her face, she would tell how the white man had ruined the country. He had built fences so the Indians could not roam about and gather their food. He had plowed up the fields and killed the wild flowers. He had killed most of the Indians and crowded the rest off their lands."[11]

Though Audubon had foreseen progress, the conversations that week were all about loss. They were between a Yokut woman who had lived her life among whites and a white man who had become a Yokut. They were about disasters and about what might have been.

SANTA ROSA

Jesse's photographs lead me, as modern ones often do, to older photographs. In 1903 C. Hart Merriam took a photograph at what was then the Tachi village of Wiu. This village, and later the Santa Rosa *rancheria* where today the Tachis have their casino, were remnants of a disaster. Merriam did not identify the five people in the photograph, but Frank Latta, the great local historian of the San Joaquin Valley and author of *Handbook of Yokuts Indians*, named two of them. The man was George Garcia, whose children became Latta's informants, and the woman standing next to him was Mollie Garcia, whom Latta also interviewed. The other three people were her children.[12]

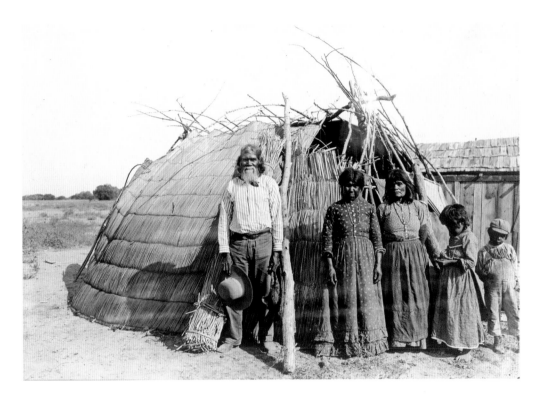

Village of Wiu (Santa Rosa rancheria*) Kings County, California*

Merriam was a mammologist, the head of the U.S. Bureau of Biological Survey, and a friend of Theodore Roosevelt. He became fascinated with California Indians. Merriam collected and recorded information about the Indians, but he rarely published. His ethnographic papers, often little more than notes or lists, reside at UC Berkeley in the Bancroft Library.[13]

Merriam visited the Santa Rosa *rancheria* in 1903 and 1904. It was then, he said, an 80-acre tract. There were six or eight families living in small board houses along the road.[14] One house is visible at the edge of the frame; the house at the center is a traditional tule structure. The Tachis made baskets using tule roots and willow to sell to tourists as well as for their own use. The Tachi men were sheep shearers, a task that Indians dom-

inated in the region, and all the adults picked the grapes, peaches, pears, and apricots in the basin's commercial orchards and vineyards.[15]

The Tachis told Merriam that their old village had been where Lemoore now stands. In the photograph the land is arid and vegetation sparse, but in the mid-nineteenth century the site of Lemoore stood on the edge of Tulare Lake. The modern Santa Rosa *rancheria* would have been beneath its waters. Today the casino has created enough prosperity for a gated Tachi community to adjoin it. In part it looks like a Southern California subdivision, but to anyone who has spent much time in Indian country, some of the houses, with their collections of old cars, trucks, and equipment, look like those on a reservation.[16]

Tulare Lake was known as *Laguna de Tache*

on the old Spanish and Mexican maps. The Tachis lived along the north and west sides of the lake. The Chunut lived on the east and the Wowol lived on the south and southwest shores. The Nutunutu resided alongside the Tachi in the Kings River Delta.[17] Today descendants of the Chunut and Wowol live on the Tule River Reservation. In 1904 the Tachis told Merriam that all but two or three of the "Noo-toon-a-ka," who had lived near the present town of Kingston, were dead.[18] At one time this area was among the most densely populated places in Native California.[19]

PHOTOGRAPHING WHAT IS NO LONGER THERE

In most years all that is left of Tulare Lake is an immense flatness, which before crops are planted registers as emptiness. In the west the lake abutted the Kettleman Hills, which rise into the Coast Range. In late October of 1819 José M. Estudillo, a Spaniard hunting down baptized Indians who had fled the missions, wrote, "I arrived at the summit of the last hills before entering the great plain of the tulares. The view from south to north is beautiful, for its end cannot be seen, with its lakes, swamps, and groves of trees." He was looking across Tachi country: northeast beyond the lake toward the San Joaquin River. It is now the sere monotony in Jesse's photograph. The hills form the blue band in the background adrift between the sky and clouds.[20]

Americans strangled the lake and dismembered it, but we have gathered its remains like harvested limbs and organs. Water has been cor-

Old Tulare Lake bed, Kings County, California

Remnants of a slough north of Tulare Lake, Kings County, California

ralled, contained, and rendered as geometric as the rest of the modern landscape. The Bureau of Land Management is trying to resurrect a portion of Tulare Lake as a kind of mini-lake just west of modern Alpaugh, a very small town on what was once an island in the lake. It was the site of a Wowol village.

It is hard to imagine the landscape that Estudillo and Audubon saw, but there are hints in the cut-off and not yet farmed sloughs between what had been the lake and the Kings River. In the early morning, with the camera filtering out what surrounds such places, hints of an earlier world emerge.

COYOTE

The Tachis that Latta and Merriam interviewed gave them accounts of an earlier time, when the lake rose and fell according to cycles that humans did not control. Tachi stories encapsulate the long centuries that preceded nineteenth-century versions of California, and in reduced and hidden forms, these stories persisted. The Tachis and other Yokuts told Merriam and other ethnologists stories of Coyote and Eagle. The Tachis, as their signs and tribal emblem show, still lean heavily on Coyote. He has moved into the twenty-first century, but he is now old and quite untrustworthy.[21]

Coyote was a common character in western Indian stories, but he has suffered the usual fate of characters dragged through the centuries and out of one culture into another. With the best of multicultural intentions, sympathetic whites have cleaned him up and reduced him to the bland, generic folklore suitable for grammar school children. In the original Yokut stories, as in Miwok and other tribal stories, Coyote was rougher stuff, often nasty—"mean," as both Miwok and Yokut informants put it. He was a creature led by his penis, which had a catholic taste in orifices. He was a creator—but not the only one—and often a colossal failure. To him we owe the world; and the world as we find it, with all its glories, deficiencies, and tragedies, seems much more explicable if Coyote made it rather than some omniscient creator. With Coyote sometimes things work out; sometimes they don't, and we are left with a dead coyote. Many Yokut Coyote stories are fragments gathered in the early twentieth century, when the tellers could not remember, did not know, or would not tell the entire story.[22]

In these stories humans and animals were all persons; the animals preceded and created humans.[23] Coyote saves humans from cannibals; Coyote dies; Coyote rises from the dead. Coyote plays dumb tricks. Coyote defecates, vomits, lies, and makes stupid mistakes. He outwits and is outwitted. Sometimes it is best that he is not around. A refrain of surviving Tachi Coyote tales collected in 1907 has Coyote saying, "I will go, too" and either Eagle—"the *tiia* or chief" or a human chief tells him not to go. It is hard to say whose side Coyote is on. Coyote is not like the Christian God that Franciscans brought. Coyote is not wise; but Coyote—or *Ki-yoo*—was, as the Yokuts said, "pretty smart." He decided that the humans the animal and bird people created should age and die. If not, "they would fill this whole valley. Then what would we do when there is no place for us to go. They would kill *Hoey'*, kill *Po'-hut*, kill me. Then, no more *Ki-yoo*. How are you going to feed that many people?"[24] Coyote feared a future with too many people to feed. Today, feeding distant people has become the rationale of farmers in San Joaquin Valley.

Sometimes when the Yokuts did give the whole tale, ethnographers hesitated to use language graphic enough to convey its meaning and tone. The Yauelmani informant who told Stanley Newman the story of Coyote and the Badger probably did not say that "Coyote insisted on homosexual intercourse" or "Coyote then subjected himself to the homosexual act."[25]

The missionaries intended to sweep Coyote away, but the only thing Christ-like about Coyote was that killing him did not make him go away. The missionaries brought many Yokuts into the missions, but they never could establish missions in the San Joaquin Valley. In 1805 Father Juan Martín urgently pushed for a mission site in the Tulare Basin, claiming—despite the two hundred children he tried to take from a single village—that unless a mission came soon, syphilis and warfare would leave no one to convert. The Franciscans never built one.[26]

WHEN THE LEGEND
BECOMES FACT

Farm Near Woodville, Tulare County

Photographs led me to the Tachis; the Tachis led me to Thomas Jefferson Mayfield, and Mayfield led me to John Wood who, if he actually lived, died by an oak tree near a bridge on the Kaweah River, just east of the Tachi homeland. Which led Jesse and me to Woodville on a February afternoon in 2018, where Jesse took the photograph on the previous page.

The field sweeps up to a small farmhouse, as common in the east Tulare Basin as it is rare to the west. The story of John Wood persists in popular and scholarly histories and in newspaper stories, but the scenery of his story—the cabin, the oaks, the bridge, the Kaweah River—are largely gone. The Kaweah now vanishes most years above Visalia. In the photograph a valley oak towers over the usual accumulation of introduced trees, including palms. The lone oak seems to be stepping toward the viewer. When John Wood came to the region about 1850, oaks were thick around the Kaweah.

The story of John Wood or John Woods (it is impossible to be certain of his name) is the founding story of American settlement in the Tulare Basin. It provides the American explanation and justification of the events Thomas Jefferson Mayfield chronicled: the dispossession and near extermination of the Yokuts.

The story took place in the Four Creeks country. In 1862 Mayfield attended school near an old cabin by an oak, where more than a decade earlier the Yokuts had allegedly flayed Wood alive and nailed his skin to the tree. Americans cited the cabin and oak as witnesses to the story.[1] By 1928, when Mayfield gave his version of the killing to Frank Latta, the cabin was gone, and the story was old. Existing versions were, Mayfield thought, "confused." He claimed to have heard of the killing long before from a survivor of the massacre. He did not name his source.[2]

Most twentieth-century versions of the Wood story were variations on the one that George Stewart, a Visalia newspaperman who later helped establish Sequoia National Park, published in the *Overland Monthly* in 1884. Stewart had no first-hand knowledge of Wood's death. Stewart was not born until 1857, and his family did not move to Visalia until 1872. He told the story as prelude to his account of the Tule River War, which Stewart considered avoidable with more moderation on the part of the Americans. Still, he wrote, the "first blood" had been shed when settlers were "cruelly massacred" on the Kaweah River.[3]

In 1850, the story goes, a "settler named Mr. Wood," part of a group of fifteen men, built a substantial log house on the Kaweah River east of Visalia, intending to form a settlement. A chief of the Kaweah Yokuts named Francisco ordered the men to leave and gave them ten days to do so. The settlers agreed to go, but on the eleventh day they were still gathering their stock. The Kaweahs fell upon them, first attacking settlers looking for their livestock in the woods; they killed eleven men and wounded another. A thirteenth man escaped unharmed. They killed the fourteenth man by convincing him that they would demonstrate their skill by shooting at targets, but he was the target. Wood, the last man, fortified himself inside the cabin. He killed seven Indians before running out of ammunition. When the Kaweahs captured him, they tied him to an oak and skinned him alive. Stewart suggested northern Indians forced the Kaweahs to act, but he also conceded that someone in the settlers' party might have committed some offense.

Stewart said that "General Patten" arrived from Fort Miller soon after the massacre, verifying the event, but Major G. W. Patten does not seem to have visited the site until the fall of 1852, nearly two years later, following an attack of whites upon Indians.[4]

County histories and local writers adopted Stewart's account and elaborated on it, but the details remained unstable. Orlando Barton's 1905 version in the *Early History of Tulare County* had Wood, whose name he thought was John, entering the county in 1850 in the "Hudgins" train. Barton was not sure of the number of the party or who led it. The accounts he had heard were "contradictory," and it would take a "large book" to contain them all. Eugene Menefee's and Fred Dodge's *History of Tulare and Kings Counties* (1913) said Wood came in December 1850. Frank Latta later said he came in 1849. Francisco, the leader of the Kaweahs, was an ex-mission Indian, or as the later histories put it, a renegade. The day of the attack was sometimes the tenth day from the ultimatum instead of the eleventh. Menefee and Dodge wrote that the Yokuts captured Wood wounded but alive. Wood defied his torturers until the end. They nailed his skin to an oak tree. In other accounts Wood died as they flayed him or got up skinless, walked a distance, and died. Sometimes they took his skin off in strips; sometimes they took it off in a piece like skinning an animal. Sometimes the Indians numbered nearly a thousand; sometimes they were a small party. Sometimes most of Wood's party escaped; sometimes all but one man named Boden died. Sometimes the others were in a pasture near the cabin; sometimes they were hunting stock in the oak groves. In all the narratives, the Yokuts predictably morphed from specific Indians to racialized stereotypes, who in

flaying Wood alive took "a revenge in consonance with the Indian spirit."[5]

In Thomas Jefferson Mayfield's version there was no warning to Wood, no agreement to leave, and the Indians had cause. "Two members of the Woods party had done something to arouse the enmity of the Indians. This was made quite clear to me by the party from whom I received my information. It is probable that what had been done was known only to a few members of the Woods party." Mayfield said that a single piece of skin was taken from Wood's back and nailed to a tree. Wood then walked or crawled to the stream and died.[6]

The story was of a type. It located American conquest in American martyrdom, innocence, bravery, and self-defense. Indians attacked cruelly and without provocation; outnumbered but courageous, Americans resisted until the end. What happened afterward counted as just revenge. The Wood story was a trope of defensive conquest that justified the dispossession and expulsion of the Yokuts.[7]

ALL THE STORIES CANNOT BE TRUE

Something happened in the Four Creeks country that led to numerous deaths. Men mentioned in the accounts were real, but all the versions of the Wood massacre cannot be true. What can be true is that the Wood story encapsulates the chronic, and horrific, violence of gold rush California in a single incident. It appears to be a conflation of several events, old fears of Indian violence, and considerable imaginative embellishment.

The Kaweah Francisco was the first character

in the story to appear in the historical record. In the spring of 1850, when Lt. George Derby of the Topographical Engineers entered the Tulare Basin and passed through the Four Creeks country where Wood supposedly settled that December, the country was peaceful.[8] Multiple Yokut groups lived in the Four Creeks country, but Derby mentioned only two large *rancherias* on the Kaweah. One was the "Cowees," which would be the Gawea (Crow Cry people) from whom the river took its name, and whom Stewart blamed for Wood's death. Later Yokuts remembered the Gawea as loud and quarrelsome. Derby rendered the other group as coming from a *rancheria* named He-ame-e-tak. These were Wolase Yokuts, who lived in He-ahme-tau ("Old Time Place"). They were reputed to be the most ancient Yokut group in the region. Frank Latta reported that a large burial mound belonging to them was leveled in the 1930s to make way for an alfalfa field. Derby reported these Indians to be friendly: "Nothing could exceed the kindness and hospitality with which they (both the Gawea and Wolase) treated us." Some, like Francisco, were ex-mission Indians, mostly from San Miguel and San Luis Obispo.[9]

A year later the Tulare Basin had become a very different place. Indian agents, treaty commissioners, army officers, travelers, and settlers left accounts that, like Audubon's, are often little better than travelers' tales. Most of these men had, only a few months earlier, never heard of the Yokuts—nor did the government have any knowledge to offer them. Federal officials ordered the treaty commissioners to learn as much as they could about the Indians while they made "such treaties and compacts with them as may seem just and proper."[10]

The reports that officials sent back in the spring of 1851 were muddled because the reporters were confused. The documents were a catalogue of their prejudices and presuppositions, but these were not stupid men. O. M. Wozencroft thought Indians to be products of diet and climate, and catalogued them accordingly: valley and coastal Indians were docile; mountain Indians were warlike.[11] Sometimes the commissioners' observations of Indians conflicted with their prejudices, forcing them to vacillate between the two. George W. Barbour and Redick McKee, two of the Indian commissioners sent to make treaties, dismissed the Indians "as a wretchedly ignorant, indolent and degraded set of beings, scarcely capable of discriminating, in the main, between right and wrong, and consequently slow to see that it would be to their interest to make treaties and live on friendly terms with the whites." Yet a day earlier, McKee had told the commissioner of Indian Affairs that the Indians had "been greatly underrated, both as to physical and mental powers. Many of them have both courage, shrewdness and enterprise."[12]

In February 1851 the first mentions of central elements of the Wood story appeared, but they appeared in pieces rather than as part of a single coherent story. In the fall of 1850 Hugo Reid had written Henry Dalton letters of introduction for a trip he planned to make from his ranchos in the San Gabriel Valley north to Stockton, Sacramento, and San Francisco. Dalton apparently intended to sell cattle. Reid wished him a pleasant journey and "success in your undertaking." On February 14, 1851, the *Daily Alta California* in San Francisco printed a dispatch from Los Angeles. It was from a letter Lewis Granger wrote on February 4 to Abel Stearns, and reported that the "Tulare Indians" had killed "Dalton's party and Captain

Dorsey's party [from San Jose]" at Four Creeks. They encamped there while Don Henrique—Henry Dalton—had gone to Los Angeles to get fresh horses. Thirteen men had died, most of them vaqueros employed by Dalton and Captain Dorsey. The Yokuts had dispersed the cattle and then attacked French's ranch, but they were driven off with heavy losses by an American emigrant party that was stopping there. Since French's ranch was far away at Tejon Pass, this account is doubtful.[13]

In attacking Dalton and his cattle, the Yokuts reinscribed the connections between their homelands and the missions. Henry Dalton was an English immigrant and merchant who had in the 1840s acquired much of the land once belonging to the Tongvas of San Gabriel Mission. Some of Dalton's vaqueros were almost certainly ex-mission Indians from San Gabriel. Dalton employed Indian vaqueros at fifty cents a day, and many were in debt to him. In the attack on Dalton's party, Indians, some of them ex-mission Indians, may have killed other Indians—also ex-mission Indians—in the employ of a man who had come into possession of cattle descended from mission herds.[14]

A few days later, as they approached Tulare Lake, the treaty commissioners reported news of "fresh outbreaks and new outrages, some of the most cruel and revolting character." They heard the story of a "white man [who] was bound and flayed alive."[15] The white man had no name; the incident had no location; who they had heard it from, they did not say.

At that stage, the story of a flayed white man and the actual attack on vaqueros at Four Creeks remained separate: they came together on March 5, 1851, when the *Stockton Times* published a letter from a Dr. Paine, a settler "from the Four Creeks." Paine prefaced the letter by objecting to treaty making by the commissioners; he urged a war of conquest. Paine had built a cabin on the Kaweah and bridges in the Four Creeks country, and on February 4, 1851, he had visited "the Four Creeks and found my bridges there partially destroyed. . . . Thirteen men were found who had been killed by the Indians at that place. Two others were wounded but had escaped on a horse; one of them has since had his arm amputated, it having become gangrenous." And then, in a revealing sentence, he added, "The Indians doubtless skinned a Mr. Johnson, who fought from my house." Paine saw the Indians driving the cattle into the mountains. He thought they had stolen 600 to 800 head of cattle in all. Despite the attack, the country was being quickly settled.[16]

Except for identifying the victim of the flaying as Mr. Johnson rather than Wood, Paine's account seems to reconcile the various stories of a flaying, a massacre, and a cattle theft. But there remains that odd phrase "doubtless skinned." Why doubtless? Why not just skinned? Surely he could identify a flayed corpse?

Most likely, he could not. By the time Paine reached the scene in February, the dead had lain outside for a month or two, subject to weather, decay, and wild animals. They must not have been a pretty sight. In all probability Paine, like the commissioners, had already heard the same story of flaying. Paine took that floating story and attached it to the massacre on the Kaweah. The Indians had "doubtless skinned" Johnson, thus providing the vague story with an actual victim.

The flaying was a story in search of evidence, and Paine claimed that Johnson's body constituted the evidence. But Johnson, whoever he was, disappeared from the accounts, and no one ever described what the flayed body looked like.

The Wood massacre still lacked its central figure: Wood. John Gage Marvin (known as Judge Marvin) was, as far as I can tell, the first to mention "Woods." In an account in San Francisco's *California Courier* in July 1851, he reported that in the fall of 1850, "John Woods from Missouri" had settled along the Kaweah River at a place where there was already a zinc storehouse built to hold army supplies, and a bridge. Dorsey's vaqueros had stopped there with 2,500 cattle when their horses gave out. On January 4, 1851, the day after a large feast, Yokuts attacked the mix of vaqueros and American emigrants.[17]

In its details and its correspondence with other accounts, Marvin's story was plausible. He put both Americans and vaqueros at the site of an actual attack. He provided abundant details, names, and survivors—B. F. Imboden (certainly the "Boden" of later stories) and J. H. Fickling—who served as sources. The Indians stripped the bodies of the dead and plundered the cabin.

What Marvin left out was equally significant: there was no last stand and no flaying of Woods, who died unheroically outside the cabin. It was Woods, not a companion, whom the Indians tricked into thinking they were only taking target practice. Imboden, weak from the loss of blood, hid in the brush. A passing group of immigrants discovered and saved him, but he lost an arm. Fickling reached "Frenchy's" beyond Kern River. By the summer of 1851 another group of Americans attempted to settle the site and occupied the cabin.[18]

After Marvin, Wood became central to the account. G. W. Barbour, one of the Indian treaty commissioners, eventually filed a report that Americanized the account. It included "Woods," the last stand, and the flaying while eliminating the vaqueros. The report is undated, but "late 1852"

is written on the cover. Barbour apparently wrote it after leaving California. He described "one melancholy act" of the "Cahiwiahs" that showed the treachery and bloody cruelty of the tribe.

—————————

In the winter of 1851 a gentleman by the name of Wood with some fifteen others were engaged in the construction of a bridge across the Cahwia River for which they had obtained the consent of the Chief and his tribe, after hostilities had commenced between the Indians and Whites, in the Mariposas country [they] had extended as far South as the Upper San Joaquin, but unknown to Wood and his party who were living on terms of the closest friendship with the Cahwias, the Chief and his warriors made a sudden attack upon them killing all except Wood who was taken prisoner after a manly resistance, they immediately suspended him to the limb of a tree, and deliberately proceeded to flay him, literally stripping the skin from his entire body whilst still alive.[19]

—————————

Barbour had not presented this full story in his earlier correspondence, which creates the possibility that he had not actually heard this version of the story in the spring and summer of 1851 when he was in the Tulare Basin. The story was still evolving. By eliminating the vaqueros, he eliminated the first and most reliable reports of the massacre. Finally, while the Marvin story had survivors and thus a source, Barbour's does not. No one survived to tell the story, so who told Barbour or his sources?

The story was now well on its way to becom-

ing myth. It was the story's moral—and what it told about the nature of Americans and Indians—that mattered. The story did not spring from the evidence of what had happened on Four Creeks in December 1850; rather the evidence was constructed around the meaning of the story. The key event—the attack on the vaqueros—vanished entirely.

Still, the meaning of the story was not yet firmly set. In 1856 John Bigelow published a campaign biography of John C. Frémont, who was running for president. He credited Marvin with yet another account of the slaughter at Four Creeks. This telling features an oak, and it gives cause. There was "a magnificent oak—the King Oak of the Mountains. It was a sacred tree to the Indians." Here they held council and buried "their chiefs and wise men." Trouble came when an unnamed cattle dealer decided that his animals should sleep "in the Indian church." The Indians attacked, killed him and his drovers, and ran off the cattle. Contrary to the standard Wood story, this one laid the blame on the Americans.[20]

This second Marvin story probably represented a conflation of the trouble in the Four Creeks country with the Mariposa War, which centered north of Four Creeks around the Merced and Mariposa rivers, where miners had been attacking Indians. Indians, defending their homes, had struck back against miners and ferrymen.[21] The second Marvin story did not take hold.

WHAT WAS AT STAKE

We can never be sure of exactly what happened on the Kaweah in the winter of 1850–51, but we can be pretty sure of the context in which the stories were told. When G. W. Barbour described conditions in the Tulare Basin in the summer of 1851, he cited aggression by white men and Sonorans, not Indians. Some had visited a *rancheria* "and offered some violence to one of their "headmen," but another party of whites had stopped them before serious injury occurred. Barbour said he feared bands "of reckless and vicious white men . . . murdering and robbing those who happen to be so unfortunate as to fall into their power" more than Indians. The murderous and vicious were common enough in gold rush Southern California.[22]

Other stories of massacres of whites by Indians in the Four Creeks country cropped up and then collapsed under investigation. In July 1852 the *Los Angeles Star* reported the recent slaughter of "eight white men living about the Four Creeks and forming a settlement for farming purposes." A week later, the paper said that it was whites who were killing Indians and destroying *rancherias* in the area. The "rumor of the Indians having murdered eight white men there . . . was premature."[23]

In some of these stories, Francisco became a kind of Indian Joaquin Murrietta, a figure who justified American fears and excesses. When Americans attacked a *rancheria* near White River, in the general vicinity of Walker's Pass, in May 1856, newspaper accounts connected it to Francisco, "who was concerned in the massacre of five or six white men at Four Creeks in December, 1850." The *Sacramento Daily Union* claimed Francisco was orchestrating a general Indian war against the whites.[24]

By 1857 newspapers that had reported the original attack on the Kaweah had begun to revise their story to fit the mythic version. They did so amid American attempts to drive the Yokuts from

the Four Creeks and Kings River country. The *Daily Alta California*, probably ignorant of its own original account of the attack, said Wood led a party of fifteen or seventeen men who pitched tents on the "banks of the Ka-wee-ah, in the summer of '51, where Woodville now stands." The Indians made their "treacherous and murderous assault" on December 13, and two men escaped by swimming the river. Wood killed twenty Indians before he ran out of ammunition. They "forced the door, tied him to the oak tree, and flayed him alive." Major Patten camped there for six weeks until all was quiet.[25]

Abraham Hilliard published a similar version of the story in the *San Francisco Mirror*, which was republished in the *Visalia Sun* in September 1860.[26] Hilliard said he came into the Four Creeks country on April 1, 1853, with his family and occupied Wood's cabin. Hilliard said Wood led a company of fourteen men, who set to work building a settlement, but completed only one cabin before Francisco, the chief of the "Kahweyas," ordered them to leave within ten days and threatened death if they remained. The settlers agreed to leave, but they went a day over the limit. On December 13, 1850, the Indians attacked with poisoned arrows, killing ten men who were in the woods gathering their horses. Two men fled, one badly wounded, leaving Wood and a companion at the cabin. The Yokuts killed Wood's companion after tricking him into holding a mark for them to shoot at, and then riddling him with arrows. Wood used the cabin as a fort and held them off, killing seven, until they cut a hole in the roof and captured him. They decided to skin him alive in revenge for their losses. "They tied him to an oak tree, which was nearby, and carried this inhuman revenge into execution." Indians alive in 1860 had

supposedly witnessed the deed and were, presumably, the sources for the account since Hilliard mentioned no white witnesses. Hilliard had "General" Patten starting to build a fort on the site of the massacre that spring, but he never finished it.[27]

The original attack on the vaqueros who had a few Americans among them had become an attack on American settlers; the cattle had turned into horses, and Wood had gone from being either absent or a minor figure to being the last man standing at the Tulare Alamo. His death had become horrific. The perpetrators were known. Revenge awaited them.[28] Hilliard's account ended with praise of the "continued increase of population and an advancement in agriculture, with the other civilized acts, which ever characterize our people in whatever country they may be placed."[29]

The mythic account could never fully remove the traces of earlier accounts. In 1876–77 Stephen Barton published a story of the massacre in the *Visalia Iron Age* as part of his *Early History of Tulare County*. Barton made no mention of torture or nailing Wood's flayed skin to the tree. Wood arrived in 1851, not 1850. He was a trader, part of a group of ten or fifteen men. One of the two survivors, now unnamed—but clearly Imboden because his arm was later amputated—grabbed a horse, hoisted the other survivor behind him and, after hiding his companion in the brush, rode for help. Barton attempted to deflect blame from the Yokuts by suggesting that northern Indians had seized their women and children and held them as hostages while the Yokuts attacked the whites.[30]

Which brings us back to Stewart. He stabilized the basic narrative. Details remained in flux but the attack on Americans, the last stand, the massacre, and the flaying had become its foundation. The story remains in circulation down to the

present time. Buried in it is the irony that what became a mythic account of American martyrdom might have its roots in a fight between Indians—Yokuts and Gabrieleños who morphed first into Mexicans and then into Americans.[31]

A WAGON FULL OF COYOTES

I can find no surviving Yokut story about whatever happened at the cabin in the Four Creeks country. But there is a Coyote story about the killing of travelers or settlers on Deep Creek, the first of the four creeks when approaching from the south. Orlando Barton recorded and published it in 1905 in relation to the Wood massacre. He took it to be a story of American settlement. The first wagon came through the country "drawn by four animals with long ears. It had a cover on it and was filled with coyotes. There were old coyotes and little ones." The Yokuts attacked, killed everyone, and let the wagon drift down Deep Creek.[32]

The story is confusing. By the 1850s the Yokuts were quite familiar with both mules and Americans. They would have been surprised by neither. They sold stolen mules to Americans. In other Indian stories along the West Coast, the first Europeans sometimes take the form of other-than-human persons, and Americans as powerful and unreliable tricksters might seem the equivalent of Coyote, but the Yokuts of mid-century knew Spaniards, Mexicans, and Americans well. They were all-too-human persons. Except for the deaths at the hands of Indians and the site of killing being the Four Creeks country, the details differ from the Wood massacre. Barton placed this story alongside the Wood story. Barton regarded the Yokut story as myth—coyotes do not drive wagons—but the Wood story was also a myth. When that legend transmuted into fact, Barton printed it as history.[33]

Chapter 10

GENOCIDE

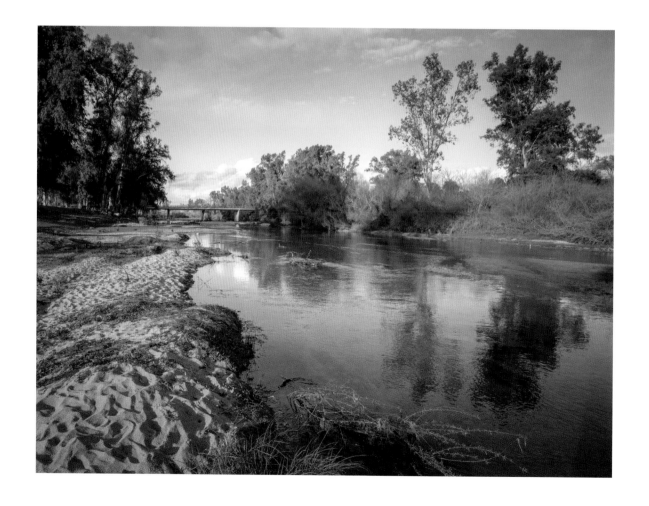

Kings River, Reedley, California

The Kings River is hard to find, let alone photograph, over much of its course in the Tulare Basin. Jesse's first photographs near where the river once entered Tulare Lake reveal a disheveled ditch, an outlet for excess alkaline irrigation waters and a dumping place for local debris. The river is no longer obvious. Parts are dry; other parts are inaccessible, lost among farm fields and "No Trespassing" signs.

We eventually went looking for open water and found a stretch upstream that runs through Cricket Hollow Park in Reedley. It is near what used to be Smith's Ferry, the second ferry established across the river at this site. Spaniards on the Moraga expedition of 1805 named the river for the Magi, the three kings of the New Testament, because it was their feast day when the expedition arrived at the river. Cricket Hollow seems a name more suited to the place.

In the late afternoon the park was largely empty. Men sat in their cars, and occasionally a car sped through the parking lot. As far as I could tell, it was a place for assignations and drug deals. But even if the parking lot was a site of illicit commerce and furtive sex, compared to what happened along this river in the nineteenth century, it was a pretty innocent place.

In the early 1850s the world of horror enveloping California had reached the Kings River. Americans were seizing Indian lands and dispossessing, murdering, and raping Indians throughout the gold country and beyond.[1] Adam Johnston, the agent for the San Joaquin Valley, despised Indians, but he recognized that the miners "have destroyed their fish-dams on the streams and the majority of the tribes are kept in constant fear on account of the indiscriminate and inhuman massacre of their people in many places for real or supposed injuries." He had "seldom heard of a single difficulty between the whites and the Indians of the valley or mountains, in which the original cause could not readily be traced to some rash or reckless act of the former. In some instances, it has happened that innocent Indians have been shot down for imaginary offences, which did not in fact exist." Americans regularly used the word *extermination* as the solution to California's "Indian problem."[2]

In the spring of 1851, treaty commissioners appealed to whites to recognize the Indians' "grief and anger at the loss of their homes." The commissioners condemned the "many instances they [Indians] have been treated in a manner that, were it recorded would blot the darkest page of history that yet been penned." "Indians," O. M. Wozencroft wrote, "have been shot down without evidence of their having committed an offense, and without even any explanation to them of the nature of our laws; they have been killed for practicing that which they, like the Spartans, deemed a virtue; they have been rudely driven from their homes, and expatriated from their sacred grounds. . . ." He denounced the actions of the Americans as unjust, inhuman, and stupid.[3]

The commissioners negotiated treaties that set aside reservations, but Congress refused to ratify them. The Americans denied the legality of Yokut claims to their own homelands. The status of Indian title to land under Mexico had been disputed since American annexation. Congress ultimately decided that the Yokuts had lost their rights to land under Mexican law, and since both land and sovereignty had passed to the United States with the Treaty of Guadalupe Hidalgo, they

had no title. The Yokuts lived on their lands by American sufferance.[4]

In 1853, with no treaties to guide him, the new superintendent of Indian Affairs for California, E. F. Beale, had to devise a substitute. He was not yet thirty, but well connected: a naval officer, a friend of John C. Frémont and Kit Carson, a veteran of the Mexican War, and a leading publicist of the gold discoveries in California. He was also a partner in the beef contracting business with Frémont. Beale established new military reservations to replace the treaty reservations. In 1853 army officers told him that most of the land along the Kings River and in the Four Creeks country had already been occupied by whites. This may have been less literally than figuratively true. Americans regarded the lands where water flowed as inevitably white man's country. For the moment, Indians retained the lower Kings, where the air was so "perfectly black with mosquitos" that spending a night seemed impossible.[5]

Beale replaced the treaty reservations with a reservation at Tejon Pass at the southern end of the San Joaquin Valley; and as a stopgap, the government rented farms on the Fresno River and the upper Kings River where the Indians could live. William Campbell owned the Kings River farm, which was a couple of miles from Cricket Hollow. He and his partner John Poole had trespassed on the older reservation under the unratified treaty to establish a ferry. He had attacked nearby Yokuts, and now he was put in charge of people whose homes he had burned.[6]

Settlers provided the main threat to the Yokuts, but in the early years the army could be equally brutal. Officers at Fort Miller—north of the Kings River on land now flooded by the Friant Dam—were feeding starving Yokuts by the end of the decade. But Pahmit, an aged Dumna Yokut who lived at *Kuyu Illik* ("sulfur water"), a *rancheria* that once occupied the site of the fort, remembered when the soldiers conscripted labor, whipped and killed Indians, burned the *rancheria*, and evicted his people. Even when the army was sympathetic, its ultimate task was to fight Indians—and soldiers did.[7]

The first white settlers were cattlemen. Cattle in the modern Tulare Basin landscape seem docile, even pathetic creatures, confined to feedlots and dairies. The dairies were losing money in 2015 when Jesse took his early photographs, but in the nineteenth century cattle meant money for whites. For the Yokuts, the cattle were complicated beasts, part of a devil's bargain. Cattle destroyed the native grasses and, along with hogs, devoured the acorn crops; but Beale and his subagents contracted with traders to provide cattle to feed Indians. The Indians never saw many of these cattle. The agents sold some to the miners—the main market for cattle—used others to feed their employees, and commandeered others to stock their own ranches.[8]

Cattlemen made poor neighbors. They intruded on Yokut lands, destroyed Yokut food sources, and drove off game. The Yokut techniques of maintaining habitat for game and wild foods—particularly burning—threatened the invading cattle. When the Yokuts set fires, Americans killed Yokuts. When starving Indians killed American animals, whites retaliated by killing Indians and burning their *rancherias*. *Yokut* became synonymous with *thief*, and settlers blamed them for all vanished livestock.[9]

"What shall we do?" Pasqual, a Kings River Yokut chief, asked in 1852. "We try to live on the lands the commissioners gave us in friendly relations with the white man, but they kill our women

and children, and, if we flee to the mountains, then they hunt and kill us. . . . We are poor and weak—the whites are rich and strong, and we pray for mercy." The assessment by the editors of the *Stockton Journal* differed little from that of Pasqual: "All the rights of the Indians have been trampled on, their peace disturbed, and defenseless women and children ruthlessly cut down, without cause or provocation."[10]

The Americans resorted to both suasion and force to move Yokuts to the new reservations. American and Yokut accounts agree that Indians came to the reservations in 1853–54, but they differ on details and the exact chronology. Indian officials portrayed the Chunuts under one of their headmen, Juan Viejo, as being eager to come to Fresno and Tejon; but Thomas Henley, who succeeded Beale as superintendent of Indian Affairs, acknowledged that the Yokuts on the Kings River resisted removal. In April 1855 he was preparing to bring "them under subjection." He intended the Tejon as a collection point until he decided on a permanent location for the Yokuts.[11]

Thomas Jefferson Mayfield told how in the process of rounding up the Yokuts on Kings River and Tulare Lake in 1853, soldiers murdered an American named Mann, who was married to a Yokut. Mann had defended his wife. This, Mayfield realized, "sounds pretty bad," and it "may give the impression that I favor the Indians and am prejudiced against the white people." But "I am not telling what I would like to be able to tell; only what I heard and saw."[12]

Yoimut, whose parents lived through these events, became one of Frank Latta's interlocutors. Her father was Chunut, born just south of the Tule River. Her mother was Wowol, born at Chawlowin on Atwell Island where Alpaugh is today. Yoimut's

mother told her that in 1854, when she was pregnant with Yoimut, the family was living at Heuumne, near where Cottonwood Creek entered Tulare Lake. Soldiers came there to take the Lake Indians to the Fresno River. They "beat the Indians with whips and hit them with their swords and ran their horses over them when they would not go. Some Indians were shot because they ran away. My mother said she saw twelve Indians killed." Those captured marched to the Fresno River Farm, land temporarily set aside to feed the Indians. Ten more died on the way. When they arrived at the farm, the soldiers slaughtered some cattle and gave them to the Indians along with wormy acorns. A few months later Yoimut's parents were among the fifty Indians marched from Fresno Farm to the Tejon Indian Reservation. Her parents escaped and went back to Tulare Lake.[13] The agent noted in a report that in November 1853, twenty Indians "were brought in" from Fresno Farm, which makes Yoimut's story credible. These Indians fled, taking horses with them. The date is slightly earlier than Yoimut's family recollected, but this may very well have been her family.[14]

RESERVATIONS

Neither forts, farms, nor reservations offered much succor to Indians. Army officers who protected Indians did not have the supplies to feed them indefinitely, and they claimed the Indian Office reimbursed only 10 percent of the cost. On the farms and reservations, agents pocketed funds, seeds, and tools appropriated for Indians. They took the crops that the Indians produced. J. Ross Browne, a federal inspector, reported that

"the reservations have been diverted from their legitimate purpose," becoming private fiefdoms. In what might have been a reference to the Kings River Farm, he wrote that "in some cases the Indians have been slaughtered in consequence of alleged depredations upon private property belonging to officers of the superintendency." The Indian agents sent the starving Yokuts to find food on the lands commandeered by American cattlemen, or in the foothills outside their native territories.[15]

The reservations became dens of thieves, which is to say that thieves ran the reservations. William Campbell collected a salary while using government equipment and supplies, treating the Kings River farm as a private enterprise that employed a few Indian laborers. He lined his own pockets.[16]

Federal inspectors, especially the peripatetic Browne, served as counterweights to men like Campbell. Browne thought the Indians had received no benefit from the reservations, which another inspector, George Bailey, called "government almshouses" where "an inconsiderable number of Indians are insufficiently fed and scantily clothed" at disproportionate expense.[17] Browne, who investigated the California Superintendency (the administrative division created by the Indian Office) for the first time in 1854–55, bedeviled the corrupt without putting much of a dent in corruption. Superintendent Thomas J. Henley replaced Superintendent Beale, who was probably only a bad administrator in a bad situation, even if his sense that public business should not prevent private profit foreshadowed what became the Gilded Age. Henley was simpler: he was a crook. In their fine detail, Special Files 159 and 266 containing records of Browne's investigation of Beale and

Henley are a historian's dream. The cost of cattle in 1850s California? It is there. How much did a vaquero get paid for driving cattle? It is there. The condition of the roads and the cost of transport? It, too, is there. The record is enormous and tedious.[18]

The record of corruption turned the investigations inward, obscuring the tragedy unfolding in the Tulare Basin. The chief Pasqual had asked for mercy. Instead, he got a cost accounting of the profits made from the death of his people. Beale thought the investigation sprang from "meanness, spite, and malice," and he blamed Commissioner of Indian Affairs George Manypenny for leaking documents to the press. In the spring of 1855 Beale confronted Manypenny, who was eating lunch in Washington's Willard Hotel. Beale slapped him hard across the face; when Manypenny did not respond, he slapped him again. Manypenny grabbed Beale by his cravat, and the two men wrestled on the floor. When friends separated them, Manypenny tried to break a chair over Beale's head. Beale challenged him to a duel. Manypenny refused. Such violence had become typical in Washington as the country drifted toward the Civil War.[19]

It was hard to see how American policy could end well for the Yokuts. Henley favored a "policy of non-interference with the progress of settlement." He did not think "a valuable tract of country should be held apart for the use of Indians to the exclusion of the citizens of the state." Browne knew this point of view favored squatters, but he also thought it was correct "in the abstract."[20]

The Tachis and the other Yokuts around Tulare Lake who had either escaped the military sweeps or returned to their homes sought to avoid trouble. Gregorio did his best, but trouble pursued him. In 1855 California entered a seven-year

drought. In the Tulare Basin the streams dried up. Whites plundered the Indians' food caches to feed their hungry animals, and the Yokuts faced famine. It was natural, settlers admitted, that the desperate Yokuts should kill cattle and hogs, "but it does not suit the owners of the stock."[21] Life for the Yokuts had resolved into a desperate search for food and protection from Americans.

In May 1856, sparked by supposed Yokut cattle raids, a minority of the settlers at Four Creeks decided on collective punishment of the Indians. Lt. Joseph Stewart at Fort Miller thought a single cow had been killed, and that cow may have been a gift to the Indians. The Four Creeks vigilantes marched anyway, but frightened by rumors that the Indians were massing, they fled back to their homes. Equally frightened Yokuts asked friendly whites if they would be attacked. Within an hour of getting assurances that they would not be harmed, six were killed. Two other deadly attacks followed.[22]

The attacks precipitated the Tule River War. The war, a participant reported, was a "cowardly farce." Panicked settlers demanded military assistance as they moved against the Indians on the Tule River, who were a hundred refugees seeking shelter "in the brush from the rowdies, who on the least occasion delight in the sport of shooting them." Other volunteers derided the Tulare Mounted Riflemen from Four Creeks, calling them the Petticoat Rangers because each soldier wore "a blouse of canvas padded with cotton" as protection from arrows. Their armor was so unwieldy that if they fell, they lay like rag dolls, unable to rise without assistance. The Americans had rifles and killed eight Indians, who were armed only with bows; the remainder retreated into the mountains, raiding from there.[23]

The war resulted in a renewed push to drive the Yokuts from the Kings River. Edward Beale had bounced back from his dismissal as superintendent of Indian Affairs to become a general in the California militia. He held a conference that included the Tachis in June 1856. His interpreter was Gregorio, whom Beale described as "a very intelligent man who accompanied General Frémont to the Atlantic States and back and speaks English very well." The Americans ordered all the Indians on Kings River above Tulare Lake to retire to the Kings River Farm; those in the Four Creeks were to go to the Tule River. Beale allowed the Tachis and others living near the lake to remain.[24]

Superintendent Thomas J. Henley thought the Indians' prospects "gloomy" and Beale's promises to protect them worthless. In this case, he was right. Settlers accused an Indian at Kings River Farm of stealing a horse (an event the military thought had not occurred) and demanded the thief's surrender. A chief offered his own horses in compensation while he investigated, but the Americans threatened to kill all the Yokuts at the farm. They fled. Vigilantes pursued them and murdered three men and a woman. The Americans launched a second attack at a *rancheria* at Dry Creek near Fort Miller on the San Joaquin River. "It was the intention of the whites," an army officer reported, "to kill all the Indians," but the Yokuts had warning and fled. The Americans destroyed everything they could find. These attacks prompted other Yokuts to escape to Fort Miller, whose commander reported that the "acts of the whites, so far, seem to me to be utterly lawless."[25]

In 1857 settlers on the lower Kings River petitioned the federal government to remove the Tachis and Nutunutus. They predictably framed

the choice as between Indians on the one hand and cattle, hogs, and grain on the other. The Americans chose livestock and crops. In the petition, the settlers highlighted one particular theft, that of a steer belonging to Daniel Rhoads. The Yokuts had lived along the Kings River for generations. Daniel Rhoads only arrived in 1857, driving in a large herd of cattle to escape the drought affecting much of California. Settlers in the Four Creeks region resented men like Rhoads, and they vowed to keep out any large herds brought into the region. But Rhoads was on the lower King, and Superintendent Henley sympathized with him and other settlers there. He assured them of his desire to "rid them of this population as soon as possible." He wanted to round the Indians up and ship them to Mendocino.[26]

In November 1858 settlers took matters into their own hands and attacked the remaining Tachi, Nutunutu, Wimilchi, and Wowol *rancherias.* The settlers marched the captives—mostly women, children, and old men—"like herds of sheep" to Fresno Farm. An observer described them as "pitiable . . . as a people their doom is fixed, their destiny is certainly evil." The army, having abandoned Fort Miller in July 1858 and sent the troops to fight Indians in the north, could neither protect the Indians nor restrain the settlers. Subagent M. B. Lewis of Fresno went to the lower Kings River to transport those who had escaped the settlers to Fresno Farm. Seventeen Tachis refused to leave the tules, "preferring as they said to 'die in the Lake with their relatives who had already perished with hunger and cold,' rather than to abandon their ancient homes." A correspondent for the *Pacific Methodist* traveling through the next spring found settlers divided. Some settlers blamed the Indian Service for the

trouble, and others blamed those whites who wanted the Indians' acorn supply to feed to their hogs. A few Indians living on Kings Farm escaped expulsion.[27]

Lewis found himself with six hundred refugees from the lower Kings River. He called the expulsions "arbitrary and uncalled for," but said it was beyond his control. The whites threatened a "war of extermination" if he did not accept the expelled Indians and prevent their return. He urged the destitute refugees to fish for salmon in the San Joaquin and then go to the mountains for acorns.[28]

The desperation of those Indians who remained became a source of profit for settlers. Whites had stolen the acorns in the Indians' food caches in order to feed their livestock, but it proved even more lucrative to sell the acorns to Lewis. They made additional money by charging for hauling the stolen goods, even though Agent Lewis had mules, horses, and wagons available. When challenged over his expenditures, Lewis justified the extra expense as an act of humanity.[29]

In the spring those Yokuts who could scattered to the mines in search of work.[30] Lewis tried to shuttle the Fresno Farm Indians back to the Kings River, but on Kings Farm Campbell threatened to hold the entire crop from starving Indians until he received what he claimed were the moneys due him.[31] The settlers soon forced the Indians at Kings River Farm back to Fresno Farm. The *Daily Alta California* reported that "the Indians were treated with the utmost kindness, and none of their property destroyed except their wigwams, which they were informed they could never inhabit afterwards." The Indians soon fled Fresno Farm and straggled back to the Kings River in 1859.[32]

Mayfield lived through this. "The Indians,"

he said, "had been dying off in the years previous to the establishment of the reservations, and there were not many of them left." They "had been deprived of their game and were rapidly starved and crowded into the hills in competition with their hostile mountain neighbors."[33]

J. Ross Browne and the new superintendent, J. Y. McDuffie, were appalled. Browne regarded the existing reservation system as too corrupt to be rehabilitated. He and McDuffie denounced the Indian farms as worse than useless and recommended their dissolution. In 1860 the U.S. Secretary of the Interior concurred. Both Browne and McDuffie suggested moving the Indians to Tule River Farm and Tejon until a new reservation on the Owens River could be created. It never would be. The Yokuts removed from the Kings River Farm went to Tule River, sixty miles to the south. Most remained there. It became a permanent reservation when the Tejon reservation was terminated in another reorganization of the California Superintendency in 1864.[34]

NAMING THE CRIME

None of this happened in the dark. In 1853 Edward Beale reported from California that "our laws and policy with respect to Indians have been neglected or violated in that State; that they are driven from their homes and deprived of their hunting-grounds and fishing-waters at the discretion of the whites; when they come back to these grounds and waters to get the means of subsistence, and also when they take cattle and stock from the inhabitants for food, they are often killed, thus giving rise to retaliation and wars."[35]

In 1859 Browne delivered a withering summary of events in California:

In the history of Indian races I have seen nothing so cruel and relentless as the treatment of these unhappy people by the authorities constituted by law for their protection. Instead of receiving aid and succor, they have been starved and driven away from the reservations, and then followed into their remote hiding places, where they sought to die in peace, and cruelly slaughtered, till but few are left, and that few without hope.

. . .

It is useless to draw distinctions. One reservation is as bad as the next.[36]

James McDuffie concurred. It appeared "to be the determination of a large number of the settlers in this state to exterminate these Indians, as is evinced by the frequent accounts of massacres of the most revolting character."[37]

Adding up the deaths and losses from sickness, hunger, violence, alcohol, and ethnic cleansing and then factoring in the malice and desire for "extermination" yields genocide (and I use the term advisedly). How many died? Americans admitted that their population figures for the Yokuts were at best only guesses, and earlier figures are no more reliable. The first Spanish explorers described the region as containing an *"infinidad de Gentiles."* There may have been between 18,800 and 35,000 Yokuts in the precontact Tulare Basin. They had declined greatly by the time the Americans arrived, but in 1850 the esti-

mates of Lt. George Derby of the Topographical Engineers put the combination of the Tachis (800) and the other Indians on the Kings River at 3,800, and he did not mention the Wimilchi, Wowol, and many other groups.[38]

An enumeration in 1859 indicated rapid depopulation. In three years the Gawea had been reduced by more than half to 110. The Wimilchi, Tachi, and Wowol on Tulare Lake had declined by from one-third to two-thirds in a decade.[39] Smallpox usually triggered such dramatic declines, but the government had vaccinated against smallpox because they feared its spread to whites.[40]

The eyewitness accounts of specific *rancherias* document horrendous losses. Mayfield said the Choynimni *rancheria* where he lived had alone numbered three hundred in 1853. Forty people remained in 1862, when he left. William Edgar, an army surgeon at Fort Miller, said the Indians at a *rancheria* near there had been "numerous and appeared healthy and happy" when he came in 1851, but the establishment of a town nearby had produced a whiskey trade, disease, and abuse by whites that aggravated the Indians' susceptibility to drought and hunger. When the post was abandoned in 1858, there was only a "remnant" of Indians; they had been reduced to a quarter of their former numbers.[41] Pahmit's memory as an old man was basically the same. "Lots Indian die whisky; lots Indian die bad white man sickness. Just few Indian left . . . White miner still whip Indian; still shoot Indian."[42]

There are survivors even after a genocide, and the Tachis who survived the catastrophes of the 1850s maintained a foothold in their homeland. By 1880 they had reestablished the Santa Rosa *rancheria* that Merriam later visited. Miss Georgia Brooks took a picture of "Indian John" and his family there in that year. Other children watch the photographer from a distance. Indian John and other Tachis went to work for whites. Some even became vaqueros caring for the cattle that had helped destroy them, living at white sufferance on the lands the Americans had taken from them.[43]

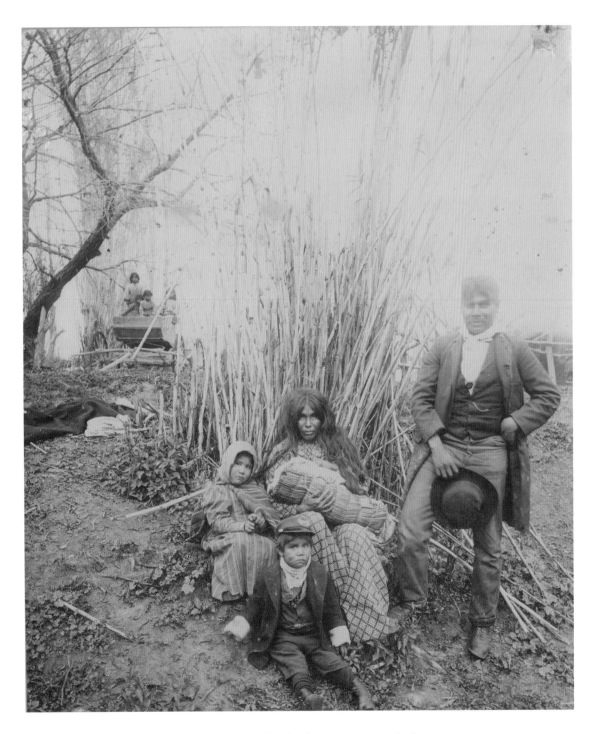

"Indian John" and his family, Santa Rosa rancheria

PART FOUR

PROPERTY

Silo and fields, Kings County

The photograph shown here is organic and relentlessly geometric, largely a collection of living things arranged in ranks and rows, squares and rectangles. The uncultivated land appears unkempt, but it too lives within right angles. The young trees in new orchards march off into the cultivated distance. Everything is natural; nothing is natural. The photograph captures an American landscape that began to take shape with the gold rush. The logic of the cadastral survey that created this landscape was to turn conquered land into private property.

The transformation of the Yokut homeland into American property is the mundane story behind the photograph. Jesse used a drone-mounted camera to capture the logic of the landscape and the power of property. Without the drone, we could not view the interior of these orchards. The only thing that San Joaquin Valley farmers believe in more than private property rights is their own privileged access to public property, which provides the water that animates this landscape. The geometric patterns the drone reveals—the roads, the boundaries of fields—derive from the American land survey that originated in 1787. Americans designed the survey to create a simple and direct mechanism for turning native homelands into private property, but the route often turned out to be circuitous.

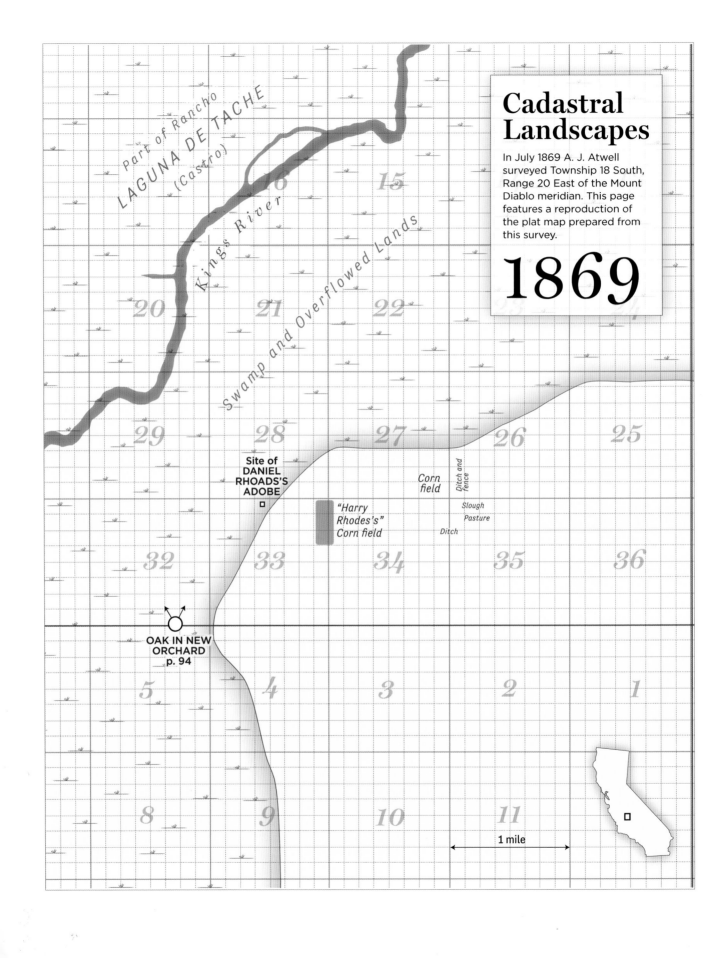

Cadastral Landscapes

In July 1869 A. J. Atwell surveyed Township 18 South, Range 20 East of the Mount Diablo meridian. This page features a reproduction of the plat map prepared from this survey.

1869

Part of Rancho
LAGUNA DE TACHE
(Castro)

Kings River

Swamp and Overflowed Lands

16 15

20 21 22 23 24

29 28 27 26 25

Site of DANIEL RHOADS'S ADOBE

"Harry Rhodes's" Corn field

Corn field

Ditch and fence

Slough

Pasture

Ditch

32 33 34 35 36

OAK IN NEW ORCHARD
p. 94

5 4 3 2 1

8 9 10 11

1 mile

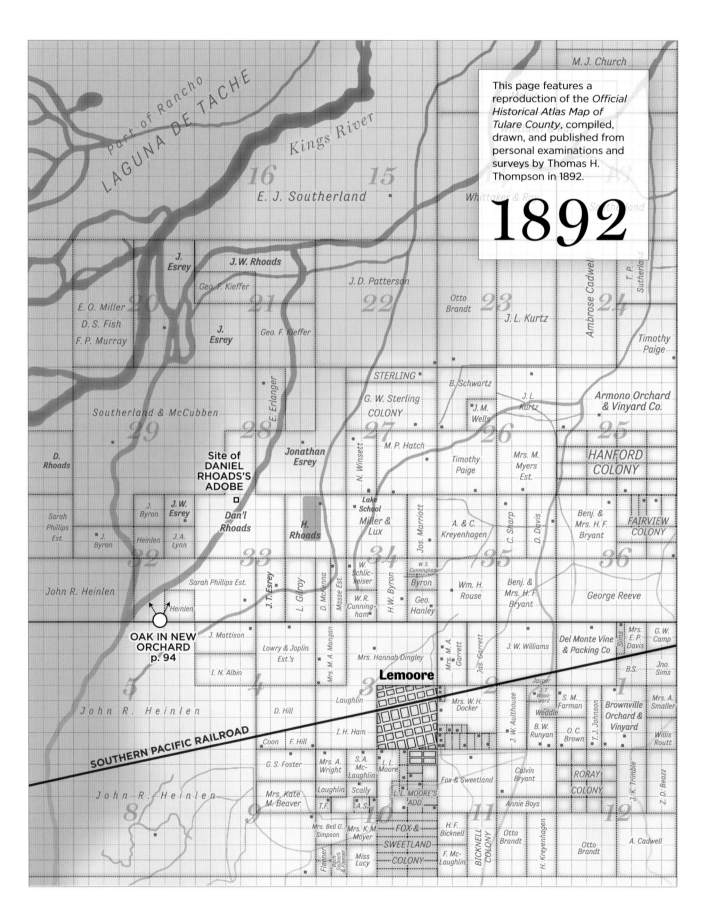

Part of Rancho
LAGUNA DE TACHE

Kings River

M. J. Church

This page features a reproduction of the *Official Historical Atlas Map of Tulare County*, compiled, drawn, and published from personal examinations and surveys by Thomas H. Thompson in 1892.

1892

16

15

E. J. Southerland

18

Whittaker & Roy

Southerland

J. Esrey

J. W. Rhoads

Geo. F. Kieffer

J. D. Patterson

20

21

22

Otto Brandt

23

J. L. Kurtz

Ambrose Cadwell

24

T. P. Sutherland

E. O. Miller

D. S. Fish

F. P. Murray

J. Esrey

Geo. F. Kieffer

Timothy Paige

E. Erlanger

STERLING

B. Schwartz

J. L. Kurtz

Armono Orchard & Vinyard Co.

Southerland & McCubben

G. W. Sterling COLONY

J. M. Wells

29

28

27

26

25

D. Rhoads

Site of DANIEL RHOADS'S ADOBE

Jonathan Esrey

N. Winsett

M. P. Hatch

Timothy Paige

Mrs. M. Myers Est.

HANFORD COLONY

Sarah Phillips Est.

J. Byron

J. W. Esrey

Dan'l Rhoads

Lake School

Miller & Lux

Jos. Marriott

A. & C. Kreyenhagen

C. Sharp

D. Davis

Benj. & Mrs. H. F. Bryant

FAIRVIEW COLONY

J. Byron

Heinlen

J. A. Lynn

H. Rhoads

J. T. Esrey

L. Gilroy

D. McKenna

Masse Est.

W. Schlickeiser

W. R. Cunningham

H. W. Byron

W.S. Cunningham

Byron

Geo. Hanley

Wm. H. Rouse

Benj. & Mrs. H. F. Bryant

George Reeve

32

33

34

35

36

John R. Heinlen

Sarah Phillips Est.

Heinlen

OAK IN NEW ORCHARD p. 94

J. Mattison

Lowry & Joplin Est.'s

Mrs. Hannah Dingley

Mrs. M. A. Garrett

Jas. Garrett

J. W. Williams

Del Monte Vine & Packing Co

Sims

Mrs. E. P. Davis

G. W. Camp

I. N. Albin

Jasper

J. T. Woodward

S. M. Farman

B.S.

Jno. Sims

5

4

3

Lemoore

Mrs. W. H. Docker

2

Weddle

1

Mrs. A. Smaller

John R. Heinlen

D. Hill

Laughlin

I. H. Ham

J. W. Aulthouse

B. W. Runyan

O. C. Brown

T. J. Johnson

Brownville Orchard & Vinyard

Willis Routt

Coon

F. Hill

G. S. Foster

Mrs. A. Wright

S. A. McLaughlin

L. L. Moore

L'L MOORE'S ADD.

Fox & Sweetland

Calvin Bryant

RORAY COLONY

J. K. Trimble

Z. D. Beazz

John R. Heinlen

Mrs. Kate M. Beaver

Laughlin

T.F.

Scally

A.S.

Annie Boys

8

9

10

Mrs. Bell G. Simpson

Mrs. K. M. Moyer

FOX & SWEETLAND COLONY

H. F. Bicknell

BICKNELL COLONY

Otto Brandt

H. Kreyenhagen

Otto Brandt

A. Cadwell

11

12

Fleener

Birch Selloch & Fleener

Miss Lucy

F. McLaughlin

SOUTHERN PACIFIC RAILROAD

Chapter 11

CADASTRAL LANDSCAPES

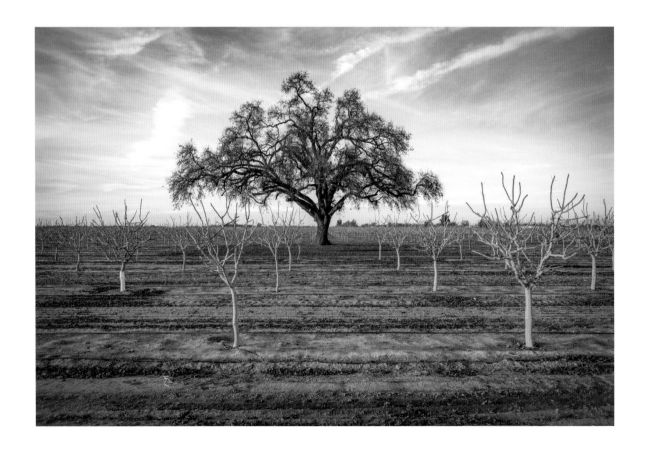

An old oak in a new orchard, Kings County

The photograph on this page poses questions. I will start with a simple one. Where was Jesse—the photographer—standing, and why? The answers, unsurprisingly, turn on property.

I wasn't there when Jesse took the photograph in 2015 and did not know his location when I first viewed it, but I guessed the cadastral grid influenced where he stood. Cadastral derives from the word *cadastre*, which refers to a public record or map used to record the boundaries and ownership of land for taxation. The grid originated with the Land Ordinance of 1785 that provided for public surveys to mark the boundaries and subdivisions of the public lands of the United States in preparation for sale.

Getting the exact location of the photograph is easy. Jesse sent me his coordinates—the longitude and latitude. When I located the spot within the cadastral survey that Americans sketched atop this land, I reached back toward American beginnings in this place. Jesse stood along the Hanford-Armona Road, which follows township lines, as rural roads often do; it is part of the grid that Americans used to mark the land they added to their empire and nation. That grid was inscribed on the land in 1869; it created the abstract spot where Jesse stood. The grid is older than the oak.

THE CADASTRAL LAND SURVEY

Few American things are as ubiquitous as the land survey. It is hidden in plain sight, and few people recognize it or its artifacts. The survey produced the squares and rectangles visible to everyone who flies across country. The surveyors over time sketched a huge and rudimentary coloring book,

drawing the lines that later generations would fill in. Their work is why modern clear-cuts in forests are often contained within straight lines; it is why the Hanford-Armona Road runs where it does.

The survey, a creation of Thomas Jefferson, began in the original Northwest Territory. It enables the basic practices of both governance and the economy, rendering the country, in the words of the political scientist James Scott, legible. Except for the thirteen colonies and Tennessee, Kentucky, and Texas, nearly every inch of the United States can be precisely located and examined by those who have never set foot on it. The survey allows property to be measured and transferred; it enables officials and bureaucrats to enforce laws, tax, and govern. Natural events—a flood or earthquake—can erase everything upon the land; but the grid, and the property it represents, remains. The survey lies at the heart of American space. Originally only a set of numbers—notations recorded in notebooks, maps, and slight marks on the landscape—the Government Land Office survey has aged into one of the oldest physical signs of American sovereignty.[1]

Surveyors had to walk this land to create the grid, and by the rules of the survey they had to create both maps and notes that outlined a story of how they marked the land. Obtaining these original maps and notes used to be hard until the Bureau of Land Management made many of them available on the Internet.[2]

In July 1869 A. J. Atwell and his deputies surveyed Township 18 South, Range 20 East of the Mount Diablo meridian, which contains the land

Jesse photographed. There were other claims to this land. Although neither the Spanish nor the Mexicans had ever settled the Yokut country on the lower Kings River, this did not stop Mexican governors from issuing land grants. After American conquest, all California land grants came before the United States Public Land Commission, set up in 1851 to adjudicate claims to land under previous regimes. In 1866 the land commissioners validated the grant to *Rancho Laguna de Tache* on the north bank of the Kings River. It passed into the hands of the grantee's lawyer, Jeremiah Clark, and its land and water rights would be litigated for years to come.[3] In the flood year of 1862, Daniel Rhoads— the same man whose lost cow led to the eviction of the Tachis—remembered Clark coming through in a boat, but surveyors did not mark the boundaries until 1864. When the patent was issued in 1866, squatters already occupied part of the tract.[4]

The land Atwell surveyed was south of Rancho Laguna de Tache, and the southern boundary of section 32 is now the road where Jesse stood. When Atwell surveyed the land, it was part of Fresno County. Originally, it had been part of Mariposa County; then, in 1852, it was part of Tulare County, and it is now part of Kings County. Political boundaries shift and move, but the township boundaries stay stable.[5]

The numbers of the sections reach into an even deeper and more distant past. The thirty-six sections in the township form a pattern called a boustrophedon, which derives from the Greek and means literally "like turning an ox in plowing." Township numbers followed a path that mimicked a farmer guiding a plow across a field, who at reaching one end turns back to cut a parallel furrow. This means the numbered sections also mimic ancient texts, whose lines proceed in

opposite directions from right to left, from left to right, and so on.

Retracing the path of this emblematic plowman involved imagining his furrows stretching six miles and lying a mile apart. Each mile along the six-mile path constitutes the boundary of a section. Sections 1 through 6 lie at the northern edge of the township. A mile south, where the plowman has turned and cut his second furrow, he has marked sections 7 through 12, the last of which abuts section 1. The entire township is six miles square with 36 square-mile sections. The township line runs east–west, the range line north–south.

Each section has 640 acres, which is a wonderful number since it can be continuously halved down to 5 acres without requiring fractions. A quarter section was 160 acres—a homestead. A quarter of a quarter section was 40 acres, one of the most common units in American land claims.

Actual surveyors like A. J. Atwell did not follow the imaginary plowman, but they did proceed

Sequence of numbers on section lines showing normal order of subdivision, section numbers in a township

methodically starting in section 36. By the time the surveyor reached the corner where section 32 meets section 33 near where Jesse stood, he had walked a difficult and often liquid landscape.

In 1869 whites no longer feared the Yokuts, but the Kings River and Tulare Lake remained threatening. Tules impeded travel and hindered agriculture. Whites associated the wetlands in which they thrived with malaria. They did not know the mechanisms of malaria and its transmission by *Anopheles* mosquitoes; instead, they attributed its cause to rotting vegetation, putrefaction, and what they called miasma, a tainted atmosphere that communicated disease. They thought for white settlement to succeed, the wetlands would have to disappear.[6]

The oak in the first photograph of this chapter stands amid the grid that Atwell constructed, but did Atwell see the oak? Was it even there in 1869? When I plugged the coordinates into Google Earth, I looked into the past, but only the recent past, stretching back to the 1990s. The cluster of trees in the left distance marked a farmstead, and the line of trees farther back outlined the bed of the Kings River. The time slider showed that the orchard was planted between 2009 and 2010. Before that the land was a field. There were more oaks in 1994, the first year that Google recorded this place, but most have gradually vanished because they inhibited the movement of farm equipment and reduced the land available for crops and orchards. Except for this tree, the surviving oaks border roads or shade buildings.

Atwell's survey notes, written in a clear and legible hand, do not literally record what he and his men saw. There seems to be a kind of code at work. Features unmentioned in the notes could still be present in the landscape. The

Kings River, which broke into branches, cut the township roughly on a diagonal. The surveyors did not mention it as a distinct river, because in July it seems the river hardly flowed. As they crossed it in section 1, it was a "water hole" surrounded by tules (reeds) and tulares, the wetlands dominated by tules. The land was "marshy and overflowing." When they set posts at the section corners of 19, 24, 25, and 30, the surveyors were between branches of the Kings River, but they gave no indication that the river was nearby. They described only the land where they stood. Even when they were virtually on the banks of the river, as sketched in later maps of sections 30 and 31, they did not comment on it.[7]

Surveyors found it hard to distinguish the river because water collected all over the township. The line between sections 32 and 33, near where Jesse took his picture, approached the margins of a swamp.

Atwell and his men described the remaining land as a sandy plain, and they rarely mentioned trees. The notation "no timber" recurs repeatedly in the two southern tiers of the township; in other sections, including section 32, they do not note trees.[8] I initially assumed that the failure to mention trees meant the township was treeless. One flaw in this reasoning was that it makes the "no timber" notation in some sections redundant. But there was a far greater problem: a nineteenth-century photograph of Daniel Rhoads's adobe.

DANIEL RHOADS

At the time of the 1869 survey, Daniel Rhoads built an adobe that still exists today in section 33, but

the surveyors made no note of the adobe. Between sections 33 and 34, they found "Harry Rhodes's" cornfield; it extended over into section 27.

Both the name of Rhoads's ranch—*El Adobe de Los Robles Rancho* ("The Oaks Ranch")—and the nineteenth-century photograph mark a grove of valley oaks. The surveyors did not mention the oaks, probably because they were so abundant that they were not worth documenting. Only their absence was noted. Today, following the two miles of road between the site of Jesse's photograph and the site of the adobe, you could count the oaks and probably not reach one hundred.

During the great drought of 1857, Daniel Rhoads had herded his cattle west from Gilroy, where he found pasture along the Kings River. He petitioned American officials for the removal of the Yokuts and built this adobe. He married Amanda Esrey, whose family had also come into the region. Two of her brothers, Jonathan and Justin Esrey, settled nearby.[9]

I would like to think that Jesse's oak was present when Daniel Rhoads arrived and when the surveyors came through, but it is doubtful. I don't know the age of the oak for certain, and I cannot get a core to count its tree rings. I ask an ex-student, who then asks a friend who studies oak phenology in a lab at Berkeley. He guesses that if there was "a lot of water available and protection from herbivory," a valley oak could get this big in maybe fifty to one hundred years.[10] This oak, then, is much younger than the Rhoads adobe. At 150 years, the girth of an oak would be around 125 inches, bigger than this one. Even at 150 years, Jesse's oak would have germinated in 1865, after Daniel Rhoads arrived. The tree is not a remnant of the old oak savanna, but probably a descendant of once-abundant oaks that sprouted

and survived in a new pastoral and agricultural landscape.[11]

In the 1850s much of this area was wetland, and, as Justin Esrey explained in an 1857 letter home, this was what attracted cattlemen. The eviction of the Yokuts was well underway, but this part of the country was unsettled by whites, and it was "good grass country and well adapted to raising stock but fit for nothing else." It was "swamp and over-flow lands." Esrey explained that the "over-flow is caused by the melting of the snow in May and June. The rivers and creeks have very low banks in this part of the country, so that when the snow water comes down they over-flow for four or five miles in width." This made the Kings River "the best [grazing] land in the state. We have got our cattle here." So, too, did "Dan Rhoads." The drought in Southern California had driven up beef prices as cattle there either died or were driven elsewhere.[12]

Justin Esrey had no idea how big the overflow could be. In the 1860s, when Tulare Lake reached its greatest extent, the township was part of a vast interior wetland that extended from the San Joaquin River Delta to Buena Vista Lake, south of Tulare Lake. Tulare Lake rose to an elevation of 215 feet during the flood winter of 1862–63, receded, and then reached that level again in the flood winter of 1867–68. In years when the whole valley flooded, it was possible to go by boat from San Francisco Bay nearly to Bakersfield.[13]

At its greatest nineteenth-century expanse during these flood years of the 1860s, Tulare Lake reached Lemoore, apparently submerging the old site of a Yokut village on its shore. Frank Latta, who was a ranch hand, carpenter, high school teacher, and vernacular historian of enviable skill, produced a hand-sketched map that shows

The Daniel Rhoads adobe

the historical elevations of Tulare Lake.[14] He gave the high elevation at Lemoore as 230 feet. Since the current elevation of the township when Jesse stood there is about 207 feet, it should have been underwater in the 1860s. But the land has sunk dramatically between the 1860s and today. Atwell and his surveyors stood anywhere from 10 to 25 feet, maybe more, above the point where Jesse stood when he took the picture of the oak. The land continues to subside. Beginning in the 1920s and accelerating in the 1960s, the land sank as farmers began tapping the aquifers and lowering the water table. The completion of federal and state water projects conveying water to the southern San Joaquin Valley temporarily halted depletion of the water table, but it resumed with the severe drought that began in 2011. As pumping hit the deeper layers of the aquitards, it drained the aquifers so quickly that they compacted and could not be recharged. It was like replacing a sponge with a board. Subsidence has become permanent, and groundwater storage capacity is reduced.

Corcoran, approximately twenty-eight miles to the southwest of where Jesse photographed the oak, has become the center of a subsidence area that stretches to Lemoore Naval Air Station just to the west of the township. Land is dropping here as fast as anywhere on earth. It fell about 13 feet between 1926 and 1970. It is dropping about twice as fast now and still accelerating. It fell an additional four feet in the three and a half years before 2012. When Jesse took the picture, it was dropping at 1.6 inches a month in areas around Corcoran. Well casings that were at ground level are now two feet above the ground.[15]

The cadastral survey was intended to put a permanent lateral frame on the land. It did not really consider verticals. If Atwell suddenly appeared in Jesse's photograph, he and his crew would be walking at a level high in the oak branches. The gridded orchard reflects Atwell's gridded landscape, but the grid sank. The land system too did not go as planned. Distribution did not go smoothly in California.

THE SHAFTERS:
A POINT REYES GENEALOGY

D Ranch

DRanch is a sliver on the horizon between grass and overcast sky. The photograph cups the buildings like small things in the palm of a hand. The scene is bucolic and isolated, the culmination of the mid-nineteenth century American land policy that intended to take Indian land, turn it into public land, and then distribute it in small amounts as the property of individual producers. The photograph, taken in 2014, is a story of property but not the one the land system intended to tell. The land system was designed to erase Indian claims; it was not well equipped to handle prior distributions by European empires and American republics.

For two centuries after Sir Francis Drake, little changed at Point Reyes. Then in 1817 Franciscan missionaries and Spanish soldiers reduced the Miwoks, removing most of them across the coastal range to the mission at San Rafael, which began as an *asistencia*—an outpost—of Mission San Francisco de Asis. When the Mexican government secularized San Rafael in 1833, it evicted the Franciscans and the land went to *rancheros*. The mission lands had supposedly been held in trust for the converts, but few of them got land. By 1834 a Miwok exodus from the mission had begun, but the Spanish and Mexicans had staked their own claims on the land.[1]

The United States made two consequential decisions about land in conquered California. The first was to guarantee in the Treaty of Guadalupe Hidalgo (1848) that the government would recognize and protect valid legal claims of Mexicans to their property. Valid Spanish and Mexican land grants would never enter the public domain and be available to settlers. They were already private property. As the Yokuts had discovered, the Americans also decided that since the Spanish and Mexicans claimed title to Indian lands, they had relieved the United States of any obligation to negotiate with Indians. The Americans redistributed Indian land outside the land grants without the inconvenience of treaties and payments.

When the first Americans arrived at Point Reyes, there were still Miwoks, descendants of the people who lived there at the time of Drake's voyage, and Mexicans. Some Miwoks had remained on ancestral lands to tend the mission's cattle. They, and those converts who returned, later became *vaqueros* on the *ranchos*. But they did not lose their older understanding of the world. One of them, in roping and killing the elk that remained on Point Reyes in 1846, called an animal "brother-in-law" and assured it that its death would give him lard for his tortillas. The Miwoks continued to regard elk as other-than-human persons, and it was necessary to obtain the animals' consent before killing them.[2] Miwok *rancherias*—villages—remained on Point Reyes in the 1870s.[3]

The Mexican rancheros trafficked by sea, and Drakes Estero continued to draw ships to their doom. Joseph—later called José—Yves Limantour was a French merchant who became Mexican. He had purchased the schooner *Ayacucho*, a fast sailer that Richard Henry Dana Jr. had seen in San Diego in the 1830s during the voyage that produced his book *Two Years Before the Mast* (1840). *Ayacucho* had then flown the English flag and had a crew of Hawaiians. In 1841 Limantour was aboard the ship with a cargo of luxury goods meant for rancheros when his pilot missed the Golden Gate in the fog and turned the schooner into Drakes Bay. He ran it aground at about the same spot where Cermeño had come to grief.

Limantour returned to retrieve his cargo, and he left his name on the beach.[4]

Soon after the shipwreck, Limantour Beach became part of *Rancho Punta de los Reyes Sobrante*. Translated literally, it was the rancho of leftovers, made up of surplus lands on Point Reyes that remained after previous grants. The recipient was Antonio Maria Osio, the brother-in-law of the first Mexican governor of California. James Richard Berry had received the separate Rancho Punta de los Reyes in 1836. Berry was one of those roaming Irishmen attracted by American revolutions. He received the rancho for his service in the Mexican Revolution; its boundaries were never clear. He would illegally sell part of it, launching a tangled history of land disputes. The first grant on the peninsula—*Rancho Tomales y Baulines*—had gone to Rafael Garcia, an ex-soldier who later took over part of Berry's grant. Suits and transfers among the landowners and their creditors ensued and continued after the American conquest.[5]

Even after the California Land Act of 1851 set up a Public Lands Commission to adjudicate the validity of land grants, the title to the ranchos proved unstable. American squatters, some of them sailors deserting whalers and trading ships, settled along the coast. Squatters refused to acknowledge the legitimacy or justice of land grants that denied them access to land. Richer Americans simply set about getting title. Andrew Randall bought up the Osio grant, living on what would become F Ranch, but he went bankrupt. An angry creditor shot and killed him, which proved not only a notably ineffective way to collect a debt but in this case a fatal one. Vigilantes lynched the murderer in San Francisco, and since the grant had been collateral for the murdered Randall's debt to his now lynched murderer, the financial situation became opaque even by California standards. The U.S. Board of Land Commissioners confirmed the grants, but so many contentious creditors claimed a share of them that ownership remained uncertain. Things got worse. When the Marin County sheriff auctioned off Randall's land to satisfy the claims of creditors, he sold it to four different people, giving each one a deed and pocketing all the proceeds.[6]

The San Francisco law firm of Shafter, Shafter, Park, and Heydenfeldt took the case of Dr. Robert McMillan, who had filed a lien against the Randall estate. Before the California Supreme Court decided in McMillan's favor and against other claimants in 1858, he had already conveyed two-thirds of his holdings to his lawyers, presumably in lieu of fees. In 1857 the firm also bought out part of the original Rancho Punta de los Reyes grant and the remainder of McMillan's interest. This was the common fate of Spanish and Mexican land grants: they were usually validated by the Public Land Commission and courts but fell into the hands of lawyers in lieu of fees. In 1865 Charles Howard, the husband of Oscar Shafter's daughter Emma, bought the interest of Heydenfeldt and Park, the Shafters' partners. Oscar Shafter probably advanced him the money.[7]

The Shafters evicted the squatters on the ranchos and brought in sheep and cattle; at some point during the owners' tenure, the elk disappeared. They leased some land to the Steele brothers, who began producing butter and cheese. By 1858 the Shafters had added other dairymen as tenants.[8]

In 1860 there were 132 people living on Point Reyes—far fewer than when it had been Miwok land. Except for Solomon Pierce, an old Vermont neighbor of the Shafters who bought land from

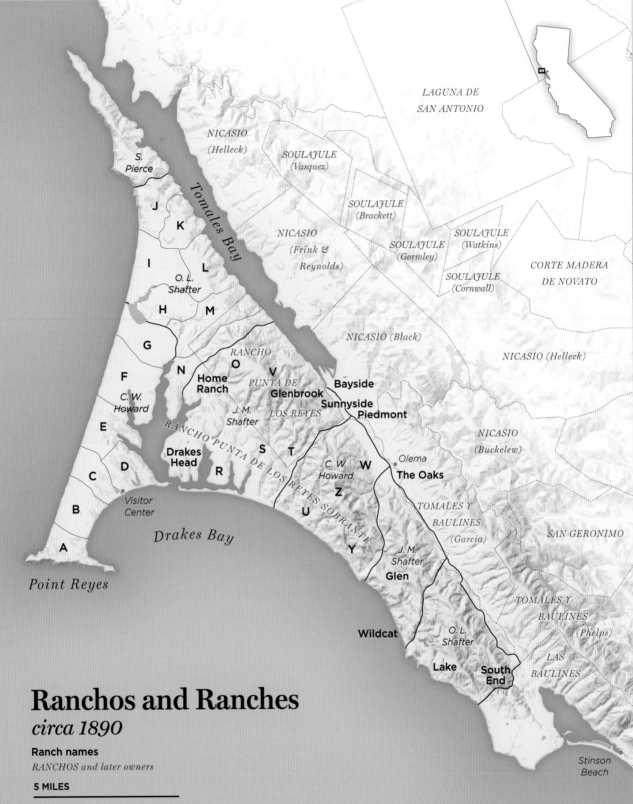

NICASIO
(Helleck)

SOULAJULE
(Vasquez)

LAGUNA DE
SAN ANTONIO

SOULAJULE
(Brackett)

NICASIO
(Frink &
Reynolds)

SOULAJULE
(Gormley)

SOULAJULE
(Watkins)

CORTE MADERA
DE NOVATO

SOULAJULE
(Cornwall)

S.
Pierce

J

K

I

L

O. L.
Shafter

H

M

G

N

RANCHO

O

V

Tomales Bay

NICASIO (Black)

NICASIO (Helleck)

Home
Ranch

PUNTA DE

Bayside

F

C. W.
Howard

J. M.
Shafter

LOS REYES

Glenbrook

Sunnyside

Piedmont

NICASIO
(Buckelew)

E

RANCHO PUNTA DE LOS

S

T

C. W.
Howard

W

Olema

Drakes
Head

R

The Oaks

Z

D

REYES SOBRANTE

TOMALES Y

C

U

BAULINES
(Garcia)

SAN GERONIMO

Visitor
Center

Y

B

J. M.
Shafter

A

Drakes Bay

Glen

TOMALES Y
BAULINES
(Phelps)

Point Reyes

Wildcat

O. L.
Shafter

Lake

LAS
BAULINES

South
End

Ranchos and Ranches
circa 1890

Ranch names
RANCHOS and later owners

Stinson
Beach

5 MILES

Alphabet Ranch locations originally compiled by Dewey Livingston in "Ranching on the Point Reyes Peninsula"

them in 1858, the inhabitants were virtually all tenants or laborers. The Shafters refused to sell any more of their holdings, which frustrated the Steeles, who moved south to purchase the Pescadero Ranch in San Mateo County. In 1866 the Shafters divided the remainder of Point Reyes peninsula west of the San Andreas Fault into tenant farms that they designated with the letters A through Z. In 1869 Oscar Shafter, James Shafter, and Howard, who was also president of the Spring Valley Water Company, split their Point Reyes holdings, and man each managed a third.[9] Oscar Shafter claimed he intended to retire to Olema. He treasured Point Reyes, in part because of its emerging connection with Drake; but he became ill, and Howard took over the management of his property.[10]

LAND MONOPOLY

Between the establishment of the alphabet ranches and the 1890s, the focus of Point Reyes could be summed up in a single word: butter. The wet winds off the ocean and the "immense fog banks" kept the pastures of both native bunchgrasses and invaders—such as filaree and foxtail—green into the summer, making it "probably the greatest dairying section on the Pacific Coast." Grass growing in the fields of the ranches on Monday was, boosters claimed, butter on San Francisco tables by Sunday. The story of how this butter came to be and where it went puts D Ranch and Point Reyes onto a larger canvas.[11]

In 1876 Charles Nordhoff, a well-known journalist who wrote popular travelogues, visited Howard's nine ranches, including D Ranch.

Howard had subdivided and fenced the fields on his ranches, built the houses—"twenty-eight by thirty-two feet, a story and a half high, containing nine rooms, all lathed and plastered"—as well as a milking room, barn, corral, and other outbuildings. On D Ranch, as on his other ranches, Howard piped in water for the house and dairy. He stocked the ranch with improved dairy cattle, which in 1876 the tenant rented at $27.50 per year. Each ranch had between 115 and 125 cows. The tenant provided the horses, wagons, furniture, and farm implements as well as the labor. The tenants made butter and fattened pigs on the buttermilk. The calves not destined to be raised for milk or sold were slaughtered and fed to the pigs.[12]

Howard and the Shafters leased the ranches for terms of three years.[13] The tenants were a mix of Americans, Swedes—often actually Danes—Germans, Irish, and Portuguese, who often came from the Azores. This diversity reflected California's population as a whole: the proportion of immigrants fluctuated between 40 percent and 55 percent in the late nineteenth century. The tenants needed an estimated $2,000 annually to run a dairy farm, and they employed milkers and farmhands who were often Portuguese, occasionally Miwoks, and sometimes Chinese.[14] In 1876 Howard hired W. H. Abbott to manage the Howard and Oscar Shafter ranches. He would stay until 1898.[15]

Nordhoff was impressed with the dairies, in part because he was enamored of a "pretty Swedish girl" who ran what he regarded as a model dairy. Who she was is unclear. Hinrik Claussen—a Dane of German extraction who had moved to Sweden and then California—had leased G Ranch and supervised the construction of these early ranches before dying of infection following an

insect bite in 1872. Hinrik's daughter, Brigitte Christine, would have been thirty-three in 1876. By nineteenth-century standards, this would have made her a spinster rather than a "girl."[16]

The Claussens prospered, but they remained tenants. They were part of a world that was in nineteenth-century terms backward and un-American. When large owners controlled the land and tenants worked it, the West replicated the South. Such a loss of independence was not supposed to happen in the West.

The prosperity of some tenants could never quite make up for their failing to be the freeholders of American ambitions. The gold rush had promised a world of free labor and individual enterprise. Tenancy was European or Southern; it should not have been Western, but it was. Point Reyes became American property, but not the freehold property of small farmers as American land policy had imagined. It was the emblem of a Californian route to tenancy that ran through the old Spanish and Mexican land grants. It would not be the only route to what Californians considered monopoly.[17]

BRADED RIVERS,
BRADED LIVES

Man on horseback, Whittier Narrows

The man on horseback is riding along the Whittier Narrows where the San Gabriel River cuts through a low range of hills. In the nineteenth century, Californios and Gabrieleños rode horses along this river. The original San Gabriel mission was nearby; the site of the present mission is about eight miles to the north. The Californios wore their hats differently than the man in the photograph; theirs had flat brims. He wears a straw cowboy hat, the kind favored by immigrants from northern Mexico. People with Spanish surnames—Spanish, Gabrieleños, Californios, Mexicans, and Americans—have lived along this river since the 1770s.

The landscape was different then. Jesse frames the picture with power lines inconspicuously in the background to remove any illusion that the horseman rides through a relic of the past. To the south along the opposite edge of the La Puente Hills is La Habra in Orange County, a suburb where my family first moved when we came to California. I finished this book in Pasadena, less than ten miles to the northwest. All of these were once mission lands.

The site of the photograph is now a nature center, but it does not preserve the original nature of the rivers. What is preserved in the enduring Mexican American presence is the Californio and Mexican American past of the region.[1]

Into the 1930s the Rio Hondo and San Gabriel rivers were still quasi-rural Mexican and Mexican American places, but they were no longer places where Californios controlled much property. Some Californios never had property; others lost it quickly, while some retained it and even added to it into the twentieth century. Poor and rich Californio families intersected, and the intertwined destinies of the Alvitre, the Temple, and the Workman families reveal how these communities were as braided as the original rivers.

In 1853 an attempted rape brought the families together. Ysidro Alvitre assaulted Antonia Margarita Workman de Temple. The Temples and Workmans had already become the dominant families in the area around the original site of the San Gabriel Mission. Antonia was the wife of Francis Pliny Fisk (F.P.F.) Temple and the daughter of Charles Workman. A vigilante court sentenced Alvitre to 250 lashes. He died from the whipping.[2]

Jonathan Temple was a New Englander and then an American merchant in Hawaii. He entered the California trade and settled in Los Angeles in the late 1820s and became Don Juan Temple. His much younger half-brother, F.P.F. Temple, followed in 1841. Both married into elite Californio families. William Workman, born in England, had reached New Mexico in 1825, where he converted to Catholicism and had two children with Nicolasa Urioste. They lived together and moved to California in 1841 but only married in 1844 in a ceremony at San Gabriel Mission. In 1842 the governor granted Workman a half share of *Rancho La Puente*. The priests at San Gabriel regarded the grant taken from the mission as a robbery of the Gabrieleños, but they could not stop it. It was the next year that F.P.F. Temple married the Workman's daughter Margarita.[3] When in 1850 Workman foreclosed on a mortgage to acquire *Rancho La Merced*, he gave half of it to his son-in-law. Both Workman and the Temples prospered with the booming cattle trade brought by the gold rush.[4]

Workman and Jonathan Temple, who died in

1866, kept their focus on ranching, but F.P.F. Temple diversified his investments.[5] The Temples and the Workman children had English names, but they were Spanish speaking. The older male children received American and British educations at Santa Clara, MIT, Harvard, and the Inns of Court in London. Ranches had provided their wealth, but they, like F.P.F. Temple, saw their futures in the emerging orchards and the evolving speculative American world of Los Angeles.[6]

F.P.F. Temple erected a grist mill, speculated heavily in Los Angeles real estate, and in July 1873 was an incorporator of the Los Angeles Petroleum Refining Company. Other investments in gas and oil followed. These efforts pointed to a California future, but at the time none of them amounted to much. Temple's most fateful investment was the founding of the Los Angeles bank, Temple and Workman, with his father-in-law.[7]

The timing—during the depression that followed the Panic of 1873—was not auspicious. The financial repercussions of the panic took a while to reach California, but in 1875 they overwhelmed the state's banking system when the reckless investments of William Ralston's Bank of California, particularly in the Comstock Lode, led to the bank's collapse and Ralston's presumed suicide. As so often happened in the nineteenth century, the collapse of one bank led others to shut their doors as they furiously tried to raise cash to satisfy their own panicked depositors and creditors. Temple and Workman had been no better run than the Bank of California, and to obtain the cash to keep afloat, Temple and his father-in-law mortgaged most of their lands to Elias J. "Lucky" Baldwin. Baldwin got his nickname because he got out of silver in the Comstock Lode just before its collapse. He was also involved in the Bank of

California but escaped, largely unscathed, and then preyed on those who didn't. Baldwin loaned Temple and Workman capital to keep the bank open. It was not enough. In 1876 it failed. Temple filed for bankruptcy and was denounced as a criminal. The day Baldwin foreclosed on William Workman's property, the old man pointed a pistol under his right ear and pulled the trigger. Lucky Baldwin took over most of their landholdings. Temple suffered a series of strokes before dying in 1880.[8]

In 1879 Theo. Wagner, the U.S. Surveyor General for California, produced a plat of the lands around Whittier Narrows just as Baldwin replaced the Temples and Workmans as owner. Rancho La Puente lay upstream from the site of the present dam. The Rancho La Merced stretched alongside the north bank of the Rio Hondo; across from it the *Rancho Paso de Bartolo* took in some of the land between the rivers.

As the Temple and Workman families went into decline, William Temple wrote that the four older brothers could take care of themselves. William's mother (with whom he had quarreled and to whom he referred as Mrs. Temple) and his three youngest siblings could not.[9] Stories of the breaking up of the old ranchos and their passage into Anglo hands were always particular, but they followed a general pattern of debt and foreclosure.

The Temple family salvaged a small 50-acre homestead from the bankruptcy. After their mother's death, two of the younger brothers, Walter and Charles Temple, became co-owners, part of a mix of Anglo and Californio smallholders in the region. An 1880 map of the old mission lands acquired by the Southern Pacific and then sold off in small tracts showed such a mixture in parts of Section 11, T 1S,

Rancho Paso de Bartolo, *Los Angeles County*

R 12W in modern San Gabriel. The surnames Guillen, Gonzalez, Flores, Ortega, and Serrano mixed with those of Miller, Tuch, Grand, and Hall.[10]

Walter Temple still lived in the Los Angeles pastoral of orchards on the edge of the city. He grew walnuts. It is easy to assume that the tranquility of the landscape mirrored the tranquil lives of its inhabitants. But the lives of Charles and Walter Temple seem the stuff of fiction. Charles Temple pursued the darker half of the family's history, but for years it looked like Walter Temple had taken the brighter path. But like the river, the family history was braided. The bright and dark could not be disentangled.

Margarita gave birth to Charles nearly twenty years after Ysidro Alvitre had attempted to rape her. Charles married Rafaela Basye in 1898. She was the daughter of Rafael Basye, who like the Workman children was of mixed American and *nuevo mexicano*—as Spanish-speaking New Mexicans were called—descent, and Maria Antonia Alvitre, a member of the same large Californio family as Ysidro and Felipe Alvitre. Rafaela died under mysterious circumstances soon after

the marriage. Her brothers suspected Charles of complicity in her death, and in 1899 James Basye wounded Charles in a gunfight. Charles survived, and since the district attorney thought Temple as much at fault as Basye, charges were dismissed.[11]

Charles remarried, and while retaining half of the Temple homestead, he also operated the "La Paloma" saloon near Old Mission. A social club for Spanish-speaking workers used the saloon as its headquarters, a practice that seems to have guaranteed them access independent of Charles. This became an important point in 1902, when a drunken party erupted into fights and Charles, who was also drinking heavily, ordered the carousing men from the saloon. Among them was another Basye brother, Thomas.[12]

A court tried to determine what happened next. Given that the available witnesses were drawn from La Paloma's pool of drunks, this was not an easy task. The only thing certain from the witnesses, who testified in Spanish, was that Basye had objected to being evicted, Charles Temple had shot him, and Thomas Basye died. Temple claimed self-defense. When arrested Temple was in the midst of delirium tremens, but when he sobered, he found other witnesses who testified to Basye's bad temper and proclivity for drunken violence. He had, in the past, threatened Temple. He had once come into the saloon, "pulled out a long dagger, and stabbing it down into the top of the counter, where it stuck quivering, he said that was for 'Cabrones.'" The term is an epithet of shame and reproach, and its application under the circumstances was an insult to Temple, but he did not take the affront. What Basye intended is not entirely clear. *Cabrón* has evolved into an all-purpose slur. Basye could have been suggesting generally that Temple was an asshole and he

would gladly fight him. But the older sense of the word was cuckold, and Basye could have been insinuating that either his own dead sister or Temple's new wife cheated on him.[13]

Temple was acquitted of the killing, but people still regarded him as a dangerous man. In 1904 his second wife left him, and a story circulated that in a drunken rage he had returned home and strangled his eighteen-month-old child. The story was a fabrication, but it spoke to Temple's reputation that so many people believed it.[14]

In 1907 Walter Temple bought out his brother's share of the homestead and embarked on a very different trajectory that also connected his family with the Basyes. Walter Temple had married Laura Gonzalez, yet another descendant of the Alvitres as well as the far more prominent Lugos and Alvarados. In 1912 Temple sold the homestead and bought back 60 acres of Rancho La Merced, which was once owned by his father, from Lucky Baldwin's estate. He moved across the Rio Hondo near the Whittier Narrows and took up residence in what had been the Basye family home—the Basye Adobe. According to the family story, in 1914 one of his children, Thomas, was playing in the Montebello Hills just after a rain and noticed that a pool in a gully had rainbow streaks and smelled of rotten eggs. It was oil. Standard Oil bought the lease and the Temples, or at least Walter's family, were rich once again.[15] In the 1920s Standard Oil Company made the Basye Adobe the headquarters for the Temple oil lease.[16]

The Temple oil lease turned out to be a lucrative if shallow pool that would largely play out by the late 1920s, but it provided Walter with a stream of oil revenue that he, in imitation of his father, invested in additional oil fields and other

Oil field, Montebello Hills near Whittier Narrows

businesses. He became a major developer of Alhambra, but his most ambitious development was the town of Temple.[17] Temple consisted of 285 acres containing 1,300 lots. Walter Temple made the development racially restrictive. Property would be "permanently protected through rigid enforcement of sensible race and building restrictions." The usual interpretation of these covenants would have excluded his mother and brother.[18]

It would be easy to think of the town of Temple as a rich man's attempt to whiten himself and his family at a time when Anglos consigned peo-ple of Mexican descent to an inferior status, but Temple spent considerable money commemorating his own family's Californio past. In 1917 Walter bought back his grandfather's old family home, the Workman Homestead in La Puente. It was the second time the family redeemed it. F.P.F. Temple had returned from MIT in the 1870s to repurchase 75 acres and his grandfather's winemaking operation from Lucky Baldwin. After F.P.F. died, the property passed to his brothers, who lost it to foreclosure in the Depression of 1893.[19]

Walter undertook a very California project. He tried to restore the past, in this case an imag-

Josephine Temple (Princess Mona Darkfeather)

ined past. He began construction on a Spanish Revival mansion—*La Casa Nueva*—whose 11,000 square feet contained twenty-six rooms and elaborate decorations meant to evoke a world of missions and ranchos. He commissioned a stained glass Madonna with bobbed hair, lipstick, and eye shadow. Since bricks had long before displaced adobe in Los Angeles construction, Temple brought in a master craftsman from Mexico to build the house of adobe.[20] His home was a private commemoration of a Californio past. Temple also contributed to the creation of the San Gabriel Mission Playhouse, the site of the Mission Pageant that romanticized the mission past.[21]

Walter was not the only Workman/Temple family member to construct a bifurcated version of the family past. His cousin, Joseph Workman, had retained nearly 900 acres of the La Puente Ranch that was not included in the Baldwin mortgage. The bank foreclosed on it in 1895.[22] Joseph's youngest surviving daughter, Josephine, ended up in Hollywood in 1909. Her family had originally prospered through the expropriation of Gabrieleño land; she expropriated an Indian

identity. She acted under the name of Princess Mona Darkfeather. Between 1908 and 1917, she appeared in seventy films.[23]

Oil and Hollywood had seemingly allowed Walter Temple and Josephine Workman to make a successful transition into a new Los Angeles by playing at living in an old one. Walter built his adobe and planted walnuts at the old Workman Homestead, but his fortunes took a downturn in the 1920s and then plummeted off the cliff in the 1930s as the Great Depression enveloped California along with the rest of the nation. Josephine Workman had the softer landing. She married and stopped acting. Her husband was in the industry, and she lived quietly until her death in 1977.[24]

The town of Temple generated debt rather than revenue, and Walter Temple's oil investments never produced like his original field. On paper, he remained a wealthy man; but few of his assets were liquid, and creditors began to press hard. By 1928 he was trying to preserve part of the Temple lease and the Workman Homestead from the disaster he saw looming. He failed.[25]

Temple lost La Casa Nueva in 1930 and moved to Baja California. When cancer struck him in the mid-1930s, he returned to California, where he lived with friends until his death in 1938. He was buried at Mission San Gabriel.[26] His son Thomas Workman Temple II, the child who had discovered oil, would become the historian of San Gabriel Mission. He would write an account of Toypurina that provided a variation on the mission myth. He made her a "witch," but a valiant one who resisted noble Spaniards before becoming reconciled to them through conversion and marriage.[27] Taken as a whole, the family's history provided a simulacrum of the development of Southern California.

PART FIVE

CAPITAL

Jesse took this photograph of a plow sitting in a field near Jackson Slough on Brannan Island in the Sacramento-San Joaquin Delta. Six of its moldboards rest half in stubble and six more, seemingly cultivating the air, are at an opposite angle above the beam. The green of the beam echoes the green strip of wetland in a landscape of brown and blue. Birds fill the air.

The photograph is a pastoral that is also a story of capital and labor. The plow is capital and so is the land; but to produce crops, capital needs labor. The photograph tells a small story about labor that seems utterly of the moment. A fieldworker has paused in preparing a field for planting, and in so doing has created a tension at the center of the image. He—for the worker driving the tractor is almost certainly male and Latino—has detached the plow at the end of the field, perhaps at the end of the day. He has flipped it so that he can attach the plow to the tractor with the reversed moldboards cutting in

Field on Brannan Island, Sacramento-San Joaquin Delta

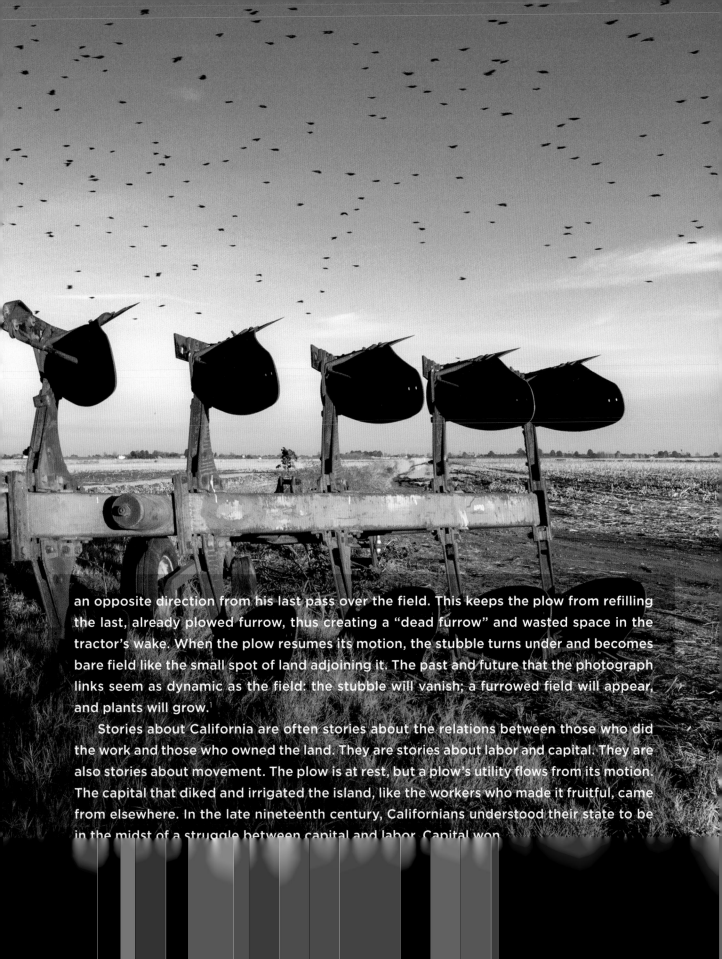

an opposite direction from his last pass over the field. This keeps the plow from refilling the last, already plowed furrow, thus creating a "dead furrow" and wasted space in the tractor's wake. When the plow resumes its motion, the stubble turns under and becomes bare field like the small spot of land adjoining it. The past and future that the photograph links seem as dynamic as the field: the stubble will vanish; a furrowed field will appear, and plants will grow.[1]

Stories about California are often stories about the relations between those who did the work and those who owned the land. They are stories about labor and capital. They are also stories about movement. The plow is at rest, but a plow's utility flows from its motion. The capital that diked and irrigated the island, like the workers who made it fruitful, came from elsewhere. In the late nineteenth century, Californians understood their state to be in the midst of a struggle between capital and labor. Capital won.

CARQUINEZ STRAIT

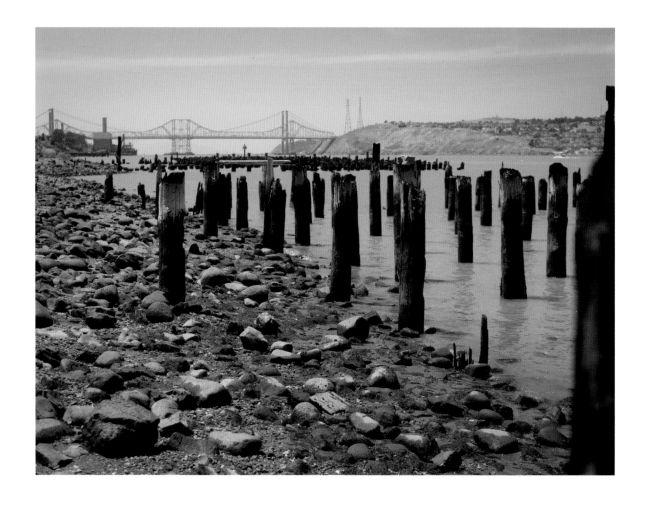

Carquinez Strait, San Francisco Bay

J esse took this photograph at low tide along the shores of Carquinez Strait, which joins San Francisco Bay to the delta, the San Joaquin and Sacramento rivers, and their valleys. The ebb tide bares stones, sand, mud, and old posts that make the shoreline look like the remains of a sunken forest. It also reveals both the geological history of California—the land sinks, oceans rise, and mountains erode—and the emergence of human beings in the state as a geological force. And although I did not realize it immediately, it bares the difficulties capital faced in making the various property regimes in California cohere.

The photograph accentuates movement. Modern movement is clear in the Carquinez Bridge and the ubiquitous electrical towers: both allow people and energy to cross the strait. The foreground of the photograph captures traces of older movements that marked the core economies of the nineteenth century California: mining and wheat. Part of the rocky debris comes from hydraulic mining in the Sierra Nevada. Grove Karl Gilbert, a turn-of-the-century geologist, estimated that miners over a couple of decades flushed 1.5 billion yards of rock, mud, and sand—eight times the amount of earth excavated for the Panama Canal—out of the Sierras. It proceeded down streams and tributaries of the Sacramento and from that river into the delta and the strait. It covered the bottom of Suisun Bay, where Carquinez Strait begins, with 3.3 feet of sediment. A century and a half after being blasted loose from the Sierra Nevada, some of the debris is still on its way to the sea.[1]

The debris is the unintended consequence of government laws to encourage mining; the rotting posts are physical remnants of policies to encourage agriculture. They are all that remain of the great wharfs from which wheat was loaded onto schooners sailing to Europe and across the Pacific. Federal laws that gave away the public domain and its resources had jump-started both gold and wheat production. By the end of the century delta farmers and wheat ranchers, both spoiled children of the state, had entered a quarrel that would force government officials to intervene.

GEOLOGY

The human history that produced the posts and debris in the photograph rests on a deeper geological history. The San Joaquin and Sacramento rivers created the delta, but from Collinsville to Suisun Bay the rivers run in a single channel. On maps, Carquinez Strait begins at Suisun Bay and terminates in San Francisco Bay near Mare Island and Vallejo, but as State Engineer William Hammond Hall wrote in 1880, it is harder in practice to say where the rivers end and San Francisco Bay begins. Like the line between wakefulness and sleep, the entry into the delta from the bay is blurred.[2]

Americans quickly recognized the observable dance of tide and flood that created and maintained the delta, but at the turn of the twentieth century the geologist G. K. Gilbert described deeper changes. Delta peat ran down forty to sixty feet and rested on the remnant of the landscape that existed before there was a San Francisco Bay. At that time, instead of meeting the bay, the merged San Joaquin and Sacramento rivers had

continued on through the Golden Gate and flowed west for miles until they met the Pacific shoreline.[3]

Only with the melting of glacial ice about ten thousand years ago did the rising Pacific reach the Golden Gate and push through to form San Francisco Bay. As the ocean rose, Gilbert calculated that the land independently subsided.[4] There was as yet no knowledge of tectonic plates to explain how this happened, but Gilbert recognized the results. What had been valleys fell beneath waves that eroded former hilltops. In the mountains, the rivers flowed along on bedrock, which provided relatively little for the rivers to scour. There was not enough silt, sand, and gravel carried to the delta and on to the bay to make up for subsidence. Left to natural processes, the delta would remain more water than land.[5]

Gold miners made sure that the delta would not be left to natural processes. In the 1860s, having exhausted the surface placer deposits, they turned to hydraulic mining: directing water from mountain streams to wash away hillsides and mountainsides that covered ancient gold-bearing streambeds. They began on a small scale. Individual miners working their claims bought water from ditch companies that appropriated the water from mountain streams and directed it downhill through ditches and flumes to the claims. By the 1870s these companies had consolidated into joint stock corporations that took over the claims of miners who defaulted on their water bills. As the companies grew larger, the technology grew more sophisticated. The companies constructed dams and thousands of miles of tunnels, flumes, and ditches to supply large water cannons or monitors that used the force of falling water to blast away mountainsides. Gravity and the annual snowmelt of the Sierra Nevada took over from there.

When the rivers left the mountains and slowed upon entering the Central Valley, they dropped their load, raising the riverbed until a stronger flood could wash the debris farther along. Higher riverbeds meant increased flooding in the permanent and seasonal wetlands, which farmers along the Sacramento River began to reclaim and plant. These wetlands took up about of a third of the Sacramento and San Joaquin valleys, but the mining debris largely affected the Sacramento drainage.[6]

The 1.5 billion tons of sand and rock created a giant slug advancing downstream. The Sacramento became a liquid pistol. Each year with the melting snows, the river fired the slug and each year it reloaded. The pistol was aimed at the delta and the bay. The slug—the creation of capital and labor—smashed into natural systems; it also threatened other creations of capital and labor.[7]

By the 1870s California capital derived from the gold rush had divided against itself. It funded the Sierra infrastructure that delivered water to the cannons that blasted away mountainsides, and it also created the infrastructure for reclaiming wetlands. The government sometimes gave the gold and the wetlands to the same people. George Roberts, who with his partners had made money during the gold rush, created the Tide-Land Reclamation Company. He used the federal Swampland Act (1850) and California's Green Act (1868) to control, individually and through the company, a quarter of a million acres in the delta by the early 1870s. He paid little or nothing for most of it, and he began diking it with Chinese labor. Roberts and other landlords made the delta a place of immense industrial farms and tenants.[8]

The lavish gifts to miners and to delta land-

lords did not easily coexist. Those who tried to turn profits derived from the mines into wetland farms opposed those who invested their profits in hydraulic mining.[9]

Repeatedly in the 1860s and 1870s, the tributaries of the Sacramento, and then the Sacramento itself, created legendary inundations. Beginning at Marysville and Yuba City, the floods left scourings from the mines on top of fields and orchards. By the 1880s, some 39,000 acres of farmland had vanished under the debris. Another 14,000 acres had sustained significant damage.[10]

A long legal battle ensued in which the miners initially more than held their own. In their approach to governance, Californians in the 1880s remained perched between a Jacksonian past, which required those benefiting from public works to pay for them and those creating a nuisance take responsibility for abating it, and a future that imagined an overarching public interest. Neither approach worked particularly well on the Sacramento River. Farmers could not identify the precise source of the debris that buried their fields and orchards, so they could not name, or sue, the persons responsible for the damage. The Drainage Act of 1880 provided a tax-funded commission that would manage the entire river in the public interest, permitting both mining and farming. It authorized dams to retard debris and provided for higher levees on the Sacramento. The bill relieved miners of responsibility for the debris, and opponents claimed it passed only through bribery. The dams failed physically, and the law failed politically and constitutionally. The state courts invalidated it.[11]

Those opposed to the tax-funded commission were not simply reactionaries. The owners of hydraulic mines claimed a public interest in taxing all the citizens of the state to repair the dam-ages inflicted by their search for gold. Landowners understandably demurred.[12]

The delta initially promised to offer a way to reconcile farmers and miners, at least in the dreams of miners. In the delta, miners argued, the debris would prove a benefit by spreading out to create new land and material for stronger dikes. The Sacramento Valley might be a casualty, but Americans could mine the mountains and farm the delta, shipping the harvest out through Carquinez Strait. The two outlets for gold rush capital would be reconciled. Farmers and miners would be in harmony.[13]

The debris did not cooperate. In the delta, the rivers rose and reclaimed land disappeared. Individual landowners did mine the debris for diking material, but the dikes repeatedly failed. Both dredging companies and landowners suggested public dredging projects to create stronger dikes and provide fill for the island interiors. Aiding delta farmers to dike their lands would have been more legislatively palatable if the farmers were not rich monopolists—robbers, as Henry George called them—who had already bent the law to their advantage and shut out small farmers. The plan went nowhere.[14]

The hydraulic miners suffered what eventually proved to be a fatal blow in January 1884 when the federal court, in *Edwards Woodruff v. North Bloomfield Gravel Mining Co., et al.*, cut through the Gordian knot of tying the debris in any given orchard to a specific mining company. Judge Lorenzo Sawyer, a friend of Leland Stanford and the Southern Pacific Railroad, ruled that hydraulic mining created such an extreme public nuisance that it must be halted. Sawyer made it clear that his decision was aimed at protecting property—not just the property of the com-

plainant, but that of all owners of riparian and wetlands now and in the future. The court banned miners from depositing any debris in the drainage of any river or stream. It would take the rest of the decade to enforce the ruling. What's more, it did nothing to remove the thirty years of debris already in the streams, which continued to move downstream.[15]

Sawyer's decision has been celebrated as a sign of an embryonic environmentalism and the birth of a new California. And it may have been, but it was also something else. Sawyer reined in mining corporations, but he also protected the interests of those who monopolized the wetlands of the Sacramento and the delta. The judge's decision resembles others he made that protected railroad land grants and those who had purchased often dubious Spanish and Mexican land grants. Sawyer was an essentially conservative justice, and safeguarding California's landed interests was the thread tying together many of his decisions. The great crop of these interests in the late nineteenth century was wheat.[16]

SHIPPING WHEAT

In the days of '49 California depended on gold; for most of the rest of the nineteenth century, it depended on wheat. The posts in Jesse's photograph once supported wharves that stretched out to other wharves, parallel to the shore, where ships loaded wheat.[17]

Sarah Meady was aboard one of the ships anchored at the wharves in January 1885; she had joining her husband Fred, who was a first mate. The ship came in on a Friday afternoon. Four

crews loaded it, and it was ready to depart for Liverpool on Wednesday afternoon. Loading was not always so quick. Four years later Fred Meady, with a Chinese cook, Chinese stewards, and a six-and-a-half-foot tall Irish mate, anticipated a wait of two weeks or more. Sarah Meady thought Porta Costa, along with Benicia, one of the twinned wheat ports on the Strait, "a very pretty place . . . amongst the mountains with old historical places around us. Marteenus [Martinez] is three miles above; Venecia [Benicia] is just acrost [*sic*] the river."[18]

In the late nineteenth century, the harvests of the San Joaquin Valley and the delta joined those of the Sacramento Valley on these docks. Farmers in California bagged their wheat; each bag, containing 115 pounds, came from a distinct farm. Cranes, derricks, and brute human labor loaded the bags into the holds of sailing ships that carried most of the wheat around Cape Horn to Liverpool, the great British wheat mart.[19]

Frank Norris's novel *The Octopus* (1901) culminates at Port Costa. The novel concerns the Southern Pacific, the child of the Central Pacific that swallowed its parent. The Central Pacific went east over the Sierras and into the desert; the Southern Pacific ran south down the San Joaquin Valley and tapped the expanding wheat harvest. Until the 1890s neither railroad carried much freight across the country, but instead carried goods into and out of San Francisco and San Francisco Bay. Their monopoly on transportation within the state made them hated and feared.[20]

In the novel Norris writes about S. Behrman, the fictional fixer for the Southern Pacific, who arrives at Porta Costa and asks directions to "the bark 'Swanhilda' that was taking on grain." Behrman had erected an elevator to load the grain into

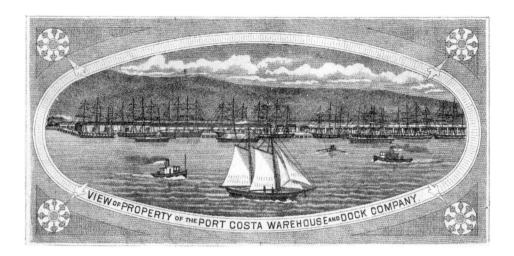

Port Costa, Carquinez Strait

the hold in bulk, as the Great Lakes ports had been doing for years. Observing the loading of the vessel, Behrman slips and falls into the hold of the ship where, amidst the din of the flowing wheat, he can be neither seen nor heard. As the wheat inexorably pours in, it "filled the pockets of the coat, it crept up the sleeves and trouser legs, it covered the great, protuberant stock, it ran at last in rivulets into the distended, gasping mouth. It covered the face." In the end, "A hand, fat, with short fingers and swollen veins, reached up, clutching, then fell limp and prone. In another instant it was covered." There is only the "wheat that continued to plunge incessantly from the iron chute in a prolonged roar, persistent, steady, inevitable."[21]

Like Drake's *Golden Hind*, the fictional "Swanhilda," would make its way from California to Asia, but it carried wheat for India instead of looted Spanish treasure. Norris was imbued with the same Anglo-Saxonism that led his contemporaries to resurrect Drake. It was everywhere in those years. One of his characters proclaims, "The Anglo-Saxon started from there [i.e., India] at the beginning of everything and it's manifest destiny that he must circle the globe and fetch up where he began his march."[22] In California, Anglo-Saxonism eventually just seemed silly, but in India it fed the imperialism of the Raj. Eventually, Anglo-Saxonism would achieve something worse: the fascist horrors of Aryanism.

STARR MILL

California exported most of its wheat as grain, but at the opening of the strait, just beyond the twinned bridges in the background of Jesse's photograph, was the Starr Mill of South Vallejo. It embodied California's ambitions to do more than export raw materials. It ground wheat into flour for export. Soon after its construction in 1869, Carleton Watkins took two photographs of the mill. One, originally a stereoscope, looked out over the water to Mare Island.

The Starr Mill had quickly displayed its limits

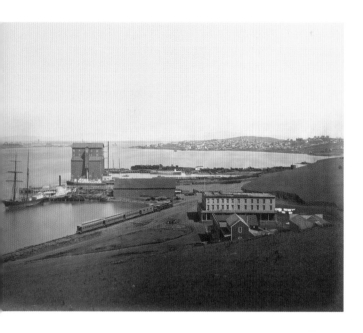

Carleton Watkins's photograph of the Starr Mill, Vallejo, California

the frogs keep up their croaking, and even at high noon the entire absence of any human face or voice." Its most notable aspects were a "tall building beside the pier, labeled the STAR FLOUR MILLS; and sea-going, full-rigged ships lay close along shore, waiting for their cargo. Soon these would be plunging round the Horn, soon the flour from the STAR FLOUR MILLS would be landed on the wharves of Liverpool. For that, too, is one of England's outposts; thither, to this gaunt mill, across the Atlantic and Pacific deeps and round about the icy Horn, this crowd of great, three masted, deep sea ships come, bringing nothing, and return with bread." Ten years later the strait was not so clearly an English outpost. Fred Meady reported that all the ships but three—two British and one German—were American.[24]

All of this—the ships, the mill, and the Frisby House as well as a train running along the shore— are present in a second photograph Watkins took in 1870. Things had been more hopeful then. The mill was new; the transcontinental railroad, subsidized by the federal government, had been completed the year before; and Californians thought they would become the hub of a commerce that stretched across the Pacific to Asia, across all of North America, and around Cape Horn to Europe. They were wrong.

By 1880 California ranked among the top five states in the value of its farmland, but its most productive farmland was in a few hands both in the delta and much of the Central Valley; on average, California farms were the largest in the country. Minnesota and Kansas had smaller farms but more of them, and these states had passed California in population. Ten years after its completion, the transcontinental railroad had disappointed most Californians. It had delivered

as an engine of growth. In 1879 Robert Louis Stevenson visited Vallejo on the first stop of his honeymoon. He and his wife had spent a memorably unpleasant night near the Starr Mill at the Frisby House, "a place of fallen fortunes," like the town, which had briefly been the capital of California. By that time, he said, the house was "given up to labourers, and partly ruinous." Dinner featured "a plague of flies" as well as "the wire hencoops over the dishes, the great variety and invariable vileness of the food and the rough coatless men devouring it in silence. In our bedroom, the stove would not burn, though it would smoke; and while one window would not open, the other would not shut."[23]

South Vallejo, wrote Stevenson, was like "many Californian towns . . . a blunder." It consisted of "a long pier, a number of drinking saloons, a hotel of a great size, marshy pools where

up the state's economy to the Central Pacific, the Southern Pacific, and their corruption. California grew, but more slowly than it had before, and far more slowly than the states of the Middle Border.[25]

Nor did the delta thrive. The delta promised, in the words of the editors of the *Daily Alta California* in 1869, a "drought-proof means of life and luxurious living for the whole population of our State, were it twice as numerous."[26] On Sherman and Twitchell islands, the places that had spurred delta land reclamation, the wetlands reclaimed much of their old domain as riverbeds rose with hydraulic wastes, levees increased the speed and power of the currents, and islands sank under cultivation. After an 1880 flood, most of Sherman Island remained underwater into the 1890s.[27] The story was much the same on Twitchell Island. Floods devastated the island repeatedly, and by the 1880s reclamation there had been largely abandoned.[28] Much of the land that did remain only pastured livestock. The "new Nile" that boosters had promised California did not arise.[29]

Over the late nineteenth century, California endured a long somnolence while resting on a pillow of wheat. A summary of California's progress in 1900 declared wheat "the great agricultural staple of California and probably will remain so," but wheat was not the state's future. Kings County lay in the heart of grain country, but farmers there were not only leaving grain farming for orchards, vineyards, and dairying, but had been doing so for ten years.[30]

Only in the twentieth century—thanks to intervention by the Army Corps of Engineers, the clamshell dredge, and new legislation—did the seesaw battle between land speculators seeking reclamation and the rivers turn in favor of the developers. By 1920 most of the delta had been reclaimed. The Army Corps and state agencies altered the Sacramento River not only to improve navigation but also to mitigate flooding. Beginning in the 1930s upstream dams also protected delta farmlands. The delta hardly became secure. Under cultivation the peat soils sank about three feet a year, so that the rivers loomed higher and higher above them and hydrostatic pressure on their levees and underlying peat increased. Catastrophic floods decreased, but they did not vanish.[31]

What did vanish was much of the export wheat trade. By the 1890s the mining of the soil that resulted from a continuous cropping of wheat without fertilization had reduced yields even as world wheat prices continued to fall. California wheat could not compete on the Liverpool market. Between 1899 and 1909 California wheat acreage fell by 83 percent. The twin pillars of California's nineteenth-century economy—gold and wheat—had fallen into ruin.

A new California grew up among the ruins. Advancing irrigation made other crops far more profitable than wheat, and improved railroad freight service made their export to the East and Midwest possible.[32] A Mediterranean California of orchards and vineyards became more than a fantasy. It—along with the real estate speculation, tourism, and oil—promised the state a new prosperity.

Chapter 15

MUSSEL SLOUGH COUNTRY

Silo near Guernsey, Kings County

The silo stands in a field in modern Kings County near Guernsey, which is now only a name on the map about ten miles south of Hanford. The little of Guernsey that ever existed was located on land once owned by James T. Guernsey, near the southeastern edge of the Mussel Slough country that stretched from the Kings River on the north and Mussel Slough on the west to Cross Creek on the east and the rapidly receding Tulare Lake on the south. Mussel Slough ran between Lake Tulare and the Kings River, part of whose overflow it originally captured. The Last Chance Ditch roughly parallels its route, sometimes cutting across it. The Mussel Slough ditch incorporated part of the original slough.

Mussel Slough was a name with considerable resonance in nineteenth-century California. It communicated bloodshed and conflict, and to escape such connotations the Mussel Slough country became informally known as the Lucerne Valley in the 1880s. *Lucerne* is the word the British use for alfalfa. The county formally adopted this as the toponym for the area in 1890. The change reflected the rise of dairying and the effort to erase the memory of the violent struggle of farmers and small-scale speculators against the Southern Pacific Railroad in the late 1870s.[1]

The silo, once filled annually with alfalfa, is unremarkable. It is of a common type built from concrete blocks. Children who grew up on farms remember silos like this one: "The little bump out on the left-hand side was where the ladder was that you use to crawl up into the silo and empty it from the top down."[2]

The photograph of the silo can serve as a palimpsest. Scrape away the modern land cover and find what was there before that; then scrape that away and keep going, layer after layer, until you reach the base. Removing the first layer is easy. Aerial photographs on Google Earth show that the young trees on the left disappeared in about 2014; those to the right of the silo vanished in about 2011 or 2012. These were the years they were planted. Before that the land was, briefly so it appears, cultivated in row crops, and before that

in alfalfa pasture. The Google Earth photographs stop in 1996, but the silo itself indicates alfalfa well before that. In Kings County there is no point having a silo without alfalfa. With row crops, there was no need for a silo. The roof vanished. A tree sprouted within it.

It is harder to determine when the silo was built. A lot of silos like this one were built after World War II, but concrete silos had already appeared around the turn of the twentieth century. Farmers near Guernsey had them in 1911.[3] There were instructions for building them out of concrete blocks as early as 1915.[4] In 1922 a farming tour visited the ranch of Almer B. Comfort. He came to Guernsey in 1912; before Guernsey lost its post office, he was the postmaster. He also owned the mercantile store and ran the lumberyard. And he owned a ranch where there was a concrete silo for his dairying operation.[5] For all practical purposes, except for the grain warehouse, Almer Comfort was Guernsey.

If Comfort's silo is not the one in Jesse's photograph, it was of the same type in about the same place. A silo and a dairy near Tulare Lake in 1922 indicated three things. First, Comfort fed his cows silage rather than, or perhaps as well as, hay. Farmers produced silage by packing newly harvested alfalfa into a silo to eliminate as much oxygen as possible. The result was arrested fermentation and preservation of the vast mass of ensilaged mate-

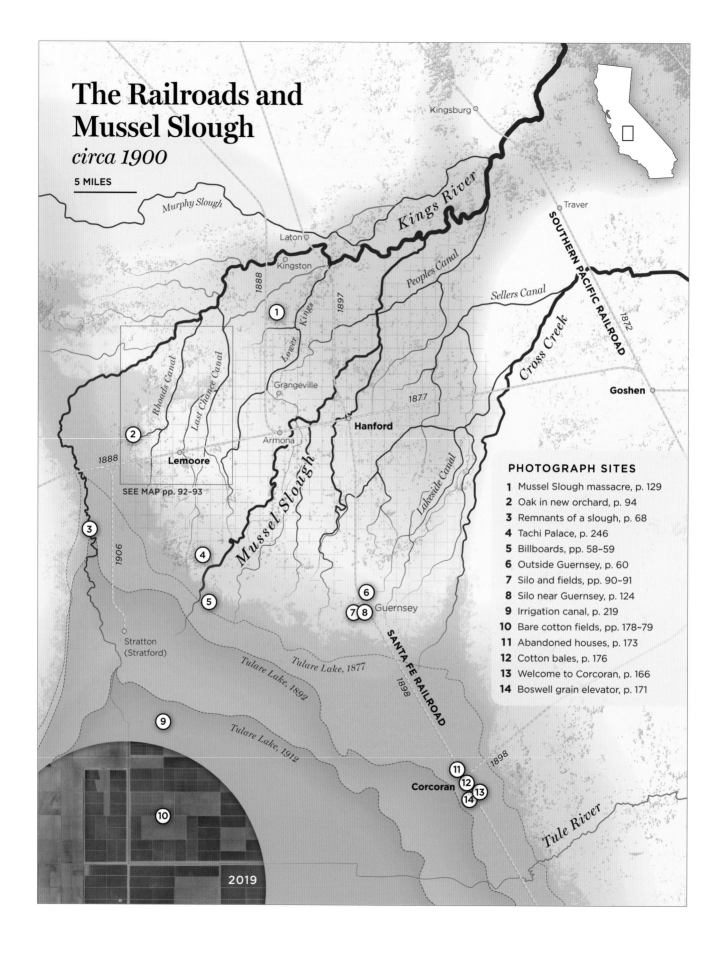

The Railroads and Mussel Slough

circa 1900

5 MILES

Murphy Slough

Kings River

Kingsburg

Traver

Laton

Kingston

Peoples Canal

Sellers Canal

SOUTHERN PACIFIC RAILROAD

1872

1888

Lower Kings

1897

Rhoads Canal

Last Chance Canal

Grangeville

Cross Creek

Goshen

1877

Hanford

Armona

1888

Lemoore

SEE MAP pp. 92–93

Mussel Slough

Lakeside Canal

1906

3

2

1

4

5

Stratton
(Stratford)

Tulare Lake, 1877

Tulare Lake, 1892

6

7 **8** Guernsey

SANTA FE RAILROAD

1898

PHOTOGRAPH SITES

1 Mussel Slough massacre, p. 129
2 Oak in new orchard, p. 94
3 Remnants of a slough, p. 68
4 Tachi Palace, p. 246
5 Billboards, pp. 58–59
6 Outside Guernsey, p. 60
7 Silo and fields, pp. 90–91
8 Silo near Guernsey, p. 124
9 Irrigation canal, p. 219
10 Bare cotton fields, pp. 178–79
11 Abandoned houses, p. 173
12 Cotton bales, p. 176
13 Welcome to Corcoran, p. 166
14 Boswell grain elevator, p. 171

9

Tulare Lake, 1912

10

11 1898

12
Corcoran **13**
14

Tule River

2019

rial. Hay had to dry before storage, removing a field from production until it did. Silage allowed more frequent harvests, yielded a more consistent product, and retained more nutrients. The practice spread from Europe into the eastern United States in the 1870s and then spread west in the late nineteenth and early twentieth centuries. Second, the silo indicated irrigation, since alfalfa was the major silage crop in Kings County and after the water table fell, it could only be profitably grown with irrigation. Third, the silo and the dairy indicated a nearby railroad; Comfort needed it to get fresh milk and butter to market quickly.

Guernsey was a shipping point on the San Francisco and San Joaquin Valley Railroad. Called "The People's Road," it was designed to break the Southern Pacific's stranglehold on the valley. The railroad was moribund until the Spreckles family, which controlled Hawaiian and California sugar production, pumped money into it in 1895 even as they stressed its dependence on small investors and local interests. Building out of Stockton, the tracks reached Bakersfield in 1897. In 1898 the Atchison, Topeka, and Santa Fe bought the road, a possibility the Spreckles family had looked favorably on from the beginning. Guernsey became a stop on the Atchison. It marked a division between largely irrigated lands to the north and unirrigated lands to the south; it also marked a boundary between anti-monopolists and landed monopoly.[6]

The huge wheat and cattle ranches were retreating south of the silo as irrigation expanded: on irrigated land fruit, alfalfa, and dairying produced much larger revenues than wheat or cattle. The grain warehouse was a relic of the large wheat ranchers. It needed to gain state approval for charging increasing fees because it lacked the revenue to survive.[7]

Hanford/Lemoore irrigation sheet,
California State Engineering Department

A map of Guernsey in 1912 shows the town sitting in Section 1 of Township 20 South, Range 21 E, right on the border of Section 6 of Township 20 South, Range 22 E. The old sloughs had not yet been filled and drained or turned into ditches. The townships to the north contained vineyards, alfalfa, and dairies. That same year the California Conservation Commission published a different map, showing that most of the land between Guernsey and the receding Tulare Lake had come under irrigation but was not in orchard crops. Ranchers produced prize-winning milk cows and workhorses in 1917. Both depended on irrigated alfalfa. Ranchers hedged against a return

of the lake. Unlike trees, horses and cows could be moved if the waters rose and the ranchers would only lose one crop of alfalfa.[8]

Go back a few years to the late nineteenth century, and the entire landscape had been a monochrome of wheat. When James T. Guernsey sold his ranch "near the lake" to J. J. Harlow in the early 1890s, Harlow grew wheat, which had become the main crop of the Mussel Slough country in the 1870s and took up 90 percent of the basin's cropland in 1884.[9]

Before the decades of wheat, the entire Mussel Slough district had been livestock country—mostly cattle and horses with sheep at its western reaches. Large cattle ranches dominated the country south of the Kings River. The animals grazed the remains of wild vegetation and introduced grasses, but in drought years there seemed to be no vegetation at all. In the early 1870s a new settler, Mary E. Chambers, remembered the Mussel Slough country as looking "like one vast corral, with no more appearance of vegetation than a well swept floor."[10] With the drought of 1876–79, the corral emptied. Cattle died by the thousands.[11]

The next layer was the last. Richard Smith, who had carried a shipment of honey across Tulare Lake to San Francisco Bay in the flood winter of 1867–68, could have sailed past the site (lat 36° 12' 19.1" N, long 119°38' 46.7" W) where the silo now stands. Or he might have sailed over it. In 1868 the site of the silo was probably beneath the waters of Tulare Lake.[12]

There is nothing unusual about the farmers' transition from low-value to high-value crops, nor of increasing irrigation on arid lands, nor of changing crop choices in response to market pressures. But such changes did not come evenly. The silo marked a boundary.

WOULD-BE MONOPOLISTS

The ownership of Mussel Slough country was always contentious. José Yves Limantour, the same man whose ship had run aground in Drakes Bay, maintained that he had received a land grant, south of the Kings River from the last Mexican governor, Manuel Micheltorena, in compensation for services he rendered the Californios. He had loaned the government money and, Americans suspected, smuggled guns to help Californios resist American conquest.

Limantour's claim to the *Rancho de Taches* was almost an afterthought; he also claimed all of San Francisco south of California Street—about half the city. The Board of Land Commissioners actually validated his San Francisco claim in 1856, and he began collecting money from some property owners. The board did not sanction his claim to the Rancho de Taches, for which Limantour produced no substantiating evidence. This was a defeat that a man who had just been given half of San Francisco could bear. By law, there was an automatic appeal from the Board of Land Commissioners to the U.S. District Court. Limantour hired General James Wilson, a two-time New Hampshire congressman, as his counsel to protect his San Francisco grant. He promised Wilson a quarter of his half of San Francisco if he won. Wilson recognized it was good to be a New England lawyer in San Francisco.[13]

The U.S. attorney hired George Davidson to examine the evidence for Limantour's claims. This was the same George Davidson who became convinced that Drake had landed in Drakes Bay. He believed what his eyes told him. Davidson had Robert Vance photograph the seals on Limantour's grants and then, using a "micrometer of

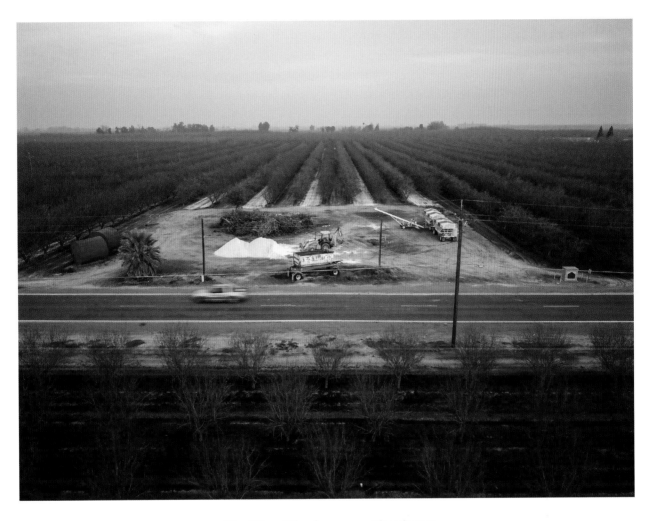

Site of Mussel Slough massacre, Kings County

'unusual delicacy,'" he compared them to photographs of known seals. Limantour's seals differed substantially. This discrepancy became a critical piece of the evidence that Limantour had forged the documents and his witnesses had perjured themselves. After being indicted for fraud following the rejection of his San Francisco claim in 1858, Limantour never returned to California. He remained in Mexico, where his talents made him a rich man and a high government official.[14]

The Mussel Slough country never became the domain of a single owner, but no place in California would become more closely associated with the battle against monopoly.

The photograph shown here juxtaposes orchards—vertical and horizontal—with a palm tree, utility poles, and farm equipment in a way that makes it clear how *industrial* modern agriculture is. All that sets the scene apart from thousands like it is the small monument on the right, which commemorates the Mussel Slough massacre. Men died here, and Frank Norris fictionalized

and memorialized their deaths in *The Octopus* (1901).[15]

The Mussel Slough plaque is only one of three historical markers in Kings County. It was not erected until 1950. It seeks to sanitize an old controversy. It acknowledges that men died because of a dispute over land titles.[16]

In *The Octopus* land monopolists—large wheat ranchers—battle a transportation monopoly, the Pacific and Southwestern Railroad, for the land and lose; but in the late nineteenth century, it was farmers who occupied the Mussel Slough country. They grew wheat and alfalfa on land also claimed by the Southern Pacific Railroad, and they speculated on the side.[17]

Henry George loved California, and he is the best guide to California's hopes and fears in the late nineteenth century. Although he was a Sinophobe and a racist, George praised gold rush California's "cosmopolitanism, a certain freedom and breadth of common thought and feeling, natural to a community made up from so many different sources, to which every man and woman had been transplanted—all travelers to some extent, and with native angularities of prejudice and habit more or less worn off." Californians, he thought, had "a feeling of personal independence and equality, a general hopefulness and self-reliance and a certain large-heartedness and open-handedness which were born of the comparative evenness with which property was distributed, the high standard of wages and comfort, and the latent feeling of every one that he might 'make a strike,' and certainly could not be kept down long."[18]

George feared the railroad would destroy his California. Whatever benefits it brought would be more than offset by the losses Californians would incur. "Captains of industry" who employed

men in "gangs" would undercut the "personal independence—the basis of all virtues." California would become a land of a few millionaires and numerous and desperate poor.[19]

In the 1870s this process seemed to be happening. George described "great wheat fields of from ten to twenty-thousand acres . . . ploughed, and sown and reaped by contract" and "ill-kept, shadeless, dusty roads, where a house is an unwonted landmark, and which run frequently for miles through the same man's land." Along the dusty roads "plod the tramps, with blankets on back—the labourers of the California farmer, looking for work, in its seasons, or toiling back to the city when the ploughing is ended or the wheat crop gathered." This was the fruit of monopoly.[20]

George was not wrong about land monopoly—it was already well established in the Sacramento-San Joaquin Delta, in the San Joaquin Valley, and at Point Reyes, and remains to this day a curse on the state—but the railroads were not the main cause. Most railroad land grants were a mistake. They went to roads that were going to be built anyway, or to roads that never should have been built; they had faults enough without being burdened with other imagined failings. Undeserved and unnecessary as they might have been, as fraudulently obtained as they often were, as inimical as they proved to Indian interests, and for all the troubles their selection and patenting presented to settlers and local governments, railroad grants—outside of timberlands—usually did not yield monopolization of land. In California, the Central Pacific and Southern Pacific sought to sell land quickly at reasonable prices for the most selfish of reasons: without settlement, they had no traffic.[21]

The struggle over the Mussel Slough country was more complicated than just honest settlers

versus a corrupt railroad, although certainly the railroad was corrupt. The basic problem was the 1865 charter for the Southern Pacific, which was vague as to the railroad's point of origin, equally vague as to a destination, and left the route to the imagination of the builders. The incorporators plotted the original route in utter ignorance of actual geography. The significance of this event to the rest of California was that in 1866, the road received a land grant as an afterthought to an act granting land to the Atlantic and Pacific, a transcontinental railroad that was supposed to go to San Diego. The A&P and the Southern Pacific would connect at the Colorado River, and the Southern Pacific would carry traffic north to San Francisco. Judge Lorenzo Sawyer later attached great significance to this, as if a goal were a route.

In 1868 the owners of the Southern Pacific filed for a change of route that would take their trains down the San Joaquin Valley, and the Associates of the Central Pacific—the four principal investors—purchased the railroad. They needed the Southern Pacific because the Central Pacific had perhaps the most useless and unprofitable route in California. The cheapest way to ship goods to and from the East remained transporting them by water via San Francisco Bay. To get freight and revenue, the associates needed to build into the fertile valleys, particularly the Sacramento and the San Joaquin, and link them to San Francisco Bay. Their railroads' survival depended on California traffic, not transcontinental traffic.[22]

The associates had pushed the Central Pacific south from Lathrop into the San Joaquin Valley, reaching Goshen by 1874, but adjacent lands were already largely engrossed by speculators. Neither the Central Pacific nor the small roads it acquired were entitled to a land grant beyond Goshen. The

Southern Pacific's progress toward the San Joaquin Valley had stalled. It reached Tres Pinos near Hollister in 1873 and stopped.[23]

To an innocent observer, the 150 miles separating Goshen from the Southern Pacific at Tres Pinos indicated that these were two separate railroads—the Central Pacific and the Southern Pacific—running to two places that few Californians could identify then or now. To create a profitable Southern Pacific, the four associates called their single line of San Joaquin Valley railroad the Central Pacific north of Goshen and the Southern Pacific south of the town. By 1870 Collis P. Huntington, whose methods involved substantial gifts to his political friends, had secured government confirmation that the Southern Pacific land grant would apply to a new route.[24] The terms of the Railroad and Telegraph Line Lands Act (July 27, 1866) did not demand a contiguous line. Whenever the Southern Pacific completed a consecutive twenty-five mile section of its "mainline," it would receive the odd-numbered sections already reserved for it over ten miles on either side of the track. The original act mandated that the Southern Pacific and Atlantic and Pacific build at least fifty miles a year and be completed by 1878—but there was no penalty attached, and these deadlines were extended. The courts ruled that even when the railroads did not fulfill the terms of the grant, the lands reserved for the railroads could not be forfeited without a specific act of Congress.[25]

Despite the land grant, the Southern Pacific did not get the prime land it desired over much of the new route. Large speculators, including W. S. Chapman, the wheat king Isaac Friedlander, and the Miller and Lux Corporation, which controlled San Francisco's cattle business, had already amassed large holdings in Fresno, Kern,

and Merced counties. The speculators used the Swampland Act, and they made cash purchases with deflated Morrill Act scrip issued to finance state agricultural colleges and military scrip issued to veterans before the Civil War. The railroad received other lands—lieu lands—as compensation, but these tracts were on the margins of the valley. Years later, these seeming wastelands proved a bonanza. They contained oil.

Tulare County was different. Homesteaders and preemption claimants who preceded surveyors had also obtained land ahead of the large speculators in the eastern part of the county. Further west, the Southern Pacific obtained prime lands along its route. The Southern Pacific largely sold this land to small farmers in tracts of 80 to several hundred acres.[26] Small farmers dominated most of Tulare County, part of which became Kings County in 1893.

Only in the Mussel Slough country was there much conflict over the Southern Pacific land grant. In 1876 the Southern Pacific began to build west from Goshen toward Tres Pinos. The Southern Pacific created the towns of Hanford and Armona before terminating at Lemoore in 1878, a town that owed its existence solely to the requirements of the 1866 legislation. The line went just far enough—the requisite twenty-five miles—to qualify for an allocation of its land grant. It would never reach Tres Pinos or connect to the western section of the Southern Pacific. The associates claimed that this stub of a railroad line—which ran essentially from nowhere to nowhere—was now the main line of the Southern Pacific and, as such, qualified for the land grant.[27]

Settlers had moved into the Mussel Slough district in advance of the railroad in the early 1870s. Some rented from Miller and Lux, which had hold-

ings in the region. Others squatted on the Southern Pacific land grant. They believed that the Southern Pacific had failed to meet the terms of the grant, and they could preempt it. Even if the railroad got the grant, they thought the Southern Pacific would sell it to those who settled on its lands for around the average price it charged elsewhere in the San Joaquin Valley: between $3 and $4.50 per acre. Despite their later claims, these settlers had no guarantee of this price from the railroad.[28]

The new Southern Pacific line did make both land and crops more valuable. The settlers no longer had to rely on long hauls by wagon. The demand for irrigated lands was high, and even unimproved Mussel Slough lands sold for over $20 an acre.[29] The railroad claimed credit for this rise in value, but settlers thought the increase in value belonged to them. As Mary Chambers put it, they had with their "energy and perseverance . . . [made] the wilderness . . . blossom and bear."[30] Charles Nordhoff, who visited Mussel Slough, just as he visited Point Reyes, agreed. He wrote that land unable to dependably support sheep in 1872 looked by the end of the 1870s like "an old-settled and rich farming country in the East."[31]

The squatters and their sympathizers contested the railroad's claim to the land. In December 1879 Judge Lorenzo Sawyer, appointed by Leland Stanford when he had been governor of California and a friend of both Charles Crocker and Stanford, ruled on appeal against Pierpont Orton, one of the earliest of the squatters. Sawyer essentially ruled that the Southern Pacific could choose any route it wanted between the Colorado River and San Francisco, no matter what its original charter said. The logic of designating a twenty-five-mile branch off the existing through route to San Francisco as the main line of the Southern Pacific remained elu-

sive, but Sawyer asserted that legally the Goshen branch was the main line. Short of overturning the decision in the U.S. Supreme Court, the matter was settled.[32]

This ruling did not end the dispute, because the issue was about more than just the title. It was also about who would reap the windfall of the difference between the original price of $2.50 of the public land within the checkerboard—the alternating sections of public and railroad land within a railroad grant—and the current market price of more than $20.00 an acre. The Associates of the Southern Pacific continued to claim that the windfall was legally theirs and that the Southern Pacific would charge between $8 and $20 for the lands, giving the squatters the first option to buy. The chief lands in dispute centered on Township 18 South, Range 21 East, and Township 19 South, Range 21 East. They both fell within the checkerboard and had access to the irrigation network.[33]

Sawyer's decision brought the simmering dispute to a boil. The squatters/settlers had attracted widespread public sympathy. They considered themselves antimonopolists, and some were affiliated with Denis Kearney's Workingman's Party of San Francisco. In 1878 some of the squatters formed the Settlers' League, which became the peaceful face of the movement. They rallied, petitioned, and sued. In 1879 some of the same settlers turned to vigilantism, organizing military companies and parading through the streets of Lemoore, Hanford, and Grangerville. They engaged in night riding and made threats against those willing to purchase railroad land. Sawyer's decision ratcheted up the intimidation and threats of violence. Attempts at negotiation failed. The Associates refused to lower the prices to anywhere near what the squatters desired.[34]

In 1880 the Southern Pacific resorted to eject-ment suits. On May 11, 1880, Marshal Alonzo Poole, accompanied by a railroad land agent, escorted Mills Hartt and Walter J. Crow, both of whom had purchased land from the railroad, to evict two Settlers' League leaders and take possession of their claims. The Settlers' League was holding a mass meeting and picnic that day in Hanford. When word reached them of Poole's presence, men, armed and unarmed, rushed off to stop the evictions. The two groups met on Henry Brewer's farm on the border of Fresno County and what was then Tulare County. Brewer held title to his farm, but he also claimed a share in the adjacent railroad section, which contained a maturing crop of wheat.

Accounts of what happened next differ in detail, but all agreed that the settlers told Marshal Poole they would not allow him to dispossess the squatters. They took Poole, who sympathized with them but insisted on doing his duty, into custody; but they did not disarm him. The accounts also agreed that Hartt and Crow were heavily armed and in a wagon. There were fifteen Settlers' League members, only about half of them armed, and more were coming. The mounted settlers circled the wagon, and an argument broke out. There was deep animosity between the parties, and Hartt, Crow, and some of the settlers were full of Western bluster. This was only empty talk most of the time, but it was dangerous when tempers were high and men were armed. Who fired first is uncertain, but it is certain that a settler, James Harris, was the first to die. Before he did, Harris may very well have fired the shot that mortally wounded Hartt. Hartt fired one shot, but to what effect was unknown. Crow lethally emptied a shotgun, purposefully loaded with pistol balls rather than birdshot, and then used his pistol. In

this storm of gunfire Hartt and five settlers, only two of whom had fired a weapon, died at the scene or were mortally wounded.[35]

Crow fled into the cultivated fields that were the prize at stake in the dispute. He was apparently heading for his home two miles away. He ran into a wheat field, and, by one account, was a quarter mile from his house when he waded across a ditch and into an alfalfa field. There he encountered a second party of settlers. They were hunting for him. He died upon being shot in the back. The settlers left the body there.[36] This made seven dead or dying.

A trial was held later with Judge Lorenzo Sawyer presiding. His instructions and decisions reflected his loyalty to the railroad. The settlers were convicted of interfering with a U.S. Marshal but acquitted of conspiracy. They were sentenced to terms of eight months and went to jail in San Jose, where they became celebrities. The doors to their cells were not locked. The family of at least one prisoner moved into the jail with him. Another ended up marrying the San Jose sheriff's daughter. On the night before the settlers' release, the citizens of San Jose treated them to an oyster supper. Most eventually settled with the Southern Pacific. Development continued.[37]

The old wheat and alfalfa fields became orchards, but some of the old oaks remained. A tree, now gone, that stood near the site of the massacre became known as the Tragedy Oak, long before the monument was placed here.

Tragedy Oak, Mussel Slough

TENANTS

D Ranch in the fog, Point Reyes

A photographer composes a picture as a whole, but a historian fractures it, dividing it into different elements that lead to different regions of the past. When Jesse photographed D Ranch as an isolated place unsheltered from a world of grass, wind, and fog, he captured how D Ranch, minus a few buildings, looked in the nineteenth century. The photograph makes D Ranch seem ghostly. The house is empty today, and from all I have been able to discover about the first tenants, it might as well have been empty then. D Ranch was a place of absentee owners, tenants, and itinerant workers: It was Henry George country. The photograph mimics the description of an early historian, who wrote in 1880 that Point Reyes was a sparsely populated place with "no homes made. Renters stop awhile and then go, making no improvements."[1] It was a land of tenants.

Trees serve as a gauge of tenants' judgments about the future. Planting a tree meant a person intended to stay for a while. The more profitable a ranch, the more likely the tenants were to plant trees early. Confidence in D Ranch seems to have come slowly.

When Jesse photographed a remnant cypress alongside a section of derelict fencing, he captured the National Park Service's attempt to link a past of tenancy with a present of historical preservation. There had once been other trees and a large windbreak. I noticed stumps of cypress and eucalyptus when I walked the ground. In the foreground of the photograph are young Douglas firs, part of the National Park Service plan to establish a new windbreak. Douglas firs never grew on the peninsula proper, but they do grow on the ridge to the east. The ridge is close enough to qualify them as native plants, but they need cages to protect them from the hungry elk that now range the ranch.

When tenants at D Ranch planted trees is not certain, but most likely it was in the early twentieth century. There is a picture—probably taken in the 1940s—of Vivian Hall, who later became Vivian Horick and lived on D Ranch for most of her life. She is bundled up against the wind and fog, and she holds flowers in her hands. Behind her the ranch sits in a semicircle of cypress and eucalyptus that shelter the buildings.

As the trees in the windbreak died, D Ranch began reverting to its original mid-nineteenth-century condition. The lack of trees allowed Jesse to capture a nineteenth-century view of the ranch before the windbreak existed. This view will vanish again as the Douglas firs grow. Although they were planted to re-create the past, their sounds and smells will not replicate the nature of the ranch Vivian Horick knew.[2]

Vivian Horick in front of D Ranch with windbreak intact

Old fence and remnant of windbreak, D Ranch

SUBSTANTIAL PEOPLE

In the late nineteenth century, Point Reyes Station was a small town whose name revealed its railroad connections. It stood apart from the "Alphabet Ranches" even as it connected to them. When county newspapers wrote about West Marin, they mostly wrote about Point Reyes Station. Stories about Point Reyes proper centered on the government lighthouse, shipwrecks, and rescue stations rather than the dairy farms. When tenants and their wives traveled into and through Point Reyes Station, their comings and goings became part of a wider chronicle of births, deaths, and gossip. They emerged from the fog that enveloped D Ranch.

F Ranch was a substantial ranch with substantial people. Today it consists only of a sign and a grove of old cypress. The buildings can be seen only in photographs. The oldest buildings extend back into the nineteenth century, and even then the cypresses were mature. In an archival photograph probably dating from the 1890s, people pose in front of the now vanished ranch house. A man sits astride a horse; other people sit in wagons and carriages. The *Marin Journal* described tenants like these as country gentlemen.[3] They did not own land, but they had established homes.

These tenants anchored West Marin. When Quinto Condoni brought a particularly impressive drove of hogs into Point Reyes Station, the *Sausalito News* noted that "They came from the respective ranches of Messrs. Reinholdt, Claussen and Hussey of Point Reyes Proper."[4] Henry Claussen, the son of Henrik, lived on G Ranch before moving to E Ranch, where he remained for forty years. He was a Mason, vice president of the state dairyman's association, and a school trustee. Henry's mother, Christine,

Tenants in front of F Ranch

returned to Sweden in 1890 following the death of Henry's wife. She seems to have gone in search of a new partner for her son, and she returned in 1891 with Miss Clara M. Wallengren. Clara and Henry wed that same year.[5] Peter Reinholdt was Henrik Claussen's cousin, and he and his brother leased B Ranch in 1885, before taking a lease on F Ranch in 1899. Reinholdt was a constable in 1891.[6]

George Hussey and his brothers worked A Ranch from 1877 to 1897, before moving to B Ranch. He was the lighthouse keeper at Point Reyes from 1889 to 1891 while his brothers worked the ranch. Some men, such as W. D. Evans of J Ranch, stayed so long that the ranches took on their names. Evans held office in the school district and served as a grand juror. His wife gave music lessons in Olema every Saturday. In all these mentions of prosperous tenants, I do not find D Ranch.[7]

Quinto Condoni, who much later came to own D Ranch, was Swiss from the Italian-speaking canton of Ticino. He immigrated in 1872 to join his brother Joe at Tocaloma, a vanishingly small place just east of Olema, the town named for Coyote. Catholic immigrants—Italian, Irish, Portuguese,

and German—were common in the Bay Area in the late nineteenth century.[8]

Quinto Condoni began by driving hogs and calves destined for slaughter from the dairies to local piers—including those on Drakes Estero—for shipment to San Francisco. When the narrow-gauge North Pacific Coast Railway reached Point Reyes Station in 1875, he bought property and became a livestock dealer. He branched out into money lending and eventually became a vice president of the Dairyman's Coast Bank, which in 1928 was swallowed by the Bank of America.[9]

Charles Webb Howard and the Shafter brothers, the original landlords, had supposedly invested $500,000 in the ranches by 1870; each cow that grazed the fields represented a small rivulet of cash flowing back from tenants' pockets to recoup this investment. By 1880 the rental price per cow had dropped from $25 to $20, and the number of cows per ranch had gone up, averaging 200. For the tenants to maintain themselves, the butter they produced annually from December to June had to exceed the $4,000 to $5,000 they paid Howard and the Shafters. On paper the farms yielded a good profit as long as butter prices were high. Cows averaged 175 pounds of butter a season, or 17.5 tons per ranch of 200 cows, which when sold for 37.5 cents a pound would yield $13,125. But from the difference between these sums, the tenants had to cover the cost of the freight, commission, help, and equipment necessary to produce, ship, and sell the butter. And butter prices did not always average 37.5 cents. In 1885, when prices fell to 18 cents, the tenants could not pay the rent. In such years, hogs and calves that could account for an estimated additional income of $1,000 became even more important. The trees planted to shelter the

houses from the wind testified to ranchers' faith that good years would outnumber bad.[10]

THE GLUE OF THE CALIFORNIA ELITE

The lives of the landlords are easier to trace than those of the tenants and their employees. Because so few people owned so much of the state, to look at any one of them in the nineteenth century is to encounter others. Avarice connected them like glue, and through them distant parts of the state came together.

Charles Webb Howard owned D Ranch. He was corrupt, a monopolist, and a thief. These were not unusual traits among wealthy Californians. Howard's greatest claim to infamy was that he was the president of the Spring Valley Water Company during the 1880s. Its visible remnants seem innocuous now; I run along the company's Crystal Springs Reservoir that lies on the San Andreas Fault north of Stanford. But in the late nineteenth century, Spring Valley was perhaps the most corrupt business operation in California, where venality set a high bar. Spring Valley had achieved a virtual monopoly over San Francisco's water supply. Before, during, and after Howard's presidency, the company bribed politicians, set its own rates, threatened the city and its inhabitants, and yielded returns on investment of roughly 60 percent. Hatred of the company was one of the major reasons for Californians' widespread public support for the damming of Hetch Hetchy, in Yosemite National Park, to secure a public water supply in the early twentieth century.[11]

The president of the Bank of California,

William Ralston, had acquired control of the Spring Valley Water Company in the 1870s. His disastrous Comstock Lode speculations left him deeply in debt, and to replace the funds and meet the demands of creditors, he sought to sell Spring Valley to the city at an inflated price. His inability to consummate the sale contributed to his probable suicide. Senator William Sharon settled Ralston's estate, shortchanging his creditors, giving his widow virtually nothing, and reserving the most valuable assets for himself. These included the Palace Hotel, which served only Point Reyes butter, and the Spring Valley Water Company, the enterprise Howard came to head.[12]

In the early 1880s Howard's presidency of Spring Valley intertwined with his secret ownership of *The Wasp*, a magazine known for its spectacular color cartoons, its Sinophobia, and its antimonopoly politics. His proprietorship remained unknown even to the magazine's editor, Ambrose Bierce. Bierce, after Henry George, was California's most famous journalist; he wrote *The Devil's Dictionary* and possessed the nastiest pen in America. Among the dictionary's definitions was this: "ABSENTEE, n. A person with an income who has had the forethought to remove himself from the sphere of exaction." This was a concise description of Howard's relationship to Point Reyes. Except for its advertisements, Howard did not much care what was in *The Wasp*. By pouring the whole advertising budget of the Spring Valley Water Company into the magazine, he diverted money from Spring Valley to his own pocket.[13]

When Ambrose Bierce found out that the antimonopoly *Wasp* was secretly owned by a monopolist, he demanded Howard either sell it or be exposed. Howard's acquiescence reveals much about the networks of wealth and power in California. Bierce was often cruel, and many of his targets did not deserve his cruelty, but the Associates of the Southern Pacific Railroad did. Bierce assailed the Southern Pacific, and particularly Leland Stanford—whom he called Stealand Landford—as monopolists. If Howard's ownership of *The Wasp* became public, it would prove embarrassing because the affairs of Howard, Stanford, and Judge Lorenzo Sawyer all intertwined.[14]

Howard neither wanted to be caught funneling money out of the Spring Valley Water Com-

The Curse of California

pany nor implicated in the attacks on Stanford. The Shafters were his in-laws, and Judge James Shafter was close enough to the Stanfords to sit, along with Judge Lorenzo Sawyer, on the original Board of Trustees for Stanford University, an institution that Bierce linked to Stanford's peculations. In *The Devil's Dictionary* Bierce defined *restitution* "as the founding or endowing of universities and public libraries by gift or bequest." Shafter delivered the university's first opening-day address. It was not memorable. More memorable was the amount of money Shafter owed Stanford.[15]

Judge Shafter had heavily mortgaged his share of Point Reyes to support investments in the North Pacific Coast Railroad and other ventures. He sold other property and borrowed from Stanford to keep afloat. When he died in 1892, his estate was heavily indebted.[16]

Point Reyes was no longer the asset it had once been, although you would not know this from reading the newspapers. In 1888 Point Reyes cows averaged a pound of butter a day, much of which went out through Point Reyes Station. The *Pacific Rural Press* summarized the advantages of the Shafter ranches by calling the conditions for dairying perfect and its butter famous. Each cow produced 150 to 200 pounds of butter a year: an "annual output of butter is about 500,000 pounds, and is sold under a legally adopted trademark, 'P. R.,' which is stamped on the end of every roll." The tenants employed "a small army of men" during milking season." Point Reyes butter sold at a premium, bringing "from 1 to 24 cents a pound more than any other in the State." In hindsight the article seems a strategic puff piece.[17]

Judge Shafter, who "has been president and for many years a director of the State Agricultural Society," had decided to imitate developers in Southern California and divide his land into "tracts of from 80 to 1000 acres each, which are offered for sale for dairy, orchard or general farming purposes." Not all the land would go to settlers. "Part of the Shafter ranch, comprising about 3000 acres, will be set apart as a summer resort and watering-place, and a hotel to cost $80,000 has already been designed." Its "accessibility . . . to San Francisco, and the charms of its scenery and climate, destine[d] it to become one of the greatest resorts on the Pacific Coast." The article touted Point Reyes—located at the same latitude as Athens and Palermo—as the California Mediterranean. Point Reyes was, and is, a breathtakingly beautiful place, but what Drake had called its stinking fogs and its gale-force winds were usually not considered charming. The National Park Service claims it is the second windiest place on the Pacific Coast and the foggiest on the continent.[18]

Readers of the article may have concluded that the Garden of Eden was up for sale and that everything from grain, vegetables, and hay to semitropical fruit would grow there. It did not "require much of a prophet to see in a vision of the near future these fertile lands converted into ideal homes, owned by the settlers, and villages and towns springing up and supported by the dairy and the general farm, as well as those great industrial resources whose development cannot long be retarded in view of the great tide of immigration now turned toward the Pacific shores."[19]

The article did not mention that James Shafter was going broke. Since the mid-1880s the price of butter had been falling, forcing Howard and presumably the Shafters to lower rents. The expanding railroad network in the Central Valley brought more butter into San Francisco, and

the increasing cultivation of alfalfa and the switch to silage meant that Point Reyes lost the competitive advantage of the longer growing season for its grasses.[20] The Shafters had responded to declining butter prices by improving the dairies and installing cream separators to increase the productivity of the "Alphabet Ranches."[21] To compensate for these investments, they extracted concessions from their tenants. In 1890 they sold the hunting rights on their ranches to a San Francisco gun club. Everyone else, including their tenants, was banned from hunting. The 1890s proved difficult years at Point Reyes, as they were throughout the state and country. Even the grass failed the farmers. In 1896 three straight dry years took their toll on the pastures. A dairyman complained in 1899 that he did not need pockets, for "money never got as far as his pocket."[22]

Howard and the Shafters were in an awkward position, but by the end of the century, most of Howard's positions were awkward. He and his wife Emma separated, and he spent much of the rest of his life trying to cheat her out of her portion of their property, including Point Reyes. Here, too, success eluded him.[23]

Point Reyes increasingly seemed a burden to those who owned it. In 1897 James Shafter and Julia Shafter Hamilton created the Point Reyes Land and Dairy Company. In the firm's title, the word *Land* stood out. The implication was that if the dairies could not meet their rents, the land could be sold for other development. In 1898 Emma Shafter tried to lighten the load of debt that her father had left. She transferred her timber property, *Rancho Lagunitas*, in settlement of an $80,000 mortgage. Then in 1898 she mortgaged the remainder of her holdings with what seemed a comfortable cushion between the interest she owed and the income from the ranches.[24]

That cushion proved thin.

THE DECLINE OF POINT REYES

Point Reyes's assets remained, but they no longer mattered as much. Fogs kept pastures green, but in the Sacramento–San Joaquin Delta and Central Valley, irrigation could do the same. Proximity to San Francisco had ensured urban markets, but as railroads connected the Bay Area to the delta and Central Valley, proximity mattered less and less.[25]

By the end of the 1890s, with butter prices still falling, dairies shifted over to milk. In 1896 "small gasoline steamers" carried fresh milk to San Francisco, replacing the schooners that had carried butter. That same year, the Point Reyes Milk and Cream Company incorporated to sell those products from the dairies. In April owners promised that their milk would keep indefinitely. Predictably, in June inspectors confiscated and destroyed a spoiled shipment in Alameda County.[26]

Those inspectors signaled other new forces that would alter Point Reyes. Jesse photographed the grade B dairy on D Ranch before either he or I knew what a grade B dairy was.

Selling fresh milk in San Francisco meant that dairy farmers had to meet the requirements of San Francisco's health laws. Grade A dairies could produce milk for sale; grade B dairies could produce only cream for use in butter, cheese, and other products. Until the end of World War II, D Ranch would be shut out of the lucrative milk market.

Grade B dairy, Ranch D, Point Reyes

In the cities children were dying from bad milk. Foul and adulterated milk had been a curse of urban consumers and public health since the mid-nineteenth century, and in the 1890s San Francisco health authorities blamed an outbreak of typhoid on impure milk. In June 1891 the *San Francisco Call* lamented "that thousands of lives, particularly those of children, have been lost in this city by the use of bad milk."[27]

Someone had to take the blame for dying children, and like virtually everything else in nineteenth-century California, public health was racialized. Reformers regularly targeted the Chinese as sources of pollution and disease,

but the Chinese did not produce milk. San Francisco health reformers and city officials in the 1890s focused initially on Italians, particularly those who grazed dairy cows on Islais Creek near Butchertown, the city's slaughterhouse district. Reformers especially feared typhoid and tuberculosis, which they blamed on impure milk.[28]

In 1895 San Francisco had appointed a milk inspector and a city bacteriologist. James Dockery, the city inspector, was not a scientist. He operated a restaurant and hotel and purchased large quantities of milk. Dockery provided copy for the newspapers. He was always "on his muscle" and fired shots at resisting dairymen in San Francisco. Although his searches were often arbitrary and his tests questionable, the courts upheld his decisions—without trial—to seize and destroy milk. He was better at detecting adulterated milk than finding contaminated milk. Dockery's attacks on urban dairies created opportunities for larger dairies outside the city, including those at Point Reyes. In 1897 dairy farmers on the San Francisco peninsula, confident that their animals were free of disease, agreed to testing and culling of herds to try to maintain their hold on the market. This put pressure on producers in Marin and Sonoma to do the same.[29]

Conservative governor Henry Gage weakened state food inspection laws, but this, too, allowed San Francisco to increase its influence. The city's real muscle came from its ability to ban uninspected milk and butter from sale within its boundaries. Dockery later testified in Sonoma to get the county's Board of Supervisors to institute inspections. Marin, too, had to respond. In 1905 the state reestablished its precedence in accordance with the Sanitary Dairy Law, which regulated conditions in dairies and prohibited the sale of milk from unhealthy cows and from dairies and farms with unsanitary conditions.[30] The grade B dairy at D Ranch was testimony to the tenants' inability to meet either the competition for fresh milk or San Francisco's health requirements.

John Rapp had made his money distributing Rainier beer; with Prohibition, he understandably felt some pressure to diversify. He bought Howard's share of Point Reyes lands from his estate in 1919 and immediately began selling off ranches A through G to tenants. Hamilton Martins had come from the Azores in 1908. He had no capital, but along with a bachelor friend, Trajano Machado, he bought D Ranch on credit.[31]

Buying a ranch on credit as the country entered an agricultural depression was not a particularly shrewd business plan, but that was only the cake. The frosting was that Ham Martins hated cows and pigs. As an old man, he recalled how miserable they had made his life. The cows kept getting bogged down in the lagoon. Neither he nor Machado were any better with machinery, which they were incapable of keeping in repair. In April 1924, the Bank of San Rafael foreclosed the ranch.[32]

The parade of failure continued. Another Portuguese immigrant, Anthony Luiz (Tony) Lucerda, took over the ranch, and he took out a second mortgage from Quinto Condoni, now well into his evolution as money lender and banker. When Lucerda failed in 1927, Condoni apparently bought out the other mortgage holders and took over D Ranch. He rented it to Manuel Gomez. In 1928 the bunkhouse and garage burned down.[33]

Gomez lasted until 1934, when Condoni leased the ranch to his daughter Alice and her husband, William Hall; they were already tenants on nearby N Ranch. Condoni had made money, but the class lines on Point Reyes remained porous.

Before his marriage, Bill Hall had been a butter maker and a plowman with his own team of horses, living in a shack "past the red barn, going toward the Mesa." Alice Hall, having finished the eighth grade, had gone to work in the creamery. She baited Bill with pies. In 1935 the Halls, who then had two children, moved to D Ranch. One of the children grew up to become Vivian Horick, the woman standing in front of a windbreak in the old photograph.[34]

Abandoned mill, Vallejo, California, seen from Mare Island

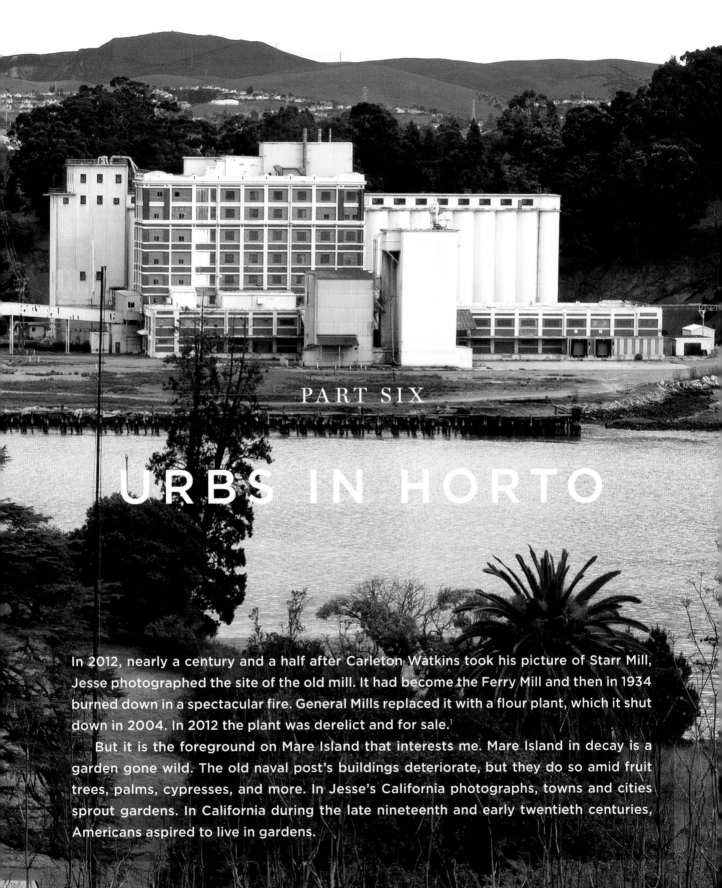

PART SIX

URBS IN HORTO

In 2012, nearly a century and a half after Carleton Watkins took his picture of Starr Mill, Jesse photographed the site of the old mill. It had become the Ferry Mill and then in 1934 burned down in a spectacular fire. General Mills replaced it with a flour plant, which it shut down in 2004. In 2012 the plant was derelict and for sale.[1]

But it is the foreground on Mare Island that interests me. Mare Island in decay is a garden gone wild. The old naval post's buildings deteriorate, but they do so amid fruit trees, palms, cypresses, and more. In Jesse's California photographs, towns and cities sprout gardens. In California during the late nineteenth and early twentieth centuries, Americans aspired to live in gardens.

Chapter 17

CITRUS

San Gabriel Mission with train in background

The freight train in the background of the photograph of San Gabriel Mission completes a complicated temporal layering. The mission, with its statue of Father Serra, has eighteenth-century Spanish and Indian roots. The railroad, which runs along the old Southern Pacific tracks, helped create nineteenth-century American California. The paved road and the automobiles are quintessential twentieth-century California. Together they constitute a twenty-first-century photograph.

The train in the photograph seems almost incidental, but of course Jesse had to wait for it to appear to take the picture. Freight trains and automobiles convey the unromantic setting of the modern missions. But for me the train carries romance. It is a California version of an old dream: *urbs in horto,* "the city in a garden."

In nineteenth-century California, railroads meant monopoly and the hated Southern Pacific. In his novel *The Octopus* (1901), Frank Norris describes a freight train moving through the Tulare Basin as "the galloping monster, the terror of steel and steam, with its single eye, cyclopean, red, shooting from horizon to horizon . . . symbol of a vast power, huge terrible, flinging the echo of its thunder over all the reaches of the valley, leaving blood and destruction in its path; the leviathan, with tentacles of steel clutching into the soil, the soulless Force, the iron-hearted Power, the monster, the Colossus, the Octopus." In Norris's book the railroad delivered wheat to the ports along Carquinez Strait.[1]

In Los Angeles and San Gabriel counties, the railroads became gentler beasts. The lion lay down with the lamb. The beast was tamed by the magic, and bloodless, word that describes California development: *subdivision.* The subdivisions did not sprout the tract houses of the twentieth century. On the outskirts of Los Angeles, the ranchos were subdivided into orchards and farms. It is hard to think of this process as antimonopoly, but it was.

In Los Angeles the prehistory of such subdivisions was not so bloodless. In 1841 William Wolfskill, an American mountain man who had come to California, married into the Lugo family and became a Mexican citizen. He planted what was supposedly the first orange grove outside the missions. He and Don Luis Vignes, a French settler in Los Angeles, became the earliest commercial growers, but their markets did not originally extend beyond the gold fields and San Francisco.[2]

These early orchards and vineyards depended on Indian labor. Even before secularization, some of the Gabrieleños worked at *Rancho Santa Anita*—owned by Hugo Reid, a Scottish immigrant, whose wife was a Gabrieleño. Thanks to his wife's "services rendered to this mission" and those of "her late husband Pablo," Reid and his wife could make a successful claim to the land. After secularization, the neophytes had become *emancipados.* Some continued to live and work on Hugo Reid's land. A few obtained land of their own. Others had begun to migrate.[3] The successful claims by ex-neophytes were small; those of Reid, Anglo-American claimants, and Californios were large. Reid helped individual Gabrieleños, but they protested Reid's acquisition of large tracts of the mission lands.[4]

Smallpox and violence cut into Indian numbers in the 1850s, and individual Americans and Californios murdered Indians. On occasion, authorities killed larger numbers while keeping the peace. In 1851 the Los Angeles county sheriff

slaughtered a group of Cahuillas to stem a brawl between them and some Californios. Mostly, Indians killed other Indians. Sometimes the murders were personal; more often they were the result of drunken violence. Bloodshed and disease made the old mission lands less and less an Indian place.[5]

As some Gabrieleños moved north around Monterey, Indians from the missions between San Diego and Santa Ynez flooded into Los Angeles County to replace them. Crews of Luisenos and Cahuillas joined the remaining Gabrieleños to prune the orchards and vineyards in the spring and harvest the fruit in the fall. This labor was not always freely provided. The Americans adopted and expanded a Mexican system of coerced labor. Natives gathered on Saturday afternoon for drinking and gambling, which regularly yielded to fighting and often murder. Sometimes the violence was random; sometimes it pitted group against group, as in 1851 when ten men died after a large group of Cahuillas attacked a smaller group of Luisenos. At sunset on Saturdays the sheriff and Indian deputies would appear, arresting all the drunks they could round up. Those who could pay the fine went free; the rest were auctioned off to the highest bidder.[6]

The auction system melded easily with the Act for the Government and Protection of Indians, passed by the California legislature in 1850. The act intended to control, not protect, Indians; it placed them under the authority of local courts, in which they could not testify against whites. The law prohibited coerced labor with one hand and ensured it with the other by allowing arrests for vagrancy and the auctioning of the vagrants. Sheriffs conducted regular roundups of drunken Indians and those accused of disturbing the peace. Los

Angeles continued to dispose of Indian "vagrants" at police auction every Monday, when employers purchased those they needed for a week of labor. The auction became a lucrative source of revenue for the sheriff and the city. "Los Angeles," attorney Horace Bell wrote, "had its slave market as well as New Orleans and Constantinople, only the slave at Los Angeles was sold fifty-two times a year as long as he lived, which generally did not exceed one, two or three years under the new dispensation."[7]

As some surviving Indians fled disease and violence and others were driven from their homes, smaller numbers sold or lost the land they had received to Anglos or Californios while the mission lands became orchards. In 1874 John Shirley Ward of Los Angeles predicted that "the country for miles around this city will in a few years be tropical orchard. The Orange, Lemon, English Walnut, Lime, Fig, citron, Olive, Almond, Grape, Apricot, Apple, Peach Pear, Pomegranate, Plum and cherry grow here to great perfection." Fruit meant money. Ward calculated the income of 100 acres with 70 orange trees to an acre minus the costs, including interest. With the appreciation of the land as the trees grew, he predicted that at the end of five years a $25,000 investment would yield $100,000. In the world of boosters, money did grow on trees.[8]

The symbiosis of orchards and railroads moved forward with the laying of tracks between the port of San Pedro and Los Angeles, but the market still remained largely confined to the West Coast until the 1880s. Only when the Southern Pacific reached New Orleans in 1881 and the Santa Fe penetrated the San Gabriel Valley in 1887 did orchards rush aggressively outward. Fresh fruit made the Southern Pacific's transcontinental line profitable for the first time by giving it lucrative

cargo that could not go by sea; in turn, the increasing perfection of refrigerated cars accelerated the expansion of the groves by creating eastern markets far larger than California could provide. The railroads also brought in buyers for the subdivided ranchos. The sign of California's connection with the world would be the fruit tree—especially the orange tree.[9]

The Southern Pacific enthusiastically cooperated in promoting Southern California as the American Mediterranean: a land of gardens and fruit, unburdened by the dangerous classes of the very rich and the very poor. The railroad encouraged the farmers' cooperatives that took over the marketing of the fruit. It embraced the garden vision and ran a locomotive through its center.[10]

Jesse's San Gabriel photographs reveal no direct traces of either orchards, which once made the spring so fragrant, or vineyards. But the orchards are present in D. D. Morse's map, View of San Gabriel, Cal. There, as in Jesse's photograph, a train ran past the mission. Young trees in symmetrical rows stretched out across the frame. By carrying the fruit of those trees east into new and expanding markets, the railroad was changing everything.

Monrovia irrigation

ORCHARDS

A real estate boom announced the new order of fruit and freight trains. Freight rates were far more critical for the development of Los Angeles than passenger rates, but the boom became visible to most people during the 1887 fare war between the Santa Fe and the Southern Pacific. The competition drove passenger rates between the Missouri River and Los Angeles down to $5.00. For a single mad day, fares fell to $1.00. The railroads advertised their routes and the California they had already promoted as a paradise of health and leisure. Travelers arrived in droves. Developers and speculators cut down existing orange groves and vineyards to build homes and sell lots, but other developers, purchasers, and speculators planted—or promised to plant—new ones.[11]

In California both the Anglo-Saxonism of the Drake myth and the new Mediterranean idyll of the mission myth became fruit of the orchards. Charles Dudley Warner, coauthor of *The Gilded*

15056. Going Thru The Orange Groves, California.
SO. PACIFIC RAILROAD

Train through orange groves

Age with Mark Twain and a friend of Charles Lummis, announced in his book *Our Italy* (1891) that although "Latin and Mongolian races" had monopolized citrus culture, now Anglo-Saxons would displace them. Small orchards would save the state from Chinese and "Mexicans." The vast ranchos with their Californio and Indian *vaqueros*, and the huge wheat ranches with their Chinese laborers, would become things of the past. A quite conscious whitening of California would take place.[12]

Orchards became symbols of rural gentrification that demanded not just white people, but white people with savings. In the 1870s Daniel Berry scouted the region as the agent for the San Gabriel Orange Grove Association, a group of Indiana investors. They bought land in Pasadena that was once part of the San Gabriel Mission before its dismemberment earlier in the century. Berry portrayed the area as one where improved men—once perhaps sickly but restored to health—transformed unimproved land. When his wagon broke down, he described the men who repaired it.

The chap who [repaired] the wagon was a lawyer once . . . and a graduate of Harvard with the consumption, and rich besides. He runs a vineyard. The chap who went for a wrench at a ranch was nephew of Edward Atkinson the great Free-trader, a graduate of Harvard, and keeps sheep for a living. The chap who owned the old wagon is an ex-judge, was a student of Judge Storey and Parsons at Harvard Law School, once an editor in Missouri, now runs a vineyard. The chap who lifted the wagon was a Senator 4 years in Nebraska. The chap who fixed the wheel and killed a tarantula was myself. All a jolly crew, and all spoiling for work. Raise little orange plants to sell, raise grapes the third year to sell, raise limes in two years to sell, it will take about two years to conquer an income from unimproved land.[13]

Water, not land, was the key. It came from the artesian belt along the San Gabriel front range. In the early twentieth century there were "40 flowing wells and 400 pumping plants" that put a "large proportion" of "55,000 to 60,000 acres of irrigated lands" in citrus.[14]

The lands of the old San Gabriel Mission, the site of so many Indians' deaths, became a refuge for health-seekers from the Midwest: men and women, often professionals, with capital to invest, who could find a second life on 20 irrigated acres with easy access to a city. The new "electrified villages" as Jared Farmer has called them, would be collections of Arts and Crafts bungalows, Victorian mansions, and small Protestant colleges whose remnants still dot the San Gabriel Valley.[15]

D. D. Morse, View of San Gabriel, Cal., *1893*

The boom represented a honeymoon of romance and business, and the happy couple spent their time selling real estate. Real estate promotion was an old American art, and by the time it reached Southern California, it had long since lost any sense of shame. Credibility was not a concern. As land prices soared in Los Angeles, the boom extended out to the old mission lands at San Fernando, which had passed through several owners and become the Maclay Rancho. The northern mission lands were subdivided into "Orchard tracts from 5 to 40 acres in and near the beautiful town of San Fernando located near the head of the famous San Fernando Valley, twenty-two miles north of the prosperous city of Los Angeles." These were some of the best bargains ever offered to the public "in the Sunny Land of California."[16]

San Fernando had a climate "as near perfection as can be expected. It is simply unsurpassed." The scenery "reminds one of Switzerland, and is surpassingly beautiful." I grew up in the San Fernando Valley, and Switzerland never crossed my mind when I lived there. In the bad Septembers of my memory, the asphalt melted and stuck to my shoes and clothing as I crawled under cars to attach hitches at Sam's U-Drive. The valley was a place "where the cactus plant and grease wood" held sway before yielding to "the all-important

orange tree," but I don't think such a place had a Swiss equivalent.[17]

A crash, of course, followed the boom of 1887. Los Angeles, a town of 10,000 in 1880, had quintupled during a decade, but many were ruined when the boom ended. Paper towns vanished along with the investments made in them. The boosters of San Fernando mission lands advertised abundant water, which they did not have and would not have until 1913 after Los Angeles tapped the Owens Valley. Jackrabbits rested undisturbed.[18]

Charles Warner visited Southern California after the speculative bubble and rightly saw the bust only as an episode rather than a barrier to future growth. He described the "whole region of the Santa Ana and San Gabriel valleys, from the desert on the east to Los Angeles" as "the city of gardens." It was "a surprise, and year by year an increasing wonder."[19] He lunched "at the East San Gabriel Hotel, a charming place with a peaceful view from the wide veranda." He described a scene "of live-oaks, orchards, vineyards, and the noble Sierra Madre range. The Californians may be excused for using the term paradisiacal about such scenes. Flowers, flowers everywhere, color on color, and the song of the mocking bird!"[20]

Our Italy was part travelogue, part real estate brochure, and part meditation of American destiny. It provided yet another iteration of an Anglo-Saxon California where, in Kevin Starr's words, the state's inhabitants would mediate "between American efficiency and Latin *dolce far niente*."[21] Warner wrote:

The picture I see is of a land of small farms and gardens, highly cultivated, in all the val-leys and on the foot-hills; a land, therefore, of luxuriance and great productiveness and agreeable homes. I see everywhere the gardens, the vineyards, the orchards, with the various greens of the olive, the fig, and the orange. It is always picturesque, because the country is broken and even rugged; it is always interesting, because of the contrast with the mountains and the desert; it has the color that makes Southern Italy so poetic. It is the fairest field for the experiment of a contented community, without any poverty and without excessive wealth.[22]

Warner insisted that Southern California required labor, but Harvard men had no intention of picking their own fruit. In Warner's illustrative tales, sickly Americans migrating with small amounts of capital did not work in the fields themselves; they supervised others who did. Warner emphasized "the hospitality of the region generally to foreign growths," but in this he meant "the trees acclimated on these slopes." The hospitality did not necessarily extend to human beings who actually did the work.[23]

The Chinese Exclusion Act of 1882 had not eliminated Chinese migration—immigrants still came across the Mexican and Canadian borders—but the act and subsequent pogroms against the Chinese did diminish the Chinese population. Exclusion drove up the cost of farm labor, as it was intended to do. The remaining Chinese took advantage of this situation to demand higher wages, which only fueled the fury against them.[24]

The dwindling Indian population could not supplement the Chinese in the fields. In other parts of California, attempts to bring in blacks

from the South and put children to work in the fields and processing sheds failed.[25] The California legislature made things worse. In 1893 California passed the Geary Act, which created an internal passport system and demanded proof of residence to regulate the Chinese. Most Chinese initially refused to register, but in one of the more chilling decisions in American history, the Supreme Court in *Fong Yue Ting v. United States* ruled in 1893 that the Constitution imposed no checks on the ability of the government to deport people in pursuit of immigrant exclusion. The power of Congress was "absolute" and "unqualified." Into the 1890s in both southern California and northern California, Chinese farmworkers faced attacks, violence, and threats of deportation. Mass deportation failed only from lack of funding. The days of Chinese labor were numbered. Men in their forties and fifties dominated the labor force, and orchards did not provide work for aging men. By 1900 the Chinese formed only 10 percent of California's fieldworkers.[26]

Increasingly, the workers who took their places were Japanese. Ambitious, determined, often militant in defense of their rights, and determined to rise, some were outcasts—*buraku jūmin*—in their native country. Organized by *keiyaku-nin*, or labor contractors similar to the China bosses of the nineteenth century, Japanese immigrants took over sectors of farm labor formerly dominated by Chinese.[27]

The militancy of Japanese workers and their success in raising wages created hostility among growers in Southern California; but, pressed by agricultural expansion and labor shortages, they could not do without the Japanese. Then in 1907 the supply of Japanese workers too was curtailed, when Theodore Roosevelt negotiated the Gentle-man's Agreement that restricted the immigration of Japanese laborers to California.[28]

Orchardists tried as long as they could to keep their workforces divided by race, but immigration restriction limited this tactic. By the 1920s they would turn to Mexicans and Filipinos, groups for whom there were no immigration quotas. They came to rely particularly on Mexicans, whom they regarded as malleable and loyal.[29]

RELICS

I lived among the relics of this history of orchards and development when my family first moved to La Habra in Orange County, south of San Gabriel in the late 1950s. In 1888 the *Rancho La Habra* was still unirrigated and not yet orchard. Basque tenants ran sheep there. When we moved there, the sheep were long gone. Orchards had come, and now they were going. The orange and avocado groves had been abandoned, awaiting the bulldozers. We scavenged them. I thought California was the land where food was free. Momentarily it was, but only until the orchards became housing developments for more people like us. This had become an enduring pattern in Southern California.[30]

As we scavenged fruit, my brothers, sister, and I ran through a history that we did not know. We inherited elements of a nineteenth-century version of California every time we picked a Valencia orange: growth, Anglo-Saxonism, and the promise of the mission myth. We were innocent of any knowledge about the place where we lived.[31] We owed it to the railroad.

ALLENSWORTH

School, Allensworth, Kings County, California

The school at Allensworth has fresh paint, broad steps, two doors that lead to adjacent classrooms, and a bell in a belfry. It has no students. It is the largest building in what is today Colonel Allensworth State Park. And it was the largest building in the town named for Colonel Allen Allensworth, one of its founders, who had retired as the highest-ranking black officer in the American army.

I had never heard of the park or Colonel Allen Allensworth when Jesse showed me photographs and took me to visit it on one of our trips to Tulare Lake. Allenworth is like Lewis Carroll's Cheshire cat: the park commemorates a town that disappeared alongside a lake that no longer exists. On my visits to the park, I have seen virtually no one there. I like empty parks, particularly ones that are refurbished ghost towns, but at this one I feel like an intruder.

In the photograph the schoolhouse seems to be in motion, pushed forward by the same winds that drive the clouds above it. The place where land meets sky in the photograph's middle ground to the left of the schoolhouse was once the water of Tulare Lake. The lake had receded far from its old shoreline when the California Colony and Home Promoting Association founded the town of Allensworth in August 1908. Allensworth was a race town, a place for black uplift with a strain of antimonopoly politics that sought to extend the movement beyond white people. It was intended to provide black homes and black advancement. It would be a black version of *urbs in horto*. No building embodied uplift more than the school.

In 1912 the inhabitants of Allensworth dedicated the school to launch their children into the future. They staffed it beyond state requirements, and they expanded the state's mandatory age for attendance to include a kindergarten when such classes were still relatively rare in California. To finance the school, the residents taxed themselves well beyond what the law required.[1]

Allensworth settlers were the kind of progressive people that the booster Edward McGrew Heermans claimed the county sought to attract. But in his pamphlet, "Kings County, California, 'The Little Kingdom of Kings,'" he ignored Allensworth. He didn't intend the county to include black people.[2]

Margaret Prince Owens was Margaret Prince when she took a job at the Allensworth school in 1914. She had been born in 1893 in Pasadena, then "a beautiful tourist town." Her father was a janitor in a bank. The only work the town "offered Black people was with rich white people." Both her parents insisted on her education, even though they knew this meant there would be no place for her in Pasadena.[3]

Margaret Prince was the only black student in her class and supposedly the first woman to graduate from Pasadena High School. She trained to be a teacher at California Normal School in Los Angeles. When she finished in 1914, the teaching profession stood closed to her unless she taught in a black school, and Los Angeles had exactly one school for blacks. California in 1900 was only 1 percent African American, but black immigration was increasing. Since the only other black woman in her class had received the job that opened in Los Angeles, Prince took the offer from W. A. Payne, a cofounder of Allensworth and principal of the school. Payne knew the obstacles the new teacher faced. Despite his experience and credentials, Pasadena schools had refused to hire him. Margaret Prince came to a town determined to expand the

occupational choices for black people with the bitter knowledge that she had no other options. She did not intend to stay for long; she remained five years until she married.[4]

Years later she still remembered all the details of her arrival. The school was neatly painted. It was cream colored then. She remarked on the spire and the "proverbial school bell." There is a photograph of Margaret and other young women in Allensworth taken soon after she began teaching. They posed in front of the school. She is on the far left.[5]

RACE MEN AND WOMEN

In the schoolhouse photograph, the sense I have of a building moving forward is an illusion, but it is not a lie. The people who founded Allensworth thought in terms of racial and individual advancement that centered on education, work, and property. Allen Allensworth and his wife Josephine Allensworth radiated respectability. They were members of the state's black bourgeoisie, and their appearance announced their status. The five directors of the California Colony and Home Promoting Association—Allensworth, Payne, J. W. Palmer, W. H. Peck, and Harry Mitchell—were all from Los Angeles, springing

Young women, Allensworth, California

from the city's small black middle class. Palmer was a successful merchant. W. H. Peck was a graduate of Wilberforce University, and W. A. Payne was a graduate of Denison College in Ohio. California was a place where black people could accumulate property. Allensworth was to be a temperance town, and its founders hoped to attract migrants from the South. Only Allensworth and Payne would buy lots in the town.[6]

Allen Allensworth had been born a slave, escaped slavery, and over the course of an eventful life left the South far behind. He became a Baptist minister, departing Kentucky for Ohio in 1884 in part to move his two daughters out of a world that was narrowing for black people. He became

Allen Allensworth

a military chaplain in 1886, but he understood his role to be an educator as well as a minister. He organized post schools, a library, and debating societies. He was not a young man in 1906 when he moved to Los Angeles, but photographs of him reveal a still strikingly handsome man who maintained his dignity and vigor. Chief among those that he recruited for Allensworth were ex-soldiers, but they also included Joshua Singleton and his family. He was the son of Pap Singleton, who had led the Exodusters—migrants from the South who founded the black towns of Kansas.[7]

The time and place of its founding determined that Allensworth was going to be a real estate speculation, and since this was Southern California, someone was going to be cheated. Allensworth and the other founders had little capital, and they owned none of the land on which the new town would sit. Instead they acted as agents for the Pacific Farming Company, which developed Allensworth as well as nearby Alpaugh, formerly an island in Tulare Lake and the site of a Yokut village. The company sold small town lots on time.[8]

The California Colony and Home Promoting Association acted as real estate agents without commission for Pacific Farming, which stood atop a set of interlocking companies that served to disguise actual ownership. Allensworth and his associates did negotiate to make sure the town had a water system, a location next to a railroad depot, and basic infrastructure. There were low down payments, but there was also 10 percent annual interest and an amortization schedule of twelve to eighteen months.[9]

Pacific Farming followed the San Gabriel Valley model of selling off land in relatively small plots. But if Pasadena was the Boardwalk in this

real estate game, Allensworth was Baltic Avenue. Unimproved land sold from $50 to $100 an acre in Kings County at the time, with 40 acres—or so boosters claimed—sufficient to begin a farm. A settler thus needed $2,000 plus the cost of stocking a farm and surviving until it began to produce.[10]

The settlers solicited by the California Colony and Home Promoting Association could not command anywhere near this amount of cash, but Pacific Farming arranged things so that they got more money per acre selling to poor people than they did by selling to the well-to-do. Most residents could afford only city lots. Allensworth consisted of 1,132 such lots, the largest of which were 50 by 150 feet, or about one-sixth of an acre. These ranged in price from $100 to $400, so that the lots brought the company up to $2,400 an acre—far above the cost of unimproved land and even improved farmland, which sold for $150. The company also sold 1-, 5-, and 10-acre rural lots for $110 an acre, roughly the maximum price for good unimproved land in the county. The price of the land was actually only $100, but the company charged an extra $10 for a share in Allensworth Mutual Water Company, which promised to provide irrigation water. The water companies and Pacific Farming had interlocking directors.[11]

In a region where water was everything, Allensworth became a town with inadequate water and expensive litigation against a failing water company. The townspeople's victory in court was hardly a victory at all. They gained ownership of a derelict water company.[12]

The Allensworth settlers had paid high prices for bad land, some of it alkali and lacking sufficient water. Much better land in Alpaugh, owned by the same company, reportedly sold for $30 an acre, but black people could not purchase it. Alpaugh stole away Allensworth's freight connections when the Santa Fe Railroad built a depot there. Under these conditions, landed independence was a long shot. Only a few Allensworth residents succeeded in buying or renting surrounding farmland. The California Colony and Home Promoting Association hoped to provide an alternative by organizing the migrants into labor brigades, for whom it would negotiate contracts with neighboring employers. The town founders would thus double as labor contractors, in an uncomfortable echo of the Reconstruction South.[13]

Allensworth was a speculation and a swindle, but it was also much more, which was why the town founders named the park next to the Santa Fe depot for Booker T. Washington. Colonel Allensworth had made industrial education part of the post schools he had founded in the army. Industrial schools were connected to Booker T. Washington, the founder of Tuskegee and a man Allensworth deeply admired. To name the park for Washington, and to seek, as Allensworth did, state funding for a Tuskegee-like school in the town, was to stake out a position in the racial politics of California and the nation.

Booker Washington had visited California in January and February 1903, positioning himself, as he did nationally, as an arbiter between white people and black people, an advocate of a certain kind of racial harmony. Many whites were in the large crowds he attracted in both the Bay Area and Southern California. When he spoke at Stanford University on January 8, two thousand people turned out to hear him. The papers reported that "no speaker ever received a more enthusiastic welcome from a Stanford audience than that given the noted negro educator." Jane Stanford enter-

Aspirational Allensworth

circa 1910

a reproduction of a

Map Showing the Pacific Farming Co.'s Subdivision for the

California Colony and Home Promoting Association

Office Address: 906 Security Bldg., Los Angeles, Cal.
Location of Tract: Allensworth, Tulare County, Cal.

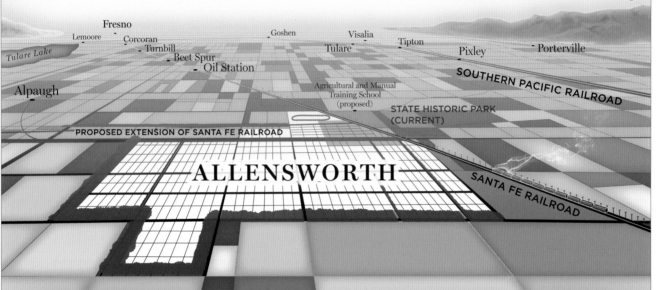

WATER

Our Colony is situated in the famous artesian belt of California. All of the water for irrigation and domestic purposes comes from deep flowing artesian wells. The water is pure and possesses health-giving qualities.

SCHOOLS

Our schools are equal to any in the State of California. Professor W. A. Payne is the only colored teacher in California. He is a graduate of Denison University, of Ohio.

PRODUCTS

The principal agricultural products of Allensworth are wheat, barley, alfalfa, rye, sugar beets, corn of all kinds, sweet and Irish potatoes, vegetables of all kinds and all sorts of fruit.

DAIRYING

A large percentage of the Colonists are engaged in dairying. Three cows can be fed in two acres of alfalfa, and a good cow will make her owner $8.00 a month selling the butter fat to the creamery. The local creamery supplies the Colonists with cows and permits them to pay for cows by monthly installments from the sale of the cream.

tained him, and the audience contributed $375 to benefit his college at Tuskegee.[14]

The next evening Washington spoke, eloquently according to the *San Francisco Call*, to an overflow crowd at the Mechanics Institute in San Francisco, where he was introduced by the mayor. He said that "colored people must now rectify a mistake which they made after their emancipation. They tried to start in at the top; they bought a carriage to ride in instead of a wagon to work with. I am trying to teach my people that they must begin at the bottom—at the soil and work up. They must learn that they must follow the growth of all nations. They must learn that liberty is a

Josephine Allensworth

conquest, not a bequest." He particularly lauded the importance of agricultural labor.[15]

Washington attracted an admiring crowd at A.M.E. Zion church in San Francisco, but his ideas received a less rapturous reception in Pasadena in August. The members of the state Afro-American Association "howled down" a resolution endorsing Washington's advice for the "withdrawal of leading organizations of the race from politics in order to devote their time to affairs more important to the colored race's upbuilding."[16]

W. E. B. Du Bois, who visited Los Angeles in 1913, was Washington's great intellectual rival. He, too, was attracted to Los Angeles, which he recognized was "not Paradise, much as the sight of its lilies and roses might lead one at first to believe. The color line is there and sharply drawn. Women have difficulty in having gloves and shoes fitted at the stores, the hotels do not welcome colored people."[17]

Allensworth saw what Du Bois had seen. Allensworth knew California was not a welcoming place, but for black people that was and is always a comparative statement. Compared to the South, it was a place of opportunity, but Josephine Allensworth and her daughters were still probably among the women who experienced the troubles that Du Bois described. Since Allensworth attended a dinner organized by the black elite of Los Angeles for Du Bois, some of Du Bois's information might have come from the Allensworths.[18]

In a surviving photograph taken of her when she was a younger woman, Josephine Allensworth radiates calm and serenity. She was a beauty, but she did not directly engage the camera. She looks thoughtful, seemingly gazing inward rather than outward. It is impossible to guess what she was seeing or thinking. We know she retained a con-

nection to her past. When she founded a library at Allensworth, she named it after her mother. Margaret Prince Owens remembered Josephine Allensworth's grace when as head of the school board she welcomed the new teacher to the town.[19]

By then Allen Allensworth was dead. A man born in slavery died a modern California death. On September 14, 1914, he stepped off a streetcar in Monrovia and was hit and killed by a speeding motorcycle.[20]

The town of Allensworth outlasted him, but the attempt to secure an Agricultural and Manual Training School modeled after Tuskegee failed. Too many black people in California opposed it, fearing it would be a step toward state-sanctioned school segregation. Once the state refused to provide an industrial school, Allensworth's trajectory had been determined. It declined along with much of rural California in the 1920s and 1930s. Its population dwindled.[21]

Margaret Prince had married and moved with her husband to the Imperial Valley, whose rigidly segregated school system offered opportunities for black teachers. Josephine Allensworth eventually left the town in 1922 to live with her daughter in Los Angeles. By then the town of Allensworth had revealed that antimonopoly, like so much else in Progressive era California and America, was racially coded. It was for white people only.

Chapter 19

CORCORAN

"Welcome to the City of Corcoran," Corcoran, Kings County, California

T he "Welcome to the City of Corcoran" sign on Santa Fe Avenue proclaims the town as "A Great Place to Raise a Family." The message must be either aspirational or historical, for it does not describe the existing place, where fewer than half of the population, which is 75 percent male, lives in families. There are homes in Corcoran, but it is not really a place of homes. Corcoran was the "home" of Charles Manson, the leader of the Manson Family and the mastermind of the Tate–LaBianca murders of 1969. He lived in the Protective Housing Unit at California State Prison from 1989 until shortly before his death in the fall of 2017. Over three thousand criminals were housed in the complex in 2017. A substance abuse treatment facility holds even more.[1]

Beginning with Jerry Brown's first administration in 1975, California came to regard prisons as the cure for social ills. During his first two terms, Brown far outstripped Ronald Reagan in the number of bills he signed to impose harsh sentencing. His successors continued the trend, and the Three Strikes Law of 1994 accelerated it. All of this meant more prisons and more jobs for Corcoran.[2]

In its skewed demography, Corcoran is both the carceral state incarnate and a throwback to the nineteenth-century West.[3] It testifies to the inability of industrial farming and the factories, such as the Boswell Company Oil Mill—the factory in the photograph—to provide middle-class jobs for more than a small set of people. To make up the deficit, modern Corcoran, and rural California in general, came to depend on the state's locking up a significant proportion of its population in small-town prisons. But after 2006, the number of prisoners began to decline as the U.S. Supreme Court forced California to address overcrowding. During his third term as governor, in 2013 Jerry Brown moved to reverse policies he had encouraged in his first two terms. The drop in the rates of incarceration hurt Corcoran. Its population dipped when the prison's population fell by about half between 2008 and 2017. Enough inmates remained so that in 2019, the state prison still had 1,962 full-time employees. The California Substance Abuse Treatment Facility had another 1,834. Together they represent a large part of the 36 percent of government jobs in the Hanford/ Corcoran area.[4]

Prisoners funnel money and influence into Corcoran beyond the funds spent to house and guard them. Because the state and federal governments apportion money and electoral representation based on population, prisoners from California's cities housed in Corcoran give the city more representation and more money without the inconvenience of more voters. Corcoran does not spend the additional state and federal funds on prisoners. Prison guards make good wages, but those wages are not necessarily spent locally. Most guards have chosen to raise their families elsewhere and commute.[5]

Between the prisoners and the reliance on noncitizen labor in the fields, Corcoran is a profoundly undemocratic place. Only a minority of the adult population can vote. Unlike Allensworth, Corcoran has survived; but it is far from the place its founder, Hobart J. Whitley, intended.

REAL ESTATE AND HOMES

Hobart J. Whitley, who developed Hollywood and the San Fernando Valley, expected Corcoran to echo the orchard/suburban communities of Los Angeles. Whitley hatched Corcoran as a real estate speculation at a Santa Fe Railroad junction in 1905, and today his name graces Corcoran's main street.

Whitley planned to follow a basic Southern California blueprint. He and his partners bought large tracts of ranch lands (at various times claimed to be from 30,000 to 40,000 acres) and subdivided them. They platted "a model farmers' town" with commercial lots and 5- to 10-acre tracts in the town at $110 to $130 an acre, as well as 40-acre tracts adjacent to the town site at $80 an acre. Prices declined with distance from the town; outlying poor lands were priced as low as $12 an acre. The partners would supply the beginnings of infrastructure—some roads, canals, and ditches—and would prime the pump by offering rebates to those who would quickly improve the land with houses, orchards, and irrigated fields. Whitley and his partners offered deep discounts and even free lots to businesses whose owners constructed substantial brick buildings. They planned to recoup their investments on the increased value of the remaining land. They also voted to change Corcoran's name to Otis—after Harrison Gray Otis, who owned a small stake in the company— "to show appreciation for his eminent worth as a man and public citizen, and his indefatigable and fruitful labors for the good of this section." Like so many other things about the town, the name change never happened.[6]

Real estate speculations thrive on confusion that makes money hard to follow. Whitley and his major partners created a set of interlocking companies—the Security Land and Loan Company, the Corcoran Realty Company, the Angiola Development Company, Corcoran Townsite Company of Los Angeles, and the State Bank of Corcoran—with near identical boards of directors that could facilitate insider dealing.[7] The Security Land and Loan Company seems to have been their major vehicle—at least it left the fullest records. It was incorporated with $1 million in authorized stock, but only about $300,000 was subscribed, and the largest stockholder—Whitley—held only $30,000 worth of stock. Since he was required initially to put down only 10 percent of the purchase price, he had only $3,000 at risk in 1905.[8]

Given its meager capital, there are questions about how the company acquired the 30,000- to 40,000-acre tract it supposedly controlled, particularly since the partners borrowed the money they needed for day-to-day operations. Money went out predictably enough, but when land was sold, the purchasers were slow to pay up.[9]

TULARE LAKE

Corcoran's fate has from the beginning been tied to Tulare Lake. When Whitley began operation in 1905, local boosters confidently predicted the lake's imminent demise. By the early 1880s no water from the Kings River reached Tulare Lake. As the lake shrank, it produced more land, which farmers regarded as a good thing.[10] An 1898 newspaper article summarized local attitudes. The receding waters marked "the dawning of a new creation, pleasant groves and fertile fields take the place of its former wastes of waters."

The lake was "shriveling, shrinking, and effacing itself from the map," and the result was "a story of enchantment."[11]

It would be years before over-allocation and waste of water began to affect farmers, but it did affect fishes, birds, and fishermen. Starting in 1884 the lake was less fished than pillaged. The lake trout and pout population declined. Whitefish planted in the lake failed to thrive and disappeared. The California Fish Commission, which recognized the problem but failed to correct it, suggested planting black bass. The once seemingly inexhaustible perch were overfished as they came into spawn. Since the summer buyers were largely Chinese, who dried the fish, whites made scapegoats of them. As the waters receded and fishes declined, pelicans, geese, snipe, mud hens, and other birds disappeared. By 1898 the lake had become a huge mudhole. The stench from dying fish that remained there was so great that farm families six miles away abandoned their homes.[12]

Then in 1906, the same year as the San Francisco earthquake, the town site of Corcoran and neighboring farms nearly vanished beneath floodwaters. When the initial purchasers complained, the Security Land and Loan Company denied any liability. Another flood threatened the railroad's tracks before the town officially "opened" in September 1907.[13]

Those who read the papers might have thought natural disasters did not deter development. Newspaper articles stressed the plans for a modern, attractive town, and the Atchison, Topeka, and Santa Fe built a new concrete station at Corcoran in 1906.[14] The Pacific Sugar Company invested $1 million in a sugar processing plant that opened in 1908. Rising five stories and made of steel and concrete, it was the largest building in

Corcoran and employed 500 people. Corcoran was billed as "the new sugar city." The Security Land and Loan Company highlighted this picture of a booming Corcoran by issuing a dividend of $10 per share at the end of 1906. Using dividends to boost confidence in a struggling company was not an unknown tactic.[15]

By comparing company records to newspaper accounts and published brochures, we can see the dangers of constructing histories only from newspapers. Many of the positive developments reported in the press should have been read as warning signs. The Santa Fe built its station only after Whitley and the other investors agreed to pay 20 percent of the cost.[16] The Pacific Sugar Company drove a harder bargain. To get the factory, the Security Land and Loan donated the factory site as part of a gift of 140 acres in Corcoran, and it agreed to give Pacific Sugar 50 percent of proceeds of the town site of Corcoran. Pacific Sugar also received 1,000 acres at Angiola and a guarantee that 6,000 acres of sugar beets would be planted. Finally, the company subscribed $100,000 to a $600,000 bond issue for Pacific Sugar and the new factory. This turned out to be a dangerous maneuver, since Pacific Sugar was soon to be sued for financial fraud. Security Land and Loan expected to recoup its expenses through land sales; they predicted land would double in price. The company did raise prices, but hardly doubled them, offering 40-acre tracts at a $100 an acre in 1909.[17]

The corporate records indicate a business plan composed of equal parts improvisation and desperation. Faced with rising costs, the company raised the price of its remaining lands west of the Santa Fe line even as it tried to lease other unsold lands and, if that failed, to put them in

crops. Then in 1907, finding it was unable to sell the land directly, the company resorted to outside agents and granted them 20 percent commissions. There was internal dissent. The company bought out P. B. Chase for $3,500 in 1907. Since he had subscribed for 200 shares, or $20,000, Chase had either never paid his full subscription or took a large loss.[18]

In early 1907, even as they subsidized the sugar factory and prepared for the official opening of the town, Whitley and his remaining partners were preparing to get out. *The Los Angeles Herald* promised that Corcoran was a "proposition backed by millionaires, who would not permit any lethargy in development, even If there were a disposition of any one to let go of the big scheme." But "let go" was precisely what Whitley and the others were trying to do. They blamed "earthquake and high water" for their failure to sell their lands. Further "delay will be attended with much expenses and tend to lessen the profits of the Company in the final settlement of its affairs." They instructed their hired agents F. P. Newport and R. V. Milner to sell the remaining lands, some at a loss if necessary.[19] Sales still lagged, and the company had at least 3,500 acres still on its hands in June 1907. The partners' desperation and the relatively small holdings that remained raised doubts about whether the company had ever really controlled 30,000 to 40,000 acres.[20] Whatever the acreage, the company leaked money. In 1908 the Corcoran Land Company did a trial balance that showed expenses amounting to $245,241.[21]

The more desperate the situation of the companies became, the more extravagant the claims for the land. Newport and Milner published a lavishly illustrated booklet entitled "Corcoran: "The Place of a Thousand Opportunities." "Seeing is believing," the booklet proclaimed, and provided photographs of gushing artesian wells, irrigation ditches, new homes, churches, abundant fields of alfalfa, fat cattle, sugar beets, asparagus, and more. Security Land and Loan, in reality desperate to liquidate, proclaimed itself stable and conservative. It was no more stable than the sugar beet factory that supposedly anchored the town's prosperity.[22]

Boosters who spin stories to catch the unwary are not necessarily a skeptical audience themselves. Whitley and his partners had subsidized Pacific Sugar and disguised the subsidies. Pacific Sugar, despite its lucrative subsidies, rewarded the partners by closing the plant several years later. In 1916 they sold it to the Pingree Sugar Company for $200,000, well below the mill's supposed original cost. Pingree sold more bonds with the factory as security and then sent the plant's equipment to Idaho. The company was sued for fraud, but the factory had been reduced to a shell. It would house German prisoners at Patterson and Gardner avenues during World War II and later disappeared.[23]

THE TOWN THAT NEVER WAS

Even as wheat declined in California as a whole, it expanded in the Tulare Basin in the early twentieth century. But wheat was not what Hobart Whitley had imagined for Corcoran. Whitley admitted that he had put in "five years of hard work and a large amount of money, which was finally at no profit to me." He dreamed of small orchards in the old lake bed. He got large wheat fields. The

Boswell grain elevator, Corcoran, California

El Rico Rancho put 6,000 acres of reclaimed land into wheat in 1915. There were in total 230,000 acres in wheat and barley that year. In 1916 boosters planned a new railroad line—a mere stub—to extend twenty miles out into the old lake. It would haul wheat.[24]

Farmers still grow grain, particularly wheat, but the most obvious monuments to wheat are ruins. In the late 1950s the *Corcoran Journal* declared that Corcoran had the second-tallest skyline between San Francisco and Los Angeles. That skyline consisted of grain elevators and warehouses. Today the modern city council is less enthusiastic about the old Boswell grain elevator,

the city's most imposing building, and wants to demolish it.[25] Jesse's photograph pairs the horizontal tracks, which seem to go on forever, and the vertical elevator they once served and now ignore.

The elevators had a narrow period of utility in the years following World War II. Well into the twentieth century, California farmers bagged their grain. Bagged grain demands warehouses, not grain elevators. Even as farmers planted on a larger and larger scale, they still measured the yield in sacks. When in 1937 thieves stole grain, they pulled up to warehouses at night and loaded sacks into trucks.[26]

Jesse's photograph of tractor, train, and silos

Outside Corcoran, California

divides the basic Tulare landscape of blue sky and seral fields nearly in half, and in the middle inserts three parallel bands that are fundamentals of Kings County agriculture: the farmer on the tractor leaving a trail of dust from his plowing, the slow train, and the silver silos and warehouse. The old elevator signals decline and magnificent ruin; the metal silos are all about functionality.

The lake had to die to allow wheat to expand, and paradoxically, the lake's refusal to die preserved the land for wheat and other field crops. As long as a flood from wet winters—such as those that plagued the old lake basin—took out only field crops, it eliminated a single year's harvest. The threat of floods held more permanent improvements at bay. After the floods of 1906, dredgers and developers again claimed to have gained the upper hand, and fields of grain pressed hard on the receding lake. This was hubris. In 1916 the lake reclaimed its own. That year 175,000 acres went under water in a wet year, and wheat farmers suffered accordingly. But they bounced back. In June 1918 the ranches along the lake produced 500,000 sacks of wheat and 250,000 sacks of barley worth about $3 million. In 1920 ranchers made a record harvest on lands always inundated

Abandoned houses, Corcoran, California

in the past. The harvest was so successful and the future looked so bright that grain dealers were relocating in Corcoran.[27] They were mistaken. The future was in cotton.

Jesse's photographs capture the evolution of the town by focusing on the amalgam of the new and the abandoned. Corcoran is littered with abandoned indvsites and old houses, many of them really shacks. The houses are boarded up, but the satellite dishes on the roofs indicate that they have recently been occupied, perhaps only by squatters. The cross—barely visible on one of the houses at the far right—is the work of an artist. Jesse calls him Corcoran's Banksy. He paints crosses, windows on the door, and, perhaps, self-portraits of himself sneaking around corners. I don't know what any of it means.

But Corcoran is also full of new neighborhoods little different from suburban neighborhoods elsewhere in Southern California. Corcoran is too complicated to be easily classified as success or failure.

PART SEVEN

WORLD WARS AND THEIR AFTERMATHS

That photographs are as much about absences as presences was Jesse's initial insight about photography. When he was four, he showed me a picture of a wall of the house next door. He said it was a photograph of a dog. "What dog?" I asked. "The dog moved," he said. Analyzing photographs involves imagining not only the dog moving out of the frame, but the moment before the dog moved into the frame.

Unlike the dog, the vanished buildings in Jesse's photographs left traces: the trees that sheltered them usually remain. Drive the backroads away from the towns and expanding suburbs and spot a detached palm or an isolated grove of trees—usually exotic—and you can be almost certain you are looking at an abandoned homesite.

On a larger scale, this is true of much of California. The developments of the mid-twentieth century have left ruins and absences. They all tell stories.

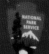

Historic
F Ranch

NATIONAL
PARK
SERVICE

Established Circa 1852
Point Reyes National Seashore

F Ranch, Point Reyes

Chapter 20

COTTON

Cotton bales, Corcoran, California

The photograph is blues and whites with dark bands in the foreground and background; it is as much geometrical as representational. Fittingly for a photograph of cotton, it mixes the natural and the industrial. The plastic cylinders standing in ranks in a parking lot in Corcoran lack all appendages but still seem faintly human. They are cotton bales, each stamped with the B of the J. G. Boswell Company.[1]

For such a secretive company, J. G. Boswell does like to brand its products and its land. Stamping cotton with a name indicates who produced it. Stamping land—usually with "No Trespassing" signs—marks who owns it. The bales of cotton and the land mark a past more complicated than private enterprise.

Jesse took the photograph in 2015, which turned out to be the year California farmers planted the lowest amount of cotton since the 1920s. Shifting markets and nature—in the form of drought and whiteflies—dictated the switch.[2] But cotton is hardly gone from Corcoran.

Three years later, in February 2018, we drove through the heart of the old lake bed, going from Lemoore to Corcoran. We traveled along 19th Avenue, a street with virtually no buildings, and eventually went east on Pueblo Avenue. Workers have reinforced some of the levees, which rise like medieval ramparts. The road ran atop the levees and then dropped back down into the old lake bed. Small drifts of cotton lay like a light snowfall on the sides of the roads.

The landscape looks like what it is—the remnants of a vast inland sea from which the water has vanished. The place is as spooky as it is private. It is as if the Red Sea has parted, but when Pharaoh's army appears, the water will come back with a vengeance. Drilling rigs and pumps were bringing up water and depositing it in the ditches that ran by the road. Off in the distance, farm equipment moved through the fields looking like ships on a dirt sea. What appeared from miles away to be farms or ranches were field stations, collections of trailers, metal buildings, and fuel tanks. There was no doubt where we were. When a farm road turned west, we saw a sign that sums up much of the western Tulare Basin. "You are entering private property, turn back now." This was followed by a series of prohibitions and threats so loved by property owners in the San Joaquin Valley and its delta. The symbol on the sign is the same *B* that marked the cotton bales.

We followed Whitely Avenue into Corcoran. On the outskirts of Corcoran, orchards have encroached on the lake bed, reminding me of bathers testing the waters. In the middle of town, a banner hung above the street. It said, "J. G. Boswell now hiring." But compared to the thousands who worked these fields before the big machines, Boswell employs few.[3]

THE COMING OF COTTON

Cotton did not come quickly to Corcoran. The first commercial producers in the Tulare Basin began modestly with cotton planted at Fort Tejon in 1865, but costs of labor and transportation made it hard to compete in national and world markets. In 1917 farmers in the Tulare Basin sowed 200 acres in Egyptian long-staple cotton, so called because

Bare cotton fields outside Corcoran, California

of its longer fibers. The plan was to sell the crop to tire manufactures in Los Angeles.[4]

World War I increased the demand for commodities and the prices paid for them. By 1918 there was a Cotton Grower's Association and plans to plant 4,000 acres in Kings County and construct cotton gins in Corcoran and Fresno.[5] Growers announced that their great advantage was climate. With no danger of rain, they could harvest the crop gradually over a long period of time and so did not need large numbers of laborers for short periods.[6]

In the early 1920s, as the boll weevil ravaged Southern cotton, irrigation of the virgin soils of the Lake Tulare basin produced prodigious yields, three times the national average. San Joaquin cotton acreage expanded from 9,000 acres in 1923 to 95,000 acres in 1926, reaching 247,000 acres by 1929, when cotton was the fourth most valuable crop in the state.[7] Most of these farms were small and located to the north and east of Corcoran, but the ranches reclaimed from Lake Tulare were among the largest in the nation. By 1929 more than 30 percent of the nation's largest cotton farms were in California, many of them in Kings County.[8] The large ranches were capital intensive—one owned by Herbert Hoover had improvements valued at $250,000 and cost $100,000 a year to operate. Big operators mechanized planting, but harvesting still required hard hand labor.[9]

The cotton boom was not simply a result of natural bounty and mechanical efficiency. It was an industry in need of discipline and organization, and large producers operating in conjunction with the state provided both. Acala cotton, a long-fibered Mexican variety, fueled the boom; but farmers, particularly those from the South, added

short-staple varieties to their fields. The result was mixed bales, badly ginned, that spun out poorly and gummed up the mills. Prices plummeted and mills began to avoid San Joaquin cotton.[10]

Large growers, federal extension agents, gin owners, bankers, and cotton merchants enlisted the state of California to correct the situation. They could not and did not rely on market competition or cooperation. In 1925 California passed the one-variety cotton law that restricted production in the San Joaquin Valley to Acala cotton and made the U.S. Department of Agriculture (USDA) the sole producer and distributor of seed. The short-term gains in uniformity and demand were immediate; the long-term problems in creating a monopoly and a one-size-fits-all program that did not allow farmers to adjust to differences in soil and microclimate and in limiting the genetic variability of the seed took longer to appear.[11]

The big ranchers were often not just ranchers; they were gin owners and finance companies who set the terms of the industry, lending money, and holding liens on the crops of smaller farmers. The smaller growers depended for credit to grow cotton on companies such as Anderson Clayton, which had migrated from the South to California, or J. G. Boswell, a Southerner, who had created his firms in California. These companies acted as factors—not only growing cotton but advancing money to other growers and taking a lien on their crops for security on the loans.[12]

As the big operators relentlessly cut costs and promoted efficiency, they set their sights on workers: of all the farmers in the state, cotton growers had the greatest percentage of expenses devoted to labor. Although many farmworkers were born in Mexico, most were not migrants moving back and forth across the border. They were overwhelm-

ingly residents of the United States. Starting in 1926, the Agricultural Labor Bureau of the San Joaquin Valley, organized by county farm bureaus and chambers of commerce, met to set the wages for picking and chopping cotton. Piece rates of $1.50 per one hundred pounds fell to $0.40 by 1932.[13]

In 1933–34 the growers organized as the Associated Farmers of California. They depended for funding on the banks, packing houses, railroads, and utility companies who feared any disruption of production. When Franklin Roosevelt's New Deal passed the Agricultural Adjustment Act and created a spike in cotton prices, the Associated Farmers sought to keep the money for themselves. Workers demanded $1 per hundred pounds; the Associated Farmers offered $0.60. The farmers counted on more than economic power to win this fight. They had considerable influence in Sacramento and worked closely with the state police and county sheriffs, often serving as deputies. Deliriously anti-communist, sometimes anti-Semitic, and on their fringes attracted to fascism, the farmers were responsible for much of the violence in rural California.[14]

But divisions between large and small farmers ran deep. In Kern County small cotton farmers denounced the men who dominated the organization as the "pseudo-farmer who merely farms the farmers . . . who is the friend of traders and financiers, and . . . assumes a leadership to which he is not entitled." That a few large finance corporations, banks, and owners of large gins controlled the cotton industry in the Tulare Basin created resentment and tension.[15]

WORKING THE FIELDS

Jesse came across this house on his way to Corcoran. It is in Delano, a Kern County town larger than Corcoran, but its prisons and agricultural economy are similar. The house is now derelict, its door ajar, its window broken; but the ragged siding retains a coat of paint—green or aquamarine—that once typified such structures. From the 1930s through the 1950s, houses like these made up the labor camps in and around Corcoran and Delano. They were often painted a uniform color that signified their location. Corcoran had the Green Camp—*El Campo Verde*—and the White Camp. Other camps had more revealing names, for example, *El Campo de las Moscas* ("the fly-infested camp"). Eventually, most of the camps were torn down and the houses either destroyed or moved as machines replaced people in the fields.[16]

Jesse's photograph centers on a single house, but such houses usually stood among others like them, just as the workers who inhabited them always stood among crowds of other workers.[17] These shacks housed itinerant laborers and their families who, unless they were part of a perma-

House in Delano, California

nent work crew, did not so much live in the town as lodge there for the four-month cotton harvest. In the 1920s and early 1930s, most of the people were Mexican born—first Mexican Americans from Los Angeles and San Francisco, and later migrants direct from Mexico.[18]

These shacks were rent free, and better than the tents they replaced, but they lacked running water, indoor plumbing, and insulation. Although the camps had electricity, the houses usually did not. In winter, workers shivered in the cold and frequently fell ill. The camps took a particular toll on children.[19]

In late November 1930, Frank Latta visited a cotton camp on the Wilbur Ranch near Tulare. He was looking for Yoimut, a Chunut Yokut, whom he sought as an informant. She was with her daughter, who was married to a Mexican American, and Latta found the whole family sleeping on the floor of an unfurnished house. She agreed to go with Latta the next morning. Yoimut's grown daughter Belle had to be in the fields by 7:00 a.m., but she stayed up all night helping her mother dress and pack.[20]

Yoimut was eighty-five years old then, and she longed to go back to "our good old home on Tulare Lake," but "now my daughter and her Mexican husband work in the cotton fields around Tulare and Waukena. Cotton, cotton, cotton; that is all that is left. Chutnuts cannot live on cotton. They cannot sing their old songs and tell their stories where there is nothing but cotton. My children feel foolish when I sing my songs, But I sing anyway." She died in Hanford in 1937.[21]

As alien as the cotton fields felt to Yoimut, they reinscribed some older connections. Just as some Yokuts had ended up at San Fernando Mission and then returned to the Tulare Basin, now some of the Mexican cotton pickers, who had originally come from the village of San Francisco Angamacutiro in northeastern Michoacán and settled in San Fernando, came seasonally to Corcoran.[22]

Falling wages provided the match that ignited California's agricultural strikes in the 1930s.[23] Kings County became the epicenter for the injustice, rage, revolutionary ferment, desperation—and hope—that California agriculture produced. Workers demanded an increase in pay and recognition of their union, the communist Cannery and Agricultural Workers Industrial Union (CAWIU). Some small growers sympathized with the strikers; but most farmers, including all the large growers, reacted with rage of their own—and violence.[24]

The opening act of the California cotton pickers strike of 1933—perhaps the greatest agricultural strike in American history up to that time—began in camps with houses like the one in Delano. Cotton pickers, following a wave of strikes elsewhere in the state, walked out on October 4, 1933, just as the cotton came ripe in the fields. In response the growers, backed by armed guards, evicted the workers from their camps. The first eviction came at the Peterson Ranch near Corcoran. Within a few days, 3,500 workers around the town had been evicted. The workers established a large strikers' camp just outside Corcoran. The camp had been forced on the union, but it proved a critical tool in effectively organizing the strike and protecting strikers. The growers recognized their tactical mistake. The camp was no worse than the labor camps maintained by the growers, but those interested in dispersing the strikers seized on sanitation as an excuse.[25] The strikers were not without local sup-

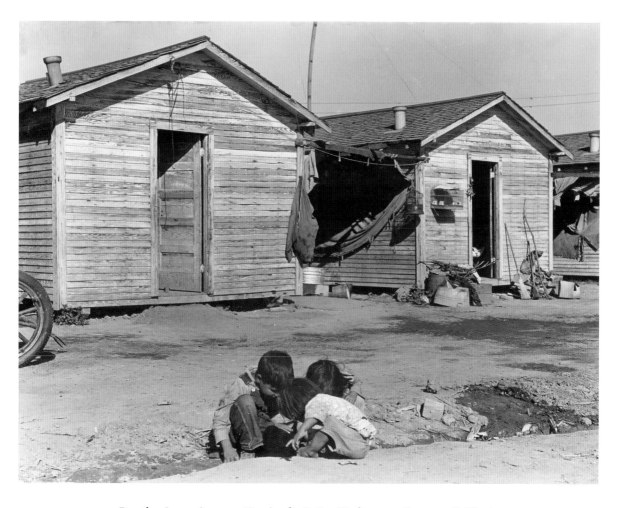

Dorothea Lange, Company Housing for Cotton Workers near Corcoran, California

port. Local merchants—most of them Mexican American, Jewish, and Portuguese—sympathized and extended credit.[26]

The violence that began with armed evictions of strikers from the camps escalated into brawls between strikers and scabs in the fields. At least one grower threatened to kill any scab who tried to join the strikers. There were clashes between strikers and police.[27]

Lethal violence was one-sided. On October 10, 1933, a caravan of ranchers descended on the strikers at Pixley, twenty miles east of Corcoran in neighboring Tulare County. The ranchers opened fire, ignoring pleas that women and children were in the union hall. The farmers sent a fusillade into the building—shredding, so the newspapers reported, the American flag hanging over the door. A worker, Dolores Hernandez, and a Mexican consular representative died. Several more were wounded.[28]

Clarence "Cockeye" Salyer was a big grower with a bad eye, a big temper, a big belly, and an appetite for land that later made him the second-largest landowner in Kings County after the

Boswells. According to his son, Salyer was a murderer who killed Dolores Hernandez and then destroyed the murder weapon.[29] No one would be convicted for the killings. The trial was, as Carey McWilliams wrote in his *Factories in the Field* (1939), "a delightful farce."[30]

To break the strike, growers tried to import labor from the South, recruit labor in Los Angeles, and shut the schools to put children in the fields. All failed. The *Corcoran News* threatened, and local officials demanded, deportation of strikers: "Many of you are visitors in this country, here only through our sufferance." Workers had no "right to dictate to American employers what they shall pay, whether they can pay it or not." The *Tulare Advance Register* threatened a federal roundup and internment camps.[31]

Deportation proved a stupid threat. One reason the growers could not replace strikers in 1933 was that the United States was already deporting noncitizen Mexicans and their citizen children. The reserve labor force the ranchers depended on flowed south, back into Mexico.

The balance of power in the strike lay with local, state, and federal government. Growers depended on local officials for the muscle to suppress and threaten strikers, but strikers eventually got significant aid from the state. The California Emergency Relief Administration fed them, and the California Highway Patrol, while indulgent of vigilantes, prevented the sheriff from precipitating violence at the Corcoran camp.[32] But what the state gave with one hand, it could take away with the other.[33] A fact-finding committee appointed by Governor Rolph of California recommended a wage of 75 cents per 100 pounds of cotton picked. The ranchers and the local press attacked the decision as rewarding communists

and aliens over American farmers. The Kings County ranchers did not view events much differently than they had in the late nineteenth century. Mexicans and Mexican Americans, like the Yokuts before them were inferior people. The farmers were "red-blooded Americans."[34]

The New Deal saved the big growers through subsidies and rising prices. It did not save the smaller ranchers. The number of farms in the Tulare Basin peaked in 1925; after that they consolidated, declining by about 10 percent between 1925 and 1945. By 1945, 64 percent of Kings County farmland was in farms of more than 1,000 acres.[35] Throughout the 1930s, men like Boswell and Salyer bought out smaller ranchers and gin owners.[36] By 1937, four companies supplied 75 percent of new investments in cotton in the San Joaquin Valley. Most prominent among these firms was the J. G. Boswell Company.[37]

The demographics of the harvests in the Tulare Basin and the inhabitants of the shacks also changed following the strike of 1933. In the mid-1930s Dust Bowl refugees—denigrated as "Okies" and "Arkies"—came to California out of desperation and sought work and more generous relief payments. As bad as things were in California, they were worse in the South and Oklahoma. But in the long term, these migrants would not solve the growers' needs. Eventually, machines would do that.[38]

THE LAKE RETURNS

Before she died in 1937, Yoimut had predicted that the lake would return and that "everybody living down there will have to go away." The floods

came in 1938 and again in 1939. The lake receded in 1944, but another flood came in 1945.[39]

The rainfall and river flows during these years were well above average but not particularly severe. Data on the Kaweah River indicated the rains created the kind of floods that normally happened every seven to ten years; but for residents who had endured a long drought that stretched over most of the years from 1918 to 1934, the floods seemed both extreme and persistent.[40]

Many ranchers succumbed to the lake. In 1937 ranchers built new levees in the old lake bed, but they could not save 23,000 acres at Liberty Farms.[41] The 1938 floods of February and March combined intense spring rainfall with a heavy snowpack. The floods hit all of Southern California hard: measurements of the Los Angeles River at Long Beach exceeded the average flow of the Mississippi River at St Louis.[42] Lake Tulare rose from the dead. When it reached an elevation of 192 feet (its height above sea level, not its depth), a large levee broke and the lake reclaimed 49 square miles of land. It eventually crested at 195 feet, above the maximum elevation of 193.1 feet in the 1906–07 flooding. Barley harvesters raced against the rising waters. By June 135,600 acres were flooded, equaling the 1906–07 flooding. At its deepest point, the lake measured 16 feet.[43]

A home movie in the California State Archives records the return of the lake. It shows a flooded labor camp at Cross Creek, and flocks of pelicans returning to nest on the levees. Tules reappeared, and trees died in the rising waters.[44] In July 1943 the lake, more than 17 feet in its deepest part, covered 112,000 acres or more than 159 square miles; but engineers succeeded in cutting off flow into the lake that month. Massive dredgers went

to work once more, reclaiming the southeastern part of the lake. In 1948 the plan was to reduce the lake to 87,000 acres.[45]

Not everyone saw the floods as a disaster. The abundant waters reduced pressure on the aquifers created by the long drought that had preceded them. By 1929 water pumped from aquifers already amounted to about twelve times the volume of streams discharged from the Sierra. For those who could claim and control it, the reemergence of the lake meant water for irrigation.[46] Floods proved a boon for those with the capital to buy out flooded farmers and then use or sell the waters. In 1946 the J. G. Boswell Company purchased the Cousins Ranch; it had been underwater since the 1938 flood.[47]

J. G. Boswell would also wage a long fight for access to government-subsidized water, which under the Central Valley Project was limited to farms of 160 acres or less. It was a fight that he and other large growers ultimately won during the Carter administration. The large landowners did little more than create a façade of paper farms, dummy owners, and interlocking companies to avoid trouble with the Bureau of Reclamation. In 1987 the Bureau issued new regulations that gave up the charade of acreage limitation.[48]

J. G. Boswell could sustain himself during the long fight with the government because he used the waters on the flooded lands of the old lake bed; then, as the lake drained, he turned to expensive new turbines that could pump water from depths of 4,000 feet. The costs made such pumps the tools of big growers. But the pumps would have ramifications of their own.[49]

Chapter 21

WORLD WAR II

Turnstile, Mare Island

The gate with its turnstiles was a small thing that had lost its purpose. There was no reason to pass through it with the road open around it. It was a remnant signifying that what was now open had once been closed. Compared to the old buildings surrounding it, it lacks grace. Compared to the steel structures that dwarf it, it lacks any majesty. It has vanished since Jesse took this photograph, but once it was a gateway to Mare Island. During World War II, workers in the yards constructed 16 submarines and 392 ships; they repaired 4,000 more. Every working day, roughly 43,000 people passed through the gates.

In the 1920s Bay Area boosters and business-men could only dream about such a flow of federal military dollars to the Bay Area. What had seemed like an early twentieth-century resurgence had dwindled. The completion in 1910 of Dry Dock 2 at Mare Island, the first twentieth-century dry dock, gave the base a facility that could hold six destroy-ers at a time and any single U.S. naval vessel then afloat.[1] With Dry Dock 2, Mare Island now had the capacity for modern construction, and Lt. Holden Evans intended to build a modern navy in a mod-ern fashion. Evans went to Mare Island under pro-test. He was a naval constructor who chafed in a service dominated by line officers. He threatened to resign rather than come to a distant place "rid-den by labor unions and politicians . . . graveyard of the ambitions of naval constructors."[2] Evans was part of a larger movement, symbolized by Frederick Taylor's "scientific management"; in the Navy as in industry, men like Evans sought to take the control of work away from workers and make men imitate machines. The goal was to insert effi-ciencies wherever possible and produce ships with more speed and less expense. Much of scientific management was hype; in Evans's hands, it seems to have worked. He took charge of building the USS *Prometheus* at Mare Island while the Brook-lyn Naval Yard built a sister ship, the USS *Vestal*. The Brooklyn Naval Yard had cheaper materials and cheaper labor. But Mare Island had better

weather, and Evans built the *Prometheus* for less. When the 450-foot-long ship slipped from Dry Dock 1 in 1919, Evans made it an argument for western shipbuilding.[3]

The *Prometheus* was nothing special, although it served with distinction in World War I and World War II. But its evolution from a collier—renamed the *Ontario*—to a repair ship with its original name restored was evidence of larger changes.[4] It was a collier in a navy fueled by coal, but it was built at a shipyard whose coal had to be brought by sailing ship around Cape Horn. But California did have oil. By 1913, when workers at Mare Island laid down the hull for the USNS *Kanawha*, they were building an oil tanker. Assis-tant Secretary of the Navy Franklin Delano Roo-sevelt was inspecting the future when he visited the island just before the *Kanawha* was launched.[5]

Shipbuilding was becoming an important part of the Bay Area economy. A delegation from Vallejo Trades and Labor Council, along with oth-ers from the Merchants Association of Vallejo and Chamber of Commerce of Vallejo, joined navy per-sonnel on Mare Island when the *Prometheus* was launched. Children from the Vallejo orphanage came. They heard the governor of California give a short talk. They ate chicken salad, shrimp salad, sandwiches, cake, and coffee.[6] Some of the roast beef in the sandwiches was bad; roughly a third of the 3,000 guests got food poisoning. A waiter

died.[7] It was not a good omen, but Mare Island was shipbuilding.

San Francisco, recognizing its old preeminence slipping away, saw Mare Island as one of the keys to the Bay Area's revival. In 1916 James D. Phelan, then a senator from California, gave a speech urging that the United States establish a Pacific fleet to guard against the rise of Japan as a naval power.[8] It was a theme he returned to in 1917, a month before the United States entered World War I, in a debate that included naval ship construction in California. The contest in Congress proved deep and Byzantine. Eastern senators acknowledged that California should get naval contracts since it had shown it could build ships as cheaply as the East. To win contracts, they simply had to underbid eastern shipyards. Phelan recognized that because prices were rising with the war, the Eastern concession was a trap. If California shipyards, constrained by inflated prices, could not meet lower eastern bids, then the state would get nothing. He argued that even if construction were more expensive on the Pacific Coast, it was a matter of national interest that the government encourage shipbuilding and repair in California.[9]

Californians united in opposition to the East, but they also fought each other. Phelan was from San Francisco. Even though Mare Island lacked a deep enough channel to handle large battleships, Phelan defended further expenditures for the shipyard by arguing it would be a mistake to abandon it when so much money—$21,298,000—had already been expended, and it could still handle 80 percent of the fleet. He feared the Pacific Fleet would be headquartered in Southern California. Ultimately, the bill to increase funding for California shipyards died because while it contained funds for San Francisco Bay area, it contained none for San Diego or Los Angeles. The other California senator, John D. Works, was from San Diego, and he opposed the bill.[10]

The disputes within California would only deepen. When the Navy designated Los Angeles, not the San Francisco Bay Area, as the main anchorage of the Pacific Fleet in 1922, it seemed that Mare Island would lose all the advances it had made during the century's first two decades. That same year, the government drastically cut both construction and maintenance contracts for Mare Island. A new submarine base on the island provided only partial compensation.[11]

San Francisco's desire for a naval base had little to do with fear of a foreign enemy. The *San Francisco Chronicle* had bluntly stated the city's aims in 1919: "What we want of the fleet is to sell it supplies, do the necessary repair work, and enjoy the company of the uniforms at our society hops. That, of course, is all the East wants of the Navy in time of peace, and hitherto they have hogged it all."[12]

Without the naval base, Vallejo was nothing, and its businessmen feared Bay Area rivals as much as those in Southern California. When the Navy accepted the donation of land for a new modern base at Alameda, Congressman Charles Curry of Vallejo engineered its defeat. Vallejo and Mare Island hung on to their roles as a supply depot and a repair facility. The inability of the Bay Area to defeat San Diego and Los Angeles and the failure of San Francisco to broker peace within the Bay Area signaled San Francisco's decline in stature.[13]

San Francisco's desire for economic growth and the Navy's dread that economic growth would eat up the land available for military expansion

USS Cummings, *1942*

eventually led to the military spending that San Francisco desired. The Navy agreed to improve and expand Mare Island while constructing additional installations in the Bay Area while land remained available.[14] Bay Area interests embraced the plan as a way to avoid the centralization of the Pacific Fleet in Southern California or Hawaii and the subordination of the region to Southern California.[15] The military provided a route to an industrial California. The urban rivalries of the 1920s and 1930s were forging what would become the military-industrial complex so central to California's growth.

WAR AND WORK

Actual war remained the last thing either business or labor wanted. But even before the United States went to war, war came to Mare Island. The Lend-Lease Act of 1941 permitted the repair of British vessels in U.S. shipyards, and British ships soon began to arrive.[16]

When the HMS *Orion* reached Mare Island in September 1941, the HMS *Liverpool*, the victim of an Italian bomber, was already in dry dock undergoing repairs. The *Orion*, a casualty of fighting in the actual Mediterranean, came to the figurative

California Mediterranean to be restored. The cruiser had been a flagship of a flotilla off Crete, involved in evacuating British troops. The evacuation had taken longer than expected, leaving the ships sailing in daylight—in range of German dive bombers, which found the ships long before the Royal Air Force planes that were supposed to give them cover did. The German bombers came in waves. The captain died alongside 111 *Orion* crewmen. Of the 1,100 evacuated soldiers, 150 died. Approximately 300 were wounded.[17]

In Alexandria, Egypt, the British evacuated the wounded and took off those dead who were accessible in the shattered *Orion*. They made emergency repairs and sent the ship on to Cape Town, South Africa, for further repairs. The remaining dead were still entombed and decaying inside the ship. The *Orion* sailed west, passed through the Panama Canal, and reached San Francisco Bay in radio silence to keep its arrival secret. It eased into the dry docks at Mare Island. When repaired and refitted, HMS *Orion* sailed out in a voyage back to the Atlantic in February 1942. By then, the United States was at war.[18]

The dead—maybe British, maybe Australians, maybe New Zealanders, probably all three—who had lost their lives in the Mediterranean were hauled out beyond the Golden Gate and buried at sea in the Pacific.[19]

Turnstiles divide; they act as sieves. The crowd presses toward them, but people pass through individually before merging again. At its peak during World War II, Mare Island had three shifts, working around the clock. Initially the shipyard wanted men, preferably white men. Nearly nine months after Pearl Harbor, it advertised for skilled workers, "men who can qualify as pipecoverer and insulators, electric welders, machinists,

electricians, laborers and general helpers."[20] The government threw up wooden dormitories for men and urged them to leave their families, at least temporarily, at home.[21]

But by the fall of 1942, it was clear that with the draft and enlistments draining away men and a parade of vessels crippled while fighting in the Pacific limping into Mare Island, the shipyards needed women. By October it offered immediate employment to "all persons interested in work."[22] It opened a nursery to provide childcare, and by early 1943 advertised for hundreds of women.[23] With its limited capacity, the nursery could admit only a tiny fraction of workers' children although the shipyard required thousands of women. In early May 1943, six thousand women were at work in the yard; the machine shops alone employed 3,900.[24] Beauticians and saleswomen became machine operators and riveters as the country struggled to repair old ships and build new ones.[25]

Among the very earliest of the new workers was Effie Walling. When she was interviewed in 1979, the war had been over for nearly a quarter of a century. Walling was born in Kansas, and her family then moved to Long Beach. She was living in Vallejo before the war. When the advertisements appeared in 1942, she was already at work, having come to Mare Island in 1941 in response to word of mouth. Women told other women that work was available. She walked through those turnstiles. She stayed until the war was over.[26]

Walling was a welder—a job with a high percentage of women—taking on simple tasks after training and then being certified for more complicated work as time went on. But Walling reported that few women completed the entire training period, and the advance training they were supposed to receive never materialized. She worked

on new construction rather than repair, usually on bulkheads in barges and occasionally submarines. Sometimes she worked on the waterfront, sometimes in the shops. She cleaned and mopped as well as welded.[27] She did not consider the jobs dangerous, but they were uncomfortable. The leather welding outfits, which the women had to purchase themselves—as well as a failed experiment in plastic bras—were hot and heavy. Many women discarded all but the heavy gloves, working in overalls instead.[28]

Walling had only fond memories of the men she had worked with. She recalled that they resented women's presence at first, but they accepted them soon enough. Walling, for her part, was accommodating; she acceded to men's superiority. She thought men were stronger and that women could not compete with them. Not all women agreed with her, but she considered such women "conceited." She said she was happy to leave her job and return to sales when the war ended, but she also described how happy she was when working in the shipyards.[29]

Walling was not so accommodating about race. She resented the black women working alongside her. She denounced them as lazy and belligerent. Black women and men at Mare Island represented a sea change in California. Attracted by war work, black people flowed into the Bay Area. The region's black population increased from 19,750 to 64,680 between 1940 and 1945. Most of the black migrants came from Louisiana, Texas, Arkansas, and Oklahoma. They referred to the trains that carried them west as liberty trains. They would not return to their home states.[30]

Walling's attitudes, writ large, dominated Vallejo: its population doubled in size during the war, and authorities segregated new housing.[31]

The town had too many people and too much work and too little of everything else: housing, food, and consumer goods. Walling remembered a world where everything was rationed.[32]

WAR AND RACE

Mare Island was a single piece of the military buildup that circled the Bay with shipyards, airfields, military bases, and supply depots during World War II. The war boosted the state's population by 1.6 million people and more than doubled manufacturing jobs. Government money—$19 billion of it—built new factories and military bases as well as funding war contracts. California ranked first not only in shipbuilding but also in aircraft facilities and new military bases. Manufacturing had never been so large a part of the state's economy, and it never would be again. The state's major cities—San Francisco, Los Angeles, and San Diego—sought funding for anything that could remotely be connected to the war: water systems, highways, housing.[33]

In looking for images of those who worked at Mare Island, I found a photograph of an Asian American worker. He was not identified, but the label said he was Chinese and his parents still lived in China. How he came to the United States in the wake of the virtual pogroms and the anti-Chinese legislation that swept over California in the late nineteenth century is unknown. He was an unwitting harbinger of renewed immigration in the late twentieth century.[34]

This Chinese worker's presence at Mare Island was all the more notable because other Asian Americans, particularly the Japanese, were

Women shipfitters on board USS Nereus

Machinist, Mare Island shipyard

absent. They were living in the region—or rather had been—when the war broke out. Japanese Americans—Issei and Nisei—had lived at Point Reyes in the 1930s and 1940s. There is a picture of a Japanese American tenant family on the beach at Drakes Bay in August 1940. They were picnicking with Italian families. All were a new generation of tenants, renting land from former tenants who had bought the ranches to grow peas and artichokes.[35]

I first saw the photograph of picnickers in a paper a student did for a class I taught at Stanford. But James Okumura, who retired and moved to the Point Reyes area, became obsessed by it and researched it. He does not identify the picnickers, but he does identify the Italian and Japanese families then at Point Reyes: the Kimuras, Bans, Miyedas, and Kameokas as well as the Lavazolis, Collis, Lombardis, Lucchesis, and other Italian families.[36]

Following the 1941 attack on Pearl Harbor, the government in May 1942 arrested twenty-three German and Italian nationals and Japanese—both citizens and noncitizens. The Italians and Germans were allowed to return to their communities that fall. The Japanese went to a temporary internment camp at Merced in the San Joaquin Valley and from there were sent to Granada Relocation Center in Amache, Colorado. The Japanese families never returned to California. They, too, became part of the changes sweeping across California.[37]

Italian American and Japanese American families picnicking, Point Reyes

PEOPLING THE DARKNESS: ABANDONED HOUSES AND THE STORIES THEY TELL

Abandoned house, Union Island, California

In the San Joaquin Delta and the Tulare Basin, Jesse photographs old houses. Most are worn; some are abandoned. Some of the houses remind me of skulls, multiorificed and hollow. No matter how I look at them, I cannot recover the lives and thoughts of the inhabitants who once animated them. The houses stare back at me, incomprehensible and uncomprehending. Built during the late nineteenth and early twentieth centuries, they emptied out during World War II, accelerating a movement that began during the Depression.

In 1945 about 21 percent of all farmhouses in Kings County had no one living in them. During the early 1940s, populations dropped in 26 of the 58 counties in the state as people moved to the coast, where jobs were abundant. One result was a landscape of abandoned and vanished homes.[1]

JOAN DIDION AND FRANK LATTA

Joan Didion and Frank Latta both came from, and ultimately left, the agricultural interior— the region that in the years following the war seemed a hinterland increasingly remote from coastal California. But to them and others who had lived there, it was a heartland. Joan Didion is a famous author; Frank Latta was a schoolteacher and the kind of vernacular intellectual I very much admire. Both of these people made California their great subject. Both fixated on California identity—their own and the state's—and grounded that identity in the American settlement represented by the old and vanished houses. Both saw the changes in California after World War II through the lens of that identity.

Frank Latta was born in 1892 in a house on Orestimba Creek in Stanislaus County, near where the El Camino Viejo crossed the stream. His father was a minister, poorly paid, with a wife and eight children. He devoted more attention to his congregations than his family. By the 1920s, Latta's birthplace was known as the old Latta place. Other houses, too, aged into landmarks: the old Williams place, the old Salty Smith place, and more. Latta worked on these ranches as a teenager and never lost his fascination for the stories he heard there.[2]

Joan Didion was born much later, but her family arrived in the state earlier—in 1852. She embraced a heritage that was, as far as I can tell, a common rehash of the California Native Sons' myths of the creation of Anglo-Saxon California. But for her it was powerful, and when she moved to New York in the 1950s, it spawned a "longing . . . a homesickness, nostalgia so obsessive that nothing else figured."[3] Her family originally settled near Florin, just south of Sacramento. Their first ranch was 360 acres and soon increased to 640. As the family expanded its holdings, this first ranch became known as the Hill Ranch, although there was no hill. The family—or rather, a family corporation—still retained the ranch when Didion was an adult. In her world, too, houses had family names. A character in her first novel, *Run River*, refers to the governor's mansion in Sacramento as "the old Gallatin place."[4]

Jesse's photograph of the settler's house by the levee on Union Island reminded me of Didion and led me to reread her. As a schoolchild in June 1948, Didion gave a speech titled "Our Califor-

nia Heritage." Houses like this were part of the heritage that she presumed she shared with her classmates, who were the children of Dust Bowl refugees.[5] Didion realized much later that these children shared little but whiteness with her, but she must have had intimations of her distance from them growing up. Parts of *Run River* read like transcriptions of conversations she heard from her parents or grandparents or neighbors. "Don't you dare pay any mind to what those Okies said about him," Edith Knight tells her daughter, Lily, when Walter Knight loses an election to Henry Catlin, a New Deal Democrat. Henry Catlin, Walter Knight tells his daughter sourly and sarcastically, was "an agent of Divine Will, placed on earth expressly to deliver California from her native sons."[6] The Okies, though Didion did not realize it, were the vanguard of all the strangers the Native Sons would come to loathe.

Published in 2003, *Where I Was From* is an explanation and a partial repudiation of the "true California" that had provided Didion with "the story on which I had grown up." That repudiation involved Didion's recognition, "a kind of revelation," that "the settlement of the west, however inevitable, had not uniformly tended to the greater good, nor had it on every level benefitted even those who reaped its most obvious rewards." She must have suspected this was the case, even as she celebrated the myth.[7]

Such suspicions swarm through *Run River* and haunt its Central Valley houses. Didion's houses contain longing, betrayal, and culpable ignorance. People smoke, drink to excess, and suffer through the heat. Didion fills the houses with infidelity, loss, disappointment, racial animosity, and decline. It is a strange world to feel nostalgic about. If this was the true California, let it go.

Didion's embrace and latent suspicion of the true California propelled her most famous essay, "Slouching Towards Bethlehem" (1967). It is about the "atomization" of California in particular and the United States in general. "The center was not holding," she wrote, without ever specifying what the center was. The rules and games that held society together were not being passed on, but she never articulates the rules of the game.[8]

It never occurred to me, in my early readings of the essay, that its action centers on homes—or rather, abodes that failed as homes. Didion interviewed people on the street and in Golden Gate Park, but mainly she visited them in Haight-Ashbury apartments. Most of the people who lived there were families only in the way the Manson family was a family. The essay ends, shockingly but predictably, in an apartment with a five-year-old tripping on LSD and a three-year-old chewing an electric cord.[9]

Everything in *Slouching Toward Bethlehem* is closely observed, and I do not for a moment doubt the accuracy of Didion's descriptions. At first I thought she portrayed everyone except herself, Arthur Lisch of the Diggers, and the Grateful Dead (the boys in the band) as idiots; but then I realized she was writing about teenagers who had ingested large amounts of drugs that they thought gave them enormous insight. Of course they sounded like idiots.

The problem isn't her representation; it is her interpretation. Didion makes Haight-Ashbury represent the Decline of the West, and she turns the now largely forgotten Diggers and the San Francisco Mime Troupe into anarchists plotting the apocalypse. All of this makes sense only against the backdrop of an imagined earlier stability.

Historians are the least likely people to find

ruptures in the past or an approaching apocalypse. We are no shrewder than other people, but we have been inoculated by working lives spent reading past claims of ruptures in the warp of time, and of coming apocalypses that have failed to occur. Historians will probably miss any actual apocalypse, but we are confident that it did not arrive in San Francisco's Haight-Ashbury in 1967.

How to explain dubious and overwrought claims in a writer as smart and effective as Joan Didion? They spring from her devotion to a California story she heard in those Central Valley houses.

In *Slouching Towards Bethlehem*, Didion is frightened by the Diggers—whose name comes from seventeenth-century Protestant levelers seeking radical equality, but also echoes the derogatory term applied to California Indians. The Diggers amplify the horrors of the Haight to make it seem an equivalent of Vietnam and turn it into a base for radical politics.

The analogy to Vietnam is apt, but, given the Diggers' name and her own origins, Didion neglected an even more apposite comparison. The Diggers' depiction of the Haight sounds like a mash-up of the settlement of California. The exaggerated problems in the Haight were reminiscent of the actual horrors of the days of '49.

Years later, in *Where I Was From*, Didion obliquely makes this point. She writes about Josiah Royce, the nineteenth-century philosopher born in the foothills of the Central Valley, and how he created an idealized California based on loyalty and community. She notes how Royce himself had recognized a different historical reality—"a community of irresponsible strangers . . . a blind and stupid and homeless generation of selfish wanderers" of "men who have left homes and families, who have fled from before the word of the Lord and have sought safety from their old vexatious duties in a golden paradise." Hippies imagined themselves as Indians, but Didion could have cut them to the quick by claiming they were like her people: the forty-niners, the Native Sons.[10]

Both readers and writings travel through time. I read this essay differently now than I did when I was twenty. In the late 1960s I regarded it as an obvious attack on hippies and radicals and, since I was both, on me. I presumed that I was one of the anonymous "misplaced children and abandoned homes and vandals who misspelled even the four-letter words they scrawled." We were the adolescents who "drifted from city to torn city, sloughing off both the past and the future as snakes shed their skins, children who were never taught and would never now learn the games that held society together." We were the evidence "that at some point we had aborted ourselves and butchered the job."[11] Rarely had we, and I, been denounced so eloquently.

Before I ever recognized the essay as a lament for "true California," I understood that I did not recognize my California in it. The Californians that I knew were not native to the place. They were part of its endless churning. This did not make them strangers—this made them Californians. What Didion lamented was not only people like me and my family, but the loss of the story she had told herself of a true California and the privileged place it provided her. As writers often do, she mistook the story she told—true California—for its subject: the state itself. People my parents' age who gleefully told me to read *Slouching Towards Bethlehem*, presumably so I could feel bad about myself, did not recognize that the essay attacked them too. They were the new people, and they

produced the hippies and radicals. Didion regretted the entire post–World War II migration that had turned ranches and orchards into subdivisions, familiar towns into identical suburbs, and replaced people like her family with people like us.

What I didn't recognize—and neither, I think, did Didion at the time—was that *Slouching Towards Bethlehem* had traveled halfway to its own partial repudiation in *Where I Was From*. When she wrote *Slouching*, a new California dream of endless middle-class expansion had replaced the true California of the Native Sons. That dream, embraced by Governor Edmund G. Brown and the Democratic Party, dominated the 1950s and 1960s. It turned dark later in that decade when it joined true California as a story of decline, loss, and regret.

Didion's stories seem at first distant from photographs of decaying houses and vanished homes, but they are not. Didion explored the darkness.[12]

FRANK LATTA AND THE WAR

No historian goes looking for a letter like Frank Latta's. It is in a collection called "Skyfarming." It is in a file named "Rancho Gazos, Pescadero" that sits between files labeled "Site of the Orestimbe School Pump" and "William Malcom Mss. and photos."[13]

Latta's letter is the story of his son, but it is also a story of people set adrift by World War II and living in a California that is changing around them. It begins in the San Joaquin Valley and ends up on *Rancho Gazos* in Pescadero near Santa Cruz, where I went to college and which evolved into a center of the counterculture. All of these California places interconnect. Latta's son Don linked the San Joaquin to Santa Cruz, just as Yokuts from the Tulare Basin ended up at Santa Cruz mission. The Steele family, who rented from the Shafters but left in search of land of their own, moved to Pescadero. Today Pescadero is celebrity ranches—Tom Steyer, the billionaire environmentalist, owns the KitKat Ranch near there—but in the 1950s it was just decaying dairy and cattle ranches that even an ex-schoolteacher could afford, though it was a stretch.

Frank Latta addressed his 106-page letter to his grandchildren and "to the descendants of Don Allen Latta," but really he wrote it to himself. He needed to understand how things fell apart. He started it on July 22, 1958, and finished it on September 13. It does not appear that he ever sent it.

Frank Latta had recorded Thomas Jefferson Mayfield's account of the early settlement of the Tulare Basin in which Mayfield in his old age had referred to his own father as "Daddy." Writing to his grandchildren, Latta uses "Daddy" to refer to his own son. "Now that your Daddy, who you should remember is also our only son, has entered the receiving center of California State Penitentiary at Vacaville," Latta's letter begins. Latta and his wife Jean were determined to go beyond the newspapers and court records that reported Don Allen Latta's conviction for three counts of burglary. It was a historian's response to tragedy. He wanted to set down "some of his early history and the events which led to such an unfortunate situation."[14]

Handwritten, Latta's letter is raw and rambling. He keens on, roaring through pain, anger, blame, and regret. The issue is not about his son's crimes but rather the "sickness" responsible for the crime and who, or what, is to blame for the sickness.

Latta tells his grandchildren that the psychiatric report "laid the entire blame for all of your Daddy's trouble on me: that I had mistreated your Daddy since he was a little boy, that he had never got over it and this bad father-son relationship was the cause of his breakdown and all of the wrong things he had done."[15]

Latta accepted some responsibility, but he laid more on others. The schools had placed his son "in a class of retarded and delinquent students, which in that community overflowing with migratory workers, meant a social group ages distant from your Daddy. He had suffered from the contact more than from his reading deficiency."[16] But mostly Latta blamed World War II and Korea.

War changed Don and aborted his prospects. "I for years had been aware that the GIs of WW II and Korea were to a large percentage to be ruined economically for life—even the GI homes they purchased with nothing down would be in a slum clearance project by the time they were paid for."[17] He blamed Don's friends, and the fraternal organizations, including the Native Sons, who abandoned his son.[18]

Most of all he blamed Don's wife Carol and a world where women sought careers outside the home. It was Carol's desire to be a commercial artist that sent Don and the family careening from Capitola, where he had been the "best Chief of Police" the town would ever have, to Bakersfield, and then Palo Alto, on to Santa Cruz, briefly into the Santa Cruz Mountains behind the town, and then to Mountain View, where he was living when they arrested him. The "biggest mistake Don ever made was in leaving Capitola."[19]

The constant movement, his inability to stay in a job and support his family, were the signs that Don was a "sick, whipped man. He was no longer the head of his family and had lost the respect of those with whom he had grown up." It was when he left the San Joaquin Valley, moving from Bakersfield to Palo Alto, that Don "lost the last shred of his self-respect." Carol called the shots, and Don followed from a fear that he would lose his wife and family. Although Don had quit school and left jobs long before meeting Carol, Frank Latta did not lessen her culpability.[20]

Latta believed that homes depended on a subordination of women and children to the male head of household. Carol kept Don hanging "in the air"; he was never sure if she would leave him. She created uncertainty, and the result was turmoil and emasculation. Well before Didion described the 1960s, Latta saw homes breaking apart and children cutting loose. But the Lattas weren't new people. They were old settlers. The decay that began in those Central Valley houses reflected the place itself. The abandoned homes of the Tulare Basin were a center that did not hold, a violation of the rules of the game.

Latta laments, without ever naming, a lost patriarchy when a man ruled his family. But this particular American reality had faded a century before. The most tragic part of Don's story was that his father thought it never needed to happen. The appropriate roles were always out there, ready to be played, if only his son and Carol had been willing to step into them. "If your mother had married a man who would have made the decisions concerning jobs and business the public would never have heard of a case such as your Daddy's. If your Daddy had married a woman who would have allowed him to be the head of the family, he wouldn't be where he is now." Why Don Latta had been complicit in Carol's control of the household was the mystery that Frank Latta sought to solve.[21]

By the time Don Latta moved back to Santa Cruz in the 1960s and his father had bought the ranch at Pescadero, Don Latta had begun to steal. He brought guns and a saddle to sell to his parents, and he gave them other goods to settle loans. They did not ask where the goods came from. They knew Don was a good trader.[22]

Becoming a thief to support his family was a symptom of Don's sickness, but it was not the sickness itself. Frank Latta was certain that other secret burdens had led to his son's crack-up. For his son to recover, those secrets had to be revealed. Don Latta's actions were a mystery that needed to be solved, and its solution would give the story a dramatic climax.

Frank Latta discovered that Don had told Carol war stories that neither he nor Jean had ever heard. One incident involved a Purple Heart; the other heroic action earned him a Bronze Star. But Frank discovered that Don had picked up the Purple Heart after a warehouse explosion, and he had made up the Bronze Star story. A man who had spent his life recording and evaluating stories decided his son's stories were lies told to impress his wife. But there remained the possibility that Don had been in two plane crashes, one of which left him with a head injury. The man who recovered the stories behind the houses and settlement of the Tulare Basin was not sure what was true; he could not give a reliable history of his son.

Latta thought a true history of his son would demonstrate a service-related disability that would send him to a Veterans Administration hospital rather than prison, but Carol would not cooperate. Latta alternated between thinking her a child and thinking she wanted Don gone for a year. It was, he thought, revenge. "She was willing to crucify your Daddy to hurt us—to see him go to the penitentiary in order to do it."[23]

The final blow, Latta wrote, "fell on the Friday afternoon before the Monday Morning, July 21, 1958, when your Daddy, the one person in the world all of you had the right to worship as your hero, was sentenced to the penitentiary. It was his long-borne fear of losing your mother that cast the die."[24]

For the six weeks Don was jailed in Santa Cruz, fear of losing his wife and family ate away at him. "He wrote a letter to your mother and . . . later he got permission to talk to your mother over the phone." He threatened to take his life if she left him, that he would make a good job of it the first try. "While talking on the phone, he collapsed and had to be put in the solitary safety cell. Not long afterward he was removed to the security ward at the county hospital in order to prevent his injuring himself."[25]

Don's parents knew nothing about this incident until that Monday, when he was sentenced to the penitentiary. They got the full story from Carol's minister, Roy Kraft, who had visited Don at the hospital on Saturday. Kraft learned the final element of the mystery. "Your Daddy said that he had been unfaithful to your mother. This had been gnawing at his conscience until he had broken, and he was determined to take his life if your mother left him."[26]

Frank Latta thought infidelity was the key to "the long string of troubles and particularly to your Mother's incredible behavior." But he was wrong; Carol had not known. The Rev. Kraft had told her only a half hour before Don was sentenced. Frank wrote, "Your Mother let him go away with the feeling that she would leave him. We saw them part."

Frank Latta drew out a moral from the story

that favored Don over Carol. "Four out of five husbands who had committed adultry would never have given such a situation a second thot, much less have confessed it. Your Daddy had collapsed over the thot of it. He didn't need to mention it except that he was scraping the bottom of the barrel to get off of his mind and conscience every pressure there was. He was bareing his soul in a way that your mother, in my opinion, never would have done and which I believe she couldn't appreciate in anyone else." Don "was wiping the slate clean, even if he gave his life in the process. He was doing what he felt was necessary to make himself a clean father, husband and citizen." There was perhaps, Frank Latta told his grandchildren, "a psychological reason for that behavior. Was not your mother's long continued practice of keeping him hanging in the air probably one of the most consuming of all forms of unfaithfulness?" (All spelling here is as in the original.)[27]

Latta's story sounded like something out of Didion; the crack-up, as in *Run River*, comes from within. The war and new people were only exacerbations; true California could not endure. It was only a mirage. The Lattas' travails in the 1950s make the 1960s seem less dramatic. To make that decade seem a sharp break, the 1940s and 1950s needed to be rehabilitated as stable. This is what Didion attempted in *Slouching Towards Bethlehem*, but not in her early first novel, *Run River*.

What Don Latta feared came to pass. Carol divorced him for extreme cruelty in August 1960. When Frank Latta died in 1983 at the age of 90, he was remembered as a chronicler of true California. His obituary mentioned that he was a past president of the League of Western Writers and the State Historical Society.[28]

The *Santa Cruz Sentinel* published Don Lat-ta's obituary thirteen years later, in 1996. It said he was a native of Tulare and had served in the Air Force, but it left out a lot. There was no mention of his divorce or any remarriage, although he had a stepson. There was no mention of prison. In the obituary, he had gone from being chief of police in Capitola to being a rancher on the coast (presumably the odd jobs he did for his father); then in the mid-1960s he had moved to Sacramento, where he worked until his retirement with the Department of Parks and Cemeteries. He retired to Santa Cruz in 1991, near his children. He loved dogs and classic cars.

There was a final item. The obituary noted that "during the 1938 World's Fair, he and his father rafted from the Kern River, near Bakersfield, to Treasure Island in the San Francisco Bay. Much of his youth was spent touring around California with his historian father, interviewing early settlers and Native Americans." In death, his family restored him to the true California that existed before everything went wrong.

The sixties, Didion complained in another essay, were "those years where no one at all seemed to have any memory or mooring," but in the light of the Lattas this, like so much of Didion's writing, seems both a striking aperçu and off the point. It was in the fifties that the Lattas lost their mooring and then rearranged their memories.[29]

Where I Was From was Didion's attempt to find the "point" of California. "It represents," she wrote, "an exploration into my own confusions about the place and the way in which I grew up, confusions as much about America as about California, misapprehensions and misunderstandings so much a part of who I became that I can still to this day confront them only obliquely." She was hardly alone.[30]

BOB HOPE AND THE INDIANS

The Bob Hope Memorial Garden, San Fernando Mission

Jesse took the photograph of the Bob Hope Memorial Garden at San Fernando Mission because he found the burial there of Bob Hope—the Hollywood comedian—to be so Los Angeles and incongruous. And it was, to someone Jesse's age. For me not so much, at least the incongruous part. Except for Our Lady lurking in the shadows, the photograph is nearly a snapshot, but it is a revealing one. Hope was born in England in 1903 and immigrated as a child. He is buried among largely forgotten and invisible Indians. Bob Hope and the old mission lands trace the arc of Los Angeles history.

There is an archaeology to one's life. Our presents can layer and bury our pasts. Jesse's photograph of the Bob Hope Garden makes me dig down into parts of my own past I rarely visit and never knew completely. I find Hollywood and the missions everywhere.

As a teenager in the 1960s, I lived in Woodland Hills and Tarzana, and went to school in Encino, all once part of the lands of San Fernando Mission and then the sprawl of Los Angeles. There was a Tongva *rancheria* called *Siutcanga* in Encino. Its inhabitants ended up at San Fernando, and many of them quickly died there. I knew nothing about the Tongvas in the 1950s and 1960s.

Charles Lummis, the architect of the mission myth, romanticized Indians, and sympathized with them, and even became an activist for Indian rights. But ultimately he saw them only through the eyes of the Franciscans. "The Spaniard," Lummis wrote, "never exterminated. He conquered the aborigine and then converted and educated him, and preserved him."[1]

Others challenged Lummis's version of Spanish beneficence, but they did not really change the place of Indians in the mission story. The monastery of San Francisco at Palma, Mallorca, where Junípero Serra taught and other missionaries studied, looks like the faux Spanish quadrangle at Stanford University, where I teach. Stanford's first president, David Starr Jordan, had been a friend of Charles Lummis. Its cofounder, Leland Stanford, had been governor of California during some of the long wars of extermination waged against California Indians. The university in its own way is an homage to the missions and dead Indians.[2]

In 1901 Henry Hudson, a Stanford English professor, wrote *The Famous Missions of California*. He noted that the Indians were "for the most part indolent, apathetic and of low intelligence," but for all the disadvantages of Franciscan tutelage, they accepted "the change from the hardships of their former rough existence to the comparative comfort of the mission . . . with a certain brutal contentment." They became "slaves under another name." The Spanish had failed "in the task of transforming many thousands of ignorant and degraded savages into self-respecting men and women, fit for the duties and responsibilities of civilization." Whether the Indians were contented Christians or slaves under another name did not alter a myth that was never really about Indians at all. Actual Indians died; mythic Indians lived on to reflect glory on Franciscans. In both myth and early histories, Indians were only the supporting cast.[3]

In the mission myth the missions begin and end. Eden came in between. Like a painting or a photograph, once created nothing essential changed within the frame. When Mexico broke free from Spain and secularized the mission, the idyll was over. The Franciscan attempts to preserve the mission lands for their congregations failed.

Mexicans, the *gente de razon*—the so-called people of reason—obtained access to the mission lands.

THE SAN FERNANDO VALLEY

In the 1950s and 1960s, when Los Angeles was not so sharply divided by wealth, Bob Hope's brother, Jack, who was a television producer ("Celebrity Golf") had owned a "ranch," the un-subdivided plat of a still earlier subdivision of mission lands, at the end of the street where I lived. He died in 1962, just before my family arrived; later his widow moved to Encino. One of the Smothers Brothers—it was the straight man, Dickie, my brother Stephen thinks—lived a couple of blocks over in our middle-class neighborhood in Woodland Hills.

My family, Bob Hope's brother, and Dickie Smothers were all children of Hobart J. Whitley—the founder of Corcoran, but much more famously a developer in Los Angeles. His wife proclaimed him "the Great Developer." Virginia Margaret Whitley wrote a deservedly unpublished but quite interesting biography of her husband, whom she loved, resented, and on occasion seemed to disdain. She was "spiritual" in the way of many theosophists, spiritualists, and members of a bewildering array of cults in early twentieth-century Los Angeles. She credited her gift of prophecy for saving her husband's life in 1910. She kept him from a meeting in the Los Angeles Times building on the night when the McNamara brothers, militants in the Iron Workers Union, blew it up; they were targeting the bitterly anti-union publisher Harrison Gray Otis.[4]

Whitley had been attending meetings at the Times building because he was part of a con-sortium with Otis that became the Los Angeles Suburban Home Company. My old neighborhood descended from the Suburban Home Company. Woodland Hills, like Dickie Smothers and Jack Hope, was the Los Angeles that television made. Hobart Whitely grew out of the Los Angeles of movies. The great noir movies about Los Angeles are an exaggerated gloss on the city's history. Everything seems to involve deception; almost everyone is corrupt.

In the Thomas Gibbon Papers at the Huntington Library, there is a letter dated August 17, 1909; it is from Harry Chandler, Otis's son-in-law, to Gibbon, a leading Democrat and the editor of the *Los Angeles Herald*. The letter could have been deposited by a scriptwriter for the film noir classic *Chinatown*. Chandler suggests that he and Gibbon take the last of the seventeen shares in the speculation to buy "47,000 acres of land, which is the cream of the San Fernando Valley . . . Gen. Sherman, Gen. Otis, H. J. Whitley, and a number of others who do not want their names used in connection with the deal, have promised to go in." Since the deal was not yet closed, "it is of vital importance that nobody here shall get an inkling as to what is going on."[5]

In 1910 Whitley, Otis, Harris Chandler, Isaac Van Nuys, James Boon Lankershim, Moses Sherman, Gibbon, and others whose names still litter Los Angeles formed the Los Angeles Suburban Homes Company to develop this land. It was a shell company to obscure the so-called Board of Control, the five leading investors whose identities at the time remained secret.[6]

The company's goal was to develop the San Fernando Valley, then arid grazing and wheatland not yet part of Los Angeles. Otis was also involved in the earlier and smaller San Fernando Mission

Land Company, an entity which, like so much of Los Angeles, united men who hated each other. What was said of two of them, Henry Huntington and E. H. Harriman, was true of all: "Their hate for each other was so terrible as to be less intense than only their love of their business interests." The company was suspect from the beginning for using inside information available to one of its members, Moses Sherman, who served on the city's Water Commission, to purchase San Fernando Valley lands whose value would increase astronomically with water. The story of the aqueduct that brought water from Owens Valley to Los Angeles is often exaggerated. Otis and his associates did not have the power to fake a drought or to arrange for the building of the aqueduct, but they did have the power to profit from their insider knowledge. In associating with Otis, Whitley had joined men who were not to be trusted, but he was very familiar with such men. He was one himself.[7]

Whitley had platted towns across the West, and he came to California in the mid-1880s about the same time as Charles Lummis. Lummis crafted a California present from a mythic past; Whitley, along with Otis, deployed a vision of Los Angeles as the "Mediterranean Land of Sunshine" to sell Indian lands that had been annexed to San Fernando mission. He was ubiquitous in the land schemes of Southern California, and, except for Corcoran, Whitley was good at selling land. Along with Moses H. Sherman and Harry Chandler, he bought and developed the site where Hollywood now stands. Whitley and his wife gave Hollywood its name and then attached their name to Whitley Heights in the town.[8]

Whitley, Chandler, and other developers exemplified the mixture of greed, sex, corruption, deception, puritanism, familial dysfunction, and Midwestern wholesomeness that often came to define early twentieth-century Los Angeles. Only Otis was exempt from this mixture. He was unrelievedly sordid. Hiram Johnson, campaigning for governor in Los Angeles in 1910, memorably attacked him:

He sits there in senile dementia with gangrened heart and rotting brain, grimacing at every reform, chattering impotently at all things that are decent, frothing, fuming violently, gibbering, going down to the grave in snarling infamy.

Otis was behind "anything that is disgraceful, depraved, corrupt, crooked, and putrescent."[9]

The sordid and the progressive often mixed. Gibbon, who thought Hiram Johnson's election was a good thing, still worked hand in glove with Otis. Gibbon's *Herald* was the supposed antidote to Otis's and Chandler's *Times*, but Otis financially backed the *Herald* and controlled it. Both papers supported the aqueduct, both promoted plans to annex the San Fernando Valley that would enable water to be distributed there, and both opposed Job Harriman, the Socialist candidate in the mayoral election of 1911 who attacked the aqueduct as a tool to enrich San Fernando land syndicates. Gibbon, Chandler, and Otis were all newspaper owners who were also part of land syndicates. Newspapers and land syndicates were symbiotic.[10]

Harriman's campaign was the last great threat to the syndicates. His campaign was fueled by organized labor, the great enemies of Otis and the Merchants and Manufacturers Association,

which enforced the city's open shop. Leading issues of the election were the supposed framing of the McNamara brothers—John J. and James B.—for the Times bombing, along with debating the need for an aqueduct. Harriman was not only the mayoral candidate; along with Clarence Darrow, he was also one of the lawyers for the McNamara brothers. When Darrow, without Harriman's knowledge, had the McNamaras accept a plea bargain just before the election, he sabotaged Harriman's campaign.[11]

The Suburban Homes Company claimed the delivery of Owens Valley water in 1913 was only a happy coincidence—and in any case the firm would not profit unduly, because it was selling off the land. This was an odd defense. Selling off the land to reap speculative gains was the whole purpose of a land company.[12] In the press, Whitley seems to have taken credit for both the annexation and access to Owens Valley water. Gibbon earned hefty legal fees for helping arrange the valley's irrigation district.[13]

It was still necessary to sell valley lands, and Chandler, an inveterate promoter, thought with good reason that he could sell anything. Dr. John J. Brinkley seemed to provide indisputable proof. Brinkley specialized in an operation that "sexually rejuvenated" his human patients by transplanting "gonads from Arkansas Toggenberg goats, a relatively odor-free breed." Chandler would later bring Brinkley to Los Angeles, where the doctor implanted glands in a *Times* editor, an editorial writer, and three printers. Chandler gave Brinkley publicity that set him on the road to fame and brought him millions. Brinkley later came within one thousand votes of being elected governor of Kansas. Compared to this, selling land in the valley was not a particular challenge.[14]

The "Board of Control" divided the southern

half of the old lands of Mission San Fernando Rey de España into 5- to 40-acre tracts that formed a mixture of orchards, garden tracts, and town sites. The dwellings would be "high class . . . especially of the Moorish and Mission designs." The mission land had already passed between a series of owners who had in the 1880s managed to evict nearly all the ex-neophytes, many of whom had obtained Mexican title to their lands.[15]

Not all these lands sold immediately, and the "H. J. Whitley Syndicate" advertised itself as the "Owners and Developers of over $2,000,000 of Sugar Beet, Bean, and Orchard lands in the heart of the San Fernando Valley and fronting Paved Boulevards and Electric Railroad, and under $2,000,000 Distribution System for Owens River Water." Whitley managed valley land for himself and for syndicate members, renting them out for the production of sugar beets and beans.[16]

Modern Van Nuys anchored the development, but for me Tarzana and Woodland Hills were more significant. Otis sold 550 acres to the author Edgar Rice Burroughs, who named it Tarzana after the character in his novels that had made him wealthy. In the 1960s my family moved into his old barn, which had been refurbished as a house. The estate was long gone. My mother hated that barn/house, which leaked a strange yellow dust that covered everything, and we moved to Woodland Hills. It was located on the edge of the hills in the lower left-hand corner of the Van Nuys/Lankershim Subdivision map.[17]

Virginia Whitley thought of her husband as a victim of the Board of Control, cheated out of his rightful gains, but she also thought he had, in turn, victimized his family. He was, she wrote, "what we call a 'self made success' devoid of the most sacred things in life—the love of home, church and reli-

Plat San Fernando Valley, Los Angeles Suburban Homes Company

gious duty and away from his family and society at large most of time—all given to the dear 'Public' his time, his money, his experience and his birthright of peace and comfort. What did it profit the great developer—a genius in his line? 'Nothing but his selfish desire to do these things that urged him on, and caused him to sacrifice his life in the name of 'Progress.'"[18] She celebrated the development of the mission lands, but their development also seemed to her a story of sin, sadness, and misplaced effort. It has always been easy to be ambivalent about Los Angeles.

MY MOTHER'S MISSIONS

When we moved to California, I could not escape the orbit of the missions. We lived in Orange County then, and my immigrant Irish-born mother, who was growing constantly more Catholic, would drag us to San Juan Capistrano. Sometimes my atheist Jewish father would come. More often, as I remember, he did not. He played Hobart Whitley to my mother's Catholic Margaret.

I did not realize at the time how sad these trips were, how much they marked the trajectory of my mother's life during and after World War II. My father was the love of her life, but by the time we arrived in Orange County there remained little obvious love in their marriage. When my mother dragged us to Capistrano, she was being Catholic, but she was also reminding herself of the woman she had been and the man she had loved. My mother and father married during the war—she an Irish immigrant with a third-grade education, he the son of an immigrant but also an army officer with a Harvard degree. When he had been sta-

tioned at the Monterey Language Institute, they had lived in Carmel, the site of a mission. It was a place they both cherished. He later told me how she would climb trees on the beach. She told me she attended Mass at the mission. For both it was a time lost, never to be regained.

San Juan Capistrano was known for the "miraculous" return of the swallows on St. Joseph's day every year. They nested in the ruins of the old church, destroyed in the earthquake of 1812. The miracle at Capistrano was bogus. The swallows began returning weeks before the saint's day; and now, with their surrounding habitat built over, they do not return at all. My mother probably hoped for a miraculous return of her own, but my father—at least the man my mother wished for—never reappeared.

I thought I had broken free of the missions by the time we lived in Woodland Hills. I went to Crespi Carmelite high school in Encino. The Carmelites had nothing to do with California missions, but Father Juan Crespi, after whom the school was named, was a Franciscan and a missionary.

Like Sir Francis Drake, Crespi had been an explorer, and like my mother, he became attached to Carmel. He accompanied the Portolà Expedition of 1769. In the great tradition of California exploration, the Spaniard Gaspar de Portolà was perpetually confused about where he was and what he was seeing. When he looked for Monterey Bay, he missed it, and instead found San Francisco Bay. He and his companions did not know this at first. They were then on the lookout for the *Bahia de San Francisco*, a name that was at the time still attached to Drakes Bay. Portolà and his men had stumbled onto what is arguably the greatest harbor in the world, but it took them several years to

realize it. In 1772 Crespi and other Spaniards were again prowling the shores of San Francisco Bay, searching for a way to get from the finest anchorage on the continent to the "real port"—Drakes Bay, one of the worst.[19] Father Crespi spent much of his remaining time in California at Carmel. He left it and then yearned to go back. Unlike my mother, he did return. He died there.[20]

Herbert Bolton, who would fall victim to the Drake's Plate hoax a few years later, edited the diaries of Crespi in 1927 when the romance of missions was at its height. Bolton thought Crespi and the missionaries "superb pioneers of civilization," who "taught their rude neophytes the elements of European culture" and "directed the labor of their charges toward bringing the frontier spaces under profitable cultivation."[21] All those dead Indians to the contrary, Bolton and the Catholic Church did not consider the missions failures, which is why Los Angeles high schools took on the names of missionaries.

Crespi Carmelite encapsulated a mid-twentieth-century California Catholicism that wiped away memories of Indians who had once lived in the valley while remembering the missionaries. But the failure of the missions found parallels in those schools, which were pregnant with failure. Many of the priests who taught me eventually left the order. The Church had trouble replacing them, and it was starting to hemorrhage congregants.

At the Bob Hope Memorial Garden and Meditation Center, a frieze of Bob Hope decorates the wall. A statue of Our Lady of Hope (of course) sits in the center of a fountain. He converted to Catholicism a few years before he died at age one hundred in 2003.[22] To bury Bob Hope at San Fernando Mission, now surrounded by the suburbs Whitley helped create, was apparently Hope's

Grave marker, San Fernando Mission

long-suffering wife's idea. In a story, probably apocryphal, when asked where he wanted to be buried, he said, "Surprise me." I rarely found Bob Hope funny, but this is a good line.[23]

Adjacent to the Bob Hope Memorial Garden is the old mission graveyard. This juxtaposition is very California. Bob Hope had not been surrounded by so many dead Indians since he starred with Jane Russell in the "Rip Roaring Technicolor Laugh Spectacle" *The Paleface* (1948), which created literally a pile of dead Indians. The representations of Indians in these movies were only superficially simple; they created representations of representations as ridiculous as the white characters. Among the supporting cast were "Chief Yowlachie," a Yakama, and Iron Eyes Cody, an Italian American born Espera or "Oscar" DeCorti, who changed his name and

played Indian. He married an Indian, and his adopted sons were Indian. In Los Angeles things are complicated.[24]

In *The Paleface* Hope kills Indians, but at the mission they are already dead. There is a cross in the graveyard commemorating the 2,425 people interred there between 1797 and 1852, most of them Indian converts. None are named, nor are there individual graves. There is no explanation of how they died. Their deaths are allotted less space than Bob Hope's. The first Indian rebellion against the missionaries at San Gabriel had come from the failure to remember and commemorate the dead.[25]

Bob Hope, my mother, my father, Father Crespi, the Whitleys, and invisible Indians are my Los Angeles. The missions run through it. For all the changes, nothing much has changed.

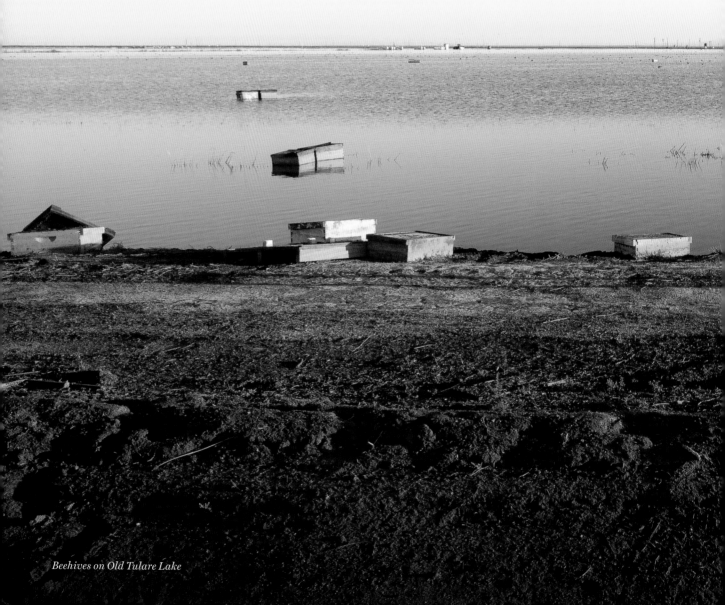

MOVING THROUGH TIME AND SPACE

Beehives on Old Tulare Lake

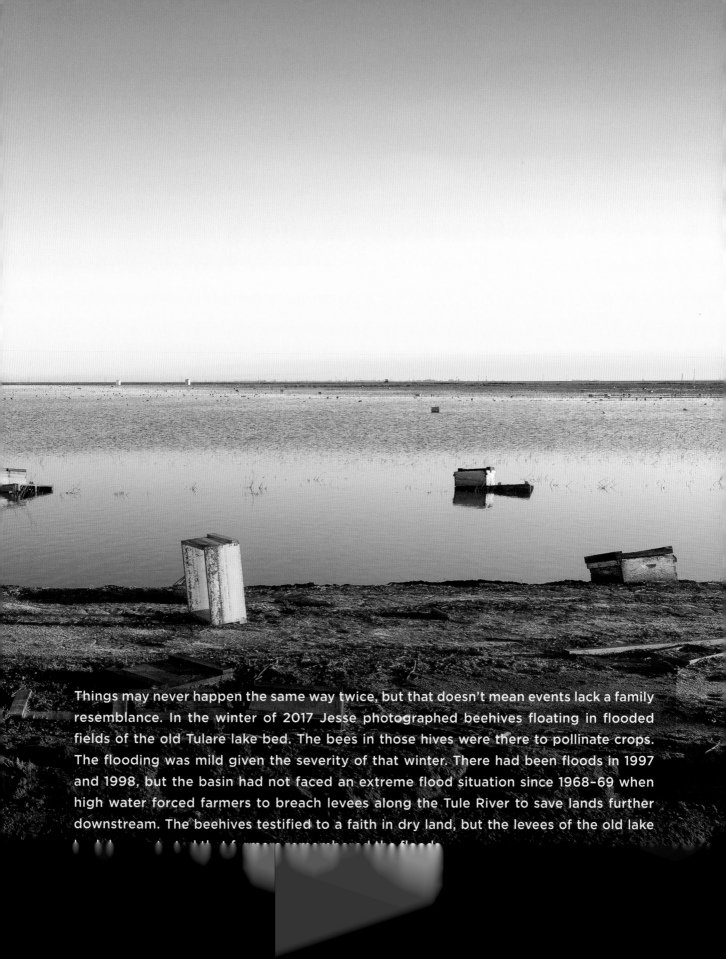

Things may never happen the same way twice, but that doesn't mean events lack a family resemblance. In the winter of 2017 Jesse photographed beehives floating in flooded fields of the old Tulare lake bed. The bees in those hives were there to pollinate crops. The flooding was mild given the severity of that winter. There had been floods in 1997 and 1998, but the basin had not faced an extreme flood situation since 1968–69 when high water forced farmers to breach levees along the Tule River to save lands further downstream. The beehives testified to a faith in dry land, but the levees of the old lake

MOVING WATER:
THE CRISIS OF THE
SAN JOAQUIN VALLEY

California Aqueduct, Fresno County, California

I n February 2013, Jesse stood on the bridge at North Russell Avenue in Firebaugh, which is west of Fresno and north of Lemoore, and took this photograph of the California Aqueduct, which moves water from north to south. Approved by the state's voters in 1961—despite opposition from everywhere but Southern California—and completed in the early 1970s, the aqueduct was designed to transfer water from Northern California, where it was relatively abundant, to Southern California, where it was scarce. It is now nearly fifty years old.[1]

The aqueduct achieves a kind of magnificence as it flows into the vast blue sky of the valley, but there is also something discordant about it. The aqueduct does what nature cannot do. It makes water move uphill, defying gravity. It sustains no vegetation along the concrete banks. The aqueduct is both life giving and lifeless.

Water can defy gravity because the California State Water Project moves energy as well as water. Dams where rivers flow out of the mountains provide electricity to pump water over other mountains. Energy and water flow together.

Many of Jesse's photographs show the extraction of water, but often not water itself. Rivers are often dry; bridges arch over sand. Sometimes pumps, which demand energy, gush water,

Dry riverbed, Kings County, California

but other times they just appear incontinent, the ground around them wet and soiled.

When I travel the landscape that Jesse photographed, I see pumps, dry rivers, and aqueducts separately; photographs allow me to juxtapose them. Together they trace a history of water transfers and landscape transformation that stretches over a century. The infrastructure of water is fundamental to the creation of modern California. It also indicates how the state must change.

MOVING WATER

A photograph of the State Water Project is really a geneaology. It involves not only the usual begats but also a list of old family quarrels, betrayals, and illicit consignations, whose ramifications ultimately involved the entire state and nation. Since those who get the water do not pay its full cost, resentments—most of them rightful—spawn lasting grudges.

The genealogy runs something like this. The State Water Plan of 1931 begat the federal Central Valley Project (CVP), when the state proved unable to fund its own plan. The progeny of the CVP included Shasta Dam in the far northern part

Irrigated orchard, Tulare County, California

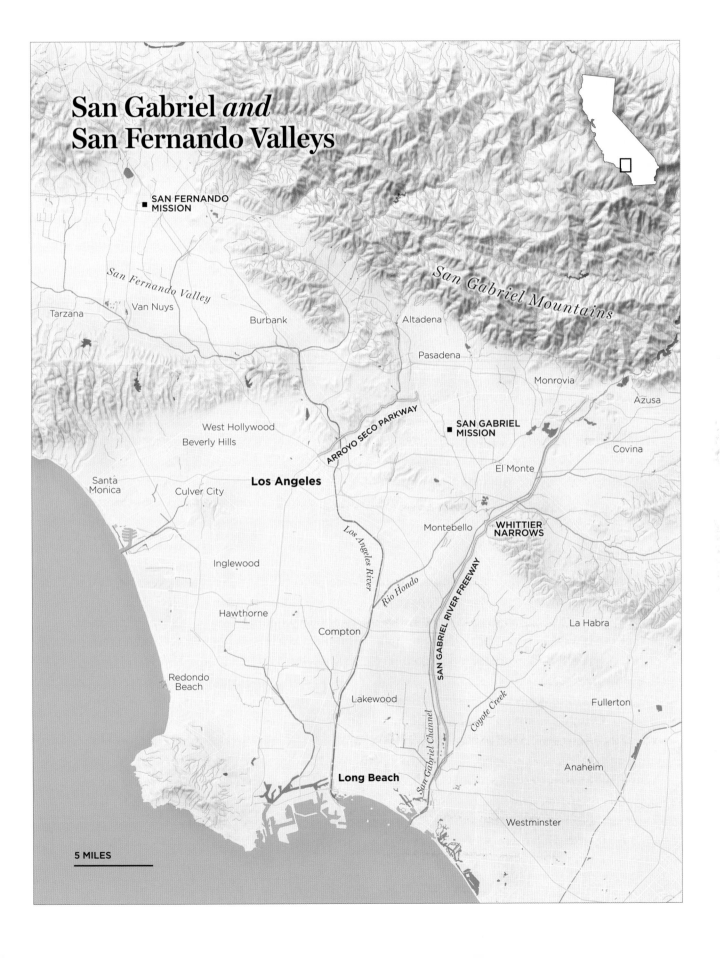

San Gabriel *and* San Fernando Valleys

SAN FERNANDO MISSION

San Fernando Valley

Tarzana

Van Nuys

Burbank

San Gabriel Mountains

Altadena

Pasadena

Monrovia

Azusa

ARROYO SECO PARKWAY

SAN GABRIEL MISSION

West Hollywood

Beverly Hills

Covina

El Monte

Santa Monica

Culver City

Los Angeles

Montebello

WHITTIER NARROWS

Los Angeles River

Inglewood

Rio Hondo

SAN GABRIEL RIVER FREEWAY

La Habra

Hawthorne

Compton

Redondo Beach

Lakewood

Fullerton

San Gabriel Channel

Coyote Creek

Long Beach

Anaheim

Westminster

5 MILES

of the state and the Delta-Mendota and Friant-Kern canals in the San Joaquin Valley. California did not want a divorce from the federal government, but it did desire a legal separation. The state built a new State Water Project in 1961, which produced the California Aqueduct.[2]

The State Water Plan of 1931 originally envisioned moving Sacramento River water south into the San Joaquin Valley as well as building an aqueduct from the Colorado River into the Los Angeles Basin. This plan became redundant when Southern California forged its own agreements for Colorado River water. The State Water Plan became a de facto Central Valley Project. It was immediately mired in controversies over public power and Southern California's resentment over being taxed for a project that would offer it few benefits. Water projects inevitably transfer not only water, but wealth. They are usually Robin Hoods gone bad—they tax everyone, including the poor, and deliver much of their profits to the wealthy. The CVP barely survived a referendum sponsored by the state's giant private utility, Pacific Gas and Electric, to kill it; but the state house and assembly, the project's parents, could not support it. In 1937 the federal government, in the midst of the New Deal, and the Bureau of Reclamation adopted the CVP and took over its financing and management.[3] New components continued to be added into the 1970s.

When finished, the CVP consisted of twenty dams and reservoirs that provided water to irrigate 3 million acres of farmland and support 2.5 million city dwellers. The dams also generated 5.6 billion kilowatt-hours of electricity. Sales of the power helped pay for the dams.[4]

Beginning with Shasta Dam to the north of the Sacramento Valley, the CVP regulates the flow of water into the rivers, then draws water from the rivers into canals that then dump the water back into reservoirs, that in turn release water into rivers further south. There is a Rube Goldberg quality to the whole endeavor. Water from the Sacramento gets diverted into the Delta Cross Channel and flows from there to Snodgrass Slough, where it follows natural channels to the Jones Pumping Plant, which lifts the water into the Delta-Mendota Canal, where part of it gets dumped into the San Joaquin River as it flows west and then north. The San Joaquin needs this water because, until recently when river restoration projects mandated leaving some water in the natural channels, another part of the project, the Friant-Kern Canal, virtually emptied the river at the Friant Dam. The dam's reservoir covered up old Fort Miller, which had offered dubious shelter to the Yokuts. From there, the canal runs south, tucked in at the edge of the foothills above the Tulare Basin, carrying water into Kern County.[5]

Both the State Water Project (1961) and Central Valley Project are children of government. The CVP was the oldest child, brought up under relatively strict rules that admittedly were not always enforced; the State Water Project was the youngest spoiled child, allowed to run wild. Bureau of Reclamation rules that governed the CVP originally prohibited the sale of water to farms larger than 160 acres, and required that farmers live on or near their land. In exchange for the benefits of, first, not being charged interest on the money advanced by the federal government to build the project and, second, having the cost of the water subsidized by revenue from the generation of electricity at the dams that stored the water, landowners had to agree that they could receive only enough water to irrigate 160 acres and that all

remaining irrigated land would have to be sold within ten years at a price reflecting the value of the land before irrigation.[6]

The CVP's extravagant engineering had relatively modest goals. It intended to promote small landholdings and stabilize rather than increase agricultural output. In the 1930s during the Depression, the United States staggered under the burden of surpluses and falling prices. The project's main focus was not on bringing new acreage into production, but on halting the dangerous drawing down of aquifers and making sure existing farmers had water when they needed it, where they needed it, and in the right amounts. Unlike its younger sibling, the State Water Project, the CVP did not so much provide for new farms as rescue existing ones.[7]

There was always good reason to doubt that the CVP would maintain small farms. Much of the irrigable land in the southern San Joaquin Valley was owned by powerful people and corporations in tracts far larger than the 160-acre maximum. A study of Kern, Tulare, and Madera counties—the counties surrounding Kings—found that farms of 160 acres or less formed 89 percent of all farms, but they accounted for only 34 percent of the irrigable land. To put it another way, the 18 holdings of over 5,120 acres had the same percentage of irrigable land (21 percent) as the 9,814 farms of 80 acres or less.[8]

The State Water Project dropped any pretense of encouraging small farms. It serves large growers, many of them corporate. The Kern Valley Water Agency to the south of Kings County has a water allocation of 982,730 acre-feet. The Chevron Oil Company, Shell Oil Company, Tejon Ranch Company, and Getty Oil Company were among the main beneficiaries: each firm owned over 30,000 acres in water districts served by the project during the 1980s.[9]

Travel Interstate 5 (I-5) through the west side of the Tulare Basin, and you will rarely see a farmhouse. The State Water Project has only twenty-nine contractors, entities that have signed on to buy the project's water. Only three are in Kings County—the Empire Westside Irrigation District, the Tulare Basin Water Storage District, and the County of Kings. Of these, the Tulare Basin Water Storage District, with an allocation of 88,922 acre-feet for 190,000 acres, is by far the largest. It stretches between Corcoran and Kettleman City. For all practical purposes, the district is the old Tulare Lake bed.[10] And the Tulare Lake bed was and still is the domain of the J. G. Boswell Company.

Some of the water managed by the project leaves the Central Valley. Water flows, in obedience to the old Western cliché, uphill toward money. The aqueduct climbs out of the San Joaquin Valley and across the Tehachapi Mountains in huge pipes visible to travelers heading into the Grapevine, which is now part of the route of I-5. When the news says that snow has trapped unwary motorists on their way into or out of Los Angeles, they have gone over the Grapevine. When mudslides envelop cars, it is again the Grapevine. When I was a teenager, the Grapevine was part of Highway 99 and, even though it had four lanes then, the road still retained the winding character and the sheer drops of the original Ridge Route. Then I always thought the resemblance of the twisting road to a grapevine gave the road its name, but the name was literal and not metaphorical. The original trail passed through tangles of wild grapes. The pipes are not like the road; straight as an arrow, they carry the allocation of

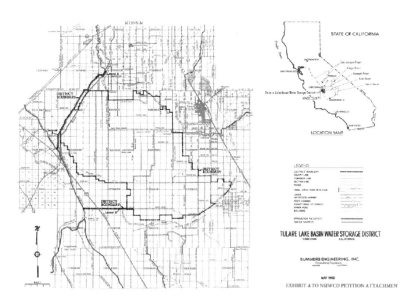

Tulare Lake Basin Storage District, May 1992

the Metropolitan Water District of Southern California to Pyramid Lake. The full allocation delivers 1,911,500 acre-feet of water to largely urban Southern California.[11]

Created in 1928 to secure and distribute Colorado River water, the Metropolitan Water District is sometimes portrayed as the agent of Los Angeles's insatiable demand for water. But with the completion of the Colorado River Aqueduct in 1941, the MWD had more water than customers. Los Angeles had annexed adjacent cities in the early twentieth century when it received Owens Valley water, but although it paid a disproportionate share of the expenses for construction of the Colorado River Aqueduct, the city drew little water from it and barely extended its boundaries after 1930. To secure new customers for its surplus water, the MWD expanded. It absorbed the San Diego Water Authority in 1946 and agricultural districts that were, with freeway expansion, about to become suburbs. After 1960 the MWD changed its financing from property taxes to water sales and redefined itself as a water broker. The MWD became the state's dominant water agency, and its goal was growth.[12]

NEVER ENOUGH

No matter how much water California moves, the state is only temporarily satiated. Access to State Water Project and Central Valley Project water initially reduced the need for pumping in the San Joaquin Valley, but the respite has proved short-lived while the damage from pumping has been permanent. Only gradually did scientists come to understand the complex geology of the hydrological systems that irrigation altered. An aquifer is often not a continuous pool of water, but rather layers of water-bearing soil or sand. Aquitards are less permeable layers of gravel or soil that seal

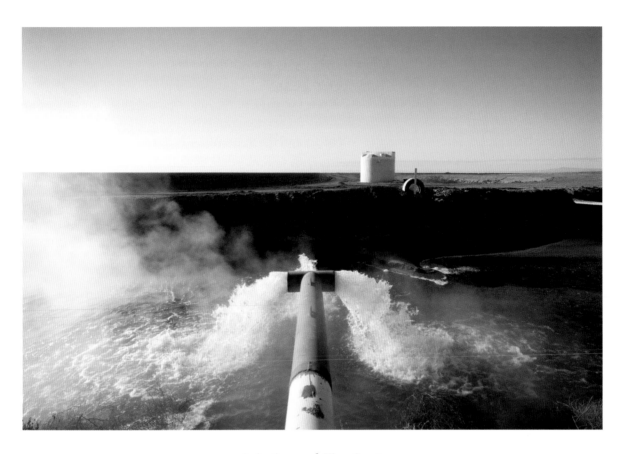

Irrigation canal, Kings County

off and separate the various levels of an aquifer. Aquitards are, however, not completely impermeable; water does slowly move through them. As aquifers empty, aquitards dry out and become compact like a dry sponge. Each cycle of depletion and recovery makes compression more severe and land subsidence more dramatic. In 1976–77 and 1987–91, droughts curtailed water deliveries and pumping increased again, leading to compaction of the aquitards and subsidence. The problem became greater still with the droughts of the early twenty-first century. The area around Corcoran sank at an alarming rate, dropping 3.94 feet during a 3.5-year period.[13]

By leading to an intensification of agriculture, particularly the spread of high-value orchard crops like almonds and pistachios, the water projects made financial sense. Tree crops bring greater return per acre-foot of water. But tree crops can take several years to come into production, and they cannot be left fallow in dry years. They did not make as much sense if the goal was to curtail water usage. By 2015 only alfalfa crops used more water than almonds and pistachios.[14]

The eastern stretches of Tulare County contain a classic California landscape of orchards set against snowy peaks. Move west into the old lake basin and the landscape turns raw and powerful. Water does not flow tranquilly through orchards, it roars out of pumps. That water maintains the

most fruitful agricultural land in the country. Ranked by market value in 2012, seven of the ten most productive agricultural counties in the United States were in the San Joaquin Valley. The Tulare Basin is an agricultural juggernaut, but in terms of California's total economy, it is less impressive. Agriculture comprises only about 2 percent of the state's economic output.[15]

Most Californians see the Tulare Basin through a car window while moving fast along I-5, which runs on the basin's western margin. There is not much to see. Maybe one-tenth of 1 percent of Kings County's original natural habitat remains. The county has as little indigenous natural diversity as any place in America.[16]

What motorists do see are billboards. On them, big growers proclaim that the dead orchards along I-5 are the result of the federal government taking "their" water. But farmers in the San Joaquin Valley routinely cut down old orchards to concentrate on more lucrative crops. Not every dead orchard is the result of the curtailment of state and federal water deliveries, but some are. Contracts with the Westlands Water District and the expansion of agriculture in Kern County added an immense burden to California's water supply. Many years there is not enough to go around.

In the second decade of the twenty-first century, the long history of American manipulation of the San Joaquin Delta and the lands that receive its diverted water seems to have reached a turning point. Californians have replaced a system with extensive wetlands and significant tidal flows and brackish water over large sections of the delta with a freshwater system and a landscape dominated by levees protecting subsided islands. The delta they created is vulnerable to natural forces beyond their control, such as earthquakes; they have exacerbated changes such as subsidence, and they have contributed to climate change, with its consequent sea level rise and changing inflows as snowpacks diminish and melt earlier.[17] The delta and the State Water Project are not just in danger of failure—they have been failing for some time now. It is not a problem that almonds and pistachios will solve.

Even before the onset of prolonged drought in 2012, salt intrusion and collapsing fisheries in the San Joaquin Delta, the source of water for the aqueducts, induced the courts to order water agencies to curtail withdrawals. With the droughts and environmental crises of the second decade of the twenty-first century aggravated by climate change, the amount of water delivered by the State Water Project has been falling. The Tulare Basin Water Storage District got less than 10 percent of its allocation in 2014. Overall since 2000, the State Water Project has provided only one-third of the water that the district has used.[18]

Pumping has made up the difference. Subsidence has reached record levels because groundwater has provided 53 percent of the county's total supply. The Tulare Lake Hydrologic Region extracts more than 6 million acre-feet per year, nearly double the amount of the San Joaquin River Hydrologic Region, the next-largest user.[19] As the land sank, roads cracked. Canals shifted and lost their gradient—and with it, their ability to move water. Bridges descended into canals. Wells supplying towns with water failed. Infrastructure crumbled. The cost ran into the billions. The costs are public; the profits private. Our consolation is that we have plenty of pistachios.[20]

KINGS COUNTY

Modern Kings County is the tenth-richest agri-
cultural county in the United States based on the
value of the crops it produces (neighboring Tulare
is the second richest), but its people do not thrive.
The California Dream does not live here; it resides
on the coast. Nearly half of the people in Kings
County are Latino, and they are poorer, sicker,
and live shorter lives than other Californians. The
county's death rate for diabetes is twice the Cali-
fornia average, as is the death rate for kidney dis-
ease. California is overwhelmingly Democratic,
but in 2016 Kings County gave a majority to Don-
ald Trump. This was not a vote of the neglected
and dispossessed: most of them could not or did
not vote. Of the nearly 89,000 adults in the county,
35,000 voted.[21]

The wealth that agriculture has created has
been concentrated at the top. In 2016, the median
per capita income in California was $60,190. In
Kings County it was $29,537, ranking it 50th out
of 58 state counties. In Tulare County the median
was $26,248—57th in the state. In measures of
health, Tulare ranked 45th and Kings 43rd, with
an estimated 14.3 percent of the population in
poverty. Agricultural productivity has not pro-
duced well-being.[22]

Part of that wealth has come from direct
federal subsidies. Cotton, rice, wheat, dairy, and
livestock have pocketed the most federal subsi-
dies in California between 1995 and 2016. Except
for rice, these are the products of the old Tulare
Lake bed. Kings County received nearly $600
million in subsidies during this period and had
four companies ranked in the top twelve recip-
ients statewide. The J. G. Boswell Company

ranked number 11. The government subsidizes
rich men in a poor county.[23]

American occupation of the Tulare Basin
sprang from violence and injustice; these forces
have changed form, but not disappeared. Wood-
ville in Tulare County was the site of the supposed
flaying of John Wood, a story that came to encap-
sulate American understandings of the righteous-
ness of all that followed in the Tulare Basin. In
October 1933, when growers attacked farmwork-
ers during the great cotton strike, Woodville was
also the site of one of their vigilante actions. "Big
Bill" Hammett, an "Okie"—as Californians called
white migrants then—"with the physical appear-
ance of John Brown" and his sons met force
with force. Hammett, a self-educated preacher,
emerged as a leader of the cotton strike.[24]

Woodville today is still a farmworkers' town.
Its per capita income is $11,352, less than half that
of the county as a whole, and the county ranks sec-
ond to last in the state. People in Woodville get by
only because of multiple wage earners in a house-
hold. The median household income is $34,159.[25]

As farmers have drilled deeper and deeper,
the water table has receded; and pollutants, a
longtime problem, have become concentrated. In
August 2016 Woodville's water became unsafe to
drink, even as Ralph Gutierrez, manager of Wood-
ville's utility district, "counted 60 new agricultural
wells just outside town during one week of his
daily commute." Farmers refused to accept limits
on pumping.[26]

Woodville residents drank some of the worst
water in the nation. Among the pollutants in
Woodville's water was 1,2,3-TCP—derived from
pesticides, it causes cancer. It took the state until
2017 to implement a standard for 1,2,3-TCP,

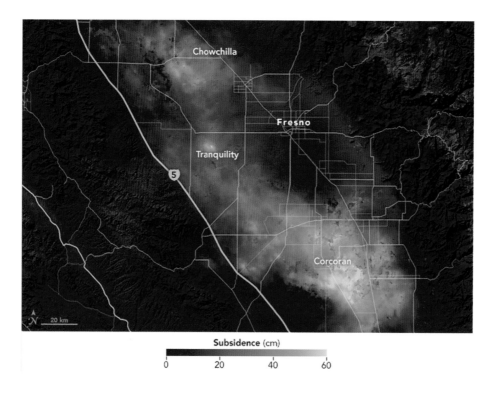

Subsidence, Kings County

twenty-five years after it was determined to be a carcinogen.[27]

There is nothing unusual in such pollution among the poorer towns of the basin. Tooleville in Tulare County also relies on groundwater. Between 1997 and 2015 the town's water supply exceeded Safe Drinking Water Act maximums for nitrates at least seven times. It also suffers from coliform contamination. Bacteria can be killed by boiling, but doing this would concentrate the nitrates.[28] In the San Joaquin Valley, the best way to find dangerous water supplies is to find majority Latino communities with high poverty rates. Poor people have greater exposure to contaminants and lack the resources to clean the water or find alternate supplies.[29]

Woodville residents also breathe some of the foulest air in California. The four most ozone-polluted urban areas in the United States are in Southern California. Los Angeles/Long Beach is number one, but the next three are in the San Joaquin Valley, including Visalia-Porterville-Hanford. Ozone is only one measure of pollution. In terms of people endangered from small-particle pollution, Kings County is ranked second in the state, making its air worse than that of Los Angeles at 16. In terms of year-round particle pollution, Kings County is also ranked second, and Tulare County is third. Los Angeles County did not make the top 25.[30]

Valley fever is a fungal disease caused by coccidioides stirred up in the valley's dust. The disease adds another element to an old public health crisis in the San Joaquin Valley that Sarah Ramirez has

characterized, echoing Henry George's critique of nineteenth-century California and the United States, as "poverty amidst prosperity."[31]

DELTA

The State Water Project and the CVP force Californians to recognize the fundamental connections between different sections of the state. Follow the main aqueduct of the State Water Project back upstream and you reach the delta, where the aqueduct begins at the Clifton Court Forebay. For delta farms to work, for irrigation in the San Joaquin Valley to expand, and for Southern California to receive water from Northern California, the water pumped from the delta has to be fresh. The forebay has all the grandeur of a trash-strewn parking lot, but it is a critical point in the engineering that produced modern California. If tidal flows push too far into the delta, as they did in the nineteenth and early twentieth centuries, the water periodically becomes saline and unusable for irrigation and urban consumption. Water from both the CVP and State Water Project reservoirs has to be periodically released to counter tidal flows and keep delta water fresh.[32]

Releases of water are widely denounced as a waste by agricultural interests in the San Joaquin Valley. In fact, without the release the current system could not keep salinity low enough for either in-delta urban and agricultural uses or water exports. Over time the amount of outflow necessary to maintain salinity standards has increased, and has "put greater pressure on CVP and SWP reservoirs to maintain water quality in the Delta." This outflow has averaged 4.5 million acre-feet

(maf) since 1995 with releases varying widely in wet and dry years. These releases dwarf the amount of water devoted to endangered species, although such water releases have also increased since 2008.[33]

California tried to manage the conflicting interests in the delta through CALFED—a cooperative state/federal process created in 1994 to mediate conflicts between stakeholders in the delta. Its motto was that "everyone would get better together," but when everyone included roughly 230 agencies, institutions, and other stakeholders, this result was always unlikely. On life support in the early twenty-first century, CALFED weakened and failed. Problems in the delta kept multiplying. A catastrophic levee break on Bacon's Island in 2004 put the spotlight on the delta's aging levees as global warming brought rising sea levels. Threatened and endangered pelagic fish populations—delta smelt, longfin smelt, and striped bass—plummeted after 2001, eventually causing the courts to curtail water exports from the delta even as a drought took hold in the early twenty-first century. The drought, in turn, facilitated the invasion of exotic species just as the earlier 1987–94 drought had done. Despite their own differences, delta farmers who wanted to retain water for the delta, environmental groups seeking to protect delta ecosystems, and Northern California cities dependent on the delta for water supplies arrayed themselves on one side. On the other side were San Joaquin Valley farmers and Southern California cities that depended on the State Water Project.[34]

As the financial basis of the CALFED process began to collapse, the goal of maintaining a fresh-water delta and the existing levee system seemed if not fantastical, then inordinately expensive. To

Clifton Court Forebay, San Joaquin Delta, California

complicate matters, housing developments had spread into the delta on lands not included in the Delta Protection Act of 1992, which sought to preserve both the delta ecosystem and agriculture. By 2010, the idea of win-win solutions for the delta seemed chimerical. There probably is no saving the delta as farmers know it. The chance of levee failure on the median delta island before 2050 is 95 percent. The probability of failure by 2100 is 99 percent. The costs of repairing such failures are substantial. The bill for the 2004 failure of the Jones Tract on Bacon's Island was $90 million, which raises questions as to whether preserving many of the islands is worth the cost. On most of the delta islands, the costs of repairing levee failures would either exceed the value of the assets being protected or would be so close as to make the decision indeterminate.[35]

Chapter 25

RESTORING THE PAST

Ruins, D Ranch

L ike a very old person who resides among the living but speaks largely to the dead she knew when she was young, D Ranch is slipping back in time. The ranch ages, but at the same time many of its buildings are restored to what they were when it was a working ranch. Even a single visit, or a single photograph, can capture the ranch's arrested decay. But an isolated glimpse cannot capture the ghosts, the strangeness of its combination of ruin and renewal, and how revealing it is of California. Research is necessary for that. In photographs the ranch's original dairy collapses, and bobcats hunt field mice in the ruins; but a few steps away, it is as if someone is running a movie backward. The old grows young. The old house, built in 1858, acquires new shingles. The beams in the old hay barn are replaced and the roof repaired. The photographs hint at stories, but they cannot tell them by themselves.

D Ranch looks like a ghost ranch: the dirty, frayed white curtains still hanging in the old house; the old, desiccated leather shoes that appeared in the yard during the drought year of 2013–14, when it was largely bare of vegetation; the doors in the cottage used by the ranch hands that suddenly swing open, revealing tattered wallpaper and a collapsed ceiling. This ranch can seem like a place best avoided at night. But the men and women who repair the ranch work for the National Park Service (NPS), and what gets repaired and what falls to ruin is not mysterious, quixotic, or random; it is quite conscious and calculated. It took Jesse's photographs for me to understand the extent of this work. In normal time, what is older tends to be the most decayed; what is newer is better preserved. At D Ranch the opposite is true. At D Ranch, the NPS curates a piece of California's nineteenth- and early twentieth-century past while more recent structures decay.

POINT REYES NATIONAL SEASHORE

Jesse's photographs are artifacts of D Ranch's inclusion in the Point Reyes National Seashore.

The park was created in 1962 and led, eventually, to the National Park Service's decision to maintain the historic structures on D Ranch. By the late 1950s the changes overtaking postwar California had reached West Marin County. There had long been summer homes around the town of Inverness, but now developers encroached on lands west of Inverness Ridge. Changing tax laws led ranchers to sell off their timber rights to the Douglas fir on the ridge. In 1960 Drakes Beach Estates, Inc., subdivided land along Drakes Bay and Limantour Estero near D Ranch. There were plans for a nuclear plant just to the north of Point Reyes. Subdivisions and development seemed likely in the future.[1]

California was growing. In the mid-1960s it had 18 million people, and a thousand new residents were arriving every day. If the state had been a separate country, it would have been the world's fifth-largest economy.[2]

The ranches were archaic by the standards of California agriculture, unable to compete with the huge industrial dairies that had emerged in the Central Valley. But it was clear that many ranchers did not want to sell out to the federal government. A national seashore was not their idea. Although the government had contemplated creating a national seashore in the 1930s, it was not until

1958 that Congress began the process of evaluating Point Reyes for inclusion in the National Park System, and not until 1959 that bills authorizing the park were introduced. In 1960 the government lacked a clear vision of the park or how it might be established.[3]

The National Park Service valued the land for its beauty, diverse ecology, potential for recreation, and proximity to San Francisco; but plans for the area were still vague and inchoate. And while the original bills mentioned ranch lands, they did not specify their preservation as a goal of the park. Nor did original proposals specify boundaries. The NPS intended to keep part of the park as a pastoral zone, but did not give details on how much land and how it was to be managed. Bay Area conservationists came to support the park, but this was more a case of the government seeking their support than local conservationists pushing the NPS. George Collins, one of the chief NPS supporters of the national seashore, imagined it as a recreation site with marinas, golf courses, stables, and equestrian trails. The first take on the park looked toward the future—providing a breathing space for urban California, not preserving the past.[4]

The government broached a plan to condemn and purchase the ranch lands to create a pastoral zone and then lease the zone back to the ranchers on the condition that they maintain current uses. This idea only created greater hostility in a local community that did not support the park. Ranchers created the West Marin Property Owners Association to oppose it. They were family ranchers: many of them had spent their whole lives there and claimed close ties to the land.[5]

The bill's supporters realized that they needed at least the appearance of local support since most of the initial advocacy for the park came from outside Marin County. The plan received its biggest boost from the Sierra Club. At the urging of David Brower, Harold Gilliam wrote *Island in Time*, published by Sierra Club in 1962. Gilliam called the peninsula "a living museum not only of the processes that have shaped the crust of the earth but the wildlife that has evolved upon it—of plants and animals that elsewhere in this part of California have long since been displaced by the inexorable advance of pavement and tract houses." Representative Clair Engle's argument for the bill emphasized Point Reyes peninsula as an "unspoiled, undeveloped, and relatively isolated historic area."[6]

Point Reyes, so long defined by its connections to San Francisco and its butter and milk, was now defined in terms of what it was not—not spoiled, not developed, not suburban, and not representative of modern California. Promoters paid less attention to what it was. When created in 1962, the Point Reyes National Seashore included working farms and ranches in a roughly 26,000-acre pastoral zone, although at one time virtually the entire park had been grazed. With the passage of the Wilderness Act of 1964, some of that old ranch land outside the pastoral zone began to mutate into wilderness. Congress ordered the reluctant National Park Service to examine former cattle and dairy ranches outside the pastoral zone for designation as wilderness. The NPS has always been wary of wilderness within parks because it denies the agency management flexibility, but the Sierra Club lobbied hard for the wilderness designation. The NPS recommended labeling 10,600 acres as wilderness at Point Reyes. In 1976 Congress overruled the service and designated 33,000 acres as wilderness. It also identified 8,003 acres of potential wilder-

ness, which included the waters of Drakes Estero adjacent to D Ranch.[7]

To most Americans, creating wilderness seemed like an oxymoron. Wilderness was the original condition—something to be preserved, not made. Point Reyes was neither an original landscape nor a wild one; humans had clearly shaped it. But wilderness is not an entity existing separate from human beings. It is a management category. Defined in the Wilderness Act as an area "untrammeled by man, where man himself is a visitor who does not remain," it was supposed to have retained "its primeval character and influence, without permanent improvements or human habitation." If *untrammeled* means "untouched or not shaped by humans," then very few—perhaps none—of the current wilderness areas in the United States fit the definition. Indian peoples had burned the landscapes, sometimes grazed and tilled them before Europeans arrived, and non-Indians had shaped them afterward.[8]

In the summer of 1981, I hiked the new Point Reyes Wilderness. It was around the time that the Trailside Killer, David Carpenter, had murdered four people in the park. The park was understandably not crowded. Nothing bad happened.[9]

The coastline was spectacular, but descriptions like "primeval" and "without permanent improvements" were a stretch for the Point Reyes Wilderness. The land betrayed signs of its ranching past, and wildlife, no longer hunted, crowded the trails with little fear of humans that I could detect. The National Park Service had installed receptacles for the trash. Raccoons did not find them an insurmountable challenge.

With the creation of wilderness and the designated pastoral area, the identity of Point Reyes National Seashore shifted. Rather than a sanctuary from modern California, it became an experiment in a hybrid landscape—part working dairies and part wilderness. That hybridity seeded confusions and controversies that continue today.

The emergence of cultural preservation as part of the NPS mandate intensified the controversy. If working dairies were allowed to expand as purely modern ventures—a scaled-down version of the industrial dairies in the Central Valley—it was hard to explain what they were doing in the park. The rationale of preserving them as small-scale enterprises had to strike a balance between retaining the characteristics that produce a pastoral landscape while allowing them to change enough to stay in business. Deciding what this meant in practice created conflict inside as well as outside of the Park Service. John Sansing, the park superintendent in the 1970s, demolished old ranch buildings and sought to restore "original" vegetation even outside the wilderness area. This became known as the "D-8 policy," named after the Caterpillar tractors used in the demolitions, including the one that claimed F Ranch.[10]

THE HORICKS

Although preservation is ongoing at D Ranch, its demise as a working ranch began when Vivian Hall Horick drove away from her home in April 1998 and never came back. She died in a car accident on April 7 near Petaluma, where, her obituary noted, her two sons lived. Her daughter, Carol, lived on Point Reyes, but not on the ranch.[11]

Vivian was seventy-six years old and the second of three generations of the Hall family who had lived on D Ranch before it was incorporated

into the park in November 1971. Quinto Condoni, who had bought the ranch from proceeds of his businesses, was her grandfather, but his wealth had not lasted. When he died in 1940, his wife Clara sold everything in Point Reyes Station. She knew nothing about real estate. Alice Hall remembered that she "gave it away." Clara also sold D Ranch to her daughter Alice and her husband Bill. They had moved there in 1936 and rented the property after leaving N Ranch, where they had lived for eleven years.[12]

Vivian grew up on the ranch. She was apparently the only Hall sibling to show an interest in ranching. She had left the ranch once, but returned during World War II. Later she married Rudy Horick, becoming his second wife, and together they worked the ranch and raised their children. When Alice sold the ranch to the National Park Service, Vivian and Rudy Horick assumed the lease. By then they had already built a modern ranch house a short distance from the D Ranch compound, where Vivian was raised and Alice still lived. Rudy died on D Ranch in 1980. Alice remained in the old house until her own death in 1991.[13]

Vivian was a cattlewoman, and she had all the credentials: member of the Cattlemen's Association, the Redwood Empire Holstein Association, and the Tomales Future Farmers of America. She was a Point Reyes–Olema 4-H leader. The death notice also mentioned that Vivian was the "dear friend and companion of Dave McCullough of Point Reyes." Dave McCullough was her foreman on D Ranch. After Rudy's death, she had run D Ranch with Dave's assistance.[14] He lived in a separate small house next to the old house. Mexican ranch hands, at least one of them with a family, also lived on the ranch.

The ranch had already entered a condition somewhere between disrepair and looming dereliction before Vivian died. The old house on D Ranch was nearly eighty years old when the Halls had moved there in 1936. Its floors already sloped, and by 1998 the house had accumulated a long list of deficiencies, as had the other aging buildings. The ranch's roughly 1,200 acres had an array of environmental issues, and NPS complaints about overflowing manure ponds and pernicious weeds on overgrazed pasture came as regularly as the grass greened in the spring.[15]

Things went south fast after Vivian died. She had not designated any successors in interest for her special use permit, which was necessary to run the ranch. The National Park Service offered a six-month extension while it and the Horicks worked out the future use of the ranch. At the end of June 1998, Todd Horick fired Dave McCullough, and soon after the family was quarreling bitterly over how to manage the ranch. Carol Horick, who sympathized with McCullough, was on one side; her brothers were on the other. Things got Western with disputes over cattle ownership, accusations of cattle theft, and mistreatment of animals. The NPS advised Todd to stay clear of Dave McCullough. Todd and Roger Horick sought to remove their sister from the trust. By mid-July the trust had hired a local veterinarian to manage the herd, and he began to sell off the milking cows. The Horicks retained the heifers on the ranch; their lawyer thought one or more of the children would continue the dairying operation, but that remained to be worked out. It would be December before the cattle and equipment were sorted out, and the various parties reached an agreement not to prosecute each other.[16]

The National Park Service staff, who liked

Vivian and were initially sympathetic to her children, found themselves in the midst of a family quarrel. Carol Horick Sethmann, at least, appreciated their forbearance. She wrote the park superintendent, Donald Neubacher, to thank him for his understanding and patience during the "most difficult transitional period," and indicated her own interest in acquiring the lease. But she also denounced her brother Todd, who was "physically occupying the ranch," and warned Neubacher that he did not speak for the trust. As the quarrel deepened and dragged on, the NPS grew annoyed.[17]

By December 1998, with the estate still unsettled, the NPS decided that whoever took over D Ranch would have to run a beef cattle operation, not a dairying operation, and the owner would have to make substantial repairs to the buildings and the sewage system, which posed considerable health, safety, and environmental threats. The NPS offered the Horicks a three-month beef cattle permit to allow them yet more time to settle their differences.[18]

It did no good. The NPS gave the Horicks deadlines to reach a settlement. The deadlines came and went. The June 30, 1999, deadline passed without the Horicks producing a possible permittee, and then July turned into August without a response; then the NPS terminated its arrangement with the family. The property was seriously deteriorating, and the NPS said it had the responsibility of maintaining the historic resources and the land. This was a National Seashore, after all. The working ranch was passing into history.[19]

A park ranger who visited the site a year after Vivian's death found collapsing roofs and rotting floors. Abandoned belongings of the family or its workers were strewn about the houses, and dead birds, dead rodents, and animal droppings were scattered inside. The heifers still on the property were likely to be heifers no longer, for a free-ranging bull lived among them. The bull had to be unhappy to see a human intruder. The cattle wandered through the abandoned and deteriorating structures. The ranch hands were gone except for a single family that occupied one of the trailers, and that family was about to leave.[20]

The National Park Service severed the Horicks' lease, discontinuing all special use permits in September 1999 and taking direct management of the ranch. It gave the Horicks time to remove their belongings and use the west pasture until the last of the thirty or forty cows remaining on the ranch were sold. Todd Horick walked through the property with NPS rangers on December 14. Sadness is reflected in the notes made as they divided the property. The NPS readily agreed that the milking equipment, the cattle chutes, and the modern addition to the historic barn were the personal property of the Horicks and could be removed. The wooden dory that Jesse photographed was theirs; but the old stone grinder and the clawfoot bathtub that Todd Horick wanted remained with the NPS. Todd Horick said the tub was his grandmother's; Gordon White viewed it as an integral part of the house.[21] In February 2000 the NPS was still writing the attorney for the Horick Trust to get family members to remove the last of their personal property.[22]

Although the documentary record is clear, with letters from the trust's attorneys along with letters and memorandums from the NPS, all dated, filed, and stored in the archives, that is not how the Horick brothers remembered it. They felt they were lied to and betrayed.[23]

This was a Horick family quarrel as much as

a quarrel with the NPS. It was no more bitter or tawdry than most of the millions of others that took place in the state.

THE GARDEN

The garden at D Ranch can be easier to discern in photographs than on the ground. In winter and spring, it mostly disappears into a jungle of weeds; in summer and early fall, it looks like only a collection of dying shrubs and trees. When the National Park Service crews cut the vegetation back, old shoes and debris litter the ground. In the drought winter of 2014, the meager vegetation could not disguise a dead coyote in its den under the bishop pine.

The garden began, as far as I can tell, in the 1930s. It is a hardy artifact of a phase in the his-

D Ranch with fresh paint

Quinto and Clara Condoni, D Ranch

tory of D Ranch when the Halls made the place a home. Some of the plants in the garden are original; others are new plantings. Besides the pine and the palm, there is a tea tree, rhododendrons, roses, hydrangeas, fuchsias, calla lilies, bear's breeches, a privet hedge, some holly, and gerbera daisies.[24]

A photograph taken after the Halls moved to the ranch shows Quinto and Clara Condoni, Alice Hall's mother and Vivian Horick's grandmother, standing in the garden, still so new that the couple dwarfed the plantings. A driftwood seal with Coca-Cola bottle caps for eyes stood in the background. Its whiskers were made of baling rope. Alice said Clara was from Paris, but her maiden name was Filippini. She was Quinto Condoni's second wife. The cypress windbreak was intact behind them.[25]

The windbreak has now vanished, but the garden and its improvements linger on. A pedes-

tal built of stones still stands; it once held a lantern that Alice Hall's husband, Bill, found washed up on Drakes Beach. The Halls hired Clementi Angeli, who ran Angie's Bar in Point Reyes Sta-

Light with pedestal, D Ranch

tion, to make the base and then hooked the lantern up to electricity.[26]

In snapshots the pedestal and its lantern hold pride of place. The shrubs are trimmed. The Halls/ Horicks had created a garden that served as more than a background to their lives. They enjoyed it as their creation.

It is possible to construct a chronology of D Ranch through Jesse's photographs of the Canary Island date palm in the garden. The Halls apparently planted it in 1936. It marks a moment when D Ranch became, perhaps for the first time, a home. It grew as the Halls' children grew, and now it dwindles, being cut lower and lower each year. Jesse accents its decline. The vibrant blue sky, the sharp whites of the houses in an earlier photograph give way to the dim light and gray tones in this later picture. The palm no longer rises above all. It is no more alive than the telephone pole.[27]

Palm in gloom, D Ranch

SAN GABRIEL RIVER

San Gabriel River Canyon

t is hard to fall in love with a Los Angeles river, but I think I am in love with the San Gabriel. It is a very modern romance. I met the river because of photographs. I visited it on freeways. I know its charms, deficiencies, and dangers.

The river makes it easy to mistake space for time. A photograph of its canyon on a winter's day can seem a move back into nature, a step back into the past. The silver of the water echoes the silver of the bridge, and the road winds with the river in the narrow canyon, but the road and the bridge are reminders that nothing is untouched. Everything is modern.

Jesse's photographs of the lower river are the other side of this coin. He was drawn to incongruities—a pelican on a shopping cart. Naturalists joke that the shopping cart is the indicator species for urban rivers, but pelicans don't care. Human infrastructure penetrates the canyons; other species find niches in the concrete channels of the lower river.[1]

The San Gabriel cannot take us back into the past, but photographs of the river reveal the

Pelican in the San Gabriel River

San Gabriel River channel

past. Where Coyote Creek and the San Gabriel merge, the whole history of modern California is on display. High-voltage power lines march east along both banks. They originate in a natural gas generating plant whose smokestacks loom in the photograph's background. The San Gabriel River Freeway runs between power lines on the left bank. Coyote Creek's name is not yet an anachronism; the river does naturalize below the junction, and coyotes are regularly sighted in Long Beach where the river flows.

The only feature of modern California missing in this stretch of river between Lakewood and Long Beach is a state college or university cam-

pus. Postwar California rearranged its waters, reorganized the movement of goods and people, generated cheap power, and provided citizens of the state with nearly free education from kindergarten through college.

WHITTIER NARROWS AND THE PLAN FOR LOS ANGELES

The San Gabriel River Freeway runs alongside the river, and it is sometimes hard to separate the river and the county's roads and freeways. The brutal-

ist concrete landscapes of both ironically arose from the ongoing attempts to reconcile the city and nature, to maintain an *urbs in horto*. In 1929, when the Regional Planning Commission of Los Angeles County issued its plan for the San Gabriel Valley, the valley was still agricultural in its eastern reaches, growing urban as it approached Los Angeles. Twenty percent of the county was subdivided; 40 percent remained "unoccupied." "San Gabriel," the commission reported, "is making plans for the saving of its historic remainders, while the modern presses in from all sides."[2]

In the 1920s planners sought to create a future Los Angeles around a persistent urban form. Indian footpaths, Mexican roadways, early railroad routes, electric railways, early automobile routes, and eventually freeways all proceeded down the same corridors.[3] Anglo migrants from the Midwest, who had made early twentieth-century Los Angeles the least immigrant-influenced of the nation's major cities, only added a new layer. The city became a tangle of intertwined necklaces of small Midwestern towns.[4]

During the 1920s and 1930s, the Los Angeles Planning Commission and the Los Angeles County Flood Control District did brilliant work, but events kept outracing them. The Major Traffic Street Plan of 1924—produced by Frederick Law Olmsted Jr., Harland Bartholomew, and Charles Cheney—and the Master Plan of Highways of 1941 are staid documents that charter a Los Angeles future built on the automobile and the single-family home. And between 1907 and 1927, that home was usually a California bungalow. Automobiles replaced the city's electric trolleys, which were inefficient, often dangerous, and geared more to real estate speculation than transportation. The railways' obligation to provide roadways alongside their spreading tracks subsidized their automotive rivals. Maintaining roads demanded roughly 10 percent of the railways' revenue and came at the expense of upgrading their own cars and tracks. In the mid-twenties Los Angeles already had a ratio of automobiles to people (1 to 2.8) unmatched elsewhere in the nation. Trolleys still carried commuters but lost much of the rest of their traffic. By the 1930s, Pacific Electric was abandoning its most unprofitable lines. There was no need of a conspiracy to destroy the transit lines. They were collapsing under their own deficiencies and their legal obligations. The increase in automobiles meant the peripheral areas of the city—including the San Gabriel Valley—grew much faster than the core.[5]

To maintain the region's identity as a Land of Sunshine, the Los Angeles Chamber of Commerce hired the Olmsted Brothers architectural firm and urban planner Harland Bartholomew to design a plan for attracting tourists and new residents. The bland title of the plan, *Parks, Playgrounds, and Beaches for the Los Angeles Region*, downplayed its authors' ambition to guide the development of the city and county over the next half century.[6]

The frontispiece of the report—an iconic winter view from the Puente Hills, looking across the San Gabriel Valley to the snow-covered San Gabriel Mountains—captured the old Los Angeles pastoral. Olmsted and Bartholomew proposed a system of parks and parkways centered on the county's rivers, including the Rio Hondo and San Gabriel. Whittier Narrows would become a park. The planners wanted to manage rather than prevent the sprawling of Los Angeles by preserving much of an existing landscape while creating "a metropolis of automobile users, living pleasantly in detached houses with plenty of room."[7]

By the time the report was completed, the Los Angeles Chamber of Commerce had grown leery of its consultants. The $230 million cost of the proposal was seven times the city budget in 1930, in a city and county already nearing the legal limits of bonded indebtedness. The plan was projected to take nearly a half century to complete, but meanwhile the city would continue to expand and encroach on the lands meant to be preserved. The planners recommended independent commissions with taxing power to institute the plan, which was anathema to the chamber. The plan—both visionary and politically vulnerable—was strangled at birth. The chamber restricted circulation of the report. The ghost of that plan—what the city might have been—haunts Los Angeles County to this day.[8]

Before World War II, planners sought to make Los Angeles a city of highways and parkways. They imagined parkways on the current routes of the Pasadena Freeway, which paralleled the Arroyo Seco, and the San Gabriel River Freeway. Each parkway originally would have preserved open land in the flood plains, provided bridle paths in the dry streambed (ancestral to the modern bike paths), and created sloping earthen levees along whose flat tops the parkways would run.[9]

The commissions dreamed parkways in the late 1930s, but freeways—high-speed roads with limited access and little connection to the lands bordering them—were the future. The first plan for a comprehensive freeway system came from the Automobile Club of Southern California in 1937. It did not include a San Gabriel River route, and neither did a parkway plan of 1939, although it did include the route of what would be Highway 10.[10] By the 1940s and 1950s, L.A. was developing limited-access concrete highways to speed drivers through the city even as they created barriers for surface streets that were the usual routes of travel. These proto-freeways did not link into a coherent system.[11]

Conceiving of freeways proved easier than securing the money to build them. A 1938 amendment to the state constitution mandated that all funds generated by the state gas tax be used for highway construction, but World War II disrupted highway building. At the end of the war, there were only eleven detached miles of what would later become freeways. In 1947 the Collier-Burns Highway Act increased the state gas tax, and funds began to flow. When in 1956 the National Highway Act used national defense to justify an interstate highway system, the floodgates opened. The federal government paid 90 percent of the cost of qualifying roads, and the San Diego (Interstate 405), Golden State (5), Santa Monica (10), San Bernardino (10), Foothill (210), and San Gabriel River (605) freeways all qualified. Construction on the San Gabriel River Freeway began in 1963.[12]

As freeways thrived, parkways died. The Arroyo Seco Parkway became the Pasadena Freeway, L.A.'s first. Completed in 1954, the freeway has curves, short entrances, and exits that reflect its parkway past; only during its last phase did it mutate into a freeway. What was supposed to be the most pleasant road in Los Angeles is now routinely regarded as the most dangerous freeway in the county.[13]

The shift from parkways to freeways paralleled a similar retreat from the pastoral along the rivers and their watersheds. In the early 1930s planners still imagined the El Monte Subsistence Homesteads on the land along the Rio Hondo and San Gabriel as part of a "rurban" Los Angeles County.[14]

Dorothea Lange, El Monte Homesteads

New Deal planners wanted to give workers a chance to grow their own food in a "wholesome" environment that would be rural and Anglo-Saxon. In 1933 Ross Gast, a horticulturalist devoted to urban farming, secured two sites for the subsistence homesteads in Los Angeles County, which then had 130,000 people on relief. The El Monte site—1,000 acres of walnut orchard—provided 100 three-quarter-acre homesteads with the rest of the land devoted to schools, roads, and parks. Gast was simultaneously attempting to negotiate an end to the El Monte berry strike, which pitted Mexican American farmworkers against Japanese tenants, but the new project had room for neither Mexican Americans nor Japanese Americans. It was closed to everyone except native-born whites with enough money ($2,600 to $3,000) to purchase a home with a forty-year mortgage. It did not intend to address unemployment; instead, it would bring "needed economic and social readjustments." When Dorothea Lange visited in 1936, her photographs captured a place where

the houses, walnut trees, and deep lots echoed the Olmsted vision of suburban homes.[15]

Following the war, the vision of urban workers living on tiny farms faded. In El Monte traces remain today in the street and park plan, occasional large lots, and some surviving houses, but the area gradually merged into the Southern California sprawl.[16]

The federal government's more lasting impact on the San Gabriel and Rio Hondo came through the Army Corps of Engineers. The Corps submitted a general plan to reduce flood danger on the San Gabriel and Rio Hondo in February 1938, a month before a weeklong deluge fell on the city and the surrounding mountains.[17] In parts of the San Gabriel Mountains, 32 inches of rain descended in a week—more than the mountains usually received in an entire year. The good news was that the levees held wherever the riverbanks, particularly on the Los Angeles River, had been turned into concrete channels. The bad news was everything else: The spread of roads and buildings in the county ensured that more water ran off into gullies, streams, and rivers, and less percolated into the soil. The flood control dams filled and overflowed. Eighty-seven people died, and this apparently did not include homeless people who were living in and along the riverbeds. In Los Angeles County, 108,000 acres went underwater. The floods wrecked railroad lines, bridges, and roads. They destroyed homes and gutted farms.[18]

After 1938 the continuing threat of floods on the San Gabriel and Rio Hondo prompted support as well as fierce opposition for a dam at Whittier Narrows. Long Beach had long envisioned a dam as a source of water that could free it from dependence on Los Angeles, as well as a bastion against the floods that threatened its oil industry.

Those living above Whittier Narrows, particularly in El Monte, attacked the plan as an attempt to turn existing homes, schools, farms, and factories into a sacrifice zone. The Army Corps, as was its wont, listened to its supporters and tried to ignore its critics. But it failed: among the critics was an influential Democratic congressman, Jerry Voorhis, who was able to block federal appropriations for the dam.[19]

In 1946 Richard Nixon defeated Voorhis for Congress in an election that had nothing to do with the dam, but much to do with a conservative turn in California politics. Voorhis, who began life as a patrician Republican, became a socialist and then a New Deal Democrat. Along the way he had alienated Standard Oil, the Bank of America, insurance companies, and developers. They, along with New York financial interests that Voorhis had opposed, funded Richard Nixon, an ambitious assistant city attorney in Whittier, to run against him. Nixon red-baited Voorhis, accusing him of being soft on communism, which by the 1940s was equated on the local level with opposition to unrestrained development.[20]

Once in Congress Nixon helped negotiate a compromise that moved the dam downstream and provided ring dikes to protect a Texaco refinery. The park that the Olmsted Brothers imagined for the Whittier Narrows also emerged in the form of an Audubon Society Preserve, which became the current Whittier Narrows Nature Center.[21]

Construction on the earthen dam began in 1950; it was finished in 1955. El Monte lost 500 homes and 2,000 residents. The government condemned a Mexican American *colonia* of 600 people known as the Old Mission Colony, and the residents got nothing for their homes. They had rented the land from white landowners who

received the government payment. The Army Corps argued that floods eventually would have destroyed the homes and driven out the residents anyway.[22] The channelization and paving of the San Gabriel and Rio Hondo under the Los Angeles County Drainage Area project was finished in 1970. It produced the river of Jesse's photographs.[23] The new river and the new freeway emerged together.

A photograph from a drone pictures a century of change: The snow-covered peaks with the cities of the San Gabriel Valley pressing against the mountains form the background. The dam and the open space preserve it creates are the middle ground, and the channelized river and homes are in the foreground. The photograph can be understood only as an anticipation of water and the architecture to control it; yet, except for the mountain snow, the photograph contains no water.

The watershed the dam protects is much more densely inhabited than when the dam was built, and the dam has aged along with the people who built it; the survivors, like the dam, are decrepit. In 2017 the Army Corps of Engineers judged the dam structurally unsafe. Heavy rains could overwhelm it and trigger catastrophic flooding if operators had to open the gates fully during a large storm. The flow could be twenty times what the concrete channels below the dam could contain. A structure built as protection against the river has become a weapon that could destroy those it was meant to protect.[24]

If the dam fails, Jesse's photograph is the before picture of a disaster.

Whittier Narrows Dam and surroundings, Los Angeles County

CONCLUSION

Tachi Palace, Kings County, California

We can only think in the present moment, but the present moment is always awash in memories and ideas produced by the past. At least professionally, historians try to discipline themselves and remember that because no moment is inherently more important than another, no moment can give a complete view. Their sorcery is summoning other moments. History is looking into the tangled and devilishly complicated connections between an infinity of moments. The relationship of those moments is what matters.

The historians' premise applies equally well to photography. Photographs capture the isolated moment and present it for scrutiny. That scrutiny reveals a past and tempts us to imagine a future. Each photograph is a report from the trenches. We need to think about them not just sequentially but also relationally.

And in that spirit, I look into four last photographs.

TACHI CASINO

Jesse took a photograph of the Tachi Casino on the Santa Rosa *rancheria* for the same reason you can't take your eyes off a diamond pinky ring on the hand of someone as extravagantly out of place as this casino is amid the fields of the Tulare Basin. His framing of the entrance allowed me to see what I, like the gamblers driving by, might never give a second glance. The entrance is an affirmation and a sly joke about a past that could make you cry. Understanding this took a while.

The simplest element of the photograph is the name, in large letters spelling out *TACHI* over the much smaller letters of *palace*. The casino began as a bingo hall in the 1980s, and the Tachi band took over management in 1994. Both have prospered, at least relatively, since then. But why call the casino a palace? Kings live in palaces, but the Tachis had no kings and nothing that could remotely be called a palace. The word *palace*, which might seem an ironic reference to Las Vegas, plays not on Tachi but on Kings: the three magi—the kings of Orient—for whom the Spanish named the river that runs through the Tachi homeland. The Tachis appropriated the magi and turned them into the joke that makes their casino into a palace. The Tachi Palace reverses history. Owned by Indians, it exists to extract money from non-Tachis.

The second major element of the photograph is the fountain. The fountain's shape derives from the top of a Yokut bottleneck basket, as does the distinctive rattlesnake band of geometric designs on its side. The spouting water echoes the artesian wells that briefly flourished in Kings County before irrigation drove the water table down. The water splashing down onto rounded rocks in the fountain reinforces the connection to the river. Tachis lived on the edge of water; the land where the casino sits was once beneath the waters of the now vanished lake. The palms lining the road to the palace are the arboreal sign of modern California, and they signal a connection between the modern Tachis and the modern state.

The current street address of Tachi tribal headquarters hints at why the Tachis were able to retain the Santa Rosa *rancheria*: 16835 Alkali Drive, Lemoore, CA. Some of the land to the south of the Tachi Palace is white with alkali. In Febru-

Yokut basket

ary 2018 it contained remnants of an old slough, filled with junk. There were bones and a coyote skull. A hawk circled and then hovered, having spotted prey. The Tachis do not attempt to farm the land. They harvest the gamblers.

If the Franciscans had succeeded in building a mission, tourists on Interstate 5 might now stop just the way they do at missions nearer the coast. Tachi Palace looks nothing like a mission, which makes it a fitting monument to the failed ambitions of the Franciscans. The palace has done more for Tachi salvation than the missions ever did. All in all, it is a joke worthy of Coyote.

AZUSA AGAINST THE MOUNTAINS

Jesse took this photograph near where the San Gabriel River exits the San Gabriel Mountains. The suburban homes seem to be advancing into the canyon, which, higher up, becomes the San Gabriel Mountains National Monument. There is something ominous about the photograph: the darkened sky; the electrical lines, telephone poles, and solitary palm grouped like a skirmish line in front of the mass of houses. The houses seem both invasive and endangered. Some have

red-tiled roofs and Spanish Revival architecture; others face forward like the shields of an advancing army. They call to mind John McPhee's essay "Los Angeles against the Mountains" in which the "phalanxed communities of Los Angeles have pushed themselves hard against these mountains." It is an essay about fire, debris flows, and flood. This subdivision tempts fate.[1]

The San Gabriel Valley changes every few miles. Once denounced as a "single, indistinguishable mass of suburbia," Los Angeles has grown more diverse and its communities more distinc-tive.[2] Blamed for the sprawl of Southern California, the freeways now run through a city whose urban core is the second densest in the country and whose suburbs are the densest in the country.[3]

I do not know who lives in the houses marching up the canyon, but I do know that below the gap in this photograph is Azusa, a town formed from Henry Dalton's ranch, which itself had been carved from the old mission lands of San Gabriel. And I do know that the population of Azusa is changing.

The U.S. Census Bureau reflects the confu-

Housing development, Azusa

sion of racial categories for Azusa and California as a whole. It is an old confusion, similar to the one that turned Dalton's Gabrieleño vaqueros into martyred white settlers at Woodville. People are not pure. Identities are not simple. Racial categories are flimsy, historical, and always changing. Azusa illustrates the results. "Whites" number 44 percent of the population, but non-Hispanic whites number only about 21 percent. Hispanics and Latinos—white and nonwhite—account for 63 percent of the population. The total is greater than 100 percent. Immigrants make up 29 percent of the town's population. In 56 percent of the homes, people speak a language other than English. In Azusa, Americans are marching into the canyon. They are not Anglo-Saxons, but they advance beneath familiar standards: red-tiled roofs, real estate speculations, battles over water, demands for state services, and disputes over government regulations. They are definitely Californians.[4] Fires that burn hotter and more frequently year by year do not care about who lives in these homes.

Azusa is the western edge of a multiethnic, multiracial San Gabriel Valley, which began in Monterey Park—now majority Asian with a significant Latino population—following World War II and gradually moved east. Whites who had become Anglo-Saxon often, but not always, moved out. This population turnover varied considerably from place to place.[5] In becoming majority minority, the San Gabriel Valley is typical of California as a whole, where the Spanish speaking and those of Latino origins outnumber non-Latino whites.[6]

In Azusa, changes in demography are less important than changes in the economy. Matt Garcia is a historian who grew up in Azusa. His father, Salvador "David" Garcia, was a second-generation Mexican American. His mother, Janet, was Anglo. David Garcia bought "Frontier Meats" in 1986, although ultimately the store owned him. In the 1980s Frontier Meats served a working-class community—white, African American, and Latino. David Garcia usually spoke English to his customers. In the 1990s as more Latino and Asian immigrants settled in Azusa, Frontier Meats became a *carnicería* (butcher shop). The language of the store was often Spanish.[7] David Garcia could adjust to new customers, but he could not stand against Food4Less, Costco, and other large discount retailers. David Garcia declared bankruptcy around 1999.[8]

Racial categories can also obscure the connections between Azusa and older suburbs along the San Gabriel River. D. J. Waldie's *Holy Land* (2005) is about Lakewood, where there was "an interleaving of houses and fields that were soon to be filled with more houses." Waldie's house originally had "whitewashed boulders from the San Gabriel River" edging the front walk. This was in the 1950s.[9]

Lakewood arose during one of the most atypical moments in American history. Immigration restriction in the 1920s and then the Depression and World War II had curtailed both legal and illegal immigration. I and people my age grew up with the result. Immigrants, like my grandfathers and grandmother and mother, had become relatively rare and exotic. People began to think of this overwhelming predominance of the native born as normal, but given the sweep of American history between 1840 and 2018, it was anomalous.

Not only had immigrants ceased to arrive, but the powerful cultural and social engines of American assimilation had worked their magic on the children of immigrants. The developers

of Lakewood were Jewish; many of its first residents were Catholic. Both groups descended from immigrants who arrived in the nineteenth and early twentieth century, and both had once fallen outside the bounds of Anglo-Saxon America. Racial covenants that confined property sales to whites were illegal by the 1950s, but they continued to be informally enforced against some groups. In Lakewood, Jews and Catholics, once excluded, were admitted; but sales to blacks, Latinos, and Asians were still prohibited. Still, the whitening of Jews and Catholics had breached the racial walls, and the breaches would grow wider.[10]

Lakewood was the kind of suburb routinely derided as faceless and anonymous. Waldie simply and eloquently shows it was neither. Its virtues—which were real—did not, as it turned out, depend on its being white. Like Azusa, Lakewood today reflects California. It is a third Latino and nearly 20 percent Asian. It is only 37 percent non-Hispanic white. Twenty-two percent of its residents are foreign born. Waldie, who has spent his life in Lakewood and works for the city, thinks the texture of life remains pretty much the same even as the demographics change. He uses the same language to describe the people who lived in Lakewood now and then: courageous, hopeful, and imperfect. The town's difficulties have more to do with class and California's growing income inequality than with race.[11]

POINT REYES

In the 1980s the National Park Service adopted a general goal of preserving cultural landscapes that "clearly represent or reflect the patterns of settlement or use of the landscape, as well as the continuum and evolution of cultural attitudes, norms, and values towards the land." In 1994 Point Reyes was judged eligible for nomination to the National Register of Historic Places as a rural historic landscape district. The period of historical significance for the ranches was designated as between "1857 and 1939." Structures built during that era and buildings that continued the region's "architectural legacy" became candidates for preservation. When Gordon White, an architect by training, arrived at the park in 1999, cultural resources achieved both intellectual and administrative heft. In 2018 the Trump Interior Department forced him out, but he had changed the place. Point Reyes's fight for a place on the National Register has been long and arduous. Individual buildings and sections of the park made their way onto the register, but only in 2018 did the Shafter ranches receive their designation.[12]

The NPS has tried to strike a balance between preservation and improvements—usually out of sight—that allowed dairies to modernize. Women and men like Vivian and Rudy Horick on D Ranch, who had been independent ranchers in charge of their own enterprises, became "cooperators." That was Rudy Horick's title in 1973. He was a cooperator, with a management plan that he had to submit to the Park Service to govern his treatment of pasture, ponds, and wildlife habitat.[13] And by the time he died and Vivian took over the ranch, the requirements imposed by the Park Service had increased. Among them was the necessity of maintaining "ranch facilities and range improvements to high visual standards."[14]

By 1991 those visual standards were specified in "The Secretary of Interior's Standards for Rehabilitation," which was included as Attachment E

Repairs, D Ranch, Point Reyes

in Vivian Horick's lease extension. The properties were to be "recognized as a physical record of its time, place and use." The historic features that deteriorated were to be repaired, and when replacement was necessary, the new feature had to match the old not only in its "visual qualities" but also, where possible, in its materials. The standards didn't rule out new additions to the ranch, but the additions could not destroy the "historic materials that characterize the property." The "historic property and its environment" needed to remain unimpaired.[15]

By 2000 National Park Service crews were bracing, repairing, and stabilizing buildings, but not all buildings. Those that failed to qualify as historic under NPS criteria were left to decay and disappear. Broadly speaking, only structures built between 1857 and 1939 were eligible for maintenance, and funding was not available for all of these. The original creamery collapsed in the winter of 2007–08.[16] The old does not become young, but it is at least repaired, stabilized, and maintained in a state of incipient ruin. The ranch maintains a kind of regulated decay. More than a century later, and in a different place, it replicates Charles Lummis's old ambitions for the missions.

I have come to appreciate the insistence of the NPS on confronting us with the artifacts of our past instead of re-creations of an imagined past. The policy also illuminates the contradictions inherent in the categories—wilderness, agricultural, recreational, and more—that we use to organize the world. It respects those categories, allows them to bend but not break, and has created one of the more interesting and challenging parks in the country.

Flooded road, Tulare Lake

TULARE LAKE

The question is not if Tulare Lake will return again, but when. The Bureau of Land Management works to restore wetlands, and this is admirable, but the lake's ambitions are larger. As global warming increases the timing and ferocity of storms and the speed of runoff, a new climate can restore an old geography. The lake is only one example. That we cannot specify when these things will happen is quite Californian. Californians live in earthquake country. Earthquakes are certain to happen; only their timing is uncertain. In California the question is always when.

God has not given California the rainbow sign. Climate change means that there will be both flood and fire next time. Californians will lose part of what Jesse's photographs reveal. What is lost is not some past perfection or a better world. If we don't create histories, we too often are left with nostalgia.

The photographs remind us that there will be incessant and sometimes hopeful change among both the horrors and the seemingly enduring and familiar. Drakes Cross wears away. Azusa marches into the canyon. We proceed forward despite and because of the dangers.

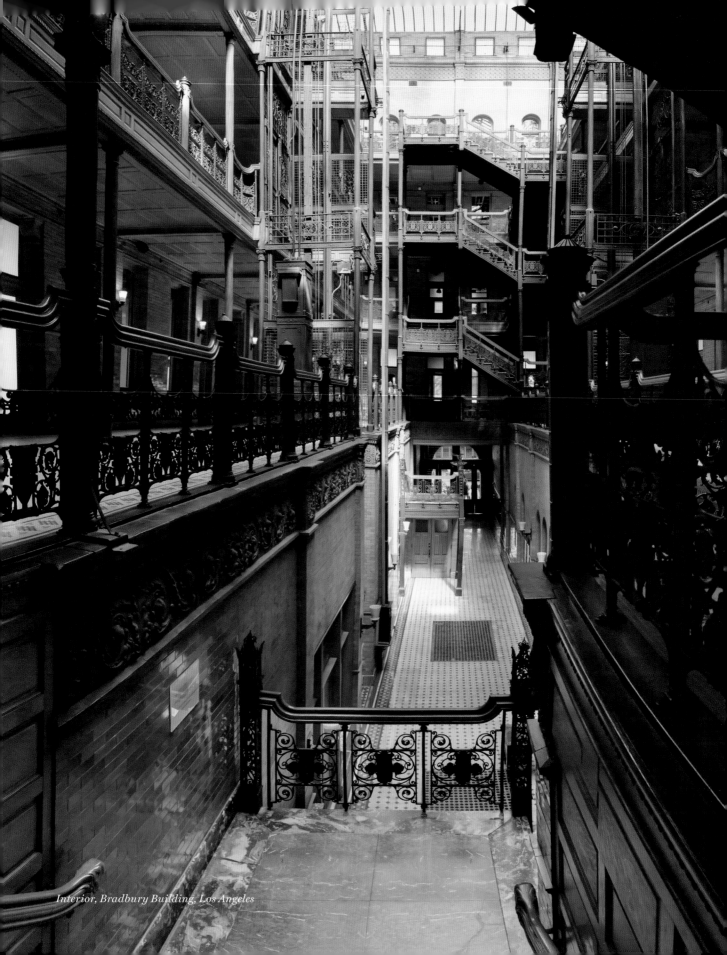

Interior, Bradbury Building, Los Angeles

EPILOGUE

When Jesse and I started working on this book, he lived in the Byrne Building in downtown Los Angeles. It is kitty-corner to the Bradbury Building, which was built in 1893. The Bradbury is pure Los Angeles. Lewis Bradbury was an eccentric who had made his millions in gold mining. He hired a leading Los Angeles architect, Sumner Hunt, to design the building but replaced Hunt with George H. Wyman, a member of Hunt's own firm who was understandably reluctant to take the commission away from his employer. Wyman was persuaded to accept the commission by a message from his dead brother. He received it through a precursor of the Ouija board.[1]

Wyman was, like many at the time, a great admirer of Edward Bellamy, the author of nineteenth-century futurist novel *Looking Backward* (1888). He was particularly struck by Bellamy's description of a late-twentieth-century building as "a vast hall full of light received not alone from the windows on all sides but from the dome, the point of which was a hundred feet above. . . . The walls frescoed in mellow tints to soften without absorbing the light which flooded the interior." According to a common story, Wyman modeled his architectural design after this description. This is a good story, which like so many good stories may not be true, since it appears that Wyman's design was the same as Hunt's.[2]

The Bradbury Building may reflect a late nineteenth-century vision of a twenty-first-century utopian future, but it also became the site of the 1982 dystopian fantasy *Blade Runner*. The movie imagined a twenty-first-century Los Angeles in which pollution was rampant, much of the population was homeless and nonwhite, and humanoid "replicants" did much of the work. The killing of replicants who escaped horrific conditions and crossed forbidden boundaries provided the movie's action and plot.

Depending on which fictions you believe, the Bradbury Building can stand in for either utopian or dystopian Los Angeles. When I visited Jesse in the Byrne Building, I began to think it was both. Downtown buildings that virtually had been abandoned in the mid- and late twentieth century, making downtown a place of "sheer irrelevance" in Reyner Banham's words, were taking on new lives. Downtown was vibrant, young, multiracial, and multicultural. It made me feel old and envious. But when I walked a few blocks from the Byrne Building, I encountered an aggregation

of misery greater than anything I had ever witnessed in the United States. In 2018 there were roughly 55,000 homeless people in the city of Los Angeles. The largest encampment was on skid row, a fifty-block area downtown where people lived on the sidewalks and in doorways in tents and boxes.[3]

The Byrne Building and the Bradbury were built by the same architects. Usually Sumner Hunt is given credit for the design. George Wyman supervised its construction. Wyman provides connections with Edward Bellamy; Hunt connects with Charles Lummis. Lummis founded the Southwest Museum; Hunt was the museum's architect.[4]

Although I set a high bar for the unlikely, there is another relationship between the Byrne Building and this book that strikes me as extremely improbable. I hold the Margaret Byrne Chair, an endowed position at Stanford University. When Jesse looked into the building's history, he found it was once owned by James William Byrne. He was the son of Margaret Byrne Irvine, who had commissioned the building and had it built. James inherited the building from his mother. James Byrne's 1925 will, probated after his death in 1930, provided the endowment for my chair, which he named after his mother. In so doing, he stripped her of the surname she had taken in her second marriage. He also imposed a singular condition on the endowment. The portrait of Margaret Byrne had to be publicly displayed in a university art gallery or library, or the endowment would either go to Berkeley or revert to the estate.[5]

In 2001 the university revoked the stipulation for displaying the portrait in a library or art gallery. Following the instructions of Stanford lawyers, my department chair had retrieved the portrait from the attic to which it had been exiled and delivered it to me. My office was public display enough.[6]

Margaret and I have lived together in an uneasy intimacy ever since. Her portrait was painted by Edmondo Pizzella, a largely forgotten artist whose main income came from San Francisco society ladies; it does not flatter her. Margaret Byrne was large, stern, and imposing. Pizzella received a gold medal from the Society for Sanity in Art. Once you encounter the Society for Sanity in Art, you realize there is nothing you can invent that tops what has actually happened. I have propped up the portrait against the bookshelves in my office. I don't dare put her on the wall, because this would involve hanging her high above my head. Stanford has had enough serious earthquakes for me to know she will eventually come down. I want to pass quietly from Stanford; I don't want stories headlined, "Donor Crushes Professor." So she rests on the floor, looking over the disarray of my office. We are both safer that way. I consider this my contribution to sanity in art.[7]

I watched Margaret Byrne stare at me for twenty years without ever wondering who she was or where the picture came from or the terms of the chair I occupied. This is an embarrassing thing for a historian to admit, particularly in a book devoted to insisting on the importance of understanding our daily lives through visual representations that capture the past. Portraits as well as photographs lead into the past.

Margaret Byrne Irvine had three children by a first marriage before she became the second wife of James Irvine in 1882. The marriage lasted until his death in 1886, and it connected her to

what would become one of the great landed fortunes of California.[8]

Margaret and James Irvine linked Northern and Southern Ireland and Northern and Southern California. They usually lived in San Francisco, but they invested in Southern California. Margaret was born in Ireland. She appears to have been Anglican. James was a Presbyterian Scots-Irish immigrant, born in Belfast. He made his initial money in the gold rush as a merchant and then invested heavily in San Francisco real estate. He was a founder of the Society of California Pioneers, and his grandson, Myford Irvine, a Stanford graduate, would serve as the society's president in the mid-twentieth century. Irvine had an eye for the main chance, and in the midst of the Great Drought of the 1860s with the ranchos of Southern California in crisis, he and three partners bought the *Rancho San Joaquin* in what was then Los Angeles County. It was the first piece of what would be the Irvine Ranch. He bought out his partners in 1876. When Orange County was established in 1889, Irvine Ranch at 105,000 acres took up about one-third of its area.[9]

James Irvine's 1886 will left Margaret some land, a guaranteed income for life, and a house in San Francisco; the bulk of his land went in trust to eighteen-year-old James Jr., his only son by his first marriage. James Jr. incorporated his holdings as the Irvine Company in 1894. He let out part of the ranch to tenants and grazed the rest.[10]

When my family moved to La Habra in the 1950s, I crossed Irvine land every summer. The ranch still contained 93,000 acres, and we passed its orchards—325,000 orange trees—and fields going back and forth to Huntington Beach, where my mother would take us on summer days.[11] The ranch had already begun to morph into one the

largest and most profitable planned developments of the late twentieth and early twenty-first century. One of the first steps was the creation of Irvine, California—now a city of more than a quarter million people—around the campus of U.C. Irvine.[12]

As a child in 1959, I associated the Irvine Ranch with a day at the beach; but Myford Irvine, the Stanford graduate and Native Son, seems to have lost the ability to derive pleasure from the place. That year he died of gunshot wounds: two shotgun blasts to the stomach and a pistol shot to the head—seemingly a peculiar way to commit suicide, but that is what the coroner concluded. Myford's father, James Irvine Jr., had transferred the majority of stock in the ranch to the Irvine Foundation in 1937, which along with the Irvine Company managed the ranch. He designed the arrangement to avoid both estate taxes and having the ranch split up among heirs. With Myford's death, the ranch passed out of the direct control of family members; what had been a remnant of an older agricultural California became a symbol of the changes sweeping through Southern California. It became the site of aerospace and electronic plants, U.C. Irvine, and eventually the planned communities that dominate it today.[13]

In 1969 the United States Taxation Act made the ownership of a for-profit company by a nonprofit foundation increasingly untenable. In 1977 one of the Irvine heirs, Joan Irvine, used the tax act to force the sale of the company to a consortium that included her. Six years later Donald Bren, who was the developer of Mission Viejo—a development whose name tells you just about everything you need to know—bought out his partners, just as James Irvine had bought out his partners years before. Despite the disputes

and drama, development proceeded in an orderly manner. Bren added more open space to the plan and a preference for palm trees and neo-Mission architecture. It was a new fantasy of Mediterranean California that would have pleased Charles Lummis. But rather than white Midwestern migrants, a different population, often Asian American, occupied this fantasy landscape. Today, Irvine is about half Asian American and half white.[14]

Following her husband's death, Margaret Byrne Irvine continued to reside in San Francisco. Of her three children, Fred had died in childhood. James and Callaghan, who died in 1909, seem to have managed her affairs and joined clubs. James Byrne was the kind of man who could be described as a "well known member of the community," but descriptions were never clear on what he was well known for. He "was identified with many . . . social activities" and was "chairman of the Building Committee of the Pacific Union Club." James hosted dinners, threw parties, played golf, and was head of the art association in San Francisco. He had "cosmopolitan experiences." James never married and lived with his mother. They traveled together to Europe and along the Pacific Coast. In a privately published memoir of the fire that followed the San Francisco earthquake, he recounted that he was staying in the Palace Hotel with his mother, ready to depart for Europe after having heard Caruso and Emma Eames open "the season with Carmen" when the earthquake struck. The Palace Hotel and the Union Club burned to the ground. Much of the account is devoted to how James saved his mother's jewels.[15]

The chair James Byrne endowed is peculiar. Its first oddity is that it is the Margaret Byrne Chair rather than the Margaret Byrne Irvine Chair, even though Margaret seems to have retained the name Irvine until her death.[16] James Byrne seems not to have wanted the chair associated with his stepfather. James stipulated that my chair was to be held "by a person who is by birth a citizen of the United States, who has been educated in America and is recognized as one sympathetic with the Constitution and laws of this country and is a believer in the general plan of government as originally established by the Constitution of the United States of America." Although endowed by a man described as cosmopolitan, accompanied by a portrait painted by an immigrant, and named for a woman who was an immigrant and whose second husband was an immigrant, my chair is, not to put too fine a point on it, a monument to early twentieth-century nativism. It is confined to birth citizens of the United States and not open to naturalized immigrants and foreigners, like James Irvine and Margaret Byrne.

I am an odd person to be sitting in the chair (which is literally a chair that I had to carry across campus after a ceremony giving it to me). Byrne endowed it at a time when my own ancestors were establishing themselves in the United States. My mother, one of my grandmothers, and both of my grandfathers were not birth citizens. One grandmother never became a citizen at all, and my maternal grandfather had his citizenship revoked. The terms would exclude not only these family members, but my American brother-in-law, born in Mexico, and my American cousin, born in Ireland.

Although genealogically suspect, I am a native-born citizen. The chair requires me to be faithful to the Constitution of the United States, which seems reasonable, but I am also supposed

to subscribe to a constitutional originalism that I, like most historians, find ridiculous. The only comfort that I can take is that Jack Rakove, who occupies the office next to me and won a Pulitzer Prize for dissecting the problems of originalism, would be an even worse occupant.

Twenty years of ignoring the woman who stared at me every day has allowed her to play me for a fool. I dismissed Margaret Byrne as someone who would have disapproved of me while assuming that I would have disapproved of her. I was willing to call things even. Her disapproval only enhanced my feeling of self-worth.

But the joke is on me. I wrote about the Anglo-Saxon myth, utterly unaware that my chair is a creation of that very myth. I looked at the role of monopolists in California while occupying a chair funded from the proceeds of monopoly in a university founded by the state's most hated monopolist. The university benefited by grants from the Irvine Foundation, whose philanthropy not only can't disguise, but is also a result of the inequality that has repeatedly created seismic fissures in the state. I thought I examined the beast from above, but I was reclining comfortably in its belly.

But then, maybe I get the last laugh. What better way to illustrate how pictures can reveal connections between our presents and the past than to discover through Margaret Byrne's portrait my own immersion in a story that I once thought separate from me?

ACKNOWLEDGMENTS

All books, at least in my experience, are nets that gather in debts. Whatever praise or criticism a book garners goes to the authors, but honest authors know that they own only the mistakes. Every sentence, paragraph, and chapter forms a collection of obligations owed to others.

The debts begin with Louis Warren and Jon Christensen, who each separately edited *Boom*, an experimental magazine of California, and invited Jesse and me to collaborate on early versions of this project. Steve Forman, my editor at Norton, suggested that there might be a book in our venture. He encouraged and patiently waited for the result, shepherding it back on track. His suggestions for the finished manuscript made it a much better book. I am grateful to Lily Gellman, who nursed the book through production. My agent, Georges Borchardt, as he always does, made sure that things went smoothly.

Steve Hackel, Rachel St. John, Mary Mendoza, Louis Warren, and Bill Deverell all read sections of the book, and their advice improved it immensely. Elliott West, Virginia Scharff, and Patty Limerick read early versions of the first section of this book and let me know what did not work. That is what old friends are for. Jenny Watts at the Huntington Library knows more about the history of photography in California than anyone in the state, and she was both patient and helpful. G. Salim Muhammed at the David Rumsey Collection helped me with historical maps. I am grateful to both of them. The staff at the California Historical Society in San Francisco was also helpful and gracious. Gordon White has for years proved a wonderful guide to Point Reyes. He has my gratitude and respect. Carola DeRooy, who ran the Point Reyes National Seashore Archives until budget cuts eliminated her position, was immensely helpful. I am grateful to the family of Raymond Aker for allowing me to use his painting. Aker was a formidable historian and a skilled researcher. I do not always agree with his conclusions, but much of what we know about Drake in California is due to his efforts.

Script doctors are famous in Hollywood, but I did not know there were book doctors until Jenny Price, a wonderful writer, suggested a set of simple but elegant changes in the organization of this volume. She, too, has my gratitude.

Erik Steiner, whose skill as a cartographer and designer has always impressed me, entered into the spirit of the book, as his maps show.

A fellowship at the Huntington Library in

San Marino allowed me to finish this book. I wrote amid wonderful colleagues while Southern California burned. The librarians who have helped me for years—Peter Blodgett and Daniel Lewis—were as knowledgeable and helpful as always. They were, unfortunately, not in charge of access to collections. I have used the Huntington for more than forty years, and it is a fabulous resource, but for the first time it refused to allow me to use a major collection—the J. G. Boswell Company Papers—central to the modern history of California. A research library should not be in the business of shutting down research, which is what the Huntington did.

The biggest debt I accrued in this project was to my coauthor and son, Jesse White. He taught me how to see. I have never enjoyed writing a book more.

And, as always, my thanks to Beverly.

NOTES

List of Abbreviations

California Commissioners *Report of the Secretary of the Interior . . . of the Correspondence between the Department of the Interior and the Indian Agents and Commissioners of California*, Senate Executive Document No. 4, 33rd Congress

California Superintendency *Letters Received by the Office of Indian Affairs from the California Superintendency, 1849–1880*, National Archives Microcopy No. M234.

CHS California Historical Society

DNG Drake Navigators Guild

Huntington Library Huntington Library, Art Collections, and Botanical Gardens, San Marino, California

Latta Collection Frank F. Latta Collection, Huntington Library, San Marino, California

PRA Point Reyes Archives, Point Reyes National Seashore

SHRC State Historical Resources Commission (California)

Preface

1. In a sense, I play John Berger to Jesse's Susan Sontag. Susan Sontag thought photographs were by nature ahistorical. They subverted history by making experience atomistic, "a series of unrelated, free-standing particles; and history, past and present, a set of anecdotes and *faits divers*." Berger said this was only true of public photographs where the viewer knew little of the contents. They were unlike private photographs, where the viewer could name people, times, and places. John Berger, *About Looking* (London: Writers and Readers, 1980), 49, 50–52, 56.

2. Richard Slotkin, "Dreams and Genocide: The American Myth of Regeneration through Violence," *Journal of Popular Culture* 5 (1971): 38–59.

Chapter 1: Is Seeing Believing?

1. D. S. Livingston, *Ranching on the Point Reyes Peninsula: A History of the Dairy and Beef Ranches within Point Reyes National Seashore, 1834–1992.* Historic Resources Study, National Park Service, Point Reyes National Seashore, July 1993, 142; *The World Encompassed, by Sir Francis Drake, Being His Next Voyage to That to Nombre de Dios Formerly Imprinted; Carefully Collected Out of the Notes of Master Francis Fletcher, Preacher in This Imployment, and Diuers Others His Followers in the Same: Offered Now at Last to Publique View, Both for the Honour o[f] the Actor, but Especially for the Stirring up of Heroick Spirits, to Benefit Their Countrie, and Eternize Their Names by Like Noble Attempts* (London: Printed for Nicholas Bourne and are to be sold at his shop at the Royall Exchange, 1628; reprinted by University Microfilms, Ann Arbor, Michigan, 1966).

2. "Site Plan, Existing Conditions, D Ranch, Point Reyes National Seashore, Cultural Landscapes Inventory" (Point Reyes National Seashore, CA: National Park Service Archives, Nov. 23, 1997).

3. Guy Kovner, "Drakes Bay at Point Reyes Named National Historic Landmark," *Press Democrat* (Santa Rosa, CA), October 17, 2012.

4. Warren L. Hanna, *Lost Harbor: The Controversy over Drake's California Anchorage* (Berkeley: University of California Press, 1972). For dispute over the anchorage, see pp. 66–82.

5. Hanna, *Lost Harbor*, 39.

6. George Davidson, *Identification of Sir Francis Drake's Anchorage on the Coast of California, in the Year 1579* (San Francisco: Bacon, 1890), 38.

7. Davidson, *Identification*, 4–5; Hanna, *Lost Harbor*, 70.

8. Davidson, 4–5; Hanna, 70.

9. Davidson, 17–25, especially 17, 19.

10. Davidson, 27.

11. Davidson, 28.

12. Davidson, 31–33.

13. Davidson, 33.

14. Davidson, 35.

15. Davidson, 37.

16. Aubrey Neasham, "Drake's Landing on the California Coast," Dec. 23, 1949, folder 21; Robert Heizer to Allen Chickering, Sept. 29, 1949, folder 4; Allen Chickering to Robert Heizer, Sept. 30, 1949, folder 4; Robert Heizer to Aubrey Neasham, Oct. 25, 1949, folder 16; all in Allen Lawrence Chickering Papers, box 2, MS 371, California Historical Society (hereafter cited as CHS).

17. Raymond Aker, *Report of Findings Relating to Identification of Sir Francis Drake's Encampment at Point Reyes National Seashore: A Report of the Drake Nav-*

igators Guild (Palo Alto, CA: DNG, 1976), 322–25; Hanna, *Lost Harbor*, 39, 303–15.

18. Zelia Nuttall, *New Light on Drake: A Collection of Documents Relating to His Voyage of Circumnavigation, 1577–1580* (London: Hakluyt Society, 1914), 1–55.

19. Hanna, *Lost Harbor*, 88, 98–100.

20. Hanna, *Lost Harbor*, 85–100, 103–06; David B. Quinn, "Early Accounts of the Famous Voyage," in *Sir Francis Drake and the Famous Voyage, 1577–1580: Essays Commemorating the Quadricentennial of Drake's Circumnavigation of the Earth*, ed. Norman J. W. Thrower (Berkeley: University of California Press, 1984); Richard Hakluyt, *The Principall Nauigations, Voiages and Discoueries of the English Nation: Made by Sea or Ouer Land, to the Most Remote and Farthest Distant Quarters of the Earth at Any Time within the Compasse of These 1500 Yeeres: Deuided into Three Seuerall Parts, . . .* (London: George Bishop and Ralph Newberie, deputies to Christopher Barker, printer to the Queenes most excellent Maiestie, 1589), Appendix V; *World Encompassed*, 221.

21. Hanna, *Lost Harbor*, 39, 303–15.

22. Hanna, 39, 303–15.

23. Davidson, *Identification*, 38–41.

24. Hanna, *Lost Harbor*, 39, 303–15, 384–86.

25. Matthew B. Dillingham, "Statement of Discovery of Drake's Cove," Jan. 10, 1979, folder 9, Point Reyes Archives (hereafter cited as PRA). John Muir, ed., *Picturesque California and the Region West of the Rocky Mountains . . . Connoisseur Edition* (San Francisco: J. Dewing Co., 1888), Section 5, 221.

26. Aker, *Report of Findings*, 343–51.

27. For the list of photographs and the reasoning, see "Spit and Cove Evolution, Inset Correlation and Creation of Drake's Cove," Oct. 23, 1979, folder State Historical Resources Commission [hereafter cited as SHRC] Hearings; Aker, *Report of Findings*, 213, 279; Raymond Aker and Edward Von der Porten, *Discov-*

ering Francis Drake's California Harbor (Palo Alto, CA: DNG, 2000), 38–45.

28. Faith Louise Duncan, "Botanical Reflections of the Encuentro and the Contact Period in Southern Marin County, California" (PhD dissertation, University of Arizona, 1992), 243–45; "Fire Ecology—Vegetation Types: Maritime Chaparral," National Park Service, Point Reyes National Seashore, accessed March 12, 2019, https://www.nps.gov/pore/learn/management/firemanagement_fireecology_vegtypes_chaparral .htm; "Grasses," National Park Service, Point Reyes National Seashore, accessed March 12, 2019, https://www.nps.gov/pore/learn/nature/grasses.htm; Harold J. Grams et al., "Northern Coastal Scrub on Point Reyes Peninsula," *Madroño* 24 (Jan. 1977): 18–24; Sally de Becker, *Coastal Scrub* (California Wildlife Habitat Relationships System, California Department of Fish and Game, California Interagency Wildlife Task Group, 1988); Mary K. Chase et al., *Two Decades of Change in a Coastal Scrub Community: Songbird Responses to Plant Succession* (USDA Forest Service Gen. Tech. Rep. PSW-GTR-191, 2005).

29. Isabel Kelly, "Some Coast Miwok Tales," *Journal of California Anthropology* 5 (1978): 21–39.

30. Kelly, "Some Coast Miwok Tales," 28–29.

31. Kelly, 31–33, 37.

32. Guild members gave various accounts of how Aker came to see Drakes Cove. The details were not fully consistent. Matthew Dillingham to Raymond Aker, Jan. 11, 1979, folder 9; Matthew Dillingham, "Statement of Discovery of Drakes Cove," Jan. 10. 1979, folder 9; Dillingham, Supplement, Jan. 10, 1979, folder 9; Matthew Dillingham, "Statement, Drake's Estero," Jan. 9, 1979, all in PRA. Aker and Von der Porten, *Drake's California Harbor*, 38–48.

33. Robert Power to David Tucker, Feb. 21, 1973; no author to ed., March 10, 1973; both in folder Santa Rosa, Point Reyes 9739, DNG, PRA. See also Captain A. S. Oko to Dr. C. M. Drury, Feb. 24, 1961; Robert Power to Professor C. M. Drury, March 2, 1961;

Lawrence C. Merriam to Clifford Drury, July 31, 1961; all in Correspondence, folder 2, Clifford Merrill Drury Papers, 1937–1971, Huntington Library.

34. Roy Power to Ray Aker, Sept. 1, 1978, Point Reyes 9739, DNG, PRA.

35. Aker to Tad, Sept. 4, 1978; "Commission Won't Decide Where Sir Francis Landed" (Oct. 24, 1978, p. 19), SHRC, 1978–79, PRA.

36. Vivian and Rudolph Horick to Miss Wilson (Oct. 18, 1978), folder 9, PRA.

37. "Fog Hampers Efforts to Retrace Drake's Course," *Palo Alto Times*, Oct. 23, 1978; "Commission Won't Decide Where Sir Francis Landed," Oct. 24, 1978, p. 19, in folder SHRC Hearing, Oct. 23, 1978, SHRC, PRA.

Chapter 2: What Drake Meant

1. "Point Reyes: Geo. W. Childs' Memorial Cross Marks A Sacred Spot, Our Plymouth Rock," *Sausalito News*, Sept. 15, 1893.

2. "At Drake's Landing," *San Francisco Chronicle*, Dec. 14, 1892; George Davidson, *Identification of Sir Francis Drake's Anchorage on the Coast of California, in the Year 1579* (San Francisco: Bacon, 1890), 54–58; "Hundreds Join in Prayer at Foot of Cross," *San Francisco Chronicle*, Oct. 30, 1922; "The Largest Cross in the World," *Los Angeles Times*, March 26, 1895; The Prayer Book Cross Service (Oct. 26, 1941), folder 5, in Allen Lawrence Chickering Papers, CHS.

3. "Appendix II, Memoranda Apparently Relating to This Voyage," Harley MS 280, folder 81; *World Encompassed*, 176; "Fame of Drake Starts Debate at Marin Fete," *San Francisco Chronicle*, May 20, 1916.

4. George Wycherley Kirkman, "Werewolves of the Waves," *Los Angeles Times*, Feb. 23, 1930.

5. Robert H. Power to David A. Tucker, Feb. 21, 1973, folder Landmarks, "State Historical Commission Hearing," PRA.

6. Assembly Bill no. 252, Chapter 530, folder Landmarks, "State Historical Commission Hearing," PRA.

7. Application for Registration of Historical Landmark, folder, Hearing, SHRC, 1978, PRA. The National Park Service had refused to get involved in the fight between landing sites. Lyle McDowell to Raymond Aker, Feb. 16, 1977, unnamed folder; "Francis Drake Still at Sea in Marin County," *San Francisco Chronicle*, March 3, 1979, folder "State Historical Commission Hearing," PRA.

8. Appendix, *Hakluyt's Account of Drake's Voyage*; John W. Robertson, *Francis Drake & Other Early Explorers Along the Pacific Coast* (San Francisco: Grabhorn Press, 1927), 266; *World Encompassed*, 115, 118.

9. David B. Quinn, "Early Accounts of the Famous Voyage," in *Sir Francis Drake and the Famous Voyage, 1577-80: Essays Commemorating the Quadricentennial of Drake's Circumnavigation of the Earth*, ed. Norman J. W. Thrower (Berkeley: University of California Press, 1984), 38.

10. *World Encompassed*, 119-21.

11. Robert F. Heizer, "Francis Drake and the California Indians, 1579," in *University of California Publications in American Archaeology and Ethnology* (Berkeley: University of California Press, 1947), 253-75; *World Encompassed*, 121.

12. Heizer, "Francis Drake and the California Indians," 264-65, 270.

13. Heizer, 272-73.

14. *World Encompassed*, 124.

15. *World Encompassed*, 125-29.

16. *World Encompassed*, 129, 132.

17. *World Encompassed*, 184.

18. Warren L. Hanna, *Lost Harbor: The Controversy over Drake's California Anchorage* (Berkeley: University of California Press, 1972), 54-65.

Chapter 3: Drake's Plate

1. Beryle Shinn, "How the Plate of Brass Was Found (a Signed Statement by Beryle Shinn)," n.d., c. 2937, Bancroft Library, University of California–Berkeley; Douglas S. Watson, "Drake and California," *Drake's Plate of Brass: Evidence of His Visit to California in 1579* (San Francisco: CHS, 1937), 19-21; A. L. Chickering to Templeton Crocker, Feb. 23, 1937, folder 12; A. L. Chickering to Sherman Kent, Dec. 27, 1940, box 1, folder 2, Chickering Papers, CHS.

2. A. L. Chickering to ?, March 4, 1937; A. L. Chickering to Henry Wagner, March 11, 1937, Chickering, March 4, 1937, folder 10, A. L. Chickering to Sherman Kent, Dec. 27, 1940, box 1, folder 11, Chickering Papers, CHS.

3. Watson, "Drake and California," 19-24. Interview with William Caldeira, April 9, 1937, in folder 10, Chickering Papers, CHS.

4. Interview with William Caldeira, April 9, 1937, folder 10; A. L. Chickering to Sherman Kent, Dec. 27, 1940, box 1, folder 2, Chickering Papers, CHS.

5. A. L. Chickering to Robert Sproul, May 6, 1937; R. Flowers to A. L. Chickering, n.d., c. 1937, folder 11; A. L. Chickering to Sherman Kent, Dec. 27, 1940, folder 2, Chickering Papers, CHS.

6. A. L. Chickering to Robert Sproul, May 6, 1937, folder 11; John Howell to A. L. Chickering, box 1, folder 2, Chickering Papers, CHS; Herbert E. Bolton, "Francis Drake's Plate of Brass," in *Drake's Plate of Brass: Evidence of His Visit to California in 1579* (San Francisco: CHS, 1937), 1.

7. A. L. Chickering to P. H. Patchin, June 28, 1939, box 1, folder 13, Chickering Papers, CHS. Colin G. Fink and E. P. Polushkin, *Drake's Plate of Brass Authenticated: The Report on the Plate of Brass* (San Francisco: CHS, 1938), 8, 14, 16-17, 21, 25.

8. Warren L. Hanna, *Lost Harbor: The Controversy over Drake's California Anchorage* (Berkeley: University of California Press, 1979), 39, 303-15.

9. Neasham contended that boron was found only near the Davidson site. Aubrey Neasham, "Drake's Landing on the California Coast," Dec. 23, 1949, in Chickering Papers, CHS; Raymond Aker, *Report Findings Relating to Identification of Sir. Francis Drake's Encampment at Point Reyes National Seashore: A Report of the Drake Navigators Guild* (Palo Alto, CA: DNG, 1976), 322–25.

Chapter 4: Drake Stories

1. Appendix II, Memoranda Apparently Relating to this Voyage, Harley MS 280, folder 81i, in *The World Encompassed*, 176. Warren L. Hanna, *Lost Harbor: The Controversy over Drake's California Anchorage* (Berkeley: University of California Press), 19, Also Appendix II, Short Abstract of the Present Voaye in Handwriting of the Time: A discourse of Sir Francis Drakes iorney and exploytes . . . 1580, in *World Encompassed*, 189–93.

2. Allen Chickering to Capt. A. S. Oko, Nov. 5, 1952, folder 5; Capt. A. S. Oko to Allen Chickering, June 22, 1956, box 2, folder 5; all in Allen Lawrence Chickering Papers, CHS.

3. Zelia Nuttall, *New Light on Drake: A Collection of Documents Relating to His Voyage of Circumnavigation, 1577–1580* (London, Printed for the Hakluyt Society, 1914), 1–55, lvi.

4. William Ford Nichols, "Why a Sir Francis Drake Association in California? Sir Francis Drake Association Leaflet No. 1, Read at the Ninth Annual Meeting August 5, 1922," in CHS 2819, Sir Francis Drake Association (1922), 8–9.

5. Douglas Watson, "Drake and California," *Drake's Plate of Brass: Evidence of His Visit to California in 1579* (San Francisco: CHS, 1937), 23–24. Editorial Memorandum, "The 375th Anniversary of Drake's Arrival at Drakes Bay, Marin County, California" (c. 1954), box 2, folder 20, Allen Lawrence Chickering Papers, CHS.

6. Richard Rayner, "The Admiral and the Con Man," *New Yorker*, April 22, 2002, 152–55; "She Plays Big Stakes," *Los Angeles Times*, June 17, 1915, p. 14; "Many Gulled in Heir Game," *Los Angeles Times*, March 7, 1927; Richard Rayner, *Drake's Fortune* (New York: Doubleday, 2002), focuses on Oscar Hartzell.

7. Rayner, *Drake's Fortune*, 13.

8. "Hoary Swindle for Americans," *Los Angeles Times*, March 15, 1914; "San Antonio Man Is Heir of Drake," *Los Angeles Times*, July 14, 1924, p. 2; "Many Gulled in Heir Game," *Los Angeles Times*, March 7, 1927, p. 9; "Drake Estate Consists of Castle in Spain," *Los Angeles Times*, Aug. 16, 1913.

9. "Drake Estate Consists of Castle in Spain," *San Francisco Chronicle*, Aug. 16, 1913; "New Claimant for Drake Millions," *San Francisco Chronicle*, Dec. 12, 1909.

10. "Hoary Swindle for Americans," *Los Angeles Times*, March 15, 1914.

11. "Old Estate Bunko Revived," *Los Angeles Times*, June 10, 1927; "Francis Drake Estate Sought," *Los Angeles Times*, April 25, 1928, 14.

12. "She Plays Big Stakes," *Los Angeles Times*, June 17, 1915.

13. "Old Estate Bunko Revived," *Los Angeles Times*, June 10, 1927; Rayner, *Drake's Fortune*, 33–70.

14. Richard Rayner, "The Admiral and the Con Man," *New Yorker*, April 22, 2002, 150–55.

15. Rayner, *Drake's Fortune*, 42–43, 65–66, 83–86.

16. Rayner, 88–140, 143–77.

17. Rayner, 158.

18. Edward Von der Porten et al., "Who Made Drake's Plate of Brass? Hint: It Wasn't Francis Drake," *California History* 81, no. 2 (2002): 118, 120, 124, 131.

19. Charles L. Camp, *Ye Preposterous Book of Brasse* (n.p.: E Clampus Vitus, 1978, reprint of 1935 edition), 9–10.

20. Robert H. Power, "Francis Drake & San Francisco Bay: A Beginning of the British Empire," ed. Davis Library Associates of the University Library (Davis: University of California–Davis, 1974).

21. Hanna, *Lost Harbor*, 255–57. Samuel Eliot Morison, *The European Discovery of America*, vol. 2, *The Southern Voyages* (New York: Oxford University Press, 1978), 2: 677–80.

22. The *San Francisco Chronicle* announced in 1979 that the plaque had been found to be a fake, but the report got the story wrong. It said that Berkeley undergraduates had made the plaque as a prank. "Francis Drake Still at Sea in Marin County," *San Francisco Chronicle*, March 3, 1979; SHRC 1978–79, "State Historical Commission Hearing," in Point Reyes, PRA.

23. Matthew Russel, "The Tamál-Húye Archaeological Project: Cross-Cultural Encounters in Sixteenth-Century California," *SCA Newsletter* 41, no. 2 (2007): 32–34; Edward P. Van de Porten, "The Porcelains and the Terra Cottas of Drakes Bay" (Point Reyes, CA: DNG, 1968), 26–28; "Drakes Bay Historic and Archaeological District Nomination," in *The Drake Navigators Guild Research Records and Publications*, ed. National Park Service (Point Reyes, CA: NPS Archive), 5–15.

24. Richard Slotkin, "Myth and the Production of History," in *Ideology and Classic American History*, ed. Sacvan Bercovitch and Myra Jehlen (New York: Cambridge University Press, 1986), 70.

25. John Sugden, *Sir Francis Drake*, 1st American edition (New York: Holt, 1990), 129; Appendix III, "A Discourse of Sir Francis Drakes iorney and exploits," in *The World Encompassed*, 183.

26. Hanna, *Lost Harbor*, 19, 52–54. Appendix II, "Short Abstract of the Present Voaye in Handwriting of the Time: A discourse of Sir Francis Drakes iorney and exploytes . . . 1580, in *World Encompassed*, 183–84; Sugden, *Sir Francis Drake*, 127.

Chapter 5: Walls and Palms

1. Kurt Baer, *Architecture of the California Missions* (Berkeley: University of California Press, 1958), 30–31, 95–96; Steve Hackel provided his unpublished collection and analysis of San Gabriel photographs.

2. Edna E. Kimbro, Julia G. Costello, and Tevvy Ball, *The California Missions: History, Art, and Preservation* (Los Angeles: Getty Museum, 2009), 97. Lisbeth Haas, *Saints and Citizens: Indigenous Histories of Colonial Missions and Mexican California* (Berkeley: University of California Press, 2014), 103; Baer, *Architecture of the California Missions*, 30–31, 95–96.

3. Jared Farmer, *Trees in Paradise: A California History* (New York: W. W. Norton, 2013), 135, 352, 354. Nathan Masters, "When Pepper Trees Shaded the 'Sunny Southland,'" KCET, accessed March 17, 2019, https://www.kcet.org/shows/lost-la/when-pepper-trees-shaded-the-sunny-southland.

4. Charles F. Lummis, *A Tramp Across the Continent* (New York: Charles Scribner's Sons, 1909), 1–2, 269. Mike Davis has an acerbic but accurate account of Otis in Mike Davis, *City of Quartz: Excavating the Future in Los Angeles* (London: Verso, 1990), 25–30.

5. Kevin Starr, *Inventing the Dream: California Through the Progressive Era* (New York: Oxford University Press, 1985), 72–75.

6. Starr, *Inventing the Dream*, 75–76.

7. Starr, 82–83. Phoebe S. Kropp, *California Vieja: Culture and Memory in a Modern American Place* (Berkeley: University of California Press, 2006), 52.

8. Helen Hunt Jackson, *Ramona: A Story* (Boston: Roberts Brothers, 1891), 16. For Lummis and Jackson, Dydia DeLyser, *Ramona Memories: Tourism and the Shaping of Southern California* (Minneapolis: University of Minnesota Press, 2005), 46–48.

9. Lummis and other photographs, Historical Society of Calif. Collection, box 17, Huntington Library.

10. Gloria Ricci Lothrop, "A Pictorial History of Mission San Fernando," *Southern California Quarterly* 79, no. 3 (1997): 312–13; Norman Neuerburg, "Biography of a Building: New Insights into the Construction of the Fathers' Dwelling, An Archaeological and Historical Resume," *Southern California Quarterly* 79, no. 3, special issue, San Fernando Rey de Espana, 1797–1997 (Fall 1997): 308–10.

11. Kevin Starr, *Inventing the Dream*, 76, 80–82; "Excerpts from Charles Lummis Diary, 1897, 1905," in Pauley, *San Fernando, Rey de España*, 66–67, 278; Kimbro et al., *California Missions*, 59–62.

12. Edith Wagner, "The Oldest Californian," *Land of Sunshine* 5 (Nov. 1896): 234–35. Serra did baptize a Gabriel Maria at San Carlos on February 4, 1775. He was the 123rd Indian Serra baptized at the mission, and the 289th baptism at the mission. He died in 1777 at age twenty-two. Thank you to Steve Hackel for this information.

13. Wagner, "The Oldest Californian."

14. Jackson, *Ramona*.

15. Juan Del Rio, "A Splendid Ruin," *Land of Sunshine* 6, no. 1 (1896): 14, 16; Charles F. Lummis, *The Spanish Pioneers* (Chicago: A. C. McClurg, 1913), 23–24. Elements of the myth were already in circulation early in the American period; see John Walton Caughey (ed.), *The B. D. Wilson Report* (San Marino, CA: Huntington Library, 1952), 47–48.

16. Brenda Denise Frink, "Pioneers and Patriots: Race, Gender, and Historical Memory in California, 1875–1915" (PhD dissertation, History Department, Stanford University, June 2010), 107–12.

17. Starr, *Inventing the Dream*, 83–86; Kropp, *California Vieja*, 47–48, 52–53, 85–86. For Lummis attacks, see Glen Gendzel, "Pioneers and Padres: Competing Mythologies in Northern and Southern California, 1850–1930," *Western Historical Quarterly* 32, no. 1 (2001): 68; James Rawls, "The California Mission as Symbol and Myth," *California History* 71, no. 3 (Fall 1992): 355–57.

Chapter 6: The Virgin and the Gabrieleños

1. Rev. William E. King, ed., *Mission San Gabriel: Two Hundred Years* (San Gabriel, CA: The Claretian Fathers of San Gabriel Mission, 1971), 50.

2. Norman Neuerburg, *Saints of the California Missions* (Santa Barbara, CA: Bellerophon Books, 1989).

3. Lisbeth Haas, *Saints and Citizens: Indigenous Histories of Colonial Missions and Mexican California* (Berkeley: University of California Press, 2014), 84, 95.

4. Steven W. Hackel, *Children of Coyote, Missionaries of Saint Francis: Indian-Spanish Relations in Colonial California, 1769–1850* (Chapel Hill: University of North Carolina Press, 2005), 164–65.

5. Steven W. Hackel, *Junípero Serra: California's Founding Father* (New York: Hill & Wang, 2013), 182–83; Haas, *Saints and Citizens*, 99. My thanks to Skyler Reidy for sending me the report of Rafael Verger to the viceroy in July of 1772, which summarized a letter from Pedro Cambon. A reproduction is in Santa Bárbara Mission Archive-Library, Santa Barbara, CA, Junípero Serra Collection, JSC 292.

6. James Sandos, *Converting California, Indians and Franciscans in the Missions* (New Haven: Yale University Press, 2004), 4–6; Steven W. Hackel, *Children of Coyote, Missionaries of Saint Francis: Indian-Spanish Relations in Colonial California, 1769–1850* (Chapel Hill: Published for the Omohundro Institute of Early American History and Culture, Williamsburg, Virginia, by the University of North Carolina Press, 2005), 262–65; Rose Marie Beebe and Robert M. Senkewicz (trans.), "Revolt at Mission San Gabriel: October 25, 1785, Judicial Proceedings and Related Documents," *Boletin: The Journal of California Mission Studies Association* 24, no. 2 (2007): 20–22, 24; Steven W. Hackel, "Sources of Rebellion: Indian Testimony and the Mission San Gabriel Uprising of 1785," *Ethnohistory* 50 (2003): 643–69.

7. Marie Christine Duggan, "The Laws of the Market versus the Laws of God: Scholastic Doctrine and the

Early California Economy," *History of Political Economy* 37, no. 2 (2005): 346–48, 354; Haas, *Saints and Citizens*, 54–55.

8. Hackel, *Children of Coyote*, 266, 341; Sandos, *Converting California*, 4–6; Beebe and Senkewicz, "Revolt at Mission San Gabriel," 20–22, 24.

9. Haas, *Saints and Sinners*, 55.

10. Ruben Vives, "Cross Returns to San Gabriel Mission," *Los Angeles Times*, March 13, 2009; Larry Gordon, "Painting Found after 14 Years. . . ." *Los Angeles Times*, June 29, 1991; Berkeley Hudson, "'La Dolorosa' Is Home Again," *Los Angeles Times*, August 25, 1991; Edna E. Kimbro, Julia G. Costello, and Tevvy Ball, *The California Missions: History, Art, and Preservation* (Los Angeles: Getty Museum, 2009), 162. The late Louise Pubols pointed out that there is another "La Dolorosa" at the Autry museum. It is unclear which one was the original San Gabriel painting.

11. Sandos, *Converting California*, 79.

12. Brenda Denise Frink, "Pioneers and Patriots: Race, Gender, and Historical Memory in California, 1875–1915," (PhD dissertation, History Department, Stanford University, June 2010), 1, 20, 22; Helen Hunt Jackson, *Ramona: A Story* (Boston: Roberts Brothers, 1891), 14.

13. Frink, "Pioneers and Patriots," 22–24, 78–79

14. Glen Gendzel, "Pioneers and Padres: Competing Mythologies in Northern and Southern California, 1850–1930," *Western Historical Quarterly* 32, no. 1 (2001): 68; Phoebe Kropp, *California Vieja: Culture and Memory in a Modern American Place* (Berkeley: University of California, 2006), 47–48, 52–53, 85–86.

15. Frink, "Pioneers and Patriots," 1, 3–4, 16–21, 75–82; Gendzel, "Pioneers and Padres," 78. For the larger story of the mission myth, see Kropp, *California Vieja*. Elizabeth Kryder-Reid, *California Mission Landscapes, Race, memory, and the Politics of Heritage* (Minneapolis: University of Minnesota Press, 2016), 91.

16. "The Landmarks Club," *Land of Sunshine* 16, no. 2 (1897): 83.

17. Starr, *Inventing the Dream*, 83–86; Kropp, *California Vieja*, 47–48, 52–53, 85–86; Gendzel, "Pioneers and Padres," 68; Eugene Sugranes, *The Old San Gabriel Mission* (San Gabriel, CA: n.p., 1921), 13.

18. Juan del Rio, "A Splendid Ruin," *Land of Sunshine* 6, no. 1 (1896): 13.

19. Del Rio, 13–14.

20. Kimbro et al., *California Missions*, 71.

21. James J. Rawls, "The California Missions as Symbol and Myth," *California History* 71, no. 3 (1992): 343–44, 350–57; Kropp, *California Vieja*, 74–77, 87–90; Frink, "Pioneers and Patriots," 109.

22. William Deverell, *Whitewashed Adobe: The Rise of Los Angeles and the Remaking of Its Mexican Past* (Berkeley: University of California Press, 2004), 207–49.

23. Kimbro et al, *California Missions*, 234–36; Norman Neuerburg, "Biography of a Building: New Insights into the Construction of the Fathers' Dwelling, An Archaeological and Historical Resume," *Southern California Quarterly* 79, no. 3 (Fall 1979): 309–10; the doorframe was painted several times between c. 1810 and the 1830s, and the bowman probably painted before 1820. Norman Neuerburg, *The Decoration of the California Missions* (Santa Barbara, CA: Bellerophon Books, 1987), 2, 67; see also 39, 46, 49.

24. Starr, *Inventing the Dream*, 82–83; Kimbro et al., *California Missions*, 236. Neuerburg, "Biography of a Building," 291–310; Kenneth E. Pauley and Carol M. Pauley, *San Fernando, Rey De Espana: An Illustrated History* (Spokane, WA: Arthur H. Clark Company, 2005), 285.

Chapter 7: *Huertas*

1. Tom Brown, "Gardens of the California Missions," *Pacific Horticulture* 49, no. 1 (1988): 3–11, accessed March 18, 2019, http://www.pacifichorticulture.org/articles/gardens-of-the-california-missions/; George Harwood Phillips, *Vineyards and Vaqueros: Indian Labor and the Economic Expansion of Southern California, 1771-1877* (Norman: Arthur H. Clark, University of Oklahoma Press, 2010), 133–40. For development of gardens after the end of mission era, Elizabeth Kryder-Reid, *California Mission Landscapes: Race, Memory, and the Politics of Heritage* (Minneapolis: University of Minnesota Press, 2016), 46–57, 86–94.

2. Juan del Rio, "A Splendid Ruin," *Land of Sunshine* 6, no. 1 (1896): 17.

3. For an idealized mission plan, see Kent G. Lightfoot, *Indians, Missionaries, and Merchants: The Legacy of Colonial Encounters on the California Frontiers* (Berkeley: University of California Press, 2005), 56–57.

4. Gloria Ricci Lothrop, "A Pictorial History of Mission San Fernando," *Southern California Quarterly* 79, no. 3 (1997): 311; Phillips, *Vineyards and Vaqueros*, 155. The statistics are from 1819.

5. John R. Johnson, "The Indians of Mission San Fernando," *Southern California Quarterly* 79, no. 3 (1997): 252.

6. Steven W. Hackel, *Children of Coyote, Missionaries of Saint Francis: Indian-Spanish Relations in Colonial California, 1769–1850* (Chapel Hill: Published for the Omohundro Institute of Early American History and Culture, Williamsburg, Virginia, by the University of North Carolina Press, 2005), 65–123; Kryder-Reid, *California Mission Landscapes*, 31–32; Lightfoot, *Indians, Missionaries, and Merchants*, 86–87.

7. "Los Angeles Basin Village Baptisms by Tribe—Interactive Visualization," http://ecai.org/ecca/InteractiveMaps/LAareaVillagesLinktoECPP.html, in Steve Hackel, Jeanette Zerneke, and Natale Zappia, *Early California Cultural Atlas*, http://ecai.org/ecca/index.html, accessed April 13, 2019; Hackel, *Children of Coyote*, 65–80; Johnson, "Indians of Mission San Fernando," 252–53.

8. Albert L. Hurtado, *Indian Survival on the California Frontier* (New Haven, CT: Yale University Press, 1988), 24–25; Johnson, "Indians of Mission San Fernando," 256–57; Steven W. Hackel, *Junípero Serra: California's Founding Father* (New York: Hill & Wang, 2013), 238–39. Phillips, *Vineyards and Vaqueros*, 132; R. Louis Gentilcore, "Missions and Mission Lands of Alta California," *Annals of the Association of American Geographers* 51, no. 1 (1961), 58; James A. Sandos, *Converting California: Indians and Franciscans in the Missions* (New Haven, CT: Yale University Press, 2004), 111–27. Steven W. Hackel puts the figure at 35–40 percent in *Children of Coyote*, 107. For higher estimates, see Robert H. Jackson and Edward Castillo, *Indians, Franciscans, and Spanish Colonization: The Impact of the Mission System on California Indians* (Albuquerque: University of New Mexico Press, 1995), 41, 43–44, 56–57; "Mission San Gabriel in 1814," *Southern California Quarterly* 53, no. 3 (September 1971): 242.

9. José María Amador, *Californio Voices: The Oral Memoirs of José María Amador and Lorenzo Asisara, Gregorio Mora-Torres, and Thomas Savage* (Denton: University of North Texas Press, 2005), 81; Hackel, *Children of Coyote*, 21.

10. Kryder-Reid, *California Mission Landscapes*, 35–46; for conversion and obstacles, see Hackel, *Children of Coyote*, 127–81.

11. Kryder-Reid, *California Mission Landscapes*, 60–69; Hackel, *Children of Coyote*, 121–23, 182–227.

12. Jackson and Castillo, *Indians, Franciscans, and Spanish Colonization*, 82–83.

13. Jackson and Castillo, 82–83; Sandos, *Converting California*, 102.

14. Eulalia Pérez, *Testimonios: Early California through the Eyes of Women, 1815-1848*, ed. Rose Marie Beebe

and Robert M. Senkewicz (Norman: University of Oklahoma Press, 2015), 96, 104, 107–08. Phillips, *Vineyards and Vaqueros*, 141.

15. Phoebe Kropp, *California Vieja: Culture and Memory in a Modern American Place* (Berkeley: University of California Press, 2005), 41–42. Elements of the myth were in circulation.

16. Amador, *Californio Voices*, 79.

17. Amador, 81.

18. Amador, 79–81; Maynard Geiger, *Franciscan Missionaries in Hispanic California, 1769–1848: A Biographical Dictionary* (San Marino, CA: Huntington Library, 1969), 204.

19. Amador, *Californio Voices*, 81–83.

20. Amador, 81–87, 91.

21. The shackles, the lash, and the stocks formed the common punishments of the missions. George Harwood Phillips, "Indians and the Breakdown of the Spanish Mission System in California," in *New Spain's Far Northern Frontier: Essays on Spain in the American West, 1540–1821*, ed. David Weber (Albuquerque: University of New Mexico Press, 1979), 264; Hackel, *Children of Coyote*, 321–32.

22. Amador, *Californio Voices*, 81, 85.

23. Amador, 87.

24. Amador, 91, 93.

25. Geiger, *Franciscan Missionaries*, 204–06. Geiger defends Quintana, as he defends all Franciscans, regarding him the victim of slander.

26. Amador, *Californio Voices*, 123.

27. Amador, 123, 127–31; Fr. Zephyrin Engelhardt, *San Gabriel Mission and the Beginnings of Los Angeles* (San Gabriel, CA: Mission San Gabriel, 1927), 306. For San Fernando and its missionaries, see Doyce B. Nunis, *The Franciscan Friars of Mission San Fernando, 1797–1847* (Santa Barbara, CA: Santa Bárbara Mission Archive-Library, 1997).

28. Amador, *Californio Voices*, 123–25; Phillips, *Vineyards and Vaqueros*, 142.

29. Amador, 125

30. Amador, 125–27. Phillips, *Vineyards and Vaqueros*, 142; Jackson and Castillo, *Indians, Franciscans, and Spanish Colonization*, 83.

31. Amador, *Californio Voices*, 121–23.

32. Geiger, *Franciscan Missionaries*, 167–68.

33. In 1813 the priest wrote and signed the Marriage Investigation Records for Jose Joaquin Ruiz and Maria Quirina Ibanna at San Gabriel, Dec. 4, 1813, William F. McPherson Collection, box 1, FAC 762 (4), Huntington Library. For a report he coauthored, see "Mission San Gabriel in 1814," *Southern California Quarterly* 5, no. 3 (September 1971): 235–48.

34. *Don Pio Pico's Historical Narrative*, trans. Arthur P. Botello (Glendale, CA: Arthur H. Clark Co., 1973), 156; Kryder-Reid, *California Mission Landscapes*, 45–46; *Californio Voices*, 127.

35. John R. Johnson and William M. Williams, "Toypurina's Descendants: Three Generations of an Alta California Family," *Boletin* 24, no. 2 (2007): 31–45.

36. Sandos, *Converting California*, 23–26, 120. The Ohlone at Santa Cruz had a tradition of polyandry, and many women had children by more than one man. Chester King, "Central Ohlone Ethnohistory," in *The Ohlone Past and Present: Native Americans of the San Francisco Bay Region*, ed. Lowell John Bean (Menlo Park, CA: Ballena Press, 1994), 223.

Chapter 8: Wild Horses and New Worlds

1. John W. Audubon, *Audubon's Western Journal: 1849–1850* (Cleveland, OH: Arthur H. Clark Co., 1906), 182–86; Frank F. Latta, *El Camino Viejo à Los Angeles* (Bakersfield, CA: Kern County Historical Society, June 1935); George Phillips, *Indians and Intruders in Central California 1769–1849* (Norman: University of Oklahoma Press, 1993),

94–95. Sherburne Friend Cook, "The Epidemic of 1820–33 in California and Oregon," in *University of California Publications in American Archaeology and Ethnology* (Berkeley and Los Angles: University of California Press, 1955), 303–22; Linda Nash, *Inescapable Ecologies: A History of Environment, Disease, and Knowledge* (Berkeley: University of California Press, 2006), 20–23. "Trapper" in "Reminiscences of Early California from 1841 to 1846," clipping in Benjamin Hayes Papers, 1849–1864, manuscript, Bancroft Library, University of California–Berkeley, vol. 1, inserted between Documents no. 217 and 218.

2. Audubon, *Western Journal*, 182–86.

3. J. S. Holliday used the phrase "world rushed in" for the title of his book based on William Swain's gold rush letters; J. S. Holliday, *The World Rushed In: The California Gold Rush Experience* (New York: Simon & Schuster, 1981).

4. Frank F. Latta, ed., *Uncle Jeff's Story: A Tale of a San Joaquin Valley Pioneer and His Life with the Yokuts Indians* (Tulare, CA: *Tulare Times*, 1929), 1–3, 9, 35. The first white negotiators with the Yokuts also held a comparatively high opinion of them, athletic, courageous and intelligent; Barbour to Luke Lea, July 28, 1851, California Commissioners, 123.

5. Latta, *Uncle Jeff's Story*, 13–17.

6. Latta, 23–28.

7. Latta, 29–34.

8. Latta, 46.

9. Latta, 48–49.

10. Latta, 49–50.

11. Latta, 35, 76.

12. Tachi, C. Hart Merriam, in C. Hart Merriam Papers, Bancroft Library, University of California–Berkeley; Frank F. Latta, *Handbook of Yokuts Indians*, 2nd ed., rev. and enl. (Santa Cruz, CA: Bear State Books, 1977), 142.

13. Wilfred Osgood, "Biographical Memoir of Clinton Hart Merriam, 1855–1942," in biographical Memoirs (Washington, DC: National Academy of Sciences of the United States of America, 1944), 15–16, 18.

14. Tachi, Near Tulare Lake, June 4, 1903; Tachi, Tulare Lake Region, Oct. 4, 1904, Merriam Papers.

15. Tachi, June 4, 1903.

16. William L. Preston, *Vanishing Landscapes: Land and Life in the Tulare Basin* (Berkeley: University of California Press, 1981), 158.

17. Sherburne Friend Cook, *The Aboriginal Population of the San Joaquin Valley, California* (Berkeley: University of California Press, 1955), 42–45, maps.

18. Tachi, Near Tulare Lake, June 4, 1903; Tachi, Tulare Lake Region, Oct. 4, 1904, Merriam Papers.

19. William Preston, "Infinidad de Gentiles: Aboriginal Population in the Tulare Basin," *Yearbook of the Association of Pacific Coast Geographers* 51, no. 1 (1989): 79–100.

20. Entry for Oct. 23, 1819, "Estudillo among the Yokuts: 1819," in *Essays in Anthropology in Honor of Alfred Louis Kroeber*, ed. A. H. Gayton (Berkeley: University of California Press, 1936), 69.

21. For a wonderful history of Coyote and coyotes, see Dan Flores, *Coyote America: A Natural and Supernatural History of Coyote and Coyotes* (New York: Basic Books, 2016).

22. A. L. Kroeber, "A Southern California Ceremony," *Journal of American Folklore* 80 (Jan.–March 1908), 40.

23. A. H. Gayton and Stanley S. Newman, *Yokuts and Western Mono Myths* (Berkeley: University of California Press, 1940), 8–11, 17.

24. S. A. Barrett et al., "Notes on California Folk-Lore," *Journal of American Folklore* 21, no. 81 (1908), 237–45; A. L. Kroeber, "Indian Mythos of South Central California," in *University of California Publications in American Archaeology and Ethnology* (Berke-

ley: University of California, 1907), 204–42; Frank F. Latta, "The Indians Come," in *California Indian Folklore* (Shafter, CA: F. F. Latta, 1936), 207–09; Barbara Thrall Rogers and A. H. Gayton, "Twenty-Seven Chukchansi Yokuts Myths," *Journal of American Folklore* 57, no. 225 (1944), 190–200, 205.

25. "Coyote and the Badgers," myth no. 99 in Gayton and Newman, *Yokuts and Western Mono Myths*, 84.

26. Phillips, *Indians and Intruders*, 45–46; Fray Juan Martin to P. P. Fray José Señan, April 26, 1815, in S. F. Cook, *Colonial Expeditions to the Interior of California, Central Valley, 1800-1820* (Berkeley: University of California Press, 1960), 243–44.

Chapter 9: When the Legend Becomes Fact

1. Frank Latta (ed.), *Uncle Jeff's Story: A Tale of a San Joaquin Valley Pioneer and His Life with the Yokuts Indians* (Tulare, CA: Tulare Times, 1929), 47–48.

2. Latta, *Uncle Jeff's Story*, 47.

3. George Stewart, "The Indian War on Tule River," *Overland Monthly and Out West Magazine*, vol. 3, no. 1 (January 1884): 46–53.

4. Major G. W. Patten, the commander at Fort Miller, apparently had never been there before since he had to get a map and directions. Albert L. Hurtado, *Indian Survival on the California Frontier* (New Haven, CT: Yale University Press, 1988), 115; Stewart, "Indian War on Tule River," 47; George Harwood Phillips, *Indians and Indian Agents: The Origins of the Reservation System in California, 1849-52* (Norman: University of Oklahoma Press, 1997), 149–52.

5. Hurtado, *Indian Survival on the California Frontier*, 115; Kathleen Edwards Small, *History of Tulare County, California*, two volumes (Chicago: S. J. Clarke Publishing Co., 1926), 41–44; Stewart, "The Indian War on Tule River," 47; Latta, *Uncle Jeff's Story*, 47–48; Frank Latta, *Handbook of Yokuts Indians*, 2nd ed. (Santa Cruz, CA: Bear State Books,

1977), 254; Orlando Barton, *Early History of Tulare County* (Visalia, CA: Tulare County Times, 1905) 2, 7; Eugene Menefee and Fred Dodge, *History of Tulare and Kings Counties, California* . . . (Los Angeles: Los Angeles Historical Record Company, 1913), 7–8. Louis Warren has reminded me that stories of flayed white men are abundant in the West and still reenacted. Heather Hamilton, "Wyoming: Lusk's Legend of Rawhide Performance Benefits Community," *Tri-State Livestock News*, July 1, 2011.

6. Latta, *Uncle Jeff's Story*, 47–48.

7. Small, *History of Tulare County, California*, 42.

8. G. W. Barbour et al. to Luke Lea, Feb. 17, 1851, California Commissioners.

9. "Reconnaissance of the Tulares Valley . . . ," by Lt. G. H. Derby, April and May 1850, Senate Executive Document 110, 32nd Congress, 1st Session, serial 621, 10–11; Gary Clayton Anderson and Laura Lee Anderson, *The Army Surveys of Gold Rush California: Reports of the Topographical Engineers, 1849-51* (Norman, OK: Arthur H. Clarke Co., 2015), 136.

10. A. S. Loughery, Acting Commissioner, to Messrs. Redick McKee, Geo. W. Barbour, O. M. Wozencroft, Oct. 15, 1850, California Commissioners.

11. For the treaties and American negotiators' view of Indians as creatures of climate and diet, see O. M. Wozencroft to Commissioner of Indian Affairs, Oct. 14, 1851; Barbour to Luke Lea, Commissioner of Indian Affairs, r. 32, California Superintendency.

12. G. W. Barbour, Redick McKee to Luke Lea, March 25, 1851; R. McKee to Luke Lea, March 24, 1851, California Commissioners, 67, 71.

13. Hugo Reid to Henry Dalton, Oct. 15, 1850, box 5, Dalton Papers, Huntington Library; "Letter of Lewis Granger, February 4, 1851," *Daily Alta California*, February 14, 1851. Lewis Granger to Abel Stearns, Feb. 4, 1851; Lewis Granger, *Letters of Lewis Granger* (Los Angeles: Glen Dawson, 1959). French had set-

tled there in the spring of 1850 and left when trouble erupted in Four Creeks. Henley to Manypenny, Sept. 22, 1854, r. 34, California Superintendency.

14. Henry Hancock, Plat of the Santa Anita Rancho finally confirmed to Henry Dalton, July 1858, Solano-Reeve Collection, SR Map 0241, Huntington Library; C. C. Baker, "Don Enrique Dalton of the Azusa," *Annual Publication of the Historical Society of Southern California* 10, no. 3 (1917): 22–30. The earliest of Dalton's surviving Indian books date from 1856, but it is likely he had been using them earlier on his ranchos since some list previous debts. Henry Dalton, "Indian Books," Wages & Accounts for Indian employees on Azusa ranch, 1857–63, Dalton Papers, Huntington Library.

15. G. W. Barbour, R. McKee, and O. M. Wozencroft to Luke Lea, Feb. 17, 1851, California Commissioners, 58.

16. "The Indian Difficulties—The Four Creeks," *Stockton Times*, March 5, 1851.

17. George Harwood Phillips, *Bringing Them under Subjection: California's Tejon Indian Reservation and Beyond, 1852–64* (Lincoln: University of Nebraska Press, 2004), 17. John Gage Marvin, "Some Account of the Tulare Valley, and the Indians from Fresno River to Tulare Pass, No. 2," in John Gage Marvin Scrapbooks, vol. 1, c. 1851, Huntington Library.

18. John Gage Marvin, "Some Account of the Tulare Valley."

19. G. W. Barbour, n.d. late 1852, "Report of the Transactions as one of the California Commissioners and Indian agent . . . four treaties with various tribes," date June 3, 10, May 13, & 30, 1851, reel 32, California Superintendency.

20. The Four Creeks were roughly seventy miles north of Walker Pass. John Bigelow, *Memoir of the Life and Public Services of John Charles Fremont . . .* (New York: Derby & Jackson, 1856), 380–81; Andrew F. Rolle, *Character as Destiny* (Norman: University of Oklahoma Press, 1999), 164.

21. *Sacramento Transcript*, Feb. 1, 1851. Thanks to John Faragher for bringing this to my attention. Benjamin Madley, *An American Genocide: The United States and the California Indian Catastrophe, 1846–1873* (New Haven: Yale University Press, 2016), 190–93; Phillips, *Bringing Them under Subjection*, 21–27. Bigelow seems to have conflated stories of violence in the Mariposa War, information from Marvin, and the killings in the Four Creeks country. Bigelow, *Fremont*, 380–81.

22. G. W. Barbour to L. Lea, July 28, 1851, California Commissioners, 125; John Mack Faragher, *Eternity Street: Violence and Justice in Frontier Los Angeles* (New York: W. W. Norton, 2016), 201–514.

23. *Los Angeles Star*, July 17 and July 24, 1852, in *The Indians of Southern California in 1852: The B.D. Wilson Report and a Selection of Contemporary Comment*, ed. John Walton Caughey (San Marino, CA: Huntington Library, 1952), 74–75.

24. "The Indian Troubles in Tulare," *Sacramento Daily Union*, May 7, 1856.

25. "Tulare Valley in Tulare County," *Daily Alta California*, July 8, 1857.

26. Abraham Hilliard, "The First Settlement of Tulare County," *Visalia Sun*, Sept. 5, 1860.

27. Hilliard, "First Settlement."

28. Hilliard.

29. Hilliard.

30. Stephen Barton, *Early History of Tulare* (Visalia, CA: Visalia Iron Age, 1876–1877), 2.

31. William Gorenfeld, "The Tule River War," *Wild West* 12, no. 1 (1999): 48.

32. Orlando Barton, *Early History of Tulare County* (Visalia, CA: Tulare County Times, 1905), 2.

33. Barton, *Early History*, 2.

Chapter 10: Genocide

1. G. W. Barbour, Redick McKee, O. M. Wozen-croft to Luke Lea, Feb. 17, 1851, 56–59; G. W. Barbour, O. M. Wozencroft to Luke Lea, March 5, 1851; G. W. Barbour, Redick McKee to Luke Lea, March 25, 1851; R. McKee to Luke Lea, March 24, 1851, California Commissioners, 56–59, 61–62, 67, 71. Benjamin Madley, *An American Genocide: The United States and the California Indian Catastrophe, 1846–1873* (New Haven, CT: Yale University Press, 2016), documents these years in California.

2. Madley, *An American Genocide,* 221, 222, 236, 238, 240, 247, 263, 264, 270, 275, 280; R. McKee to Luke Lea, Dec. 6, 1850; Adam Johnston to Orlando Brown, July 6, 1850; California Commissioners, 40, 53–54.

3. O. M. Wozencroft, "To the people living and trading among the Indians in the State of California," California Commissioners.

4. For Indian title, see G. W. Barbour, Redick McKee, and O. M. Wozencroft to Luke Lea, Feb. 17, 1851, California Commissioners, 56–59. For the legal status of the treaties, see Harry Kelsey, "The California Indian Treaty Myth," *Southern California Quarterly* 55, no. 3 (Fall 1973): 225–38. For California's position, see George Harwood Philips, *Indians and Indian Agents: The Origins of the Reservation System in California, 1849-52* (Norman: University of Oklahoma Press, 1997), 144–52, 166–182; Madley, *An American Genocide*, 164–71, 212–13, 355.

5. Enyart to Henley, Aug. 22, 1855, reel 34, California Superintendency.

6. Beale to G. Manypenny, Sept. 4, 1856, California Commissioners. The Kings River Farm at the site of Campbell's Ferry was about two miles above modern Reedley. George Harwood Phillips, *Bringing Them under Subjection: California's Tejon Indian Reservation and Beyond, 1852-64* (Lincoln: University of Nebraska Press, 2004), 146–47, 180–86; Lt. George Stoneman, Lt. John Park, and Lt. Robert Williamson to Edward Beale, Sept. 4, 1853, Special File; Gerald Thompson, *Edward F. Beale & the American West* (Albuquerque: University of New Mexico Press, 1983), 15–47, 50–51.

7. J. Ross Browne to Chas. E. Mix, Aug. 3, 1858; William Edgar to J. Ross Browne, July 18, 1858, reel 36, California Superintendency. "Pahmit's Story," Frank Latta, *Handbook of the Yokuts Indians* (Santa Cruz, CA: Bear State Books, 1949), 657–66. The specific reference was to Mendocino, but the policy was general.

8. Alfred Hurtado, *Indian Survival on the California Frontier* (New Haven, CT: Yale University Press, 1988), 128–41; Madley, *An American Genocide*, 164–172; G. W. Barbour, n.d. late 1852, "Report of the Transactions as one of the California Commissioners and Indian agent . . .," June 3, 10, May 13, & 30 1851, reel 32, California Superintendency; R. McKee to Luke Lea, Dec. 6, 1850; Adam Johnston to Orlando Brown, July 6, 1850, California Commissioners, 40, 53–54. For cattle and fraud, see Joel H. Brooks to E. F. Beale, Sept. 21, 1852; H. F. Logan to E. F. Beale, Sept. 21, 1852, reel 32, California Superintendency; Thompson, *Edward F. Beale*, 52–53. The best detailed account of the treaties and their immediate aftermath is in Phillips, *Indians and Indian Agents*, 57–67, 92–154.

9. William L. Preston, *Vanishing Landscapes: Land and Life in the Tulare Lake Basin* (Berkeley: University of California Press, 1981), 36–37; "Fires in Santa Clara," *Daily Alta California* (San Francisco), Aug. 17, 1857.

10. Phillips, *Indians and Indian Agents*, 147, 151; Frank F. Latta, ed., *Uncle Jeff's Story: A Tale of a San Joaquin Valley Pioneer and His Life with the Yokuts Indians* (Tulare, CA: *Tulare Times*, 1929), 34, 37.

11. Phillips, *Bringing Them under Subjection*, 122–24; Henley to Manypenny, Report, Sept. 22, 1854, r. 34, California Superintendency.

12. There were several Manns listed for Mariposa County in the California census of 1852, but I can find no reference to this murder. Latta, *Uncle Jeff's Story*, 35.

13. Latta, *Handbook*, 667–73. The dates differ slightly, but Henley reported that in November 1853, twenty Indians were brought in from Fresno Farm. They escaped, taking horses with them. Henley to Manypenny, Dec. 29, 1854, NA, M234, LR, reel 34, California Superintendency.

14. Henley to Manypenny, Report, Sept. 22, 1854, reel 34, California Superintendency. On the Four Creeks the settlers were demanding the removal of the Indians from their *rancherias* but seemed willing to have a reservation in the region. Petition to Henley, Aug. 28, 1855, ibid. Phillips, *Bringing Them under Subjection*, 122–24.

15. M. B. Lewis to Thomas J. Henley, July 22, 1856, 253, 255–56; Thomas J. Henley to George Manypenny, Sept. 4, 1856, 236–37; both in *Report of the Commissioner of Indian Affairs . . . for the Year 1856* (Washington, DC: A.O.P. Nicholson, Printer, 1856); L. A. Rhett Livingston, Lt. 3rd Artillery Commanding Post, to Maj. W. W. Mackall, Aug. 17, 1856; B. L. Beall, Lt. Col. First Dragoons, commanding Ft. Tejon, to Maj. W. W. Mackall, Sept. 29, 1856; Lt. Lucien Loeser, commanding Fort Miller, to Maj. W. W. Mackall, Oct. 28, 1856; all letters in *Indian Affairs on the Pacific*, 136–37, 140–41. Thomas J. Henley to Charles E. Mix, Sept. 4, 1858; both in *Annual Report of the Commissioner of Indian Affairs to the Secretary of Interior for the Year 1858* (Washington, DC: Wm. A. Harris, Printer, 1858), 283–84. John P. H. Wentworth to Wm. P. Dole, Oct. 10, 1861, *Report of the Commissioner of Indian Affairs . . . for the Year 1861* (Washington, DC: Government Printing Office, 1861), 146; Phillips, *Bringing Them under Subjection*, 212–13.

16. Thos. Henley to Manypenny, Jan. 15, 1858; Thos. Henley to Charles Mix, Nov. 19, 1858; J. Ross Browne to Charles Mix, Aug. 2, 1858; J. Ross Browne to Chas. E Mix, Aug. 3, 1858; J. Ross Browne to Charles Mix, Nov. 1, 1858, reel 36, California Superintendency.

17. J. Ross Browne to Chas. E Mix, Aug. 3, 1858; J. Ross Browne to Charles Mix, Nov. 1, 1858; G. Bailey to Charles Mix, Nov. 4, 1858, reel 36, California Superintendency.

18. J. Ross Browne to Chas. Mix, Nov. 17, 1858, reel 36, California Superintendency. For investigations see Special Files 159 and 266. J. Ross Browne to A. B. Greenwood, Sept. 19, 1859, *Report of the Secretary Interior Communicating . . . the Correspondence between the Indian Office and the Present Superintendents and Agents in California, and J. Ross Browne . . .*, SED 46, 36th Congress, 1st Session, 18–20.

19. Thompson, *Edward F. Beale*, 76–78. For violence in Washington, see *Joanne B. Freeman: The Field of Blood: Violence in Congress and the Road to the Civil War* (New York: Farrar, Straus and Giroux, 2018), 142–264.

20. J. Ross Browne to Chas. E Mix, Aug. 3, 1858; William Edgar to J. Ross Browne, July 18, 1858, California Superintendency.

21. M. B. Lewis to Thomas J. Henley, July 22, 1856, *Report of the Commissioner of Indian Affairs . . . for the Year 1856* (Washington, DC: A.O.P. Nicholson, Printer, 1856), 253, 255–56; Phillips, *Bringing Them under Subjection*, 216–17; John T. Austin, *Floods and Droughts in the Tulare Lake Basin*, 2nd ed. (Three Rivers, CA: Sequoia Parks Conservancy, 2014), 153, 182–83; LA Rhett Livingston, Lt. 3rd Artillery Commanding Post to Major W. W. Mackall, Aug. 17, 1856; *Indian Affairs on the Pacific*, 136–37. For hunger on Kings River, see Campbell to Henley, July 23, 1855, reel 34, California Superintendency. For shortage of acorns in San Joaquin Valley, see D. A. Enyart to Henley, Nov. 3, 1854, ibid.

22. Lt. J. Stewart, commanding Fort Miller, to Asst. Adj. Gen. D. R. Jones, May 1, 1856, *Indian Affairs on the Pacific*, 121.

23. Madley, *An American Genocide*, 244–45; Phillips, *Bringing Them under Subjection*, 186–88; W. C. Kibbe, Quartermaster and Adjutant General, California, to Maj. Gen. John E. Wool, May 14, 1856; *Indian Affairs on the Pacific*, 122.

24. Phillips, *Bringing Them under Subjection*, 188–89; Report of General Beale, misdated as July 12, 1855, instead of 1856, in Stephan Bonsal, *Edward Fitzgerald Beale: A Pioneer in the Path of Empire, 1822–1903* (New York: G. P. Putnam's Sons, 1912), 191–94.

25. The *rancheria* was probably either Shoko or Wamihlow, two of the villages of the Gashou Yokuts; Latta, *Handbook*, 163; LA Rhett Livingston, Lt. 3rd Artillery Commanding Post, to Maj. W. W. Mackall, Aug. 17, 1856; *Indian Affairs on the Pacific*, 136–37. Thomas J. Henley to George Manypenny, Sept. 4, 1856, *Report of the Commissioner of Indian Affairs . . . for the Year 1856* (Washington, DC: A.O.P. Nicholson, Printer, 1856), 236–37; Phillips, *Bringing Them Under Subjection*, 190, 213. White accounts of the horse theft differed, but on the whole the military accounts are more accurate than newspaper accounts. In this case, the stolen horse was returned with the explanation that Indians east of the mountains had taken it.

26. Copy of Petition, Oct. 25, 1857; Henley to Lewis, Sept. 19, 1857; Henley to Mix, Dec. 18, 1857, reel 36, California Superintendency; Phillips, *Bringing Them under Subjection,* 214–16. Rhoads also appears at Rhodes and Rhoades.

27. William Edgar to J. Ross Browne, July 18, 1858, reel 36, California Superintendency; James Y. McDuffie to M. B. Lewis, Aug. 27, 1859, *Report of the Commissioner of Indian Affairs . . . For the Year 1859* (Washington, DC: George W. Bowman, Printer, 1860), 442; Phillips, *Bringing Them under Subjection,* 217–20; Hurtado, *Indian Survival*, 153; "Arrival of the Steamer Hermann from New York," *Sacramento Daily Union*, Nov. 29, 1858; "Observations in Tulare Region," *California Farmer and Journal of Useful Sciences* 11, no. 9 (April 1, 1859); Lewis to Henley, Dec. 27, 1859, reel 37, California Superintendency.

28. Lewis to Henley, Nov. 15, 1858, reel 36, California Superintendency; Lewis to Henley, Jan. 8, 1859; Lewis to Henley, Jan. 15, 1859; Lewis to Browne, Feb. 28, 1859; Lewis to McDuffie, Aug. 22, 1860, reel 37, California Superintendency.

29. J. Ross Browne to A. B. Greenwood, Nov. 4, 1859, *Report of the Secretary of the Interior*, Senate Executive Document No. 46, 36th Congress, 1st Session, 16; Lewis to Browne, Feb. 28, 1859, reel 37, California Superintendency.

30. Lewis to Henley, April 9, 1859, reel 37, California Superintendency.

31. Lewis to Henley, May 12, 1859, reel 37, California Superintendency.

32. "Trouble about Indians in King's River Valley" [*sic*], *Daily Alta California* (San Francisco), Jan. 3, 1859; James Y. McDuffie to M. B. Lewis, Aug. 27, 1859, *Report of the Commissioner of Indian Affairs . . . for the Year 1859* (Washington, DC: George W. Bowman, Printer, 1860), 442; Phillips, *Bringing Them under Subjection*, 217–20; Hurtado, *Indian Survival*, 153. In 1859 stories of Indian cruelty among themselves circulated in the press; see "Indian Cruelty to an Orphan Boy," *Sacramento Daily Union*, March 18, 1859.

33. Latta, *Uncle Jeff's Story*, 34–35.

34. J. Y. McDuffie to Sec. of Interior, Aug. 9, 1859; Sec. of Interior to Greenwood, Jan. 30, 1860, reel 37, California Superintendency. J. Y. McDuffie to A. B. Greenwood, Nov. 19, 1859, and J. Ross Browne to A. B. Greenwood, Sept. 19, 1859, SED No. 46, 36th Congress, 1st Session, 17, 20. John P. H. Wentworth to Wm. P. Dole, July 14, 1861, *Report of the Commissioner of Indian Affairs . . . For the Year 1861* (Washington, DC: Government Printing Office, 1861) 142–43; Phillips, *Bringing Them under Subjection*, 250.

35. Beale Report, February 1853, in Carl Briggs and Clyde Francis Trudell, *Quarterdeck & Saddlehorn: The Story of Edward F. Beale, 1822–93* (Glendale, CA: Arthur H. Clark Company, 1983), 133.

36. J. Ross Browne to A. B. Greenwood, Oct. 18, 1859, in *Report of the Secretary of the Interior*, Senate Executive Document No. 46, 36th Congress, 1st Session, p. 15.

37. McDuffie to A. B. Greenwood, March 31, 1860, reel 37, California Superintendency.

38. William Preston, "Infinidad de Gentiles: Aboriginal Population in the Tulare Basin," *Yearbook of the Association of Pacific Coast Geographers* 51 (1989): 90, 95–98; Preston, *Vanishing Landscapes*, 39–55. Willi Derby to Canby, April 9, 1850, *Report of the Secretary of War, Communicating . . . a Report of the Tulare Valley, Made by Lieutenant Derby*, Aug. 24, 1852, SED 110, 32nd Congress, 1st Session, 7, 12, 13, 16. There are more detailed, but not necessarily accurate, enumerations in the 1850s.

39. For general population estimates, see Madley, *An American Genocide*, 346–47. For particulars, see the appendix.

40. Phillips, *Bringing Them under Subjection*, 222; Hurtado, *Indian Survival*, 153. For vaccination, see Adam Johnston to Wm. Ryan, Aug. 31, 1851. It was regarded as necessary to protect whites; see Ryan to Johnston, Sept. 26, 1851. Both in reel 34, California Superintendency.

41. Latta, *Uncle Jeff's Story*, 37; William Edgar to J. Ross Browne, July 18, 1858, reel 36, California Superintendency.

42. "Pahmit's Story," Latta, *Handbook*, 666.

43. Photographer unknown, *Indian Family at Santa Rosa Rancheria Near Lemoore*, 1880. San Joaquin Valley Library System. *Calisphere*, accessed March 23, 2019, http://oac.cdlib.org/ark:/13030/kt12901735/?brand=oac4.

Chapter 11: Cadastral Landscapes

1. James Scott, *Seeing Like A State: How Certain Schemes to Improve the Human Conditions Have Failed* (New Haven, CT: Yale University Press, 1999), 36–40.

2. For the records, go to "General Land Office Records," ed. Bureau of Land Management, U.S. Department of Interior, accessed March 23, 2019, http://www.glorecords.blm.gov/default.aspx.

3. William L. Preston, *Vanishing Landscapes: Land and Life in the Tulare Lake Basin* (Berkeley: University of California Press, 1981), 190; Kenneth M. Johnson, *José Yves Limantour v. the United States* (Los Angeles: Dawson's Book Shop, 1961), 21; *United States v. Jose Y. Limantour*, in *Reports of Land Cases Determined in the United States District Court for the Northern District of California, June Term 1853 to June Term 1858, Inclusive*, by Ogden Hoffman, rep. Numa Hubert (San Francisco: Sumner Whitney, 1862), 392; George Cosgrave, "Rancho Laguna de Tache Grant," *Fresno Morning Republican*, May 9, 1920, 4–5, box 99, folder 57, Latta Collection.

4. "Rancho Laguna de Tache," box 99, folder 14 (2) 57, 1–2, Latta Collection.

5. General Land Office, "Field Notes for Township 18 S, Range 20E by A. J. Atwell, Deputy U.S. Surveyor" (Aug. 31, 1869), ed. Department of Interior, Bureau of Land Management.

6. Linda Nash, *Inescapable Ecologies: A History of Environment, Disease, and Knowledge* (Berkeley: University of California Press, 2006), 64–67.

7. "Field Notes for Township 18 S, Range 20E."

8. Moving south on the first tier of sections on the east and west boundaries, they noted "no timber" when they set the four-mile posts at the corner of sections 19, 24, 25, and 31, and noted the same when they set the five-mile posts on sections 25, 30, 31, and 36. In running the south boundaries of sections 18, 19, 20, and 21, they also noted no timber and also none at the western part of the northern boundary of section 3. "Field Notes for Township 18 S, Range 20E."

9. Robin Michael Roberts, *Images of America: Kings County* (Charleston, SC: Arcadia Publishing, 2008), 25–26.

10. Author conversation with Erin Beller, Jan. 7, 2016.

11. Arthur Dawson, "Oaks through Time: Reconstructing Historical Change in Oak Landscapes," in *General*

Technical Reports (Albany, CA: U.S. Forest Service, U.S. Department of Agriculture, c. 2006), 631.

12. Justin Esrey, Sept. 16, 1857, Esarey-Esrey & Rhoads-Esrey Letters: Records of a 19th century American migration, accessed March 23, 2019, http://www.esarey.us/reunion/1857Sep16.htm.

13. John T. Austin, *Floods and Droughts in the Tulare Lake Basin*, 2nd ed. (Three Rivers, CA: Sequoia Parks Conservancy, 2014), 200.

14. Austin, *Floods and Droughts*, 200.

15. Tom G. Farr, Cathleen Jones, and Zhen Liu, "Progress Report: Subsidence in the Central Valley," *Progress Report* (Pasadena: California Institute of Technology, 2015), 1–2; Austin, *Floods and Droughts*, 149–50; Department of Water Resources State of California, "Summary of Recent, Historical, and Estimated Potential for Future Land Subsidence in California," ed. California Department of Water Resources (2014), 7, 9, figure 4.

Chapter 12: The Shafters

1. D. S. (Dewey) Livingston, *Ranching on the Point Reyes Peninsula: A History of the Dairy and Beef Ranches within Point Reyes National Seashore, 1834–1992*, Historic Resource Study: Point Reyes National Seashore (Point Reyes Station, CA: National Park Service, 1993), 1; Robert H. Jackson and Edward Castillo, *Indians, Franciscans, and Spanish Colonization: The Impact of the Mission System on California Indians* (Albuquerque: University of New Mexico Press, 1995), 94.

2. Livingston, *Ranching*, 1–9. Indian vaqueros remained in 1858 when the Shafters acquired the land; Oscar Shafter to Father and Mother, Sept. 19, 1858; Oscar Lovell Shafter and Flora Haines Loughead, and Emma Shafter Howard, *Life, Diary and Letters of Oscar Lovell Shafter, Associate Justice Supreme Court of California* (San Francisco: The Blair-Murdock Co., 1915), 197.

3. J. P. Munro-Fraser, *History of Marin County, California: Including Its Geography, Geology . . .* (San Francisco: Alley, Bowen, 1880), 250.

4. "The Limantour Claims" (San Francisco: Federal Courthouse, 1983), 2; *United States v. Jose Y. Limantour*, in *Reports of Land Cases Determined in the United States District Court for the Northern District of California, June Term, 1853 to June Term 1858, Inclusive*, by Ogden Hoffman, rep. Numa Hubert (San Francisco: Sumner Whitney, 1862), 414; Dewey Livingston and Carola DeRooy, *Point Reyes Peninsula: Olema, Point Reyes Station and Inverness*, Images of America Series (Charleston, SC: Arcadia Publishing, 2008), 22.

5. Livingston, *Ranching*, 1–5; Paul M. Engel, "Towards an Archaeology of Ranching on the Point Reyes Peninsula" (MA thesis, Cultural Resources Management, Sonoma State University, 2012), 16–18.

6. For several years, I taught a class on Point Reyes and had the students conduct archival research on the ranches. Shih-Hung Chen et al., *New Perspectives: A Study of Early Dairy on the Point Reyes Peninsula* (Stanford University, 2001), 1–12; Munro-Fraser, *History of Marin*, 301–4; Livingston, *Ranching*, 7–11, 173–75.

7. Livingston, *Ranching*, 6–11, 31; also see D. S. (Dewey) Livingston, "A Good Life: Dairy Farming in the Olema Valley: A History of the Dairy and Beef Ranches of the Olema Valley and Lagunitas Canyon," Golden Gate National Recreation Area and Point Reyes National Seashore, Marin County, California (San Francisco: National Park Service, Dept. of the Interior, 1995), 34–38.

8. Livingston, *Ranching*, 6–11, 12–22.

9. Livingston, *Ranching*, 19–20, 31, 443–46; Engel, "An Archeology of Ranching," 92; Oscar Shafter to Father, c. Aug. 1858; Oscar Shafter to Father, Oct. 19, 1858; Oscar Shafter to Father, March 19, 1860; Shafter et al., *Life, Diary and Letters*, 194, 198–99, 202–3.

10. Shafter et al., *Life, Diary and Letters*, 7; Livingston, *Ranching*, 35.

11. Munro-Fraser, *History of Marin County*, 297, 300.

12. Charles Nordhoff, *Northern California, Oregon, and the Sandwich Islands* (New York: Harper & Brothers, 1874), 179–81; Livingston, *Ranching*, 35–37. Munro-Fraser, *History of Marin County*, 301.

13. "Dairy Ranches of Hon. J. McM. Shafter," *Pacific Rural Press* (San Francisco), Feb. 17, 1877.

14. Nordhoff, *Northern California*, 180–81. Livingston, *Ranching*, 38, 156, 189–91; Hinrik Nicholaus Johan "Henry" Claussen, accessed March 23, 2019, https://www.findagrave.com/cgi-bin/fg.cgi?page=gr&GRid=43725914.

15. *Marin Independent Journal*, May 25, 1899; Livingston, *Ranching*, 42–44.

16. Nordhoff, *Northern California*, 180–81; Livingston, *Ranching*, 38, 43, 156, 189–91; Hinrik "Henry" Claussen, https://www.findagrave.com/cgi-bin/fg.cgi?page=gr&GRid=43725914.

17. For land monopoly in California, see Tamara Venit Shelton, *A Squatter's Republic: Land and the Politics of Monopoly in California, 1850–1900* (Berkeley: University of California Press, published for the Huntington–USC Institute on California and the West, 2013).

Chapter 13: Braided Rivers, Braided Lives

1. Hugo Reid, *The Indians of Los Angeles County: Hugo Reid's Letters of 1852*, Southwest Museum Papers no. 21 [*Los Angeles Star*], edited and annotated by Robert E. Heizer (Los Angeles: Southwest Museum, Highland Park, 1968), letter 17, p. 72–73. Online copy at Library of Congress, accessed March 23, 2019, https://cdn.loc.gov//service/gdc/calbk/007.pdf.

2. John Mack Faragher, *Eternity Street: Violence and Justice in Frontier Los Angeles* (New Haven, CT: Yale University Press, 2016), 4.

3. Paul R. Spitzzeri, *The Workman & Temple Families of Southern California, 1830–1930* (Dallas, TX: Seligson Publishing, 2008), 11–20, 26, 33–35, 41–49, 60–62, 64, 76.

4. Spitzzeri, *Workman & Temple Families*, 87–106, 114. Both the Temple and Workman families were of mixed Californio and Anglo ancestry.

5. Spitzzeri, 87–108.

6. Spitzzeri, 128–29.

7. Spitzzeri, 112–13, 146–50, 159–63.

8. Spitzzeri, 163–76, 184–95, 199–200.

9. Spitzzeri, 190–91.

10. Kent G. Lightfoot, *Indians, Missionaries, and Merchants: The Legacy of Colonial Encounters on the California Frontiers* (Berkeley: University of California Press, 2009), 79–80; "Map of a Part of San Gabriel Mission, Recorded June 4, 1880, by Henry Hamilton," HM 79258–79259, Huntington Library.

11. "Basye Discharged," *Los Angeles Herald*, May 3, 1899; Paul Spitzzeri, "The Basye Family of La Missión Vieja: The Center of Greater Los Angeles," Oct. 17, 2014, accessed March 23, 2019, http://misionvieja.blogspot.com/2014/10/the-basye-family-of-mision-vieja.html.

12. "Evils of Social Club," *Los Angeles Herald*, Aug. 5, 1902.

13. "Temple's Defense Begins," *Los Angeles Herald*, Jan. 16, 1903; "Courthouse and City Hall," *Los Angeles Herald*, Jan. 18, 1903. "Evil of Social Club, Charles Temple in County Jail," *Los Angeles Herald*, Aug. 5, 1902.

14. "Strangles Own Child to Death," *Los Angeles Herald* no. 161 (March 8, 1904); "No Truth in Murder Story," Los Angeles Herald no. 162 (March 9, 1904).

15. Spitzzeri, *Workman & Temple Families*, 195, 222–26.

16. "The Basye Family," http://misionvieja.blogspot.com/2014/10/the-basye-family-of-mision-vieja.html; "All Over the Map: The Temple Oil Lease

at Montebello," *Homestead Blog*, accessed March 23, 2019, https://homesteadmuseum.wordpress.com/2016/11/23/all-over-the-map-temple-oil-lease-at-montebello/.

17. Spitzzeri, *Workman & Temple Families*, 229–44.

18. Spitzzeri, 238–42; Mexicans were nominally white but still usually excluded; Laura Redford, "The Intertwined History of Class and Race Segregation in Los Angeles," *Journal of Planning History* 16, no. 4 (2017): 315. The case that began the end of restrictive covenants, *Doss v. Bernal* (1943), involved Mexican Americans; Thomas A. Delaney, "How Orange County Began the End of Racially Restrictive Covenants," *Daily Journal/California Lawyer*, Nov. 14, 2017.

19. Spitzzeri, *Workman & Temple Families*, 197–98, 227.

20. Paul R. Spitzzeri, "Wo/Men at Work (Labor Day Edition): Adobe Makers for La Casa Nueva, ca. 1922–1927," Sept. 4, 2017, *Homestead Blog*, accessed March 23, 2019, https://homesteadmuseum.wordpress.com/?s=adobe+makers+for+la+casa+nueva.

21. Spitzzeri, *Workman & Temple Families*, 227–33, 244; Spitzzeri, "Wo/Men at Work," https://homesteadmuseum.wordpress.com/?s=adobe+makers+for+la+casa+nueva.

22. Spitzzeri, *Workman & Temple Families*, 199.

23. Spitzzeri, 199–200.

24. Spitzzeri, 199–200.

25. Spitzzeri, 238–46.

26. Spitzzeri, 247–48.

27. Paul R. Spitzzeri, "On This Day: The Birthday of Thomas Workman Temple II, 1905–1972" *Homestead Blog*, Jan. 4, 2018, accessed March 23, 2019, https://homesteadmuseum.wordpress.com/?s=thomas+workman+temple+II; Steven Hackel, "Sources of Rebellion: Indian Testimony and the Mission San Gabriel Uprising of 1785," *Ethnohistory* 50 (Fall 2003): 649–51, 658.

Part Five: Capital

1. Thanks to L. J. Turner for explaining this process to me.

Chapter 14: Carquinez Strait

1. Matthew Booker, *Down by the Bay: San Francisco's History between the Tides* (Berkeley: University of California Press, 2013), 120–22.

2. William Hammond Hall, *Report of the State Engineer to the Legislature of the State of California—Session of 1880*, Part II (Sacramento: J. D. Young, Supt. State Printing, 1880), 23.

3. Karl Grove Gilbert, *Hydraulic-Mining Debris in the Sierra Nevada*, Department of the Interior: U.S. Geological Survey (Washington, DC: Government Printing Office, 1917), 23.

4. Booker, *Down by the Bay*, 16–17.

5. L. Allan James, "Sustained Storage and Transport of Hydraulic Gold Mining Sediment in the Bear River, California," *Annals of the Association of American Geographers* 79, no. 4 (1989): 581–82; Gilbert, *Hydraulic-Mining Debris*, 16–24.

6. David Beesley, "Beyond Gilbert: Environmental History and Hydraulic Mining in the Sierra Nevada," *Mining History* 7 (2000): 75, 77; Gilbert, *Hydraulic-Mining Debris*, 25–38.

7. Booker, *Down by the Bay*, 120–22; Ann Vileisis, *Discovering the Unknown Landscape: A History of America's Wetlands* (Washington, DC: Island Press, 1997), 25–26; David Igler, *Industrial Cowboys: Miller & Lux and the Transformation of the Far West, 1850–1920* (Berkeley: University of California Press, 2013), 92–110.

8. Henry George, *Our Land and Land Policy, The Complete Works of Henry George* (New York: Doubleday, Page & Co., 1904, orig. edition 1871), 62–63; "Report of the Joint Special Committee to Investigate Chinese

Immigration," United States Congress (Washington, DC: Government Printing Office, 1877), 441; William Hyde Irwin, *Augusta Bixler Farms: A California Delta Farm from Reclamation to the Fourth Generation of Owners* (Brookdale, CA: 1973), 4–5, 10–11; John Thompson, "The Settlement Geography of the Sacramento–San Joaquin Delta, California" (PhD dissertation, Stanford University, 1957), 226–27; Paul W. Gates, "Public Land Disposal in California," *Agricultural History* 49, no. 1 (1975): 165–66; Booker, *Down by the Bay*, 91–92; J. T. Gibbes, "Map Showing the Lands of the Tide-Land Reclamation Company" (San Francisco: Tide-Land Reclamation Company, 1869) 1; Sucheng Chan, *This Bittersweet Soil: The Chinese in California Agriculture, 1860–1910* (Berkeley: University of California Press, 1986), 171, 178–79, 181.

9. This is all summarized in Gates, "Public Land Disposal in California."

10. Vileisis, *Unknown Landscape*, 89–90; Hall, *Report of the State Engineer to the Legislature of the State of California*—Session of 1880, Part II: 14. This is the story told in Robert Kelley, *Battling the Inland Sea: Floods, Public Policy, and the Sacramento River* (Berkeley: University of California Press, 1989); see particularly 202–03.

11. Kelley, *Battling the Inland Sea*, 207–16; Vileisis, *Unknown Landscape*, 71–78; Hall, *Report of the State Engineer to the Legislature of the State of California—Session of 1880*, 13–14.

12. Kelley, *Battling the Inland Sea*, 207–16.

13. *Grass Valley Union*, Sept. 12, 1869, in *Fresh Water Tide Lands of California* (San Francisco: M. D. Carr & Co. 1869), California Land Titles and Pamphlets, Special Collections, Stanford Library, 40–43.

14. John Thompson and Edward A. Dutra, *The Tule Breakers: The Story of the California Dredge* (Stockton, CA: The Stockton Corral of Westerners, 1983), 28; John Thompson, "Early Reclamation and Abandonment of the Central Sacramento–San Joaquin Delta," *Sacramento History Journal* 6, no. 1–4

(2006): 46, 48–49, 51, 60–61; John Thompson, "The Settlement Geography of the Sacramento-San Joaquin Delta, California" (PhD dissertation, Stanford University, 1957), 220–21, 226–27; Kelley, *Battling the Inland Sea*, 47–53; Hall, *Report of the State Engineer to the Legislature of the State of California—Session of 1880*, Part II: 11–12. Gilbert, *Hydraulic-Mining Debris*, 25–50, 80–83; Booker, *Down by the Bay*, 81–84, 91–92; "Fresh Water Tide Lands of California," 4–5, 7, 36; Henry George, *Our Land and Land Policy*, 62–63; "Report of the Joint Special Committee to Investigate Chinese Immigration," U.S. Congress (Washington, DC: Government Printing Office, 1877), 441; Irwin, *Augusta Bixler Farms*, 4–5, 10–11; Gates, "Public Land Disposal in California," 165–66; Chan, *This Bittersweet Soil*, 171, 178–79, 181.

15. *Woodruff v. North Bloomfield Gravel Mining Co. and Others*, 18, no. 14, 797 (1884), 217–18.

16. Richard Maxwell Brown, *No Duty to Retreat: Violence and Values in American History and Society* (New York: Oxford University Press, 1991), 105; Hubert Howe Bancroft, "Lorenzo Sawyer: A Character Study," in *Chronicles of the Builders of the Commonwealth* (San Francisco: 1891), 439–41.

17. For wheat trade, see Rodman Paul, "The Wheat Trade between California and the United Kingdom," *Mississippi Valley Historical Review* 45, no. 3 (Dec. 1958), 391–412.

18. Sarah Meady to Brother, Jan. 28, 1885, HM 72052, and Fred Meady to Sarah Meady, April 9, 1889; both in box 1, Fred Meady Letters, Huntington Library.

19. Lawrence J. Jelinek, *Harvest Empire: A History of California Agriculture* (San Francisco: Boyd & Fraser Publishing Company, 1979), 39–46.

20. Richard White, *Railroaded: The Transcontinentals and the Making of Modern America* (New York: W. W. Norton, 2011), 166–73; Frank Norris, *The Octopus: A Story of California* (New York: Doubleday, Page & Co., 1901), 639, 646.

21. Norris, *The Octopus*, 639, 646.

22. Norris, 647.

23. Robert Louis Stevenson, *The Silverado Squatters* (San Francisco: The Arion Press, 1996), 5.

24. Fred Meady to Sarah Meady, April 19, 1889, box 1, Fred Meady Letters, Huntington Library; Stevenson, *Silverado Squatters*, 4–5.

25. Historical Statistics of the United States, Table Da291–356—Value of farmland and buildings, by region and state: 1850–1997; Table Da225–290—Average acreage per farm, by region and state: 1850–1997; Table Da93–158—Farms, by region and state: 1850–1997; White, *Railroaded*, 458–60.

26. "Reclaiming Submerged Islands," *Daily Alta California* (San Francisco), July 25, 1869.

27. Thompson, "Settlement Geography," 480–81.

28. Thompson, "Settlement Geography," 230.

29. Irwin, 16–18; Thompson, "Early Reclamation," 54, 57–58, 66; "Items from Stockton," *Daily Alta California*, Nov. 24, 1881; "Levee Broke on Union Island," *Sacramento Daily Union*, June 24, 1884; "Levee Cut—Experts Sworn In," *Sacramento Daily Union*, Nov. 24, 1881; "Union Island," *Daily Alta California*, March 12, 1878; "Union Island," *Pacific Rural Press*, Aug. 4, 1877.

30. M. M. Barnet and J. O'Leary, *Statistics of California Production Commerce and Finance for the Years 1900-01 . . .* (San Francisco: John Partridge, c. 1901), 64; Kings County California for Diversified Products and successful Agriculture Viticulture and Horticulture [*sic*] (n.p, c. 1902), 5.

31. Thompson, "Early Reclamation," 66–67. For the politics of Sacramento and Delta reclamation, see Anthony E. Carlson, "The Sacramento River Valley in National Drainage and Flood Control Politics, 1900–1917," in *River City and Valley Life: An Environmental History of the Sacramento Region*, Christopher J. Castaneda and Lee M.A. Simpson, eds. (Pittsburgh: University of Pittsburgh Press, 2013), 135–57; John Thompson and Edward A. Dutra, *The Tule Breakers:*

The Story of the California Dredge (Stockton: Stockton Corral of Westerners, University of the Pacific, 1983), 159, 167.

32. Paul, "Wheat Trade," 411–12.

Chapter 15: Mussel Slough Country

1. "Coast Items," *San Francisco Call*, Sept. 21, 1890.

2. Thanks to Gary Haug for helping me understand the silo.

3. "Alfalfa Silage and a Concrete Silo," *Pacific Rural Press*, April 11, 1908; "Another Way to Make a Round Silo," *Pacific Rural Press*, July 18, 1896. "Livestock Notes," *Pacific Rural Press*, March 18, 1911.

4. Edward Smith Hanson, *Concrete Silos: Their Advantages, Different Types, How to Build Them* (Chicago: Cement Era Publishing, 1915); Loran Berg, "The Farmer's Tower: The Development of the Tower Silo," *Historia* 20 (2011): 38–55.

5. "A Big Day's Outing," *Holstein Breeder and Dairyman* 1 (May 22, 1922), 346; Eugene Menefee and Fred Dodge, *History of Tulare and Kings County California . . .* (Los Angeles: Los Angeles Historical Record Company, 1913, 1923), 417–18.

6. Dairying was only beginning in the county in the mid-1880s. Botsford and Hammond, "Tulare County, California: Truthful Description of Its Climate Soil, Towns, and Vast Agricultural and Other Resources" (Visalia, 1885), 25; William L. Preston, *Vanishing Landscapes: Land and Life in the Tulare Basin* (Berkeley: University of California Press, 1981), 165–66. For railroad, see Keith Bryant, *History of the Atchison, Topeka, and Santa Fe Railway* (New York: Macmillan, 1974), 174–81. G. Holterhoff, *Historical Review of the Atchison, Topeka and Santa Fe Railway Company (With Particular Reference to California Lines)* (Los Angeles: n.p., 1914), 10; Stuart Daggett, *Chapters in the History of the Southern Pacific* (New York: Ronald Press Co., 1922), 324–34.

7. Decision 4623 Railroad Commission of the State of California, "California Railroad Commission Decisions" (Sacramento, 1919), 933–36; "Kings County Fair Largely Attended," *Pacific Rural Press*, Sept. 29, 1917.

8. "Map of Kings County, Cal.," in *David Rumsey Historical Maps* (San Francisco: Punnett Brothers, 1912); *Report of the Conservation Commission of the State of California, January 1, 1913* (Sacramento: Friend Wm. Richardson, Superintendent of State Printing, 1912), Plate II, Irrigation Map of Central California. For lake, see "Tule River Raging," *Los Angeles Herald* 33, no. 177, March 26, 1906.

9. Botsford and Hamm, "Tulare County," 22–23; Preston, *Vanishing Landscapes*, 135; "Local Brevities," *Hanford Weekly Journal*, June 13, 1893.

10. Preston, *Vanishing Landscape*, 96–97; "Correspondents Are Alone Responsible for Their Opinions Lucerne Valley, Tulare County," *Pacific Rural Press*, Oct. 6, 1888; Richard Maxwell Brown, *No Duty to Retreat: Violence and Values in American History and Society* (New York: Oxford, 1991), 98; "Coast Items" *San Francisco Call*, Sept. 21,1890; George Cosgrave, "Rancho Laguna de Tache Grant," *Fresno Morning Republican*, May 9, 1920, 4; box 99, folder 57, Latta Collection.

11. Johnson Account, Tulare Lake—Misc., box 99, Sky 12 (20) 13, Latta Collection.

12. John T. Austin, *Floods and Droughts in the Tulare Lake Basin*, 2nd ed. (Three Rivers, CA: Sequoia Parks Conservancy, 2014), 86–87.

13. The fullest account of the claim, the evidence, the trial, and the outcome are in Johnson; for San Francisco, 29; for claim and trials, 29–77; "The Limantour Claims" (San Francisco: Federal Courthouse, 1983), 2–10; *United States v. Jose Y. Limantour Hubert*, 448.

14. *United States v. Limantour*, 389–451; "The Limantour Claims," 10–12.

15. Frank Norris, *The Octopus: A Story of California* (New York: Doubleday, Page & Co., 1901).

16. Mike Eiman, "Kings County in 50 Objects: Mussel Slough Memorial," *Hanford Sentinel*, Jan. 12, 2015.

17. C. E. Grensky, "Water Appropriation from Kings River," U.S.D.A., Office of Experiment Stations, Report of Irrigation Investigations in California under the Direction of Elwood Mead (Washington, DC: Government Printing Office, 1901), 259–60, 299–301.

18. Henry George, "What the Railroad Will Bring Us," *Overland Monthly and Out West Magazine* 1 (October 1868): 297–306. Henry George, *Progress and Poverty: An Inquiry into the Cause of Industrial Depressions and of Increase of Want with the Increase of Wealth* (New York: Robert Schalkenbach Foundation, 1933).

19. George, "What the Railroad Will Bring Us," 305.

20. Henry George, *Our Land and Land Policy, The Complete Works of Henry George* (New York: Doubleday, Page & Co., 1904, orig. edition 1871), 69.

21. Richard Orsi denounces the myth of land monopoly by the Southern Pacific. Richard J. Orsi, *Sunset Limited: The Southern Pacific Railroad and the Development of the American West, 1850-1930* (Berkeley: University of California Press, 2005), 59–74, 81–82.

22. Orsi, *Sunset Limited*, 94–95; Railroad and Telegraph Line Lands Act (July 27, 1866); *Southern Pacific Railroad Company v. Pierpont Orton* (1879).

23. Orsi, *Sunset Limited*, 19; J. L. Brown, *The Mussel Slough Tragedy* (self-pub., 1958), 27–29.

24. Richard White, *Railroaded: The Transcontinentals and the Making of Modern America* (New York: W. W. Norton, 2011), 95.

25. Railroad and Telegraph Line Lands Act, sections 4, 8, 18; Orsi, *Sunset Limited*, 19. The Central Pacific and Southern Pacific often built under the names of subsidiary companies that were then absorbed into the parent companies. Brown, *Mussel Slough Tragedy*, 28–30; David Maldwyn Ellis, "The Forfeiture of Railroad Land Grants, 1867–1894," *Mississippi Valley Historical Review* 33, no. 1 (June 1946), 30–31.

26. Khaled Bloom, "Pioneer Land Speculation in California's San Joaquin Valley," *Agricultural History* 57, no. 3 (1983): 298–307; Preston, *Vanishing Landscapes*, 123; Cameron Ormsby, "Speculative Spaces: Land Speculation and Social Formation in Two California Counties," *Spatial History Project*, accessed March 28, 2019, http://web.stanford.edu/group/spatialhistory/ cgi-bin/site/pub.php?id=87&project_id=.

27. Preston, *Vanishing Landscapes*, 123; "California Railroad Commission, Station Construction Data, 1855–1893," *Spatial History Project*, accessed March 28, 2019, http://web.stanford.edu/group/spatialhistory/ cgi-bin/site/viz.php?id=97&project_id=0.

28. For a full account see Orsi, *Sunset Limited*, 94–98; see also fn. 23, p. 449, and fn. 20, p. 468. Justin Esrey to Miller & Lux, Oct. 18, 1875; Justin Esrey to Miller and Lux, Nov. 8, 1875; M. S. Babcock to Miller & Lux, Oct. 24, 1875, box 19, folder 19, Latta Collection

29. Brown, *Mussel Slough*, 31–32; Justin Esrey to Miller & Lux, Oct. 18, 1875; M. S. Babcock to Miller & Lux, Oct. 24, 1875, box 19, folder 19, Latta Collection; Orsi, *Sunset Limited*, 98–99, fn. 20, p. 468.

30. Brown, *Mussel Slough*, 98; Paul W. Gates, "Public Land Disposal in California," *Agricultural History* 49, no. 1 (1975): 158–78.

31. Charles Nordhoff, *California for Health, Pleasure, and Residence: A Book for Travellers and Settlers* (New York: Harper & Brothers, 1873), 150.

32. *Southern Pacific Railroad Company v. Pierpont Orton*, 32, F. 457 (1879).

33. Nordhoff, "California for Health," 150; Orsi, *Sunset Limited*, 98–99.

34. Orsi, *Sunset Limited*, 99–102.

35. The fullest account of the gunfight is in Brown, *Mussel Slough*, 61–78.

36. "Mussel Slough Tragedy," reprinted from *Fresno Republican*, May 15, 1880, box 99, folder 57, Latta Collection.

37. Brown, *Mussel Slough*, 89–102.

Chapter 16: Tenants

1. J. P. Munro-Fraser, *History of Marin County, California: Including Its Geography, Geology . . .* (San Francisco: Alley, Bowen, 1880); *History of Marin*, 303; Paul M. Engel, "Towards an Archaeology of Ranching on the Point Reyes Peninsula (master's thesis, Sonoma State University, Cultural Resources Management, 2012), 40.

2. D. S. (Dewey) Livingston, *Ranching on the Point Reyes Peninsula: A History of the Dairy and Beef Ranches within Point Reyes National Seashore, 1834–1992*, Historic Resource Study: Point Reyes National Seashore (Point Reyes Station, Marin County, CA: National Park Service, 1993), 141–42, 148–49.

3. *Marin Journal*, Nov. 4, 1886; Livingston, *Ranching on Point Reyes*, 47; A. Bray Dickinson, *Narrow Gauge to the Redwoods: The Story of the North Pacific Coast Railroad and San Francisco Bay Paddle-wheel Ferries* (Los Angeles: Trans-Ango Books, 1967), 33.

4. *Sausalito News*, April 4, 1890.

5. Christiane Charlotte Fredrika Reinholdt Claussen, accessed March 29, 2019, https://www.findagrave.com/ cgi-bin/fg.cgi?page=gr&GRid=43725280; "Point Reyes Pioneer Passes Away," *Marin Journal*, Nov. 18, 1915; Livingston, *Ranching on Point Reyes*, 86–88; 155–162

6. *Sausalito News*, Jan. 30, 1891; Livingston, *Ranching on Point Reyes*, 105.

7. Point Reyes Lighthouse, accessed March 29, 2109, http://www.lighthousefriends.com/light.asp?ID=66; Livingston, *Ranching on Point Reyes*, 86–88; *Sausalito News*, Aug. 9, 1889; *Marin County Tocsin*, Oct. 4, 1890; Carol Schwab, Newspaper Extracts from the Sausalito News, February 12, 1885, to Dec. 26, 1890 (Novato, CA: Marin County Genealogical Society, Heritage Books, 2006), 282; Carol Schwab, "Newspaper Extracts from the Marin Journal and Marin County Tocsin," Jan. 1, 1891, to Dec. 31, 1891 (Novato, CA: Marin County Genealogical Society, Heritage Books, 2006), 7, 61.

8. Jack Mason, "Mr. Point Reyes Station," *Point Reyes Historian* (Winter 1980): 537.

9. Mason, "Mr. Point Reyes Station," 537.

10. Munro-Fraser, *History of Marin County*, 301, 303; Livingston, *Ranching on Point Reyes*, 37, 46.

11. Robert Righter, *The Battle Over Hetch Hetchy: America's Most Controversial Dam and the Birth of Modern Environmentalism* (New York: Oxford University Press, 2005), 36–42.

12. Gray Brechin, *Imperial San Francisco: Urban Power, Earthly Ruin* (Berkeley: University of California Press, 1999), 86, 89–90.

13. Ambrose Bierce, *A Sole Survivor: Bits of Autobiography* (Knoxville: University of Tennessee Press, 1998), 198–99; Roy Morris Jr., *Ambrose Bierce: Alone in Bad Company* (New York: Crown Publishers, 1995), 173–76, 189; Richard O'Connor, *Ambrose Bierce: A Biography* (Boston: Little, Brown and Company, 1967), 147; David Lindley, *Ambrose Bierce Takes on the Railroad* (Westport, CT: Praeger, 1999), 75–89; Ambrose Bierce, *The Devil's Dictionary* (Cleveland, OH: World Publishing Company, 1911), 16.

14. Morris, *Ambrose Bierce*, 175–76.

15. Stanford University, Circular no. 5, *The Exercises of the Opening Day of Leland Stanford Junior University*, Thursday Nov. 1, 1891; Bierce, *Devil's Dictionary*, 290.

16. *Marin Journal* (San Rafael), Dec. 1, 1898; Livingston, *Ranching on Point Reyes*, 358.

17. "An Ideal Home," *Pacific Rural Press* (San Francisco), Dec. 1, 1888.

18. "An Ideal Home," Dec. 1, 1888.

19. "An Ideal Home," Dec. 1, 1888.

20. *Sausalito News*, May 5, 1893.

21. *Sausalito News*, May 5, 1893; D. S. (Dewey) Livingston, "A Good Life: Dairy Farming in the Olema Valley: A History of the Dairy and Beef Ranches of the Olema Valley and Lagunitas Canyon, Golden Gate National Recreation Area and Point Reyes National Seashore, Marin County, California" (Point Reyes Station, CA: National Park Service, 1993), 53.

22. *Sausalito News*, July 4, 1890; *Marin Journal*, May 22, 1890; *Sausalito News*, Nov. 25, 1899.

23. Livingston, *Ranching on Point Reyes*, 46–47. "Charles Webb Howard Is Sued by His Wife," *Pacific Rural Press*, Nov. 27, 1915; "Mrs. Howard Wins Contest for $250,000," *San Francisco Call*, Dec. 17, 1910; "Large Dairy Buys Purebred Bulls," *Pacific Rural Press*, Nov. 27, 1915.

24. *Sacramento Daily Union*, Jan. 7, 1897; *Marin Journal*, Dec. 1, 1898; Livingston, *Ranching on Point Reyes*, 46, 358., 46, 358.

25. Edward McGrew Heermans, "Kings County, California: The Little Kingdom of Kings" (Hanford, CA: Kings County Exposition Commission, 1915), in the Huntington Library; Kings County California for Diversified Products and Successful Agriculture Viticulture and Horticulture [*sic*] (n.p., c. 1902), 7, in the Huntington Library.

26. Livingstone, *Ranching on Point Reyes*, 147; *San Francisco Call*, Jan. 5, 1896; *Sausalito News*, April 18, 1896; *San Francisco Call*, June 17, 1896.

27. "California Dairy Products," *San Francisco Call*, June 21, 1891; Robert L. Santos, "Dairying in California Through 1910," *Southern California Quarterly* 76, no. 2 (Summer 1994): 175–94; Andrew Robichaud, "The Animal City: Remaking Animal and Human Lives in America, 1820–1910 (PhD dissertation, History Department, Stanford University, 2015), 161–62.

28. Robichaud, "Animal City," 162–64, 170. For scapegoating of Chinese as unhealthy and racialization of disease, see Nayan Shah, *Contagious Divides: Epidemics and Race in San Francisco's Chinatown* (Berkeley: University of California Press, 2001).

29. *San Francisco Call*, Oct. 2, 1897; Robichaud, "Animal City," 164–68, 170–79; *Sausalito News*, Sept. 25, 1897.

30. *Healdsburg Tribune, Enterprise and Scimitar*, vol. 8, no. 25, Sept. 16, 1897; Robichaud, "Animal City," 180, 182; "Dairymen Confer with Board of Health in San Francisco," *Sonoma Democrat*, Sept. 25, 1897; Livingston, "A Good Life," 59–60; Robichaud, "Animal City," 182. For list of laws and regulations, see "Milk and Dairy Food Safety: Branch History," *California Department of Food and Agriculture*, accessed March 29, 2019, https://www.cdfa.ca.gov/ahfss/Milk_and_Dairy_Food_Safety/MDFS_History.html.

31. Livingston, *Ranching on Point Reyes*, 69, 142–43; *Sausalito News*, vol. 36, no. 1, Jan. 3, 1920; "Rapp Buys Big Acreage," *California Grocers Advocate*, vol. 25 (1920), p. 9.

32. Jack Mason, "The Man from Pierce Point," *Point Reyes Historian* (Winter 1976): 78–83, 91; Livingston, *Ranching on Point Reyes,* 142–43.

33. Livingston, *Ranching on Point Reyes*, 142–44. "Record of the Miscellaneous Events of the Day, Point Reyes Coast Guard Station," March 19, 1928, ACC, Point Reyes 583, CAT866, D Ranch, PRA.

34. Alice Hall and Vivian Horick, interviewed by Dewey Livingston and Sue Bay on Oct. 27, 1987, in Oral History Project (Inverness, CA: Jack Mason Museum, 1987, p. 2; copy in Point Reyes National Seashore Archives); Livingston, *Ranching on Point Reyes*, 144–45.

Part Six: Urbs in Horto

1. "History of the Vallejo Marine Terminal," http://www.vallejomarineterminal.com/history/ (site unavailable as of May 17, 2019).

Chapter 17: Citrus

1. Frank Norris, *The Octopus: A Story of California* (New York: Doubleday, Page & Co., 1901), 51. The copy of the novel in the Huntington Library belonged to Jack London. He, presumably, was the one who bracketed this passage in pencil.

2. H. D. Barrows, "William Wolfskill, The Pioneer," *Annual Publication of the Historical Society of Southern California and of the Pioneers of Los Angeles County* 5, no. 3 (1902): 287–94.

3. Julia Lewandoski, "Small Victories: Indigenous Proprietors Across Empires in North America, 1763–1891" (PhD dissertation, History Department, University of California, Berkeley, 2019), chapter 4, "California Indigenous Proprietors from Secularization to Allotment." My thanks to Julia Lewandoski for allowing me to see the chapter.

4. Hugo Reid, "The Indians of Los Angeles County: Hugo Reid's Letters of 1852 [*Los Angeles Star*]," edited and annotated by Robert E. Heizer, Southwest Museum Papers, no. 21 (Los Angeles: "Southwest Museum, Highland Park, 1968), letter 2, p. 15, and letter 22, p. 100. Online copy accessed March 29, 2019, Library of Congress, https://cdn.loc.gov//service/gdc/calbk/007.pdf; George Harwood Phillips, *Vineyards and Vaqueros: Indian Labor and the Economic Exploitation of California, 1771–1877* (Norman, OK: Arthur H. Clark Co., 2010), 230–31, 246–47; Lewandoski, "Small Victories," 12–13, 15–16.

5. John Faragher, *Eternity Street: Violence and Justice in Frontier Los Angele*s (New York: W. W. Norton, 2016), 245–50, 461; Robert H. Jackson and Edward Castillo, *Indians, Franciscans, and Spanish Colonization: The Impact of the Mission System on California Indians* (Albuquerque: University of New Mexico Press, 1995), 94–98.

6. Reid, "The Indians of Los Angeles County," letter 2, p. 15, and letter 22, p. 100; Phillips, *Vineyards and Vaqueros*, 230–31, 246–47; Faragher, *Eternity Street*, 246–49, 460; Richard Henry Street, *Beasts of the Field: A Narrative History of California Farmworkers, 1769–1913* (Stanford, CA: Stanford University Press, 2004), 122; Kelly Lytle Hernandez, *City of Inmates: Conquest, Rebellion, and the Rise of Human*

Caging in Los Angeles, 1771–1965 (Chapel Hill: University of North Carolina Press, 2017), 33–39.

7. Street, *Beasts of the Field*, 118–24; Faragher, *Eternity Street*, 246–47.

8. "Orange Culture in Los Angeles" (excerpt from letter of John Shirley Ward of Los Angeles to Nashville, Tenn. *Rural Sun*), *California Agriculturalist* 4, no. 2 Feb. 1, 1874, box 6, Latta Collection.

9. Richard J. Orsi, *Sunset Limited: The Southern Pacific Railroad and the Development of the American West 1850–1930* (Berkeley: University of California Press, 2005), 324–33; Faragher, *Eternity Street*, 461.

10. Orsi, *Sunset Limited*, 322–33; Lawrence J. Jelinek, *Harvest Empire: A History of California Agriculture* (San Francisco: Boyd & Fraser Publishing Co., 1979), 50–60; Matt Garcia, *A World of Its Own: Race, Labor, and Citrus in the Making of Greater Los Angeles, 1900–1970* (Chapel Hill: University of North Carolina Press, 2001), 17–19.

11. Joseph Netz, "The Great Los Angeles Real Estate Boom of 1887," *Annual Publication of the Historical Society of Southern California* 10, no.1/2 (1915–1916): 55–58, 60–61.

12. Ian Tyrrell, *True Gardens of the Gods: Californian-Australian Environmental Reform, 1860–1930* (Berkeley: University of California Press, 1999), 38–39, 46–47; Charles Dudley Warner, *Our Italy* (New York: Harper & Brothers, 1891), 95; Garcia, *A World of Its Own*, 17–32.

13. Walter Nugent, *Into the West: The Story of Its People* (New York: Alfred A. Knopf, 1999), 90–91. For Charles Dudley Warner's version of such success, see Warner, *Our Italy*, 94, 112.

14. Walter C. Mendenhall, "Ground Waters and Irrigation Enterprises in the Foothill Belt, Southern California," Department of the Interior, U.S. Geological Survey, Water-Supply Paper 219 (Washington, DC: Government Printing Office, 1908), 8, 47–50.

15. Jared Farmer, *Trees in Paradise: A California History* (New York: W. W. Norton, 2013), 241–42; Tyrrell, *True Gardens of the Gods*, 38–39, 46–47.

16. "The Maclay rancho [cartographic material]: ex Mission of San Fernando, Cal.," Author: San Fernando Land & Water Company (Los Angeles), Lithograph 1888, Huntington Library.

17. "Maclay rancho," Huntington Library.

18. Netz, "The Great Los Angeles Real Estate Boom," 67–68.

19. Warner, *Our Italy*, 124.

20. Warner, 127.

21. Kevin Starr, *Inventing the Dream: California Through the Progressive Era* (New York: Oxford University Press, 1985), 77; Warner, *Our Italy*, 25–26, 109, 135.

22. Warner, 147

23. Warner, 88–89, 133.

24. Street, 338–46.

25. Street, 338–70.

26. Street, 371–403; for Geary Act, 377–79; for decline, 396. The best account of the Geary Act is in Hernandez, *City of Inmates*, 65–91. *Wong Wing v. United States* (1896) modified Fong Yue Ting and decriminalized illegal residence. Immigrants could not be imprisoned as punishment, but they could be temporarily confined awaiting deportation.

27. Street, *Beasts of the Field*, 407–39; Andrea Geiger, *Subverting Exclusion: Transpacific Encounters with Race, Case, and Borders, 1885–1926* (New Haven, CT: Yale University Press, 2011), 3–5, 16–35, 45–52.

28. Street, *Beasts of the Field*, 474, 476, 478; Garcia, *A World of Its Own*, 54–58.

29. Garcia, 101.

30. William Hammond Hall, State Engineer, California State Engineering, Detail Irrigation Map, Monrovia

Sheet, David Rumsey Map Collection, Stanford University Library, Stanford, CA; Farmer, *Trees in Paradise*, 243.

31. Farmer, *Trees in Paradise*, 240–41.

Chapter 18: Allensworth

1. Eleanor Mason Ramsey, "Allensworth—A Study in Social Change" (PhD dissertation, Anthropology Department, University of California–Berkeley, 1977), 116–20.

2. Edward McGrew Heermans, "Kings County, California, "The Little Kingdom of Kings," no pagination (Hanford, CA: Kings County Exposition Commission, 1915), Huntington Library.

3. Ramsey, "Allensworth," 145–47.

4. Ramsey, "Allensworth," 145, 149; Kevin Marvin Hamilton, *Black Towns and Profit: Promotion and Development in the Trans-Appalachian West, 1877–1915* (Urbana: University of Illinois Press, 1991), 144–45; Marne L. Campbell, *Making Black Los Angeles: Class, Gender, and Community, 1850–1917* (Chapel Hill: University of North Carolina Press, 2016), 71–73.

5. Alice C. Royal, *Allensworth: The Freedom Colony, California African American Township* (Berkeley, CA: Heyday, Bay Tree Books, 2008), 39.

6. Hamilton, *Black Towns*, 138, 144; Campbell, *Making Black Los Angeles*, 84–85.

7. Ramsey, "Allensworth," 17–24; Hamilton, *Black Towns*, 139, 143–44; Michael Eissenger, "Allensworth: The Least Successful All-Black Rural Community in Central California" (MA thesis, California State University, Fresno, 2009), 4.

8. Hamilton, *Black Towns*, 140; Ramsey, "Allensworth," 155–58.

9. Ramsey, "Allensworth," 49–57; Hamilton, *Black Towns*, 141–43.

10. Heermans, "Kings County."

11. Ramsey, "Allensworth," 49–57; Hamilton, *Black Towns*, 141–43, Heermans, "Kings County."

12. Kathleen Weiler, "The School at Allensworth," *Journal of Education* 172, no. 3 (1990): 12.

13. *Los Angeles Herald*, August 2, 1908; Heermans, "Kings County."

14. *Los Angeles Herald*, Jan. 3, 4, 6, 9, and 13, 1903.

15. *San Francisco Call*, Jan. 9, 1903.

16. *Los Angeles Herald*, Jan. 3, 1903; *San Francisco Call*, Aug. 20, 1903; Campbell, *Making Black Los Angeles*, 1.

17. Quoted in Weiler, "The School at Allensworth," p. 12

18. Weiler, "The School at Allensworth," p. 12; Campbell, *Making Black Los Angeles*, 104.

19. Hamilton, *Black Towns*, 144.

20. Hamilton, 144.

21. Hamilton, 145–46.

Chapter 19: Corcoran

1. *Public Records Online*, accessed March 31, 2019, https://suburbanstats.org/population/california/how -many-people-live-in-corcoran. The town's population in 2017 was 24,818. Of these 18,528 were male and 6,285 are female. There were only 11,118 people living in families in the town, not that much more than those residing in prison. The population at the state penitentiary is 3,157—only about half of what it was in 2008; *Light in Prison*, accessed March 31, 2019, https://lightinprison.org/us/ca/institutions/california -state-prison-corcoran-cor/.

2. Miriam Pawel, *The Browns of California: The Family Dynasty That Transformed a State and Shaped a Nation* (New York: Bloomsbury, 2018), 378–79; for the long history of incarceration in the making of California, see Kelly Hernandez, *City of Inmates: Conquest, Rebellion, and the Rise of Human Caging in Los Ange-*

les (Chapel Hill: University of North Carolina Press, 2017).

3. Pawel, *Browns of California*, 379–80.

4. State Employee Demographics, Active State Employees by Department/Facility, Data as of September 2019, http://www.sco.ca.gov/Files-PPSD/empinfo_ demo_dept.pdf; "Prison Population Dips Hit Avenal, Corcoran," *Hanford Sentinel*, May 2, 2013; another 5,814 were in the substance abuse facility. U.S. Department of Labor, Bureau of Labor Statistics, Hanford-Corcoran Local Area Unemployment Statistics, https://data.bls.gov/timeseries/LAUMT0625260 00000006?amp%253bdata_tool=XGtable&output_ view=data&include_graphs=true; U.S. Department of Labor, Bureau of Labor Statistics, Hanford-Corcoran, Economy at a Glance, March 2019, https://www .bls.gov/eag/eag.ca_hanford_msa.htm#eag_ca_ hanford_msa.f.3. All websites in this note accessed March 31, 2019.

5. "Prison Population Dips Hit Avenal, Corcoran"; Mark Arax and Rick Wartzman, *The King of California: J. G. Boswell and the Making of a Secret American Empire* (New York: Public Affairs, 2003), 417–18.

6. Board of Directors meeting, July 3, 1905, Proxy Papers, p. 15; Board of Directors meeting, Sept. 2, 1905, Security Land and Loan Company; Board of Directors meeting, Jan. 23, 1906; Board of Directors meeting, Jan. 30, 1906; Large Ledger, Security Land and Loan Company—all in Large Ledger, Security Land and Loan Company, box 7; H. J. Whitley to Mr. Van Eaton, Los Angeles, Dec. 20, 1917, Scrapbook, box 1. All these sources are in Hobart Johnstone Whitley Papers, Collection 744, Special Collections, University of California–Los Angeles.

7. Minutes July 15–16, 1907, Corcoran Realty Company, box 11, Whitley Papers; Stock Journal, in Angiola Development Company, box 18, Whitley Papers, "State Bank of Corcoran"; Appendix to the Journals of the Senate and Assembly, Thirty-Seventh Session of the Legislature of the State of California, vol. 2 (Sac-

ramento: W. W. Shannon, Superintendent of State Printing, 1907), 248; *Los Angeles Financier*, Dec. 14, 1907, 17.

8. Proxy Papers and Incorporation Papers, Security Land and Loan Company, Large Ledger, box 7; Incorporation papers, Minutes July 15–16, 1907, Corcoran Realty Company, box 11, both in Whitley Papers. A major investor was George Hanna, who had made money speculating in Los Angeles lands and through the West Los Angeles Water Company; James Miller Guinn, *A History of California and an Extended History of Its Southern Coast Counties*, two volumes (Los Angeles: Historic Record Company, 1907), 2:2248; A. J. Pickerell was a mining manager and investor, *Mining and Scientific Press*, May 9, 1903, p. 306; P. B. Chase seems to have been a cattleman.

9. Board of Directors meeting, Jan. 23, 1906, Feb. 6, 1906, Large Ledger, Security Land and Loan Company, box 7, Whitley Papers. "Hon. J. W. Guiberson," Eugene N. Menefee and Fred G. Dodge, *History of Tulare and Kings Counties California with Biographical Sketches* (Los Angeles: Historic Record Company, 1913), 412.

10. Department of Engineering of the State of California, "Fifth Biennial Report of the Department of Engineering of the State of California, December 1, 1914 to November 30, 1916," ed. Department of Engineering of the State of California (Sacramento: California State Printing Office, 1917), 42–43, 47; Macy H. and W. H. Heileman Lapham, "Soil Survey of the Hanford Area, California," ed. Bureau of Soils U.S. Department of Agriculture (Washington, DC: Government Printing Office, 1901), 451–53; C. E. Grensky, "Water Appropriation from Kings River," USDA, Office of Experiment Stations, Report of Irrigation Investigations in California under the Direction of Elwood Mead (Washington, DC: Government Printing Office, 1901), 276–82.

11. "Tulare Lake Drying Up," an article from the *Tulare County Times*, Aug. 4, 1898, quotes the *Hanford Sen-*

tinel, box 99, Sky 16 (4) 20, Latta Collection; *Tulare Co. Times* (weekly) Thursday, July 28, 1898, box 99, Sky 16 (4) 20, Latta Collection.

12. *Tulare Daily Register*, Friday, Feb. 8, 1889, Tulare Lake—Fishing, box 99, Sky 16 (4) 21, 1889; *Tulare County Register*, Tuesday, Jan. 29, 1889, box 99, Sky 16 (4) 21, 1889, both in Latta Collection; "Tulare Lake Drying Up in 1898," newspaper clipping, box 99, folder 16, Latta Collection.

13. *Report of the Conservation Commission of the State of California, January 1, 1913* (Sacramento: Friend Wm. Richardson, Superintendent of State Printing, 1912), 202–203; "Tule River Raging," *Los Angeles Herald*, vol. 33, no. 177, March 26, 1906; Board of Directors meeting, July 21, 1906, Security Land and Loan Company, Large Ledger, 120–21, box 7, Whitley Papers; "Tulare Lake Filling Up," *Los Angeles Herald*, April 15, 1907; "Tulare Lake Still Rising," *San Francisco Call*, June 21, 1906.

14. "Plans for the City of Corcoran Are Modern, Streets Wide, and Buildings Grouped," *Los Angeles Herald*, Sept. 10, 1907; "Opening of the Town Site of Corcoran Sept. 9 1907," *Los Angeles Herald*, Sept. 1, 1907; "Royal Road to Corcoran," *Los Angeles Herald*, March 21, 1909; J. L. Krieger and Glen Icanberry, *Valley Division Vignettes* (Hanford: Valley Rail Press, 1983), 82, 106.

15. Torsten A. Magnuson, "History of the Beet Sugar Industry in California," *Annual Publication of the Historical Society of Southern California* 11, no. 1 (1918): 77–78; "Sugar Factory to Cost a Million," *Sacramento Union*, June 6, 1907; "Sugar Factory, Depot, and Acreage at Corcoran," *Los Angeles Herald*, March 21, 1909; Board of Directors meeting, Dec. 11, 1906, Security Land and Loan Company, Large Ledger, box 7, Hobart Johnstone Whitley Papers, Collection 744, Special Collections, UCLA.

16. Board of Directors meeting, Dec. 28, 1906; Meeting Jan. 7, 1907, Security Land and Loan Company, Large Ledger, box 7, Whitley Papers.

17. Board of Directors meeting, May 8, 1907; Board of Directors meeting, June 4, 1907, Security Land and Loan Company in Large Ledger, box 7, Whitley Papers; "Plans for the City of Corcoran Are Modern, Streets Wide, and Buildings Grouped," *Los Angeles Herald*, Sept. 10, 1907; "Opening of the Town Site of Corcoran Sept. 9 1907," *Los Angeles Herald*, Sept. 1, 1907; "Royal Road to Corcoran," *Los Angeles Herald*, March 21, 1909; Arax and Wartzman, *King of California*, 84; "Conspiracy Charged in Business Dispute," *San Francisco Call*, June 27, 1911.

18. Board of Directors meeting, Aug. 23, 1906, Security Land and Loan Company; Agreement between Security Land and Loan Company and F. P. Newport and R. V. Milner, Board of Directors meeting, Feb. 1907, p. 6; Board of Directors meeting, Jan. 28, 1907, Security Land and Loan Company, all in Large Ledger, box 7, Whitley Papers.

19. "Plans for the City of Corcoran Are Modern, Streets Wide and Buildings Grouped," *Los Angeles Herald*, Sept. 10, 1907; Board of Directors meeting, Feb. 11, 1907, p. 162; Agreement between Security Land and Loan Company and F. P. Newport and R. V. Milner, Board of Directors meeting, Feb. 1907; Agreement between Security Land and Loan Company and E. P. Newport and R. V. Milner, June 1907, both in Security Land and Loan Company, Large Ledger, box 7; Prices of Turnbull Ranch, Jan. 23, 1909, Ledger Corcoran Land Company, box 32, all in Whitley Papers.

20. Agreement between Security Land and Loan Company and E. P. Newport and R. V. Milner, June 1907, Security Land and Loan Company, Large Ledger, box 7, Whitley Papers.

21. Trial Balance, Nov. 20, 1908, Ledger Corcoran Land Company, box 32, Security Land and Loan Company Ledger, 1, Box 7, Whitley Papers.

22. "Corcoran: The Place of a Thousand Opportunities," Newport and Milner advertisements, c. 1910; "Land Opening . . . Corcoran District," both in Scrapbook, box 34, Whitley Papers.

23. "Sugar Plant in Kings Co. Sold," *Los Angeles Herald*, July 18, 1916; "James Pingree," *Facts About Sugar*, ed. E. W. Mayo (vol. 15, July, 15, 1922), 59; "Conspiracy Charged in Business Dispute," *San Francisco Call*, June 27, 1911; "May Close up Sugar Factory," *Madera Mercury*, Oct. 18, 1918; "Sugar Beet Acreage Short," *Pacific Rural Press*, June 8, 1918; "Sugar Beet Growing Patriotic and Profitable," *Pacific Rural Press*, Jan. 5, 1918; "Sugar Factory Will Run Entire Season," *Madera Mercury*, Jan. 25, 1918; "County Valuation Increases Million," *Mariposa Gazette*, July 14, 1917; Historic California Posts, Camps, Stations and Airfields, Corcoran Prisoner of War Branch Camp (Lakeland Prisoner of War Branch Camp), accessed March 31, 2019, http://www.militarymuseum.org/CorcoranPWCamp.html.

24. H. J. Whitley to Mr. Van Eaton, Los Angeles, Dec. 20, 1917, Scrapbook, box 1, Whitley Papers; *Madera Mercury*, Nov. 9, 1907; May 7, 1915; Oct. 27, 1916; Jan. 23, 1920.

25. Arax and Wartzman, *The King of California*, 282; Corcoran City Council, Joint Powers Finance Authority, Successor Agency for Corcoran RDA, & Housing Authority Agenda, Monday, March 3, 2014, p. 101, accessed March 31, 2019, http://www.cityofcorcoran.com/civica/filebank/blobdload.asp?BlobID=3606.

26. *San Francisco Call*, Sept. 1, 1910; California Conservation Commission Report, 1912, 202–203; *Madera Mercury*, Jan. 10, 1914; *Madera Mercury*, May 7, 1915; *Madera Tribune*, Jan. 8, 1937.

27. "Tulare Lake Bed Soon to Be Drained," *Madera Mercury*, Jan. 29, 1915; "Wheat Is Drowned Out at Lake," *Madera Mercury*, May 12, 1916; "11,000 Acres of Grain Lost in Levee Break," *Press Democrat*, April 4, 1916; "$700,000 Loss as Cal. Levee Breaks," *Los Angeles Herald*, April 3, 1916; "Big Crop Expected on Tulare Lake Country," *Madera Mercury*, June 28, 1918; "Heroic Efforts to Save Grain," *Madera Tribune*, May 25, 1920; *Madera Mercury*, July 15, 1920; "Relocates in Corcoran," *Madera Mercury*, Oct. 13, 1920.

Chapter 20: Cotton

1. For an account of the ginning and packaging at J. G. Boswell, see *Jeremy Birky*, "Boswell Ranch," Nov. 13, 2013, accessed April 1, 2019, https://jeremybirky.wordpress.com/2013/11/27/boswell-ranch/.

2. "California Cotton Acreage May Be Lowest Since the 1920s," *Sierra Sun Times*, April 8, 2015; https://goldrushcam.com/sierrasuntimes/index.php/news/local-news/2835-california-cotton-acreage-may-be-lowest-since-the-1920s.

3. For an example of changes, see A. L. Vandergriff, *Ginning Cotton: An Entrepreneur's Story* (Lubbock: Texas Tech University Press, 1997), 52–58.

4. *Madera Mercury*, no. 146, Nov. 9, 1917, p. 6. The first California cotton was planted in the Imperial Valley; see John Turner, *White Gold Comes to California* (Bakersfield, CA: Acala, 1981), 22–23, 30.

5. "To Plant Cotton in the Valley Meeting," *Madera Mercury*, no. 31, Jan. 4, 1918; "Cotton Gin Corcoran," *Madera Mercury*, no. 39, Feb. 22, 1918.

6. "Cotton Growing Is Success," *Madera Mercury*, no. 12, Aug. 16, 1918.

7. Devra Weber, *Dark Sweat, White Gold: California Farm Workers, Cotton, and the New Deal* (Berkeley: University of California Press, 1994), 20, 21, 25–26.

8. Weber, *Dark Sweat*, 23.

9. Weber, 23–24; "Cotton," *Madera Mercury*, no. 211, Feb. 17, 1920; "Begin Harvest of Cotton Crop," *Madera Mercury*, no. 302, Oct. 5, 1920.

10. Weber, *Dark Sweat*, 29.

11. John H. Constantine, Julian M. Alston, and Vincent H. Smith, "Economic Impacts of the California One-Variety Cotton Law," *Journal of Political Economy* 102, no. 5 (Oct. 1994): 951–55, 970–71; Weber, *Dark Sweat*, 29–31.

12. Weber, 20–21, 31–32.

13. Weber, 34, 38–41, 55; Mark Arax and Rick Wartzman, *The King of California* (New York: Public Affairs, 2003), 149. The conditions of the cotton harvest do not seem have changed much between the 1930s and 1950s. The most complete description for Corcoran dates from the 1950s; see Jess Martinez, *Harvest of Tears* (Xlibris: n.p., 2014). Cletus E. Daniel, *Bitter Harvest: A History of California Farmworkers, 1870–1941* (Ithaca, NY: Cornell University Press, 1981), 178–79.

14. The classic denunciation and description of the Associated Farmers was in Carey McWilliams, *Factories in the Field: The Story of Migratory Farm Labor in California* (Boston: Little, Brown and Company, 1939), 230–39; Norris Hundley, *The Great Thirst* (Berkeley: University of California Press, 2001), 264; Donald Worster, *Rivers of Empire: Water, Aridity and the Growth of the American West* (Oxford, England: Oxford University Press, 1985), 226; Weber, *Dark Sweat*, 118–23. Hearings Before a Subcommittee on Education and Labor, United States Senate Seventy-Sixth Congress, Third Session; Part 54, Agricultural Labor in California; in Paul S. Taylor and Clark Kerr, "Documentary History of the Strike of the Cotton Pickers in California 1933," in Paul Taylor, *On the Ground in the Thirties* (Salt Lake City, UT: Peregrine Smith Books, 1983),130–31; Daniels, *Bitter Harvest*, 179–80.

15. Weber, *Dark Sweat*, 118–19, 122.

16. Jess Martinez, *Harvest of Tears: A Story of the Lives of Migrant Farmworkers in the Cotton Fields and Labor Camps of Corcoran, California* (n.p, n.d. 2014), 15–16, 19, 88. James Boswell led efforts to remove the camps to eradicate evidence of the "Grapes of Wrath days," Arax and Wartzman, *The King of California*, 311.

17. Weber, *Dark Sweat*, 43–44.

18. Weber, 54–55; Line of houses, Caption (orig. description), Photograph, children "Corcoran, San Joaquin Valley California. Company housing for Mexican cotton pickers on large ranch," Dorothea Lange (1895–1965), Blue pencil.svg wikidata:Q230673 q:en:Dorothea Lange, (NARA record: 1372774), Department of Agriculture, Bureau of Agricultural Economics, Division of Economic Information. (ca. 1922–ca. 1953), April 5, 1940, National Archives and Records Administration, College Park Link back to Institution infobox template wikidata: Q6970415, Still Picture Records Section, Special Media Archives Services Division (NWCS-S). Wikimedia Commons.

19. Arax and Wartzman, *King of California*, 138–39, 143; Weber, *Dark Sweat*, 72–74.

20. Frank F. Latta, *Handbook of the Yokuts Indians* (Santa Cruz, CA: Bear State Books, 1977), 667–69.

21. Latta, *Handbook*, 730.

22. Weber, *Dark Sweat*, 65.

23. Weber, 63–64, 68–76.

24. Weber, 81–90, 97–102.

25. Weber, 81–90; Hearings Before a Subcommittee on Education and Labor, United States Senate Seventy-Sixth Congress, Third Session; Part 54, Agricultural Labor in California, in Taylor and Kerr, "Documentary History of the Strike of the Cotton Pickers in California 1933," in Paul Taylor, *On the Ground*, 19–20, 41–43, 61–66 (hereafter cited as "Documentary History"); McWilliams, *Factories in the Field*, 214–20; Daniels, *Bitter Harvest*, 180–83.

26. "Documentary History," 58–59; Weber, *Dark Sweat*, 99. For a worker's memories of the strike—with the emphasis on memories—see Interview of John Sanchez by Harvey Schwartz, Labor Archives and Research Center, J. Paul Leonard Library, San Francisco State University, Boxid OL100020606, Identifier csfst_000027; Projectidentifier cavpp001540, 1998, accessed April 1, 2019, https://archive.org/details/csfst_000027/csfst_000027_t1_b_access.mp3. For an image of "Pickets on the highway calling workers from the fields, 1933 cotton strike," see Inter-

national News Photos, Inc., California Cornerstones: Selected Images from The Bancroft Library Pictorial Collection Single Items From Various Co.

27. "Documentary History," 36–38, 41–43, 48, 81–92.

28. Arax and Wartzman, *King of California*, 153–55; "Documentary History," 82–86. Daniels, *Bitter Harvest*, 196–201.

29. Arax and Wartzman, *King of California*, 14–16.

30. McWilliams, *Factories in the Field*, 221; Daniels, *Bitter Harvest*, 201–202.

31. "Documentary History," 52–53.

32. "Documentary History," 93–96; "Documentary History," 73–80; Weber, *Dark Sweat*, 103–105, Daniels, *Bitter Harvest*, 194–95.

33. "Documentary History," 94–95, 112; Weber, *Dark Sweat*, 103–104. Daniels, *Bitter Harvest*, 204–205, 212–21.

34. "Documentary History," 20, 45–46.

35. William L. Preston, *Vanishing Landscape: Land and Life in the Tulare Basin* (Berkeley: University of California Press, 1981), 200.

36. Arax and Wartzman, *King of California*, 134–36; Weber, *Dark Sweat*, 105.

37. Weber, *Dark Sweat*, 122.

38. James Gregory, *American Exodus: The Dust Bowl Migration and Okie Culture in California* (New York: Oxford, 1989), 29, 53, 55–56.

39. Latta, *Handbook of the Yokuts Indians*, 729.

40. John T. Austin, *Floods and Droughts in the Tulare Lake Basin* (Three Rivers, CA: Sequoia Parks Conservancy, 2014), 161, 239–44.

41. Austin, 250–58; "Kern and Kings River Floods Swelling Tulare Lake Waters," *Madera Tribune*, no. 13, May 15, 1937.

42. Austin, *Floods and Droughts in the Tulare Lake Basin*, 259–60.

43. Austin, 260.

44. "Pelicans, Tulare Lake, flood scenes at Doyle" by Armor, Albert, 1938, Topics californialightandsound, Amateur films, home movie. This film depicts flooding in the Tulare Lake Basin, at Cross Creek and in nearby levees; possibly Elmer Von Glahn's farm; flocks of pelicans and pelican chicks at Tulare Lake, accessed April 1, 2019, https://archive.org/details/chi_000047#.

45. Tulare Lake Shrinks, clipping, "$500,000 Federal Project Reducing Lake Area," Box 105m f. 11 Tulare Lake Water, Box 105.

46. *San Bernardino Sun*, vol. 46, Dec. 11, 1939; Preston, *Vanishing Landscape*, 192.

47. Austin, *Floods and Droughts in the Tulare Lake Basin*, 268.

48. Worster, *Rivers of Empire*, 285–95; Hundley, *The Great Thirst*, 255-68; Arax and Warzman, *King of California*, 382–85; Marc Reisner, *Cadillac Desert: The American West and Its Disappearing Water* (New York: Viking, 1986), 334–35, 349–50.

49. Preston, *Vanishing Landscape*, 219.

Chapter 21: World War II

1. Arnold S. Lott, *A Long Line of Ships: Mare Island's Century of Naval Activity in California* (Annapolis, MD: U.S. Naval Institute, 1954), 155.

2. Lott, *Long Line of Ships*, 145.

3. Lott, *Long Line of Ships*, 148; Statement in Regard to Naval Personnel, n.d., Sidney Morgan Henry Papers, 1905–1981, Bancroft Library, University of California–Berkeley.

4. James L. Mooney, editor, *Dictionary of American Naval Fighting Ships* (Washington, DC: Naval His-

torical Center, Department of the Navy, 1970–1991), 5:392–93.

5. Lott, *Long Line of Ships*, 156–57; Image, *Pediment*, accessed April 2, 2019, https://www.pediment.com/blogs/news/vallejos-mare-island-a-brief-history-in-captions.

6. USS Prometheus Launching Program/Agenda, Dec. 5, 1909, Sidney Henry Morgan Papers, Bancroft Library, UC—Berkeley.

7. Lott, *Long Line of Ships*, 149.

8. "The Necessity of a Permanent Pacific Fleet," Speech of Hon. James D. Phelan of California in the Senate of the United States, July 18, 1916 (Washington, DC, 1916), 3–5, in *Speeches of Hon. James D. Phelan in the 64th Congress*, Huntington Library.

9. "Pacific Coast Defense: Debate on the Need of Increased Naval Appropriations for San Francisco Bay," in *Speeches of Hon. James D. Phelan*, 3–12.

10. "Pacific Coast Defense," 3–12, 13–15; Roger Lotchin, *Fortress California: From Warfare to Welfare, 1910–1961* (New York: Oxford University Press, 1992), 52.

11. Lotchin, *Fortress California*, 53–55.

12. *San Francisco Chronicle*, May 29, 1919, quoted in Roger W. Lotchin, "The City and the Sword: San Francisco and the Rise of the Metropolitan-Military Complex, 1919–1941," *Journal of American History* 65, no. 4 (March 1979): 996–99.

13. Lotchin, "City and the Sword," 999–1003; Lotchin, *Fortress California*, 48–49, 53.

14. Lotchin, "City and the Sword," 1004.

15. Lotchin, "City and the Sword," 996–1020.

16. Roger W. Lotchin, *The Bad City in the Good War: San Francisco, Los Angeles, Oakland, and San Diego* (Bloomington: University of Indiana Press, 2003), 15–16.

17. Wayne Padgett, "Orion Limps to Mare Island," *Naval History* 13, no. 4 (July/Aug. 1999): 38ff.

18. Padgett, "Orion Limps to Mare Island," 38ff.

19. Lotchin, *The Bad City*, 15–16.

20. "Need More Workers at Mare Island," *Healdsburg Tribune, Enterprise and Scimitar*, Aug. 24, 1942; "Navy Yard Makes Appeal for Men," *Healdsburg Tribune, Enterprise and Scimitar*, Aug. 31, 1942.

21. "Male Help Wanted at Mare Island," *Sotoyome Scimitar* (Healdsburg), no. 49, Sept. 3, 1942; Interview with Effie Walling, Women Workers in World War II: Oral History Transcripts of Tape Recorded Interviews Conducted by Students in History 103D, University of California, Berkeley, in May 1979, and related material, 1979, Bancroft Library, University of California, Berkeley, p. 36.

22. "Mare Island Seeks Workers for Shipyards," *Madera Tribune*, no. 202, Oct. 26, 1942; Lotchin, *The Bad City*, 14–15.

23. "Navy Plans Nursery Aid Working Mothers," *Madera Tribune*, no. 193, Oct. 15, 1942; "Women Will Be Needed at Mare Island Navy Yard," *Sausalito News*, no. 10, March 11, 1943.

24. "Women in Navy Yard," *Madera Tribune*, no. 58, May 6, 1943; Interview with Effie Walling, 11.

25. Paul Rhode, "California in the Second World War: An Analysis of Defense Spending," in *The Way We Really Were: The Golden State in the Second Great War*, by Roger W. Lotchin (Urbana: University of Illinois Press, 2000), 96.

26. Interview with Effie Walling, 4, 15, 16.

27. Interview with Effie Walling, 6–7, 24–25; Marilynn Johnson, *The Second Gold Rush: Oakland and the East Bay in World War II* (Berkeley: University of California Press, 1993), 63.

28. Interview with Effie Walling, 20–22, 29.

29. Interview with Effie Walling 8–9, 26, 28, 31–32. For gender and sexual tensions in shipyards, see Johnson, *Second Gold Rush*, 63–66.

30. Johnson, *Second Gold Rush*, 52, 54; for racial tensions in shipyards, 64–66, 71–76.

31. Johnson, 111.

32. Interview with Effie Walling, 18–19; Lotchin, *Fortress California*, 165.

33. Lotchin, 131–69; Paul Rhode, "California in the Second World War," 93–95; Lotchin, *The Bad City*, 8–9.

34. "An unidentified Chinese-American worker whose parents are in China. US Navy Yard, Mare Island, CA," circa 1943, National Archives and Records Administration Blue pencil.svg wikidata:Q51815NARA's Pacific Region (San Bruno) (NRHAS), Record Group 181.

35. James Okumura, "Ancestors & the Land: 75 Years Ago," *Point Reyes Light*, March 30, 2017, accessed April 2, 2019, https://www.ptreyeslight.com/article/ancestors-land-75-years-ago. The student project by Shih-Hung Chen, David Halliday, Megan Knize, Jeffrey D. Port, and Katherine Tarlock was titled "New Perspectives: A Study of Early Dairy on the Point Reyes Peninsula."

36. Okumura, "Ancestors."

37. Okumura.

Chapter 22: Peopling the Darkness

1. William Preston, *Vanished Landscapes: Land and Life in the Tulare Lake Basin* (Berkeley: University of California Press, 1981), 202; Paul Rhode, "California in the Second World War: An Analysis of Defense Spending," in Roger W. Lotchin, ed., *The Way We Really Were: The Golden State in the Second Great War* (Urbana: University of Illinois Press, 2000), 100.

2. F. F. Latta, *El Camino Viejo à Los Angeles* (Bakersfield, CA: Kern County Historical Society, 1936), 18; Mss. Letter of Frank Latta, p. 10, Latta Collection.

3. Joan Didion, *Telling Stories* (Berkeley, CA: Friends of the Bancroft Library, 1978), 8.

4. Joan Didion, *Where I Was From* (New York: Vintage, 2003), 14, 16–17; Joan Didion, *Run River* (New York: Vintage, 1961), 35.

5. Joan Didion, *Where I Was From*, 14.

6. Joan Didion, *Run River*, 44–46.

7. Didion, *Where I Was From*, 151, 155–56, 159, 160–61.

8. Joan Didion, *Slouching Towards Bethlehem* (New York: Farrar, Straus and Giroux, 1968), xiii, 84–85.

9. Didion, *Slouching*, 127–28.

10. Didion, *Where I Was From*, 28.

11. Joan Didion, *Slouching*, xiii, 84–85.

12. Didion, *Where I Was From*, 170–71.

13. Mss. Letter of Frank Latta, Latta Collection.

14. Mss. Letter of Frank Latta.

15. Mss. Letter of Frank Latta, 79–80.

16. Mss. Letter of Frank Latta, 16–18, 801.

17. Mss. Letter of Frank Latta, 53–54, 89.

18. Mss. Letter of Frank Latta, 10–12.

19. Mss. Letter of Frank Latta, 33.

20. Mss. Letter of Frank Latta, 24–26, 32–34, 36, 41.

21. Mss. Letter of Frank Latta, 105.

22. Mss. Letter of Frank Latta, 51, 64.

23. Mss. Letter of Frank Latta, 73, 99–100.

24. Mss. Letter of Frank Latta, 59–60.

25. Mss. Letter of Frank Latta, 101–102.

26. Mss. Letter of Frank Latta, 103.

27. Mss. Letter of Frank Latta, 103–104.

28. *Santa Cruz Sentinel*, Aug. 16, 1960, p. 12; *Santa Cruz Sentinel*, May 12, 1983, p. 10.

29. Joan Didion, *The White Album* (New York: Farrar, Straus and Giroux, 2009; orig. edition, 1979), 58.

30. Didion, *Where I Was From*, 17–18.

Chapter 23: Bob Hope and the Indians

1. Glen Gendzel, "Pioneers and Padres: Competing Mythologies in Northern and Southern California, 1850–1930," *Western Historical Quarterly* 32, no. 1 (2001): 69.

2. H. G. Bolton, *Fray Juan Crespi: Missionary Explorer of the Pacific Coast, 1769–1774* (Oakland: University of California Press, 1927), frontispiece.

3. Phoebe Kropp, *California Vieja: Culture and Memory in a Modern American Place* (Berkeley: University of California Press, 2006), 53; William Henry Hudson, *The Famous Missions of California* (New York: Dodge Publishing Co., 1901), 65. Gendzel, "Pioneers and Padres," 74.

4. Manuscript biography, box 3, folder 2, Hobart Johnstone, 61–63, Whitley Papers.

5. Harry Chandler to Gibbon, Aug. 17, 1909, Series 2: Subject, Subseries 2: Numbered Subject files, box 23, folder 13 Harry Chandler, Gibbon Papers, Huntington Library.

6. List of Complaints, apparently by H. J. Whitley, March 8, 1914, Interviews—Sherman Foundation, box 583, folder 583/5, Los Angeles Times Company Records, Huntington Library.

7. William L. Kahrl, *Water and Power: The Conflict Over Los Angeles Water Supply in the Owens Valley* (Berkeley: University of California Press, 1982), 94–103, quote on 99; Abraham Hoffman, *Vision or Villainy: Origins of the Owens Valley–Los Angeles Water Controversy* (College Station: Texas A&M University Press, 1981), 125–28, 154–57. The best evaluation of the myth and reality of the Owens Valley aqueduct is Steven Erie, *Beyond Chinatown: The Metropolitan Water District, Growth, and the Environment in Southern California* (Palo Alto: Stanford University Press, 2006), 30–38.

8. M. H. Sherman to H. Whitley, Dec. 9, 1918, in Interviews, Sherman Foundation, box 583, folder 583/5, Los Angeles Times Company Records, Huntington Library. For San Fernando Valley Development, see Kahrl, *Water and Power*, 186.

9. Kahrl, *Water and Power*, 189.

10. For Gibbon, see William Deverell, "The Neglected Twin: California Democrats and the Progressive Bandwagon," in William Deverell and Tom Sifton, *California Progressivism Revisited* (Berkeley: University of California Press, 1994), 72–98; for approval of Johnson, 96–97, for Otis and Herald, 86–89. Gibbon to S. C. Smith, June 5, 1909, Series 2: Subject, Subseries 2: Numbered Subject files, box 23, folder 9, Los Angeles Aqueduct, Gibbon Papers, Huntington Library. For opposition to Harriman, see Kahrl, *Water and Power*, 174–75.

11. Hoffman, *Vision or Villainy*, 158–60; Kahrl, *Water and Power*, 170–79.

12. Van Nuys-Lankershim 47000-Acre Subdivision [at upper right] Suburban Los Angeles Homes . . . Rancho Ex Mission de San Fernando Los Angeles County California—V. J. Rowan Surveyor, Nov. 1910, Los Angeles, 1910, The Barry Lawrence Ruderman Map Collection, accessed April 3, 2019, https://purl.stanford.edu/jw357py5564; Catherine Mulholland, *The Owensmouth Baby: The Making of a San Fernando Valley Town* (Northridge, CA: Santa Susana Press, 1987), 3–4, 7–8, 11, 19–20; H. J. Whitley, sample letter, 1910; Press Release, "Greater New Los Angeles," May 1, 1915, both in Los Angeles Suburban Home Company, box 215, folder 215/14, Los Angeles Times Company Records, Huntington Library.

13. *Hollywood Citizen*, Dec. 29, 1916, box 1, Whitley Papers; see box 50, folders 7 and 8, Gibbon Papers, Huntington Library.

14. "The Advanced Gland Treatment," *Los Angeles Times*, May 21, 1922; "Goat Gland Hospital Is Urged Here,"

Los Angeles Times, April 20, 1922; "Times Editor Operated on at Hospital," *Los Angeles Times*, May 19, 1922; "Papers Reveal Joys, Woes of 'Goat Gland Doc,'" *Wichita Eagle and Beacon*, June 3, 1979; "Brilliant, Innovative, and a Certified Quack," *St. Louis Post-Dispatch*, Nov. 4, 1984; Goat Gland Treatment, all in box 215, folder 215/11, Los Angeles Times Company Records, Huntington Library.

15. H. J. Whitley, sample letter, 1910; Press Release, "Greater New Los Angeles," May 1, 1915, both in Los Angeles Suburban Home Company, box 215, folder 215/14, Los Angeles Times Company Records, Huntington Library; Julia Lewandoski, "Small Victories: Indigenous Proprietors Across Empires in North America, 1763–1891" (PhD dissertation, History Department, University of California, Berkeley, 2019), chapter 4, "California Indigenous Proprietors from Secularization to Allotment."

16. Whitley to Gibbon, June 9, 1916; Gibbons to J. W. Johnson c/o H. J. Whitley Syndicate, 1001 Title Insurance Building July 10, 1916, Series 2, Subject, Subseries 1: Numbered Subject files, box 27, folder 14, San Fernando Valley Lands, Gibbon Papers, Huntington Library.

17. Kahrl, *Water and Power*, 188.

18. Manuscript biography, Chapter 14, pp. 6–7, box 3, folder 2, Whitley Papers.

19. Frank F. Latta, *Handbook of the Yokuts Indians*, 2nd ed., revised and enlarged (Santa Cruz, CA: Bear State Books, 1977), 49; Raymond Wood, "Juan Crespi, the Man Who Named Los Angeles," *Southern California Quarterly* 53, no. 3 (1971): 216–19, 224.

20. Maynard Geiger, *Franciscan Missionaries in Hispanic California, 1769–1848* (San Marino, CA: Huntington Library, 1969), 52–54.

21. Bolton, *Crespi*, iii.

22. Mission Tour.org, "Mission San Fernando Bob Hope Memorial," accessed April 3, 2019, http://missiontour .org/wp/sanfernando/mission-san-fernando-bob -hope-memorial.html. Andrew Walther, "Hope Who 'Gave Hope' Converted to Catholic Faith a Few Years Ago," *National Catholic Reporter*, Aug. 10, 2003.

23. Walther, "Hope," *National Catholic Reporter*, Aug. 10, 2003.

24. Bosley Crowther, "The Screen in Review; 'The Paleface' Without Bing Crosby and Dot Lamour, Opens at the Paramount," *New York Times*, Dec. 16, 1948. For Indians in Western comedies of the period, see Liza Black, "Picturing Indians: American Indians in Film, 1941–1960" (PhD dissertation, History, University of Washington, Seattle,1999), 32–36.

25. Francis J. Weber, *Memories of an Old Mission: San Fernando, Rey de Espana* (Mission Hills, CA: Saint Francis Historical Society, 1997), 93; Bosley Crowther, "The Screen in Review; 'The Paleface' Without Bing Crosby and Dot Lamour, Opens at the Paramount," *New York Times*, Dec. 16, 1948.

Chapter 24: Moving Water

1. Donald Worster, *Rivers of Empire: Water, Aridity, and the Growth of the American West* (New York: Oxford, 1992), 290–92.

2. The best guide is Norris Hundley, *The Great Thirst* (Berkeley: University of California Press, 2001), 242–72.

3. Hundley, 246–57.

4. Hundley, 255, 258–59; William Preston, *Vanishing Landscapes: Land and Life in the Tulare Basin* (Berkeley: University of California Press, 1981), 192–93, 216–17.

5. Hundley, *Great Thirst*, 256–61; Worster, *Rivers of Empire*, 4–6, 240.

6. Hundley, 260.

7. Marc Reisner, *Cadillac Desert: The American West and Its Disappearing Water* (New York: Viking, 1986), 349–50.

8. Edwin E. Wilson and Marion Clawson, "Agricultural Land Ownership and Operation in the Southern San

Joaquin Valley," U.S. Department of Agriculture, Bureau of Agricultural Economics (Berkeley, CA, June 1945), Table 6, p. 26. Hundley, *The Great Thirst*, 255-56.

9. Don Villarejo, "New Lands for Agriculture: A Report on Land Ownership and Land Use in the State Water Service Area of the Upper San Joaquin Valley," California Institute of Rural Studies, Davis, CA, 1981, 5–7; "Water Deliveries and Contractor Payments," accessed April 4, 2019, http://www.restorethedelta.org/wp -content/uploads/Pages-54-and-55-Water-Deliveries -and-Contract-Payments.pdf.

10. State Water Contractors, accessed April 4, 2019, http://www.swc.org/our-members; Summers Engineering Inc., Tulare Lake Basin Water Storage District, *2015 Agricultural Water Management Plan*, adopted Nov. 2015, 14 (for map, see Attachment 2, District Map of Tulare Lake Basin), https://www .water.ca.gov/LegacyFiles/wateruseefficiency/ sb7/docs/2015/plans/2015%20AWMP%20-%20 Tulare%20Lake%20Basin%20WSD.pdf; Jackson Walker, LLP, "Who Really Controls California Water," League of California Cities, Sept. 14, 2017, Sacramento; "Water Deliveries and Contractor Payments," accessed April 4, 2019, http://www.restorethedelta .org/wp-content/uploads/Pages-54-and-55-Water -Deliveries-and-Contract-Payments.pdf; Mark Arax and Rick Warzman, *King of California: J. G. Boswell and the Making of a Secret American Empire* (New York: Public Affairs, 2003), 351, 382–83; "Tulare Lake Basin Water Storage District," *Water Association of Kern County* website, accessed April 4, 2019, http:// www.wakc.com/whos-who/tulare-lake-basin-water -storage-district/, April 2018. The district also gets water from the Kings, Kaweah, and Tule rivers (pp. 11–12); the water goes largely to field crops (p. 17). For sources of water since completion of SWP, see pp. 20– 21. For first cutbacks to protect the delta, see Hundley, *Great Thirst*, 504–505.

11. Renée Johnson and Betsy A. Cody, "California Agricultural Production and Irrigated Water Use," June 30, 2015, Congressional Research Service, Con-gressional Research Service, 7–5700, www.crs.gov, R44093, p. 19; Hundley, *Great Thirst*; "Water Deliveries and Contractor Payments," accessed April 4, 2019, http://www.restorethedelta.org/wp-content/ uploads/Pages-54-and-55-Water-Deliveries-and -Contract-Payments.pdf; George Phillips, *Indians and Intruders in Central California, 1769-1849* (Norman: University of Oklahoma Press, 1993), 32–33.

12. Robert Gottlieb, *Reinventing Los Angeles: Nature and Community in the Global City* (Cambridge, MA: MIT Press, 2007), 112–20; Steven Erie, *Beyond Chinatown: The Metropolitan Water District, Growth, and the Environment in Southern California* (Palo Alto, CA: Stanford University Press, 2006), 54–64, 77–80.

13. Devin Galloway and Francis S. Riley, "San Joaquin Valley, California: Largest Human Alteration of the Earth's Surface," in *Land Subsidence in the United States*, D. L. Galloway, D. R. Jones, and S. E. Ingebritsen eds., Circular 1182 (Menlo Park, CA: U.S. Geological Survey, 2006), 28–31; James W. Borchers and Michael Carpenter, April 2014, "Process Guide: California Water Plan Update 2013," California Department of Water Resources, October 2015, 17, 27–32, 46–49; John T. Austin, *Floods and Droughts in the Tulare Lake Basin* (Three Rivers, CA: Sequoia Parks Conservancy, 2014), 155; William M. Alley and Rosemarie Alley, *High and Dry: Meeting the Challenges of the World's Growing Dependence on Groundwater* (New Haven, CT: Yale University Press, 2017), 156.

14. Blaine Hanson, "Irrigation of Agricultural Crops in California," accessed April 4, 2019, https://www.arb .ca.gov/fuels/lcfs/workgroups/lcfssustain/hanson, p. 4; Renée Johnson and Betsy A. Cody, "California Agricultural Production and Irrigated Water Use," June 30, 2015, Congressional Research Service, 7– 5700, www.crs.gov, R44093, pp. 1, 4, 11. According to the U.S. Geological Survey, about 61 percent of California's water usage is attributable to irrigation. This is much lower than the commonly cited 80 percent (pp. 15–16).

15. Tim Hearden, "Ag Woes Have Big Impact on San Joaquin Valley Economy," *Capital Press*, May 21, 2015.

16. Halstead & Associates, "Biological Resources Survey, Resource Conservation Element Update, Kings County General Plan," (Kings County Planning Agency, 2008), 16.

17. Jay Lund et al. *Comparing Futures for the Sacramento–San Joaquin Delta* (San Francisco: University of California Press and Public Policy Institute of California, 2010), 49.

18. Jackson Walker LLP, "Who Really Controls California Water"; "Water Deliveries and Contractor Payments," http://www.restorethedelta.org/wp-content/uploads/Pages-54-and-55-Water-Deliveries-and-Contract-Payments.pdf; Arax and Warzman, *King of California*, 382–83; "Tulare Lake Basin Water Storage District," Water Association of Kern County website, http://www.wakc.com/whos-who/tulare-lake-basin-water-storage-district/; "Tulare Lake Basin Water Storage District, 2015 Agricultural Water Management Plan, Prepared Pursuant to Water Code Section 10826 in Accordance with the Water Conservation Act of 2009 . . . ," adopted Nov. 2015; prepared by Summers Engineering, Inc., Hanford, CA, 6, 14. The district also gets water from Kings, Kaweah, and Tule rivers, pp. 11–12; the water goes largely to field crops, p. 17; for sources of water since completion of SWP, 20–21; For map, see Attachment 2: "District Map and Tulare Lake Basin Topography," https://www.water.ca.gov/LegacyFiles/wateruseefficiency/sb7/docs/2015/plans/2015%20AWMP%20-%20Tulare%20Lake%20Basin%20WSD.pdf. For first cutbacks to protect the delta, see Hundley, *Great Thirst*, 504–505; W. Alley and R. Alley, *High and Dry*, 157.

19. James W. Borchers and Michael Carpenter, *Full Report of Findings: Land Subsidence from Groundwater Use in California, California Water Plan Update, April 2014, California Water Foundation*, 50–53, https://water.ca.gov/LegacyFiles/waterplan/docs/cwpu2013/Final/vol4/groundwater/13Land_Subsidence_Groundwater_Use.pdf; W. Alley and R.

Alley, *High and Dry*, 157–59; "Did You Know?," *Kings River Region Groundwater Info Portal*, April 12, 2018, accessed April 4, 2019, http://kingsgroundwater.info/partners/.

20. W. Alley and R. Alley, *High and Dry*, 159.

21. "California Nephritis/Kidney Disease Death Rate Per 100,000," *CaliforniaLifeExpectancy*, accessed April 4, 2019, http://www.worldlifeexpectancy.com/usa/california-nephritis-kidney-disease; for the most recent population figures and estimates, see https://www.census.gov/quickfacts/fact/table/US/PST045218.

22. "California Median Income by County," *California Franchise Tax Board*, 2013, accessed April 4, 2019, https://data.ftb.ca.gov/PIT-Charts/California-Median-Income-by-County/6gsn-ex6f/data; "Median Household Income," County Health Rankings & Roadmaps, accessed April 4, 2019, http://www.countyhealthrankings.org/app/california/2015/measure/factors/63/data; "Quick Facts, California," *U.S. Census Bureau*, accessed April 4, 2019, https://www.census.gov/quickfacts/fact/table/CA/INC110216#viewtop; Amanda Noss, "Household Income: 2013 American Community Survey Briefs" (Issued September 2014), *U.S. Census Bureau*.

23. Arax and Wartzman, *King of California*, 414. Subsidy data from "Total USDA Subsidies in California, 1995–2017," *EWG's Farm Subsidy Data Base*, accessed April 4, 2019, https://farm.ewg.org/top_recips.php?fips=06000&progcode=total®ionname=California.

24. Cletus E. Daniel, *Bitter Harvest, A History of California Farmworkers, 1870-1941* (Ithaca, NY: Cornell University Press, 1981), 183–85.

25. "Woodville, CA, Profile: Facts & Data," *U.S. Gazetteer, California*, accessed April 4, 2019, https://california.hometownlocator.com/ca/tulare/woodville.cfm.

26. Ryan Sabalow, Dale Kasler, and Phillip Reese, "Farmers say, 'No apologies,' as well drilling hits record levels in San Joaquin Valley," *Sacramento Bee*, Sept. 25, 2017.

27. Sasha Khokha, "California Finally Begins Regulating Cancer-Causing Chemical Found in Drinking Water," *KQED Science*, accessed April 4, 2019, https://www.kqed.org/science/560344/theres-a-cancer-causing-chemical-in-my-drinking-water-but-california-isnt-regulating-it.

28. Carolina Balazs and Isha Ray, "Water Justice in California's Central Valley," in *Sustainable Water: Challenges and Solutions from California*, ed. Allison Lassiter (Berkeley: University of California Press, 2015), 244–45.

29. Balazs and Ray, "Water Justice," 246–63.

30. "State of the Air 2018," pp. 20–23, *American Lung Association*, accessed April 4, 2019, https://www.lung.org/our-initiatives/healthy-air/sota/city-rankings/states/california/.

31. See Sarah Mercedes Ramirez, "Enumerating Invisibility, Humanizing Numbers, Public Health and the Production of Inequities, 1958–1976" (PhD dissertation, Program in Modern Thought and Literature, Stanford University, 2010), particularly pp. 360–61.

32. The two best accounts of the crisis in the delta come from the Public Policy Institute of California: Lund et al., *Envisioning Futures for the Sacramento–San Joaquin Delta* (San Francisco: Public Policy Institute of California, 2007); for fresh water policy, pp. 40–41. The other account is Jay Lund et al., *Comparing Futures for the Sacramento–San Joaquin Delta* (Berkeley: University of California Press and Public Policy Institute, 2010); for reengineered delta, pp. 3–4; for original ecosystem, pp. 17–19; for policy of freshwater delta, pp. 26–35.

33. Jeffrey Mount et al., "Accounting for Water "Wasted to the Sea,'" *San Francisco Estuary and Watershed Science* 16, no. 1 (April 2018): 2, 6–7; Samuel N. Luoma et al., "Challenges Facing the Sacramento–San Joaquin Delta: Complex, Chaotic, or Simply Cantankerous?" *San Francisco Estuary and Watershed Science* 13, no. 3 (2015): 14.

34. Lund et al., *Envisioning Futures*; for CALFED, see pp. vi–vii, 38–41, 87–98; for fish populations, 70–73; for fresh water policy, 40–41. Lund et al., *Comparing Futures*; for crisis and CALFED, 8–15, 35–38. For exotic species, see John R. Durand, "Evaluating the Aquatic Habitat Potential of Flooded Polders in the Sacramento–San Joaquin Delta," *San Francisco Estuary and Watershed Science* 15, no. 4 (2017): 3–4. Number of stakeholders, Luoma, et al., "Challenges Facing the Sacramento–San Joaquin Delta," 5; also for exotic species, p. 15. For an account of CALFED, see Steven Erie, *Beyond Chinatown: The Metropolitan Water District, Growth and the Environment in Southern California* (Palo Alto, CA: Stanford University Press, 2006), 152–68.

35. Robyn Suddeth, Jeff Mount, and Jay Lund, "Levee Decisions and Sustainability of the Sacramento–San Joaquin Delta," *San Francisco Estuary and Watershed Science* 8, no. 2 (Aug. 2010): 1–23; quote, p. 2.

Chapter 25: Restoring the Past

1. Paul Sadin, "Managing a Land in Motion: An Administrative History of Point Reyes National Seashore," prepared for National Park Service, Point Reyes, California, Oct. 2007, 55–57; Laura Alice Watt, *The Paradox of Preservation: Wilderness and Working Landscapes at Point Reyes National Seashore* (Berkeley: University of California Press, 2016), 75–76, 82–85.

2. Miriam Pawel, *The Browns: The Family Dynasty that Transformed a State and Shaped a Nation* (New York: Bloomsbury Publishing, 2018), 149. California's rank fluctuates. It fell during the Great Recession only to rise again. "California Is Now the World's Fifth-Largest Economy, Surpassing United Kingdom," *Los Angeles Times*, May 4, 2018.

3. Sadin, "Managing a Land in Motion," 46–49, 71–75; Watt, *Paradox*, 67–98.

4. Sadin, "Managing a Land in Motion," 74–75, Watt, *Paradox*, 80–81; John Leonard, "John L. Sansing, Oral History," 12, PRA.

5. Sadin, "Managing a Land in Motion," 76–79, 80–81; Watt, *Paradox*, 76–80.

6. Howard Gilliam, *Island in Time: The Point Reyes Peninsula* (San Francisco: Sierra Club, 1962), 60; Sadin, "Managing a Land in Motion," 71.

7. Sadin, 89, 93, 168–71. The size of the pastoral zone shifted as the park took shape; Watt, *Paradox*, 77–89.

8. The Wilderness Act of 1964, Public Law 88–577 (16 U.S.C. 1131–1136), 88th Congress, Second Session, Sept. 3, 1964.

9. Lidia Wasowicz, "Four Bodies Found at Popular Seashore Park," UPI, Nov. 30, 1980; "'Trailside Killer' Goes on Trial in S.D.: Already on Death Row, He Faces Additional Murder Charges," *Los Angeles Times*, Jan. 5, 1988; William Murray, "Suspect Arrested in Hiker Slayings," May 15, 1981, UPI Archives, accessed April 5, 2019, https://www.upi.com/Archives/1981/05/15/Suspect-arrested-in-hiker-slayings/9836358747200/; Jaxon Van Derbeken, "DNA ties Trailside Killer to '79 S.F. Slaying," *San Francisco Chronicle*, Feb. 24, 2010; David Carpenter, *Murderpedia*, accessed April 5, 2019, http://murderpedia.org/male.C/c/carpenter-david-joseph.htm.

10. Sadin, "Managing a Land in Motion," 303–04.

11. "Obituary: Vivian Horick," *Marin Independent Journal*, April 10 1998.

12. "Alice Hall and Vivian Horick, Interviewed by Dewey Livingston and Sue Bay, Oct. 27, 1987," in Oral History Project (Inverness, CA: Jack Mason Museum), 7.

13. Max Mickelsen to Don Neubacher, July 21, 1998, Horick Correspondence, D Ranch, folder 11, PRA; Obituary: Vivian Horick," *Marin Independent Journal*, April 10, 1998; "Rudolph Horick Obituary," *Petaluma Argus-Courier*, July 2, 1980.

14. "Obituary: Vivian Horick."

15. John Sansing to Vivian Horick, July 28, 1993, Horick Correspondence, D Ranch, folder 11, PRA; "Alice Hall and Vivian Horick Interview," Oct. 27, 1987, pp. 3, 7–8; Memorandum from Public Health Consultant, Pacific West Region, May 19, 1998, Horick Correspondence, D Ranch, folder 11, PRA.

16. D. Neubacher to Carol Horick, Todd Horick, and Roger Horick, May 26, 1998; Memorandum from Charlie Strickfaden, Nov. 13, 19, and Dec. 6, 1998, Mutual Release, Dec. 1, 1998; Max A. Mickelsen to John E. Zimmerman, July 7, 1998; Memorandum from Charlie Strickfaden, July 1, 1998; Carol Horick Sethmann to Donald Neubacher, Sept. 18, 1998; Max Mickelsen to D. Neubacher, July 21, 1998; all in Horick Correspondence, D Ranch, folder 11, PRA.

17. Carol Horick Sethmann to Donald Neubacher, Sept. 18, 1998, Horick Correspondence, D Ranch, folder 11, PRA. Watt, *Paradox*, 169–71, gives an account less sympathetic to the National Park Service.

18. D. Neubacher to M. Mickelsen, Dec. 8, 1998; D. Neubacher to Ronald A. Silveira, Dec. 8, 1998, Horick Correspondence, D Ranch, folder 11, PRA.

19. Don L. Neubacher to Max Mickelsen, Aug. 16, 1999, Horick Correspondence, D Ranch, folder 10, PRA.

20. Memorandum, July 31, 1999, Angelina Gregorio to Don Neubacher, Horick Correspondence, D Ranch, folder 10, PRA.

21. Site Visit of the Horick Ranch on Dec. 14, 1999; Don Neubacher to Max Mickelsen, Dec. 27, 1999, Horick Correspondence, D Ranch, folder 10, PRA.

22. Don Neubacher to Max Mickelsen, Feb. 11, 2000, Horick Correspondence, D Ranch, folder 10, PRA.

23. Watt, *Paradox*, 170–71.

24. National Park Service, "Cultural Landscapes Inventory, 1997," D Ranch, Point Reyes National Seashore, 32, PRA.

25. Jack Mason, "Mr. Point Reyes Station," *Point Reyes Historian* (Winter 1980): 534–37. "Alice Hall and Vivian Horick Interview," 1, PRA

26. "D Ranch: Interview with Mrs. Alice Hall and Mrs. Vivien Hall Horick, June 10, 1980," CAT # 866, box D Ranch, PRA.

27. National Park Service, "Cultural Landscapes Inventory, 1997," 31, PRA.

Chapter 26: San Gabriel River

1. Blake Gumprecht, *The Los Angeles River: Its Life, Death, and Possible Rebirth* (Baltimore, MD: Johns Hopkins University Press, 2001), 239.

2. The Regional Planning Commission, County of Los Angeles, *A Comprehensive Report of the Regional Plan of Highways*, Section 2-E, San Gabriel Valley (Los Angeles, Hall of Records, 1929), 16, 127, map facing 136.

3. David Brodsly, *L.A. Freeway* (Berkeley: University of California Press, 1981), 2–3, 9.

4. Reyner Banham, *Los Angeles: The Architecture of Four Ecologies* (Berkeley: University of California Press, 2001, orig. edition 1971), 65–73; Robert M. Fogelson, *The Fragmented Metropolis: Los Angeles, 1850–1930* (Berkeley: University of California Press, 1993, orig. edition 1967), 137–204.

5. Brodsly, *L.A. Freeway*, 2–4, 71, 74–115, particularly 77, 82, 91, 95–96. The best guide to the Olmsted plan and Los Angeles planning in general is Greg Hise and William Deverell, *Eden by Design: The 1930 Olmsted-Bartholomew Plan for the Los Angeles Region* (Berkeley: University of California Press, 2000), 1–63; Frederick Law Olmsted, Harland Bartholomew, and Charles Henry Cheney, *A Major Traffic Street Plan for Los Angeles* (Los Angeles: Committee on Los Angeles Plan of Major Highways, 1924).

6. Hise and Deverell, *Eden by Design*, 1–3, 38–48.

7. Olmsted Brothers and Bartholomew and Associates, *Parks, Playgrounds and Beaches for the Los Angeles Region: A Report Submitted to the Citizens' Committee on Parks, Playgrounds, and Beaches . . .* (Los Angeles, 1930); Jared Orsi, *Hazardous Metropolis: Flooding and Urban Ecology in Los Angeles* (Berkeley: University of California Press, 2004), 55–101, plate 1, p. 21 and plates 46, 48. For context, evaluation, and description, see Hise and Deverell, *Eden by Design*, 46–56.

8. Gumprecht, *Los Angeles River*, 263–69; Hise and Deverell, *Eden by Design*, 1–3, 38–56.

9. Regional Planning Commission, *Report of the Regional Plan of Highways, Section 2-E, San Gabriel Valley*, 75. See Highway Plan facing, p. 16; Olmsteds and Bartholomew, *Parks, Playgrounds, and Beaches*, 195, 203, 227, 230–32.

10. Regional Planning Commission, *A Comprehensive Report*, 75; Brodsly, *L.A. Freeway*, 98, 103, 106.

11. Matthew William Roth, "Concrete Utopia: The Development of Roads and Freeways in Los Angeles, 1910–1950" (PhD dissertation, History Department, University of Southern California, 2007), chapter 6: 34–36.

12. Brodsly, *L.A. Freeway*, 101–26.

13. Robert Gottlieb, *Reinventing Los Angeles: Nature and Community in the Global City* (Cambridge, MA: MIT Press, 2007), 221–25.

14. My thanks to Robert Carriker for giving me the coordinates (34.092459, -118.006743) for the homesteads.

15. Robert M. Carriker, *Urban Farming in the West: A New Deal Experiment in Subsistence Homesteads* (Tucson: University of Arizona Press, 2010), 81–82, 84–87, 89, 92, 97, 99, 100, 101. El Monte federal subsistence housing. Three-room house. Seventeen dollars and seventy cents rent applied on purchase. Father: carpenter. Library of Congress Prints and Photographs Division Washington, D.C. 20540 USA http://hdl.loc.gov/loc.pnp/pp.print.

16. Carriker, *Urban Farming*, 114–16.

17. Gumprecht, *Los Angeles River*, 205–15.

18. Gumprecht, 114, 215–20; Orsi, *Hazardous Metropolis*, 110–11.

19. Sarah S. Elkind, *How Local Politics Shape Federal Policy: Business, Power, and the Environment in*

Twentieth-Century Los Angeles (Chapel Hill: University of North Carolina Press, 2011), 83, 85–90, 92–103.

20. Kevin Starr, *Embattled Dreams: California in War and Peace, 1940–1950* (New York: Oxford University Press, 2002), 282–86.

21. Gumprecht, *Los Angeles River*, 239.

22. Elkind, *How Local Politics*, 103–10; Orsi, *Hazardous Metropolis*, 127–28.

23. Orsi, 26–28, 120–28; Gumprecht, *Los Angeles River*, 232; "Old Mission Colony Folk Lose Homes in 60 Days," *Los Angeles Times*, July 1, 1951.

24. Louis Sahagun, "U.S. Army Corps of Engineers Says Whittier Narrows Dam Is Unsafe and Could Trigger Catastrophic Flooding," *Los Angeles Times*, Sept. 14, 2017.

Conclusion

1. John McPhee, *Control of Nature* (New York: Farrar, Straus and Giroux, 1989), 184.

2. David Brodsly, *L.A. Freeway* (Berkeley: University of California Press, 1981), 131.

3. Wendell Cox, "California's Dense Suburbs and Urbanization," March 15, 2018, *NewGeography*, accessed April 6, 2019, http://www.newgeography.com/content/005908-californias-dense-suburbs-and-urbanization.

4. Natalia Molina, *How Race Is Made in America: Immigration, Citizenship, and the Historical Power of Racial Scripts* (Berkeley: University of California Press, 2014), 2–11; "QuickFacts, Azusa city, California," *U.S. Census Bureau*, accessed April 6, 2019, https://www.census.gov/quickfacts/fact/table/azusacitycalifornia/PST045216.

5. Wendy Cheng, "The Changs Next Door to the Diazes: Suburban Racial Formation in Los Angeles's San Gabriel Valley," *Journal of Urban History* 39, no. 1 (2013): 15–35.

6. "QuickFacts, California," *U.S. Census Bureau*, accessed April 6, 2019, https://www.census.gov/quickfacts/CA.

7. Matt Garcia, *A World of Its Own: Race, Labor, and Citrus in the Making of Greater Los Angeles* (Chapel Hill: University of North Carolina Press, 2001), 258.

8. Personal communication from Matt Garcia, June 5, 2018.

9. D. J. Waldie, *Holy Land: A Suburban Memoir* (New York: W.W. Norton, 2005; first edition 1996), 3, 45.

10. Waldie, *Holy Land*, 159–62.

11. "QuickFacts, Lakewood city, California," *U.S. Census Bureau*, accessed April 6, 2019, https://www.census.gov/quickfacts/fact/table/lakewoodcitycalifornia/PST045217; Waldie, *Holy Land*, 190–91.

12. Paul Sadin, "Managing a Land in Motion: An Administrative History of Point Reyes National Seashore," prepared for National Park Service, Point Reyes, California, Oct. 2007, 304–14; the quote on p. 311 is from Robert Z. Melnick, Daniel Sponn, and Emma Jane Saxe, *Cultural Landscapes: Rural Historic Districts in the National Park System* (Berkeley: University of California Press, 1987); Laura Alice Watt, *Paradox of Preservation: Wilderness and Working Landscapes at Point Reyes National Seashore* (Berkeley: University of California Press, 2017), 146–54. Personal Communication from Gordon White, May 11, 2018. National Park Service, Cultural Landscape Inventory, 1997, D Ranch, Point Reyes National Seashore, 13.

13. Record of Cooperator's Decisions . . . , Rudy Horick, June 1973, Horick Correspondence, D Ranch, folder 10. PRA.

14. Ranch Plan, Unit 102, Vivian Horick—Agricultural Lease, 1991, PRA.

15. "The Secretary of the Interior's Standards for Rehabilitation," Attachment E, Special Use Permit, Vivian Horick, from Dec. 1, 1991, PRA.

16. Watt, *Paradox*, 171–72.

Epilogue

1. Alice Y. Hom, "The Bradbury Building Lives On," *Southern California Quarterly* 66, no. 4 (Winter 1984): 359–61; "Los Angeles' Stride," *San Francisco Call*, Sept. 5, 1895.

2. "Byrne Building (1895)," *PCAD*, accessed April 6, 2019, http://pcad.lib.washington.edu/building/5022/; Hom, "The Bradbury Building," 359–61. I have relied on an unpublished paper by Christopher Hawthorne, "Fifty Percent Plus a Feather."

3. Gale Holland, "L.A.'s Homelessness Surged 75% in Six Years: Here's Why the Crisis Has Been Decades in the Making," *Los Angeles Times*, Feb. 1, 2018, accessed April 6, 2019, http://www.latimes.com/local/lanow/la-me-homeless-how-we-got-here-20180201-story.html; Reyner Banham, *Los Angeles: The Architecture of Four Ecologies* (Berkeley: University of California Press, 2001, orig. edition 1972), 190.

4. "Los Angeles' Stride," *San Francisco Call*, Sept. 5, 1895; "Byrne Building (1895)," http://pcad.lib.washington.edu/building/5022/.

5. An old newspaper article claimed that James W. Byrne and his brother Callaghan designed the building named after their deceased brother Fred, but neither was an architect. "Los Angeles' Stride," *San Francisco Call*, Sept. 5, 1895; *San Bernardino Sun*, Dec. 27, 1930. Per Paragraph SIXTEEN of the last will and testament of Donor, James W. Byrne executed on Sept. 14, 1925. I received this information from Dean Denise Ellestad.

6. Information from Dean Denise Ellestad, Per Gardner Trimble's memo dated June 15, 1901.

7. "Edmundo Pizzella, 1878–1941," in *Edan Milton Hughes, Artists in California 1786–1940*, 3rd ed. (Sacramento, CA: Crocker Art Museum 2002), 2: 883.

8. "Married," *Sacramento Daily Union*, June 16, 1882.

9. Robert Glass Cleland, *The Irvine Ranch of Orange County, 1810–1950* (San Marino, CA: Huntington Library, 1952), 51–53, 67–73, 101, 147. Margaret Byrne, p. 65, Schedule 1, First Precinct of Ward 10, San Francisco California, United States Census, Population, 1870, National Archives and Record Administration, Ancestry.com.

10. Cleland, *Irvine Ranch*, 93–94, 107–108.

11. Ann Forsyth, *Reforming Suburbia: The Planned Communities of Irvine, Columbia, and the Woodlands* (Berkeley: University of California Press, 2005), 55–56, 59.

12. Forsyth, *Reforming Suburbia*, 55,

13. Forsyth, 57–59; for continuing speculation about Myford Irvine's death, see "What Really Happened to Mike Irvine?" *Coast Magazine, Orange County Register*, Jan. 6, 2011, accessed April 6, 2019, https://www.ocregister.com/2011/01/06/what-really-happened-to-mike-irvine/.

14. Forsyth, *Reforming Suburbia*, 57–60, 62, 104–105. For a full story of Irvine Ranch development, see Forsyth, 62–106.

15. Edward A. Morphy, Introduction to *James W. Byrne, Recollections of the Fire*, reprinted from *The Argonaut*, Nov. 27, Dec. 4, and Dec. 11, 1926 (San Francisco: Privately printed, 1927), v–vii, 10–11, 53–56.

16. "Last Will and Testament of James William Byrne," copy at Stanford University, Sept. 14, 1925; *San Francisco Call*, Oct. 29, 1909; *San Francisco Call*, June 16, 1909; "Prominent Clubman Dies in This City," *San Francisco Call*, Oct. 2, 1908; "James W. Byrne is the Host at a Large Dinner," *San Francisco Call*, Feb. 13, 1902; *San Francisco Call*, Nov. 12, 1905; *San Francisco Call*, Nov. 20, 1897; *San Francisco Call*, June 3, 1906; *San Francisco Call*, Dec. 8, 1906. Margaret Irvine, listed in the California Death Index, 1905–1939, p. 5257, on Ancestry.com.

ILLUSTRATION CREDITS

All photographs without a credit in this list were taken by Jesse Amble White.

All maps were created by Erik Steiner, except where credited otherwise.

5 Courtesy of the Library of Congress Geography and Map Division, Washington, DC; believed to have been published in Amsterdam by I. Hondius in 1595.

11 (top) Painting by Raymond Aker (1955), reproduced courtesy of the Raymond Aker Family.

17 Roy D. Graves Pictorial Collection, BANC PIC 1905.17500.10:350—ALB. Courtesy of The Bancroft Library, University of California, Berkeley.

21 The Plate of Brass, BANC PIC 19xx.031:053—OBJ. Courtesy of The Bancroft Library, University of California, Berkeley.

26 Nicola van Sype, *La herdike enterprinse faict par le Signeur Draeck D'Avoir cirquit toute la Terre*, Hans and Hanni Kraus Sir Francis Drake Collection, Library of Congress [Antwerp?: s.n., 1581].

36 California Historical Society Collection, 1860–1960, University of Southern California Libraries, Los Angeles, California.

37 Huntington Library, San Marino, California.

38 Huntington Library, San Marino, California.

39 Huntington Library, San Marino, California.

40 Stanford Library.

49 Geoffrey Holt, *Restoration Drawing: Wall Decoration over Doorway, Façade of Mission House*, c. 1937, watercolor, Index of American Design 1943.8.5941, National Gallery of Art, Washington, DC.

52 California Historical Society Collection, 1860–1960, University of Southern California Libraries, Los Angeles, California.

65 C. Hart Merriam Collection of Native American Photographs, ca. 1890-1938, BANC PIC 1978.008—PIC. Courtesy of the Bancroft Library, University of California, Berkeley.

89 Image courtesy of the Kings County Library, Hanford, California.

96 U.S. Public Land System.

99 Image courtesy of the Kings County Library, Hanford, California.

109 Solano-Reeve Collection, Huntington Library, San Marino, California.

111 Ralph and Carole Temple Collection, Workman and Temple Family Homestead Museum, City of Industry, California.

112 Douglas Neilson Collection, Workman and Temple Family Homestead Museum, City of Industry, California.

121 Port Costa, Carquinez Strait, P93-065 (SAFR 21374), San Francisco Maritime Museum classified photograph collection, 1575–1984, San Francisco Maritime National Historical Park.

122 Digital image courtesy of the Getty's Open Content Program, J. Paul Getty Museum.

127 California State Engineering Department, David Rumsey Map Collection, Stanford University Library.

135 Courtesy of John Walker, *Fresno Bee*.

137 Vivian Hall Collection, Point Reyes National Seashore Archive.

140 Anne T. Kent California Room, Marin County Free Library, San Rafael, California.

142 Published in *The Wasp*, August 19, 1882.

153 California State Engineering Department, David Rumsey Map Collection, Stanford University Library.

154 Pacific Novelty Co., San Francisco, Agua Caliente Cultural Museum, Palm Springs, CA.

155 Library of Congress Geography and Map Division, Washington, DC.

160 California Department of Parks and Recreation: Photographic Archives, Colonel Allensworth State Historical Park.

161 California Department of Parks and Recreation: Photographic Archives, Colonel Allensworth State Historical Park.

164 California Department of Parks and Recreation: Photographic Archives, Colonel Allensworth State Historical Park.

183 Dorothea Lange, *Company Housing for Cotton Workers near Corcoran, California*, November 1936, Library of Congress Prints and Photographs

Division, LC-USF34-009934-C [P&P] LOT 344 (corresponding photographic print).

189 Photograph from the Bureau of Ships Collection, Naval History and Heritage Command, National Archives, Washington, DC.

192 (top) *Women Shipfitters Worked on Board the USS* Nereus . . . *U.S. Navy Yard, Mare Island, CA*, National Archives and Records Administration, NARA's Pacific Region (San Bruno), Wikimedia Commons.

192 (bottom) National Archives and Records Administration, NARA's Pacific Region (San Bruno), Wikimedia Commons.

193 Point Reyes Archives, National Park Service, Point Reyes National Seashore, HPRC 056120.

207 Huntington Library, San Marino, California.

218 "Tulare Lake Basin Storage District: 2015 Agricultural Water Management Plan," prepared by Summers Engineering (Hanford, CA: November 2015), 47. Map dated May 1992.

222 NASA, from earthobservatory.nasa.gov.

233 (top) Anne T. Kent California Room, Marin County Free Library, San Rafael, California.

233 (bottom) Point Reyes Archives, National Park Service, Point Reyes National Seashore.

241 Dorothea Lange, *El Monte Federal Subsistence Housing. Three-Room House. Seventeen Dollars and Seventy Cents Rent Applied on Purchase. Father: Carpenter. California*, February 1936, Library of Congress Prints and Photographs Division, LC-USF34- 001944-C [P&P] LOT 361 (corresponding photographic print).

248 Yokut basket, Courtesy of the Oakland Museum of California.

INDEX

Note: Page numbers in *italics* refer to photographs. Page numbers followed by *n* refer to notes.

Indians, in California
 and American Indian policy, 81–89, 151–54
 Audubon's views on, 61
 in Central Valley, 58–89, 247
 corruption, victims of, 84
 Drake and, 18
 genocide of, 81, 87–88
 labor in orchards and vineyards, 151
 land seizure, 81
 land system and claims, 101
 and missions, 39–49, 51–57, 203, 208
 move into Los Angeles, 152
 myths of, xv
 at Point Reyes, 18–19
 representation in movies, 209
 roundups of drunken, 152
 sexuality of, 54
 and smallpox, 151
 See also missions; *specific tribal groups*
Indian reservations, 83–87
 as corrupt system, 87
 federal inspectors for, 84
industrial schools, 162
interstate highway system, 240
Inverness Ridge, 227
irrigation, 144, 154, 206, 223, 302n
 canal, *219*
Irvine, California, 259–60
Irvine, Joan, 260
Irvine, Margaret Byrne, 258–59, 260.
Irvine, Myford, 259
Irvine Ranch, 259
Island in Time (Gilliam), 228
Italian nationals, arrest after Pearl Harbor, 193

J Ranch, 140
Jacks Bay, 3
Jackson, Helen Hunt, 37, 39–40
Japanese immigrants, 157, 191, 193, 241
Japanese Americans, arrest after Pearl Harbor, 193
Jefferson, Thomas, 95
J. G. Boswell Company, 184, 185, 217, 221
Johnson, Hiram, 15, 205
Johnston, Adam, 81

Jones Pumping Plant, 216
Jordan, David Starr, 203
José, Nicolás, 44

Kanawha (USNS), 187
Kaweah River, 71, 185
Kaweah Yokuts, 71
Kearney, Denis, 133
keiyaku-nin (labor contractors), 157
Kelly, Isabel, 9
Kern County, 217
 cotton farmers, 180
Kern Valley Water Agency, 217
Kettleman Hills, 66
Kings County, 132, 221–23
 abandoned houses, 195
 agricultural strikes, 182–84
 Allensworth school, *158*
 billboards, Santa Rosa *rancheria*, 59
 California Aqueduct, *212*
 dry riverbed, *213*
 farmland, 184
 irrigation canal, *219*
 median per capita income in 2016, 221
 Mussel Slough massacre site, *129*
 old oak in new orchard, *94*
 pollution, 222
 silo and fields, *90–91*
 silo near Guernsey, *124*
 slough north of Tulare Lake, *68*
 subsidence, *222*
 Tachi Palace, *246*, 247–48
Kings River, *81*, 81, 97
 cattle grazing land, 98
Kings River Farm, 82, 84
 horse theft by Indian, 85
Kirkman, George Wycherley, 16
Ki-yoo (Coyote), 69
Kraft, Roy, 200
Kuyu Illik rancheria, 82

labor
 and capital, 114
 for cotton growers, 180